LIFE BETWEEN THE LEVEES

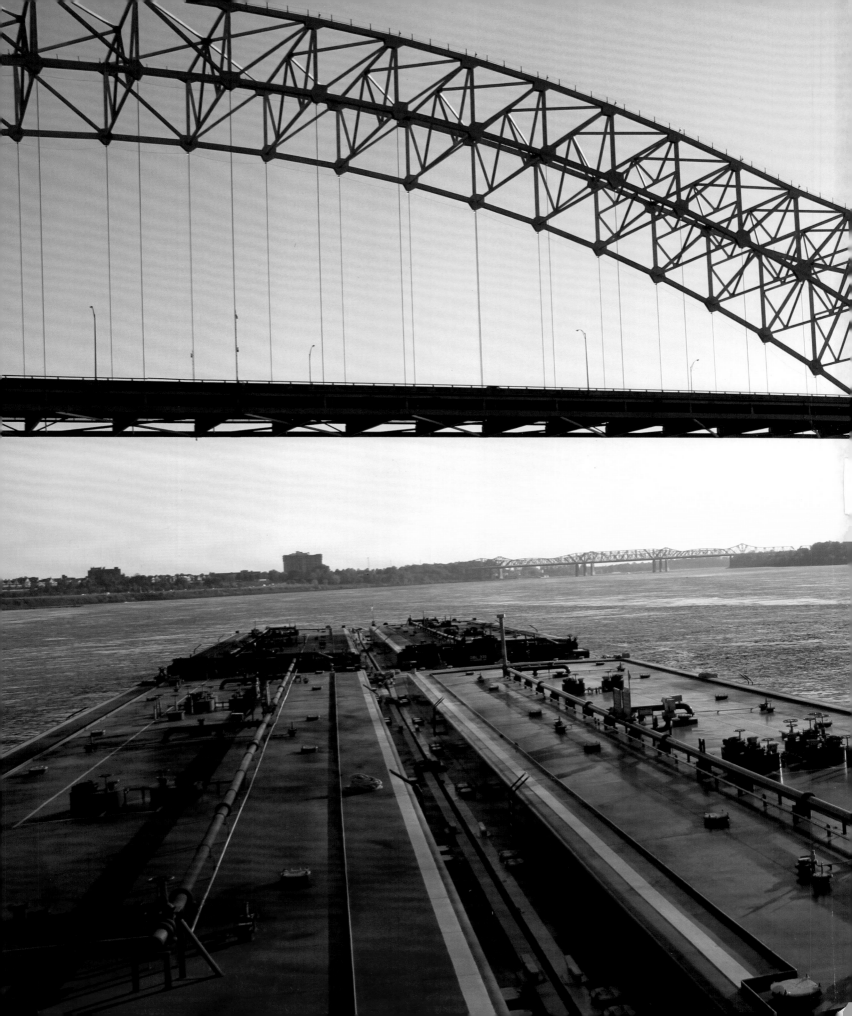

Life Between the LEVEES

America's Riverboat Pilots

MELODY GOLDING

University Press of Mississippi / Jackson

The University Press of Mississippi is the scholarly publishing agency of
the Mississippi Institutions of Higher Learning: Alcorn State University,
Delta State University, Jackson State University, Mississippi State University,
Mississippi University for Women, Mississippi Valley State University,
University of Mississippi, and University of Southern Mississippi.

www.upress.state.ms.us

The University Press of Mississippi is a member
of the Association of University Presses.

Designed by Todd Lape

All photographs by Melody Golding

First printing 2019
∞

Library of Congress Cataloging-in-Publication Data

Names: Golding, Melody, author, photographer.
Title: Life between the levees : America's riverboat pilots / Melody Golding.
Description: Jackson : University Press of Mississippi, [2019] | "All photo-
graphs by Melody Golding." | "First printing 2019." | Includes index.
Identifiers: LCCN 2018037093 (print) | LCCN 2018053839 (ebook) | ISBN
9781496822857 (epub single) | ISBN 9781496822864 (epub institutional) |
ISBN 9781496822871 (pdf single) | ISBN 9781496822888 (pdf institutional)
| ISBN 9781496822840 (cloth : alk. paper)
Subjects: LCSH: Inland navigation—United States. | River boats—United
States. | Pilots and pilotage—United States—Interviews.
Classification: LCC HE629 (ebook) | LCC HE629 .G65 2019 (print) | DDC
623.88092/273—dc23
LC record available at https://lccn.loc.gov/2018037093

British Library Cataloging-in-Publication Data available

⋆ ⋆ ⋆ ⋆ ⋆

This book I affectionately dedicate to my husband and true-life river man, Steve Golding, without whose expertise, unending support, and encouragement, it would never have been written

⋆ ⋆ ⋆ ⋆ ⋆

ix / Acknowledgments
xiii / Introduction
xvii / Western Rivers and Inland Waterways

INTERVIEWS
3 / William V. Torner, 1915
6 / Steve John Butkovich, 1928
8 / George Wilson "Sonny" Banta, 1929
11 / Odis Lowery, 1930
13 / Louis E. "Jackie" Neal, 1930
18 / Louis Edward Rineheart, 1930
23 / Frank William Banta Sr., 1931
25 / Gene Neal, 1931
27 / Charles F. Lehman, 1932
29 / Albert L. Wolfe, 1932
34 / Leo J. Braun, 1933
36 / Franklin E. "Gene" Goins Sr., 1934
38 / Garland Shewmaker, 1934
40 / Jerald "Jerry" Tinkey, 1934
45 / Clarke C. "Doc" Hawley, 1935
50 / James Bernard "Suitcase" Simpson, 1935
52 / Howard Hayes Brent, 1937
55 / William Alfred "Peanut" Hollinger, 1937
59 / John S. "Smitty" Smith, 1937
62 / Malcolm Gunter, 1939
66 / Joseph V. Gale Jr., 1940
69 / Harold Schultz, 1940

73 / William "Murry" Couey, 1941
77 / Delfred J. Romero, 1942
79 / Charles Turner, 1942
84 / Jimmy F. Sharp, 1943
86 / Jerry Faulkner, 1944
88 / Menville Trosclair Sr., 1944
93 / Perry Wolfe, 1944
96 / Joe Zeiczak, 1944
100 / Richard "Dickey" Mathes, 1945
104 / Larry Ritchie, 1945
107 / John Louis "Sonny" Carley, 1946
109 / James W. "Jim" Ghrigsby Sr., 1946
113 / Emile P. Dufrene, 1948
118 / Andy Burt, 1950
121 / Joseph T. Davisson, 1950
125 / Charles Wesley Brown, 1951
129 / David E. Dewey, 1951
132 / Gary Guidry, 1951
140 / Herman Blatz "Butch" Harrington Jr., 1951
143 / Charlie Ritchie, 1951
149 / Gregory James "Greg" Menke, 1952
154 / David Christen, 1953
157 / James W. "Jimbo" Davis Jr., 1953
164 / Keith E. Menz, 1953
166 / William R. "Randy" Scarborough, 1953
167 / Rex Williams, 1953
169 / William "Billy" Allen, 1954

CONTENTS

172 / William "Bill" Rankine, 1954

178 / Rudy Ward, 1954

184 / William B. "Bill" Winders Jr., 1954

187 / John Henry Walker, 1955

189 / Cecil D. Duncan, 1956

192 / Harley Hall Jr., 1956

198 / Markham Dewayne "Bozo" Mandolini, 1956

201 / Joy Mary Manthey, 1957

206 / Rodney W. Cockrell Sr., 1958

208 / Mark Haury, 1958

211 / Charles K. "Kenny" Murphy Jr., 1958

216 / Terri L. Smiley, 1958

219 / John S. Boswell, 1959

221 / Christopher R. Edwards, 1959

223 / John Grammer, 1959

225 / Daniel Lee "Danny" Redd, 1960

230 / Joseph E. Gaudin Jr., 1961

232 / Ronald "Jonesy" Jones, 1961

234 / Dale E. Cox, 1962

237 / Steven Hearn, 1962

239 / Patrick Soileau, 1962

244 / Danny Casey, 1963

246 / Perry Hillard Jones, 1963

248 / Mark "Red" Jones, 1964

250 / Timothy D. "Tim" Miller, 1964

252 / Marty Rineheart, 1964

256 / Robert Wayne "Bob" Matchuny, 1965

258 / David "D. W." Wetherington, 1966

260 / Earl M. Conner Jr., 1967

262 / Chris Wakeland, 1968

264 / Katherine A. Chaplin, 1969

268 / Perry Maupin, 1969

271 / Todd Hundley, 1970

274 / Jody LaGrange, 1970

276 / Tim Bennett, 1971

277 / Richard T. Bondurant, 1971

282 / Boyce "Pete" Stuckey, 1972

284 / Gustave Anthony "Butch" Marie III, 1973

286 / Mitchell Scott Coulter, 1974

287 / John Hall, 1974

288 / Jason Paul Jones, 1974

292 / Brett H. Shannon, 1975

294 / Jeremy Brister, 1977

296 / M. Sage Cole, 1977

298 / J. R. Miller, 1977

300 / Eric Stern, 1977

304 / Jeffrey Orr, 1979

306 / Brad Juneau, 1980

308 / Michael Paul Ditto, 1983

310 / David John King, 1984

312 / Jason Pitre, 1984

313 / Max Taber, 1987

317 / Index

ACKNOWLEDGMENTS

I would like to give thanks to God for giving me the ability to do this work.

I am deeply thankful to and would like to acknowledge with sincere gratitude the mariners who so generously shared their stories so that others would know and appreciate "life on the river."

Furthermore, I am thankful to my publisher, the University Press of Mississippi, and my editor, Craig Gill, who has believed in my work from the very beginning. Many thanks especially to Golding Barge Line Captain Todd Hundley and Mike Gatti, who aided me along the way.

Last and not least I would like to thank my family, Steve, Austin, and John Reid, who have encouraged and supported me through this journey.

May God Bless all of you.

Almighty God our Heavenly Father, Creator of the Universe and Author of Salvation, we give thanks for all of the great rivers which flow from this nation but most especially we give you thanks for the noble Mississippi River and her tributaries which helped propel this nation into greatness. The gift of abundance you provide us through these rivers would be for naught except for the skill and dedication of the American Merchant Mariner. Be pleased to hear us and to let your blessing rest always upon these who plough the rivers of this nation. Reach out your hand to them as you did to blessed Peter when he walked upon the sea. Send a holy angel from on high to watch over them and to aid their navigation. When they have completed their watches, bring them back to their homes and kin where they may, with glad and grateful hearts, be pleased to give you thanks for all things. And finally we pray that when each of us has completed our final watch here on earth that you, in your mercy, will navigate our soul to the everlasting shores of peace and to that quiet harbor of our heart's desire where you live and reign now and forever. AMEN

Chaplain Michael C. Nation (LMR/GIWW)
The Seamen's Church Institute
New Orleans Area Field Office
512 E. Boston Street
Covington, LA 70433

INTRODUCTION

I come from a river family. My husband, Steve, has been in the riverboat and barge business for more than forty-five years, and our second date was a trip down the Mississippi River in May of 1979 from Vicksburg to Natchez on the old M/V (motor vessel) *Martha May* with Captain L. C. Williams. Upon arrival, we climbed off the boat and into a skiff and headed to the notorious bar Natchez Under the Hill. My destiny was sealed that day, a destiny that has included two barge companies and the blessing of countless friendships. Steve has been a licensed pilot and gone from the company Ole Man River Towing to present-day Golding Barge Line, our family-owned business. Now our sons, Austin and John Reid, are businessmen following in their father's footsteps.

Since that spring day in 1979, I have spent many a night and even some holidays with my family and the crew on the river. Playing poker with the guys in the galley after supper was always fun, and I have tried unsuccessfully to swing a line that weighed as much if not more than me. Probably the best meals I have ever had have been out on that river. Bernice Flenner, one of the cooks, made the best chocolate-covered cherries, and Shirley, who kept her cigarettes rolled up in her undershirt sleeve,

made the tastiest, from-scratch chocolate cake in the world. Captain Eric Stern has a chili that is so fantastic it will make you cry, and if you make a trip with Captain Tim Miller and his crew you will undoubtedly gain ten pounds in a matter of days. And that is just for starters. Everyone knows that the food on the river is the best.

It is understandable that people are fascinated with the river. I am and probably always will be. Sitting up in that pilot house, I have asked many a pilot a million questions and always seem to have just one more. My close connection to the river is what enabled me to capture and treasure the personal experiences from the pilots entrusted to me in this book. Please know that the reflections within this book are a very rare look into the personal lives of those who have dedicated their lives to the river. It is authentic, honest, sometimes funny, outrageous, often sad, and even tragic as is true with all real-life stories no matter the profession. It is a slice of genuine American folklore.

The long journey of writing this book began almost ten years ago. When asked to write "a book about the river," I seriously pondered this monumental task and realized that the pilots on the river are the people who needed to tell the story. Within

these pages are the personal narratives of more than one hundred pilots, both men and women from all walks of life, employed by different companies, who worked and lived on our inland waterways or work and live there today.

This book chronicles a seventy-year time span, as the oldest pilot was born in 1917, and the youngest pilot was born in 1987, and includes stories from the 1920s to today. The stories are presented in chronological order according to the year of the pilot's birth, from the eldest to the youngest, with the year listed after his or her name. In this seventy-year period, the stories start with those who were "broke in" by early steamboat pilots who had piloted from the late 1800s. The navigational tools at the turn of the last century were old carbon lights or lanterns that were lit on the banks of the river. The early pilots in this book witnessed the transition from steamboats to diesel boats, to present-day technology, including computers, radar, sonar, automatic identification system (AIS), the Satellite Compass, and electronic charting software (ECS).

Many pilots are from maritime families. Generations of family members pass down the knowledge and skills that were passed down to them from their fathers, grandfathers, and uncles. The pilots are from Deep South Louisiana and the Cajun culture to the far north Maine sound and the lobster boatmen, from the panhandle of Florida to the Intracoastal Waterway in Texas, and from the Upper Mississippi River to the Missouri, to the Monongahela, the gateway of the early pioneers traveling west of the Appalachian waters and from all the rivers, tributaries, and towns in between.

Most of the pilots in this book not only have piloted the Mississippi River but have piloted almost all of the rivers in the Western Waterways as well. Most will say, "Give me nine foot of water, and I will go." Some of the rivers have good reputations, and some, bad. Others have reputations of beauty and wonder. Some are considered a lazy river or a wild river, and again others are "like cruising in a bathtub," or pilots describe how the canal is like a ditch. The rivers and waterways have each earned a certain reputation and personality all their own.

Many of the pilots have been on ships and have circumnavigated the globe and have been to many foreign lands. But the focus in this book are the inland water pilots or those who pilot "brown water." Blue water is considered ocean going.

All of the pilots reflect on the time spent away from home because of their careers. Instead of cutting those segments out of their stories for the fear of repetition, I left them in because this aspect of having a career on the water defines in many ways who they are. The struggle and pain of being away from home and missing important events such as birthdays, holidays, and graduations is a universal reality for all mariners. However, their unique and highly skilled job gives them the ability to provide for their families in ways that perhaps they never could without a career on the river. As many pilots say when they talk about the river, "I hate her when I'm with her, and I miss her when I'm gone."

This anthology of narratives told to me by these pilots is unique. Today it is nearly impossible for a person who is not connected to the river or authorized to be on the river to be able to "go out on a working vessel." It was a gift for me to be able to interview those who dedicated or continue to dedicate their lives to the water and for them to share their stories with me, and I humbly thank them. It is a closed society not only by personal association but also by the regulations enforced by the US Government to keep our waterways safe. In order for a person to be able to board any vessel now, he or she must have a Transportation Workers Identification Credential (TWIC) card or be escorted by someone who has a TWIC card. However, a person can board a steamer passenger boat as a tourist without such restrictions.

I traveled thousands of miles to interview my pilots and went all over the Inland Waterways System to many towns and ports in my quest, climbing aboard vessels, and carrying my backpack,

cameras, recording gear, and lifejacket. It has been well worth the trek.

Since starting this project, many of my pilots have passed away. It was an honor to have recorded their stories, which will continue to be shared within these pages. I only wish that they could have seen their words in print.

In today's world, the river is virtually an unknown territory to those who live and work on land. Most people have ridden in vehicles on bridges that span rivers, but many have never been "on" the river or even have knowledge of the lifetimes and careers of the men and women who work out there and are responsible for the commodities that we all use daily. Waterways and ports in the Mississippi corridor move billions of dollars of agricultural products throughout the United States and foreign markets. Much of the fuel that powers vehicles and airplanes, chemicals that are used in the manufacturing industry, grain, sand, gravel, soybeans, corn, and sugar are transported on the river. The inland waterways encompass more than ten thousand miles of the US Inland Waterways System. They are known as the Western Waterways. We could not do without the river and the transportation of goods that it provides.

To be able to pilot a vessel, whether it is pushing one barge or forty, takes a tremendous amount of skill, education, and certainly nerves of steel. In this book, you will often hear the old timers say, "Boats are made of wood, and men are made of steel." Some of the pilots are legends and some are well on their way to becoming legends. The *Sprague*, built in 1901 and nicknamed *Big Mama*, is mentioned numerous times by a few of the old-time pilots. It was the world's largest steam-powered sternwheeler towboat. The boat wrecked and burned in Vicksburg on April 15, 1974, but is still legendary.

The river has an allure and mystique. Present-day river life is very professional and serious, where in years previous it was the "Wild West" and "anything goes." You will learn this as you read the stories. But the river is a serious place. It is not for recreational boaters. Safety is number one, and the safety of the crew (and passengers) is first and foremost followed by the safety of the vessel and cargo.

The romance of the river is still there though. If you are ever lucky enough to sit out on the end of a barge as it goes up or down the river, even in this modern age, you will experience a peacefulness that is far removed from the traffic, noise, and intrusions of everyday life. Wildlife abounds. By day, the river shines brilliantly in the sun, and at night, the stars light up the sky. A full moon at night is magical out in the river wilderness and reflecting off of the water. All of the pilots talk about this peacefulness and being isolated from society while out working on the river.

To all the mariners out there, stay safe, and thank you.

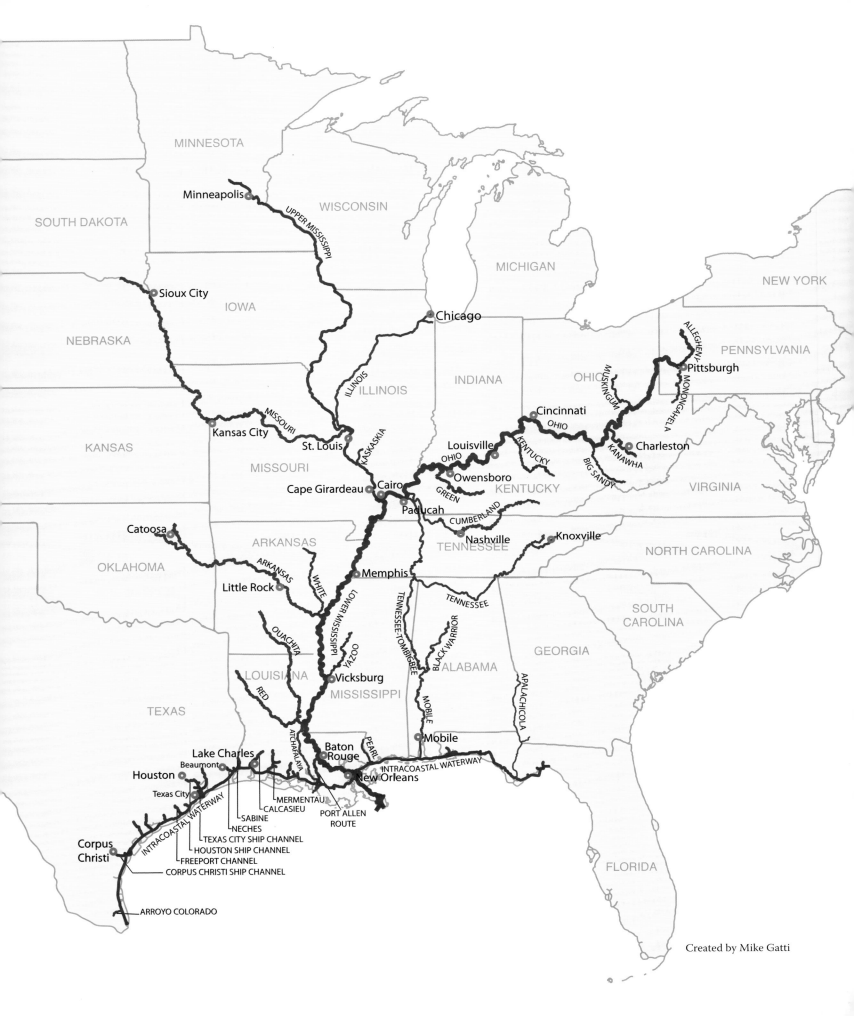

Created by Mike Gatti

WESTERN RIVERS
AND INLAND WATERWAYS

Navigable Inland Waterways

Lower Mississippi River
Port Allen Route
Atchafalaya River
Red River
Ouachita River
Yazoo River
White River
Arkansas River
Ohio River
Tennessee River
Cumberland River
Tennessee-Tombigbee Waterway
Black Warrior River
Green River
Kentucky River
Big Sandy River
Kanawha River
Muskingum River
Allegheny River
Monongahela River

Kaskaskia River
Missouri River
Illinois River
Upper Mississippi River
Sabine River

Gulf Intracoastal Waterway:
St. Marks, FL—Brownsville, TX

Apalachicola River
Mobile River
Pearl River
Mermentau River
Calcasieu River
Neches River
Texas City Ship Channel
Houston Ship Channel
Freeport Channel
Corpus Christi Ship Channel
Arroyo Colorado River

INTERVIEWS

WILLIAM V. TORNER

– b. 1915 –

I am one of the few river men still living who has worked on a steamboat built in the 1800s. The year is 1940 and the towboat is the steam stern-wheel *Reliance* of the Union Barge Line out of Pittsburgh, Pennsylvania. The *Reliance* had a wooden hull and burned lump coal hand-fired with coal wheeled from the fuel flat towed on her port side. There were about three thousand steam-powered towboats known to have operated on the Mississippi River system. The *Reliance* sank in the Allegheny River in 1947 and was scrapped.

When I came onboard the *Reliance* I brought my camera with me. Photography being my hobby, I thought I could make a photographic documentation of life and work on a towboat. The second day I was on the *Reliance*, after breakfast when I came off watch, I took my camera and went to the pilot house to take some pictures. I wanted one looking out over the tow as the pilot sees the tow and the river. I walked into the pilothouse, but never got to take a picture; my onboard photography on the *Reliance* was over before it began. Captain Booth did not appreciate my photographic ambition and desires. When I came on watch that afternoon, Pete asked me to help him splice an eye on a leaving

line. As we worked with a fid and marlin knife making the splice, Pete calmly told me that the pilothouse was the exclusive domain of mates and pilots. That deckhands only went to the pilothouse when they were called for, and when they were called, they went on the double. They did what they were asked or told to do, quickly and quietly and only spoke when they were spoken to. Routine deckhand duties in the pilothouse were sweeping and mopping the floor, bringing coal for the stove, carrying out the ashes, and cleaning the windows. Then there would be things the pilot on watch would want done. On the *Reliance*, the call for a deckhand to the pilothouse was a short low moan of the whistle.

If there was such a thing as a typical day in the life of a deckhand on the *Reliance*, that would be it. A full fuel flat had peaks of coal left by the clamshell bucket that loaded the flat. The first thing to be done was to level peaks where the planks for the wheelbarrows would be placed. These planks would run from about the center of the stern of the flat to the gunnel beside the firebox of the towboat. On the outside of the fuel flat from the gunnel down to the deck of the towboat were short planks, usually three wide, known as run boards. The planks for

wheeling coal in the fuel flat were one foot wide. A misstep while pushing a loaded wheelbarrow could result in spilling the coal onto the coal in the fuel flat. No harm done other than a little lost time and more shoveling to do reloading the wheelbarrow. As the coal was used, the wheelbarrow planks go deeper into the fuel flat until they reach the bottom. This means pushing a loaded wheelbarrow up a greater incline. Also, as the coal is used, the fuel flat floats higher, so the run boards become steeper. The coal had to be distributed across the access to the coalbunkers and placed in such a manner that took the least number of footsteps to shovel the coal through the fire doors into the furnaces. There also had to be clear deck space for feet so you could use a slash bar, or rake ashes from the ash pan down the ash well into the river. On the *Reliance,* the coal in the bunkers was held in reserve while the boat steamed on coal from the fuel flat. While in the firebox I should mention the medicinal benefits of the ash pan. All crewmembers get the "river runs" at one time or another, and there are many prescriptions and over-the-counter remedies for diarrhea. Under the furnace grates was the ash pan where there was always water running through the pan to cool ashes and help wash them into the ash well and the river. When I had the "river runs" I reached for a tin cup, filled it with water from the ash pan, and drank the whole cup of water. It stopped the diarrhea with no ill or side effects.

The *Reliance* had short stacks to clear the low bridges over the Allegheny River and Monongahela River in the Pittsburgh area. So depending on the wind direction, if there was any wind, there would be times that the *Reliance* would be surrounded by her own smoke and soot. Add to that the coal dust from the fuel flat. The *Reliance* was painted white, which became a dirty gray quite regularly. Captain Booth was determined that the *Reliance* would be a clean white boat when it passed through the Pittsburgh harbor. So regardless of weather conditions, the outside bulkheads were scrubbed before any trip through the harbor. It was the deckhands that did the scrubbing. In 1940, the *Reliance* was towing gasoline in six tank barges rated at six hundred tons each.

The Monongahela River is usually referred to by boat crews as the Mon or as the Sweat River or other descriptive terms that will not be used in this narrative. A hard work river, to say it politely. The lock chambers of the dams were small, and on the Upper Mon were hand operated by the deckhands of the boats using them. On a cold rainy night, blowing the whistle for one of those locks was a navigational formality and a waste of steam as no lock tender would get out of bed and come to the lock. On the Lower Mon were steel mills upriver from Pittsburgh. By day, they were large gray- and rust-colored buildings with rows of smokestacks spewing smoke and acrid fumes often making breathing difficult and killing all vegetation on the hillsides. At night, these mills took on a totally different appearance that could only be seen from the river. The fire and hot metal of the blast furnaces lit up the sky, making silhouettes of the buildings and smokestacks. Lined up along the riverbank were huge ingots of red hot metal standing on end, glowing in the dark as they cooled.

The *Reliance* was heading upriver with her tow of six tank barges and being followed by another steam stern-wheel towboat with a tow of hopper barges at a respectable distance astern of the *Reliance.* We were wheeling coal out of the fuel flat when we became aware that the following tow was overtaking us. Other members of our crew were also watching as the following tow was closing the distance between them and us. In a short time, our paddle wheel was throwing water on the head of the following tow. Speculation! Was the pilot on the following tow intending to cripple the *Reliance* by ramming her stern wheel, or was his tow closer to us than he realized? Whichever it may have been, the following tow eased to port, and it was clear that the pilot was trying for a two-whistle passing. That is when Captain Schagle pulled the ship-up gong twice. That is the signal for a trace of lard in the furnace and hang a weight on the safety valve; "All she's

got," and the race was on. Being first at the arrival point of the next lock was the prize for the winner. The loser would clear the lock about twenty four hours later. As the tow of hopper barges began to come up on the port side of the *Reliance* and before they got up to the fuel flat, the port hopper barge on the overtaking tow suddenly started climbing the river bank, and the race was over. I never saw the name on the towboat that lost the race.

Since the 1940s there are many new locks and dams on the Ohio and Monongahela Rivers, making tow boating much better than when I was on the Reliance. The things that I learned in my time on the Reliance were very valuable to me when I was in the US Navy during World War II, and that is another story! Live steamboats forever!

STEVE JOHN BUTKOVICH

– b. 1928 –

My name is Steve John Butkovich. I worked on the river for forty-five years. I started in 1944. When I was sixteen years old, I got my tankerman license, and we were loading big barges. We'd load sixteen barges. This was during the war in 1945. Then when my relief came, he was only sixteen years old. So it was a bunch of young kids working on the river. That was at Wood River on the Mississippi. I worked on there for a couple of years. I knew all the lights from Wood River to Saint Paul. Then I got drafted. Harry Truman selected me. I didn't even know Harry Truman. But some way or another he must have liked me. I got drafted for two years, but they let us out in twenty-one months. So I spent eight months in North Korea.

The first captain I worked for was Captain Roy Miller. He was a big guy. Kind of nervous. He was gassed in World War I. He was in World War I. For some reason or another he just chased everybody out of the pilothouse. He said, "Everybody get out of here." He was probably born in the 1800s. He worked on a steamboat. A lot of those old guys worked on a steamboat.

Captain Vincent Bruno, I associated with him. He was from Memphis. He worked on the

Alexander MacKenzie, which was a steamboat, as the mate. And he used to always say we didn't have to use black pepper because of all of the coal dust.

The *Sprague* was still running when I was working on the river, and it used to have a big paddle wheel. I think about how they'd have four barges strung out, and he'd make such big waves. The captains would say at the dinner table or something say, "I wish he'd slow that big . . ." It was pushing oil barges. Then they had the steamboat *Rathbone*. Then they had *Willard*. Union Barge Line had the *Jason*. I remember all those boats. A lot of those old pilots said they were glad to get off of them. Some of them were coal burning. They used to wheel coal. Then some of them went into burning oil like the *Jason* and some of the others; the *Rathbone* and the *Willard*, they burned oil for their boilers.

When I first went to work on a boat, I told my mom, I said, "I'm going on a boat." I had a little duffel bag. I didn't have much clothes, a few change of jeans and shirts and underwear and a pair of shoes. I told my mom, I said, "I'll see you." She didn't act like anything. I left, and I walked all the way to Hartford. So, my mom, she says, "Awww, don't worry." Said, "He'll be back in an hour or so." Said,

"He wants to go on a boat, and they won't hire him." I was gone three weeks. She never heard from me. I was fifteen years old, and it was 1944. My mom called me *bebah*. That's "baby" in our language, *bebah*. We spoke at home our language which was Yugoslavian. That's where they came from, Croatia.

Captain Joe Hightower was from Memphis, Tennessee. He worked until he was eighty years old, and he was quite the pilot and captain. He played the guitar while he was making the lock, especially if we had guests on a boat. Usually you have a speaker out on the head of the tow. He'd play and sing, and the lock men all knew him. Everybody knew just as soon as they heard the guitar that that was Joe Hightower. He could sing songs, and how he could remember all those words, I couldn't believe it. But I'd pick up the phone. I'd say, "Jealous Heart." And he'd say, "Go to another channel," and he'd sing it. He was a character.

We were going up the river with six oil barges on the TriCities. It was hot summertime. Wimpy Williams was the cousin of Captain Lauren Williams. And these barges are 175 by 35. He said, "Steve," he said, "Captain Shorty wants to go swimming." He said, "Get a bucket and cool the barges down." I got a bucket and went to wetting the barges. I cooled them all the way back, and we tied some lines off on a stern barge. Shorty Williams—Captain Williams I called him. Everybody called him Shorty except us deckhands. We called him Captain. He walked like a duck, and he wasn't very tall. Well, after I cooled the barges off, here he comes out with his swimming suit. I know he had somebody up there steering. I'm sixteen years old. He gets about to the side of the barge not in the front of the barge. He dives off to the side. We're running. They wouldn't allow you to do that today. Well, hell, he dove in. I dove in right after him. I was a pretty good swimmer when I was young. So then we would get back and catch the line back there. We had a little ladder, too. We'd climb up that ladder, and old Shorty he walks like a duck. He'd go out there and dive again. I'm right behind him. We used to swim all the time when we were tied up. You can't let them do that nowadays and all, but we swam all the time. He was quite the swimmer, too. We'd go off to the side. But that boat was only eight hundred horsepower. We weren't moving all that fast. But it's still kind of dangerous.

GEORGE WILSON "SONNY" BANTA

– b. 1929 –

My name is George W. "Sonny" Banta. I was born in 1929. The first time I remember being on the river I was about four years old, and my dad brought me on to a steamboat at Bayou Plaquemine Lock. He sat me on a big high stool that they had in the pilothouse, and it was a small steamboat. The name of the steamboat was the *Miriam Werner*, owned by Baton Rouge Coal and Towing Company. It was going somewhere out in the oil field. It had two oil barges. Of course, this steamboat didn't have flanking rudders. It just had rudders that were behind the wheel with none in front of the wheel, actually. He had the barges in front of him, and he was backing down through the bayou. At every turn he came to, he had to slack off the ropes on one side of the boat and in the between the barges also. So he had men out on the barges slacking off depending on which way he was turning. Then he'd back up a little bit more, and he'd have control when he backed up. But when he came ahead, he didn't have a steering rudder. It didn't have steering power. So it was a slow, tedious procedure going down to the bayou. I remember looking out and then watching them slacking the lines. I was about four or five years old, about 1933. My dad was the trip pilot. They hired him just for the trip. My dad's name was Captain James Wilson Banta.

I went with my father a lot on the boats. I can remember one day Frank, my brother, and I were the only ones up on the boat. Dad was taking a nap, and the other boy that was working with us, he must have been taking a nap too. Frank and I were running all over that timber and jumping into the Mississippi River and swimming back to the timber. At one point, we got some small logs that were kind of waterlogged, and we'd throw them down and see how long they would stay down before they came back up. This was in the middle of the timber. One time, Frank threw one down, and he lost his balance, and he went down with it. It scared me because it took him a while to come back up, and I was afraid he had drifted up under the timber somewhere. But he came back up in the right place, and I said we're not going to do this anymore. I was six, six and a half, seven. He was four and a half or five, and we were all over that river.

We're all pilots. Our dad broke us in. When I was a child, I was steering the boat for my dad. I was tall enough to see over, but I was usually out there with my dad on the barge. I can remember we brought a barge down to Avondale Shipyard. Daddy and I

were out on the front of the barge, and Frank was steering the boat as daddy indicated to him. The head of Avondale, Mr. Jordan hollered down to my dad. Said, "Cap, I don't see anybody steering that boat back there." He said, "Who you got steering it back there?" Dad said, "Look real closely." He said, "You'll see a little white-headed top over those windows." And he looked and, "Yeah, okay," he says. That was Frank when he was about four or five years old. When you do that a lot, you learn how to steer pretty good. My dad was a good teacher. Later on in life, when I was a pilot coming down the Mississippi, I had three or four grain barges, and just below Helena, Arkansas, coming down the middle of the river, I hit something. I happened to be talking to my dad just a little while after that on the radio on a ship-to-shore radio. I said, "I hit something down there just below Greenville." He said, "Yeah." He says, "There's a middle bar out there. You got to watch that middle bar down the Arkansas." But we all memorized the river.

After I got out of high school, I went to college for a couple of years. Then I came back and worked on the river. I was nineteen or twenty, and when I got right out—it was my second year of college—I worked for Canal Barge Company for about six months as a deckhand. Captain Philo Marineaux from Plaquemine was captain of that boat. They were a lumber company, and they built that steamboat to tow logs out of the Atchafalaya Basin. It was a steamboat, and they're tied up in Bayou Plaquemine right close to where we tied up because Captain Philo lived on the other side of the bayou right close to us. I knew quite a few of the steamboat captains. Nineteen forty-six was when I got out of high school, and that was kind of a transition period from the steamboats. All the steamboats then were being tied up, and diesel boats were taking their place.

In the 1927 flood, my dad was working with the New Orleans Corps of Engineers, but they had the buoy boats all the way up to Vicksburg. He was up in Vicksburg, and somebody in the government commandeered his steamboat and sent him out picking up people that were flooded out. He said he was fifty miles away from the river picking up people off of hills. He said when he'd push up to a hill that people would be waiting to get on. He said there would be horses and mules and pigs and chickens, and he said everything jumped on when he pushed up there. They didn't have to run them on. Took them to Vicksburg. The steamboat had probably a two- or three-foot draft, very shallow. So he was going out across fields and going through towns. He was innovative even in putting out buoys. He told me you put a buoy down at the low end of the barge. You go up there and with the steamboats you had to sound, find out where the shallow place is, and that was where you needed a buoy. You put a buoy there, and then you'd sound around it and make sure it was in the right place. If it wasn't in the right place, you'd pick it up and start over. He got a buoy, and if they put it in the wrong place and he sounded it, instead of moving that one, he would take another one and used that one as a guide and put that one and pick up the other one. The other steamboat captains would pick up that buoy and then have to hunt all over for the right spot to put it in again because you didn't have much control over steamboats anyway.

My dad and I went on the *Sprague* a couple of times together. He was running this little boat, and the *Sprague* was stopped. I didn't go up into the wheelhouse because I stayed with the little boat down below. But he went up, talked to the captain and pilot, and some of the guys he knew on there. But we looked like a little *bateau* alongside of the *Sprague*. That was a big old boat. A *bateau* is what the Frenchman call a little paddle boat that they paddle around the bayous with. But all the steamboats were quiet. You could hear someone holler from the bank on a steamboat because they didn't make much noise. The *Sprague* was the biggest ever built.

I rode with some steamboat pilots later on, and they weren't as good as some of the pilots I had trained myself. Lot of those guys I didn't know how they took the boat out away from the barges; they

couldn't hardly get it back lined up to make up to the barge. They didn't know how to handle a boat. They always steered the boat after it was made up and all the barges were made up and had a big tow with them. My dad had a steamboat license. That trumped everything. We had uninspected motor vessel licenses after that. We didn't have to have a steamboat license to run the diesel boats. The steamboat's license[s] were superior.

The *Frank W. Banta* was the first boat that we built. We built it with a long stern so that we could tow barges. Because back in those days you towed all your empties in the canal because you couldn't hold them up in the wind most of the time and so you would tow the empties. I don't know how I wound up with two loads and the three empties coming back from Texas. I came up through Bayou Plaquemine with the three empties pulling behind and two loads pushing ahead. That was about 1952, '53. When you put them behind you, you just let them drag. It wasn't as much stuff to hit on the side of the bank as you have today. You couldn't do that today. As far back as I can remember, a lot of people lived in houseboats down on Bayou Plaquemine and Bayou Pigeon and Bayou Sorrel. When I was a kid, everybody down there lived on houseboats. There were maybe two houses on the bank, and you had to be careful that you didn't make too big of a wave when you went by there because they'd come out with a shotgun.

A true river man or a true riverboat pilot has good common sense and good eyesight and is able to take stress. Anytime you're working with people, you're going to have stress. You wind up with their problems.

Captain Philo Marineaux, I rode with him for about six months. He was one of the best pilots out there on the river. He came out of the bayou and ran that *Carrie B. Schwing,* the old steamboat, and then he went to work for Canal Barge Company, and he was one of the best they had. He and my dad were pretty close to the same age I guess. My dad was born in 1900.

Talking about family being on the boat, that summer I wasn't on that boat very much with my dad then. It must have been 1945 or something like that. But my mother, whose name was Laura, was on the boat with him, and two of my sisters were on the boat. And Merlin was just a little boy then. They were all on this wooden-hull boat that had a sleeping room. You had to go down into the hull to get to where they slept. It was hot in the summertime, but, on the river, you usually cool off when you're on the water. Another thing about the summertime too, when we ran between St. Louis and St. Paul, when you got down to St. Louis in the summertime, it was hot as the dickens, and every day you'd go a hundred miles up the river it got a little cooler. Another hundred miles it got a little cooler. By the time you got up to St. Paul, it was comfortable.

I've seen the transition from the steamboat to the diesel. It was a good life out on the river. A lot of people never get to see the things that I've seen, and all that other pilots and river men see.

ODIS LOWERY

– b. 1930 –

My name is Odis Lowery, and I'm eighty-four years old. I was raised on a shanty boat on the river under the Vicksburg I20 bridge. We lived there until after World War II, after the war started. A shanty boat is a boat with very little room, and it floats. It goes up and down with the river as the river rises and falls. My dad was a logger. He caught drift logs on the river, and he commercial fished. He was a boat pilot also.

I had no favorite rivers. To me it was just a day's work, that's all, and whoever paid the most money. Early on, I worked for Jones & Laughlin Steel Corporation. I was a coal passer. You take a wheelbarrow and come out of the fire box of that boat, out of the front of it, and go down in that barge. Get you a wheelbarrow of coal and push it up there and then dump it. It was so hot. Oh, it was so awful hot. Me and my buddy, that's what we did. It was a steamboat. It was a steamboat and was coal fed. My buddy got fired because of what he did. He jammed that coal chute up going down into that fire box and shut that boat down. It ran out of steam. But we worked on it from Memphis down to New Orleans. When he got back to Memphis he quit, or they fired him. On the steamboats they had a big crew. The

deckhand job was an easier job. The coal passer was a tough one.

My family from on my mother's side and all my daddy's side all did something related to the river. My great grandfather was a logger. Pap was a logger. My mama's family and all of my daddy's family, they were commercial fishermen or loggers. Me and my other three brothers were all riverboat pilots. I trained most of them. We are all just river people.

When I first was starting out, we went on the long trips, and we would stay out for forty days on and eight days off, and we got paid $140 a month flat rate. That was when I worked for Anderson Tully. After I got up with Anderson Tully and was making top money, I would bring my wife with me. After we had our children, I was over all the towboat pilots for Anderson Tully. My wife was scared to stay at home by herself. So we'd all load up, my wife and all the kids, and we'd go to the tugboat, and I'd go out in the river and do whatever needed to be done or swapped out, and my wife would put the children to bed in the cabins on the boat.

I knew the I-20 bridge was going to be built. I knew they were going to need a tender to get the men out to the piers where they were working and

to push the concrete. I went to work on that boat in my back yard then. But that's why I built the boat. I knew that the bridge was coming. I helped build that I-20 bridge. We poured all the concrete for the piers.

Back when I first started out, there was a lot more life on the river bank than what there is now. Much more. There were a lot of shanty boats, and there were a lot of shootings. There were a lot of killings on that river too. Those river rats didn't get along with one another, and I tell you what, there were a lot of fights. The people who lived in those shanties, they would just make their living on the river, and they did a lot of stealing too. There was a lot of stealing their fish off their hooks and lines. It wasn't really a kind place to live. It was a tough place. If fishing got bad, they'd crank up those little engines and drag that shanty boat up and go someplace else.

When I was just a kid, we were living up there in Milliken Bend. And that's where we lived when my little sister died. She was three years old, and she got sick. She had dysentery. It went into colitis, and she died. At the time when she was in the hospital dying, our little house on the shanty boat burnt down. My little sister was laying there crying, wanting to go home, and we didn't have a home to take her to. We had some awfully hard times, awful hard times.

There were buoys in the river, and they had lights on the bank, and that was the age of navigation. That was all of it right there. I remember my grandfather and my uncles lit those lights. My grandfather was the light tender. They were fired by coal oil. A coal oil lantern was in that light. The lantern was up on the bank. If you put your stern on the light, and it crossed over to the other one, then you put your head on that one over there, and you'd go across the river. You stood the channel of the river. That was your aid and navigation. That was it. If somebody didn't light the lights, somebody went aground. But those pilots back then, they knew where to go. In fact, when you got your license, that's what you did. You drew a map of that river, of that channel the way it went, cross over. You knew where to go and where to stay and what line to run to.

The river was in my blood, so I knew that I would always be out there.

LOUIS E. "JACKIE" NEAL

– b. 1930 –

My name is Jackie Neal. I worked for several companies over the years. I was a bad drunk in Wine Haven, my hometown of Greenville, Mississippi. My earliest days going to the river with Uncle Gilder, one of my memories is I did see the *Sprague* in tow going up. I still remember the tow. I mean the way the *Sprague* sounded. I must say that all of us old river rats are kind of sentimental. But that was the biggest and most powerful steamboat. I think one old captain—Captain Wayne Carpenter who I trained under. Captain Wayne said you could put the *Sprague* out here at Vicksburg or anywhere else in still water against one of these 8400s, and he believed the *Sprague* would push it backwards.

I don't mind telling of how I got on the river. Of course, my daddy worked on the river. My brother had thirty-nine years with the navy and the army engineers. I started on the river when I was thirty-one years old. I had been in a couple of other businesses in Greenville, Mississippi. And the truth be known, I drank them up. I did not miss the whiskey out on the boat because I carried it with me. I didn't quit drinking whiskey until they put me in Winehead U they called it in Jackson, Mississippi, on State Street at Baptist. I was captain on the *Valda*.

I'd catch that boat with a laughing half in each boot and one behind my belt. I'd taper down. I was tough. I could handle it then. I know some more captains the same way. But they said, "We got to get old Jackie sober," and Jackie needed to get sober because I was getting sick and crazy. They put me in for sixty-one days. I came out thirty-four years ago, and I've never had another drink.

An old river man, his name was Edgar Allan Poe . . . knew me, and I'd be sitting there at the Ergon dock north of Nashville. Wamp was his nickname. Wamp would be coming down through there on the *General Jackson* with the people dining and dancing. It's a steamboat, and they are not as easy to drive. I trained under the steamboat pilot, Captain Wamp. He used to dive on a sunken boat over there on the Upper Mississippi River. The boat had sunk, and when they were kids, they would plunder out of the sunk steamboat boat whiskey and stuff. That was at mile 52, Cape Girardeau, Missouri.

Captain Ernie Mathes, who I trained under told me, "Jackie, you're good. You're going to be a good pilot. You make your living. Go on, get to be a captain if it's what you want to do. You can do it." But he said, "Just one thing. If they tell you to go up the

Missouri River, be nice but don't go. Just don't go, and you'll keep your job." I said, "Well." You know I went, but everything is bad about the Missouri River. Anything you want to think of. There's no dike. It is an open river. A lot of other places have dikes on both sides.

I trained under a steamboat captain, Wayne Carpenter. He told me of an incident that they were all drunk at Jim Buoy's place Under the Hill in Natchez. Towboat people used to drink too much. Anyway, they were at the bridge right below there, and they were all drunk and got back on the steamboat. The tow was up the river somewhere. They said they were going to let the chief engineer drive. The second engineer was running in the engine room. So he backed away from Jim Buoy's, and that toward that bridge. Captain Wayne said he wasn't paying attention, and he was backing fast. He said, "By the time I had sense enough—and we were all drunk—to get it coming back ahead—you have to ding so many dings to get the reverse." He got it coming ahead, but the outside corner of that steamboat touched that bridge. He headed down. It didn't hurt anything. Then he went to coming ahead. I remember Captain Wayne telling me that. Natchez Under the Hill, it's still interesting. Still, in some ways, it's all quieted down. I don't know if I like that or not.

If I met a young man that wanted to make a career out on the river, the kind of advice I would give him is learn how to do without your lady. It gets kind of lonesome out there. You don't always have a pretty little cook. But my little African American friend girl from Tallulah, the savage beast, she was a little bitty thing and so pretty she'd hurt your eyes. She rode the boat awhile, and I lived with her awhile. She was a cook on the boat. They brought her on the boat, and I wound up living with her over at Tallulah after she quit the river. Anyway, that was what I would say—if you can handle that, if you can be away from the ladies.

Until 1972, you didn't have to be licensed to run the *Sprague* or any of those big steamboats or diesel boats. So the government, in their infinite wisdom like they always do, they figured out everybody better be licensed. So they have their first licensing test at the Yacht Club in Greenville, Mississippi. The next day some of the Brent pilots might have been there, but me and George Reed, Gene, Joe Hicks, my relief captain all those years, George and Clem, and one of the Hendersons [were there]. But it was representative from a lot of the companies. George wouldn't care. We were buddies, and everybody that knew him knew that George Reed couldn't read and write. Everything from where he ran, he knew it; he had a photographic memory. Anyway, we were in there, and the Coast Guard didn't know what to do. We made up the test form. Now, you had rules of the road before, but you didn't have to be licensed. So George got tired of that. After a while, he said, "I don't know about all that." Then he said something else—that they were foolish. We were trying to help him make up the test. But anyway, George got tired of it, and he just got up and said, "Come on, Jackie. We ain't got to listen to all of this. Let's go." I said, "Hey, George, I ain't George Reed. I need this license." Of course, what happened, Senator James O. Eastland sent his license through the mail in a few days. But really, the Coast Guard, in a lot of ways, they do a good job.

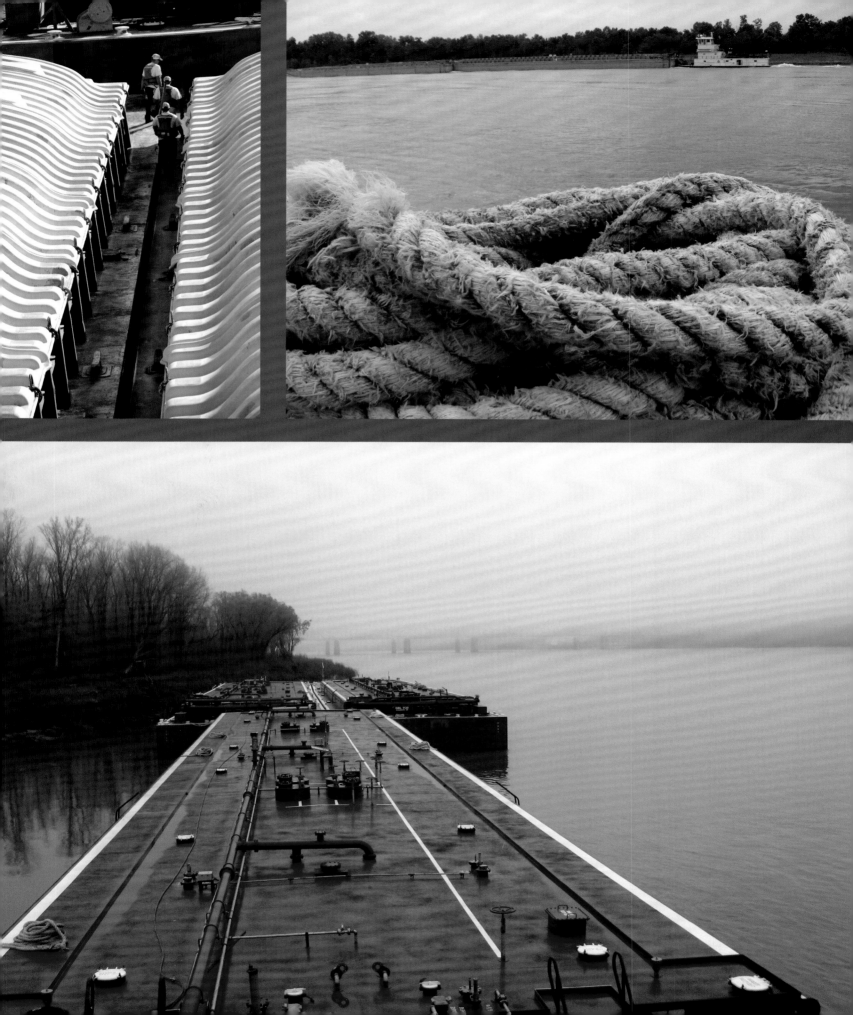

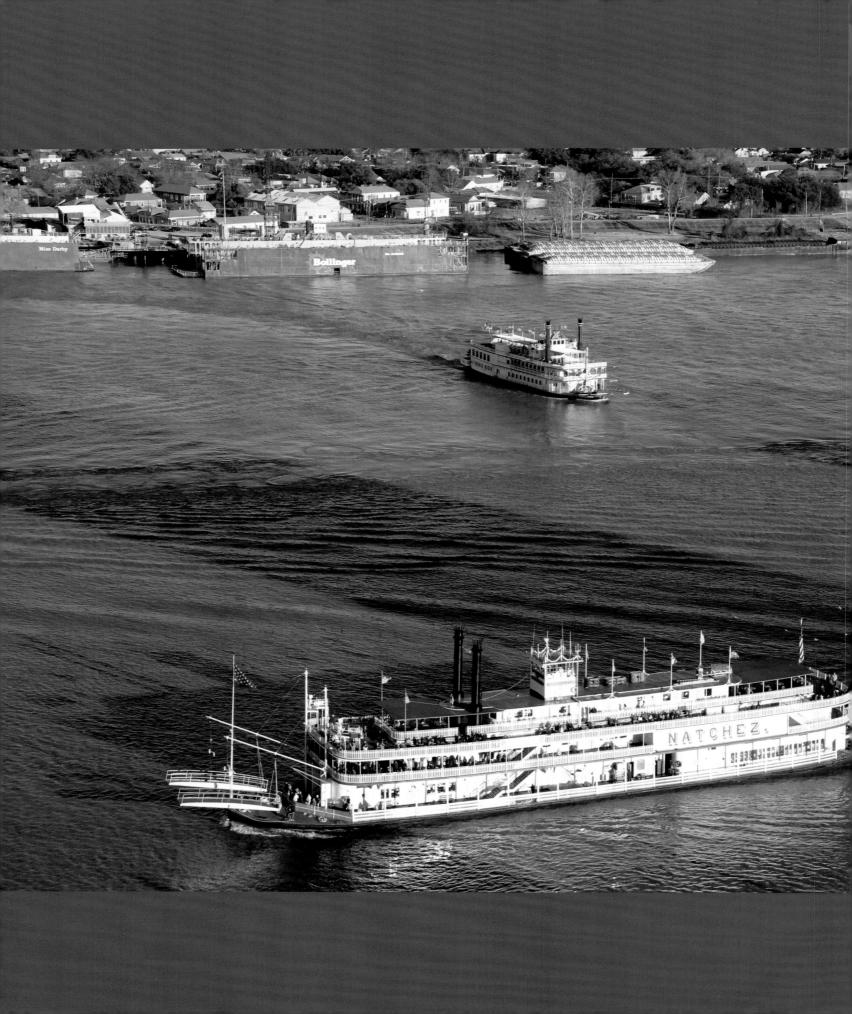

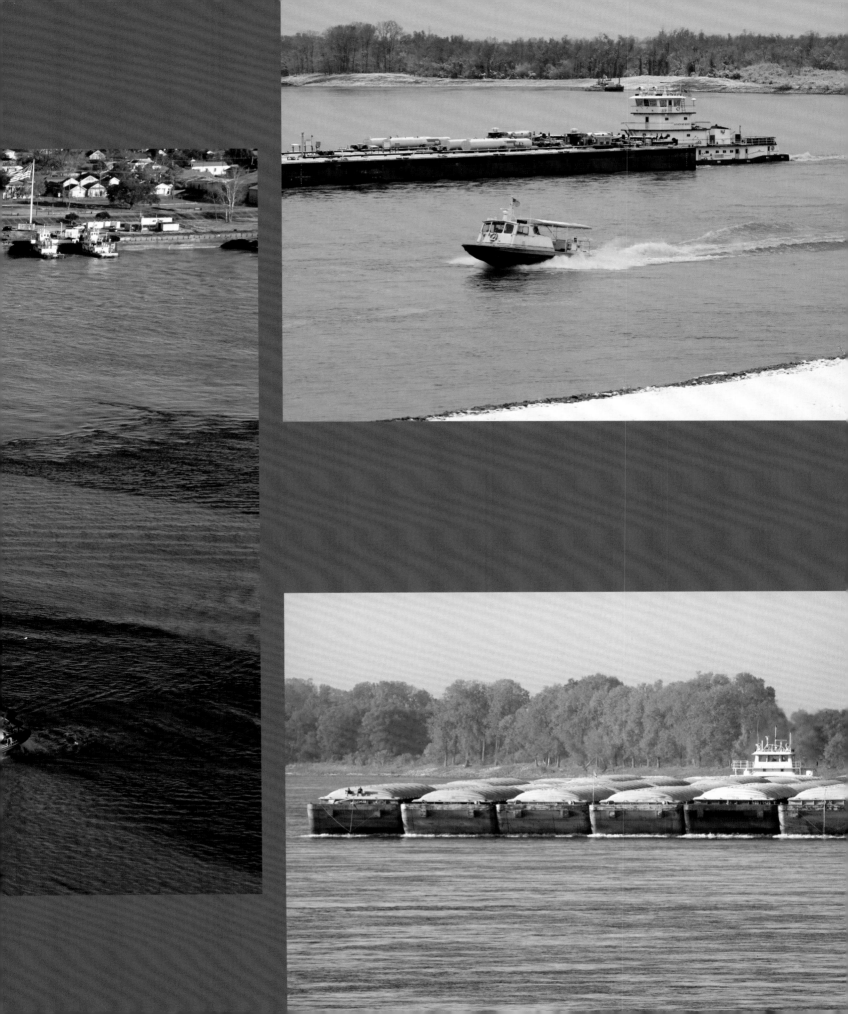

LOUIS EDWARD RINEHEART

– b. 1930 –

My name is Louis Edward Rineheart, and I am from Plaquemine, Louisiana. I'm the oldest of eighteen children. My dad lost his health and couldn't work any longer, so I went to work to help feed my little sisters and brothers. I was just thirteen years old, and I started working as a deckhand. The war was going on, and crewmembers were hard to come by. This was in 1943. I went to work for Plaquemine Towing Company, J. W. Banta Towing Company back during that time. Little tug they called the *Tessler*, sixteen hundred horsepower. Went to work as a deckhand, $115 a month. And I worked for that company twenty years. I worked myself up to chief engineer, and I left from there and went to the pilothouse.

When I first started out on the river, it was rough. The first trip I came out on the boat, we got right down here at Vicksburg and tied off to take fuel in the barges. The next morning, the river was frozen over. We stayed right down here below the bridge fourteen days and nights. Every morning about four o'clock, I would take five gallons of water and put it on the butane stove in the galley and get it hot so I could pour it around the cook's door to get her out of her room, so she could cook breakfast. They had a war going on. And the company

I was working for, they didn't pay very much money. They had a very hard time getting crewmembers, so I lucked up and got a job.

I worked on the river fifty-seven years. I have been on all of the rivers. I have no education. I had to memorize all this stuff. Thank God I did a good job. But I wound up captain on big ole lady eighty-four-hundred-horsepower boat, the *Gale C*. I came down on the bridge at Vicksburg with thirty-five loads, sometimes forty-two. I never backed up to any bridges and no locks. I've had pilots, and captains, and it's the honest-to-God truth they tell me, "Oh, I need to run downstairs to the bathroom." They were scared to make the Vicksburg Bridge, the Greenville Bridge. Whenever they looked down and saw the bridge, they would start shaking. I said, "Well, go ahead and do what you got to do. Just don't look over my shoulder." I stayed out there fifty-seven years. It was a lot of years, but I worked my way up through the ranks.

I like this big muddy Mississippi River. It's got a lot of adventure to it. A lot of history is behind this river. I remember a many a time we'd go up, and the river channel would be on one side. Come

back down the river, and it would have shifted to the other side. The sandbar had built up.

We knew the river, but you can know it ever so good, but that channel will change overnight. And that sand shifted and built up. Back during that time, you had one boat behind the other one, a lot of boat traffic. That helps keep this river open where the wheel wash with slow-moving barge-line tows.

I think all these air conditioners and all that stuff spoiled a lot of us old timers. We weren't used to all that easy going, and especially when you have all this horsepower. We used the little horsepower and would get to a bad bridge. We'd tie off half our tow and trip this bridge on up to get to it. We didn't have enough horsepower to push the barges all through there at one time. We had one of those old tugs I was on.

We had a cook that drowned up there below Greenville. I was sitting in the . . . door of the engine room. I was on watch. She was called up to cook. She had been there since day one that I was on there. She walked out with a pan and had to empty something overboard of the galley. And when she did—she was a great big lady, and I guess her knees were about to the top of the bull rail on that tug, and she never stopped—she went over head first in that freezing water about twenty miles below Greenville. They call it Grand Lake. They never did recover her body. We missed her very much. She was a fine old lady. Her name was Othelia Harris. She was out of Plaquemine. Her relief was another little bitty old colored lady. Her name was Lucy Jackson. She used to take us boys and pass out blue jeans and sew our clothes when they got torn, which was very often. She raised us boys. I didn't know how to read and write. She would sit out and write letters to my mama and daddy. I would tell her what I wanted to tell them. Bless her old soul. She took care of us little white boys just like we were her own children. And I never will forget the first morning I went on that boat to Plaquemine Locks. Captain Banta himself come up there and picked me up at the lock. I sat up there

all night long in that old barroom waiting for him to come get me the next morning. He had his relief captain I met that day working on one of the other old boats down at the canal down there, an old wooden-hull boat. And he's the man that hired me. He told me, he said, "You be up there at Plaquemine Lock at six o'clock in the morning, and I'll have Captain Banta come out and pick you up." I said, "All right, sir." I was only thirteen years old. I sat up there in that old wooden rocking chair all night long with my back up to that steam boiler at Plaquemine Lock, and it was freezing cold outside.

My first trip out on the river I was thirteen years old. I stayed on the boat for four and a half months without going home. It took us that long from Plaquemine to Phillips Oil Dock, East St. Louis, with three barges because we stayed iced up and broken down. Every time you turn around that old engine was breaking down. At thirteen, I could do a man's work. I was used to hard work. I worked on my grandfather's fishing boat when I was younger. My grandfather was an alcoholic. And we'd get to Morgan City, and he'd get a taxicab and hit all the juke joints and night spots. He left me on the boat. I was too young to go with him anyway. The next morning, I was over all the fish, crabs, and whatever he had on board. I washed the iceboxes out; I pumped the bilge out with a jigger pump and took the three-hundredpound blocks of ice that came down through that chute. I grabbed a swing and dropped them in the icebox after I washed the iceboxes out. And then, my grandpa, he'd come in. He'd be back there laying down in the bed with a hangover. We were leaving from Morgan City. I had dropped down there and got fuel and the fuel to gas the fuel tank on the boat to run the main engine, and I did all the work. I ran that boat from Morgan City back to Bayou Sorrel. And there was a store up on the hill. We'd get our groceries from Morgan City Wholesale and load them on the fishing boat. You could get them cheaper down there. When we got up there, we had to unload them in the store. Well, of course, that was my job.

Well, the old man, my grandfather, I loved him. He practically raised me, you know, working with him. But he had a built-in alarm clock in his head. That old feller didn't have but about three strands of hair on his head. He'd get his brush. We'd get to about three miles below the store. He'd get out of that bed, and hot water was coming out of that discharge there from that motor, and wash his face and wet his hand, and he'd brush his three or four strands of hair he had up there. Well, by that time I got it. He'd take over the pilot wheel. I'd go out there and tie the boat, and it would be around two o'clock, and grandma would be standing there with her hand on her hip. I think I can see her now. "Babe, you got something to cook, coffee for me?" he said. "Yeah, Johnny, I got coffee, and I got something to cook," my grandmother said. He said, "I'm tired. I'm just so tired and burn out." And he had been drunk all night. I did all the work, everything. He slept all the way from Morgan City to Bayou Sorrel. I was the one that was tired.

Back during the early days, you didn't have sounder machines. No radar, no radios, and nothing like that. Whenever you hit the bare stretch of river, that captain of that pilothouse would send you out on the head of that tow out there. You either had lead line, throw the old sounder in the water, hollering back at him at the pilothouse with a bullhorn held up, not like the intercom system radios you have today, sounder machines and all that. You don't have to leave the pilothouse today to know what you have under your boat. But you'd be standing out there and your feet froze to the deck of the barge.

Back when I first started that old *Sprague* was still running. They came down to the city front of Helena, Arkansas, up there. And they'd back down, and a big rowboat would go in, and they'd go and get the mail at the wharf at the city front at Helena and bring it back out to that big ole *Sprague*, that big ole steamboat there.

Back when I first started working on the river, they had oil barges made out of wood—wooden oil barges. Exxon refinery in Baton Rouge, a big outfit like that. They would push the oil up and down the river in wooden barges. It's hard to believe that we've come this far.

I remember, on one boat, a man had his wife were on there, and they had two hound dogs. It was an old boat, an up-and-down pilothouse boat by the name of the *Bull Durham*. The captain once owned that out of Red River, and he was something else. We used to laugh at him. We hated to make the same lock that he did. You could smell that old boat before you would see it because just the whole crew on there was just plumb filthy. He'd wear those old blue overalls, and I believe if he had taken them off they would have stood up by their self. That woman, she'd come out there—Nellie was in the back. She'd open the door and walk out on the back of the boat, but how in the world they could eat her cooking, I don't know. They had those two hound dogs on the boat with them. She would walk out there and set the plates down on the back of the boat with those hound dogs.

There used to be people living on houseboats along this Mississippi River. Most of them fished and lived off the land like we did on the Atchafalaya River. They get out and hunt for fresh game, deer, rabbit, squirrels. They'd catch fish, and they'd eat the fish and sell them to the market. They raised their families on the houseboats. That's where I was raised, on a houseboat. There were eighteen of us. Mama and daddy had eighteen children, eighteen children by the same mother and daddy. Well, they passed the law where children had to go to school. Of course, I was working on boats by then, but my little sisters and brothers, they went to school. That was on the Atchafalaya in Louisiana. I'm a half Cherokee Indian. My daddy was full-blooded Cherokee Indian. My mother was Irish. My grandpa was Irish and Indian. My grandmother was fullblooded Cherokee Indian. They came from Oklahoma down into Louisiana in a covered wagon when my daddy was a baby. They moved out on the Atchafalaya River, and they raised their family out there. I was

born in 1930. My mother, she was fair complexion. That's who I take after. My daddy was dark, dark. My daddy never sat in the chair. He'd squat. He would squat on the steps and watch that water out there all day long. He fished. He loved to fish and hunt, and he was good at it. Out of the eighteen kids my parents had, I'm the oldest. She had all the babies on the houseboat. There wasn't such a thing as a hospital back then. They had midwives.

On the river, I like the high water. Let the current do the work for you. When I first started, and when we took off from Plaquemine while the boat went to Freeport, Texas, and when it come back to Plaquemine Locks, the boss man came to pick me up. Told me, said, "Let's go, Louie." He called me Little Louie. "Let's go, Little Louie," he said. "I need you." He worked me in the engine room back during that time. When I was off watch some of the pilots and captains wouldn't take time to help me. But the old man on the boat did. And when I was off watch he'd be glad for me to come up there. There wasn't any power steering. It was just a big ole pilot wheel, and you had to manhandle it. It was a big wooden oak pilot wheel, a big varnisher. And whenever you pulled that hard down—you would get hard down. Sometimes you would have to slow the engine down to get it hard over, again that wheel wash, and you had to rope this side over here and the pilothouse anchored down. And you put your foot on that pilot wheel and hold it down, so it wouldn't get away and cripple you. And you would take the eye of that rope and put it on the spoke of the pilot wheel to hold it in place until you got ready to release your rudders, take some of the pressure off of your steering. Those boats back during those days, you didn't have all this power steering and hydraulic steering, electric steering, automatic pilot, and stuff like that.

A friend of mine told me here a couple of months ago, a gentleman, "Captain Louis," he said, "I bumped into something the other day." He said, "You ought to get a copy of it for your grandchildren and great grandchildren." I said, "What's

that?" He said, "You know back in Port Allen over there in the Hall of Fame, something kind of a big deal." He said, "You know your name is there bringing the largest tow down the Mississippi River." I said, "No, I didn't know nothing about that." Well, he told me, he said, "I just happened to stagger upon to it in the history books over there in Port Allen." It was about fifty-two loads down one trip during high water. I was pushing grain.

We've had some good captains. Captain Marineaux, he was one of my favorite captains, I guess, he and Captain Billy Kleinpeter, all Plaquemine boys, all old homegrown boys that had to come up the hard way. They worked hard to get where they got. They're all gone now to the Promised Land, but they helped me out a lot along the way.

When I was young, I remember all of those old DPCs [Defense Plant Corporation towboats]: *Tacoma*, *Lunga Point*, and the *Illinois*, the *Iway*, Federal Barge Line boats. They were so big. They were close to a three-hundred-foot barge. They had what they call watchmen on there that would go around checking everything, just a whole bunch of people that you wouldn't have on the diesel boats. But it was amazing to see those big ole steamboats and big smokestacks and black smoke a rolling. Some of the later ones that came out, they were equipped to burn crude oil. But I used to love to hear those whistles blow.

Back when I was young, it was wild on the river, especially when you would get to a town. Oh, yeah. I had a few fights on them boats. I used to be rowdy. But that old lady we had cooking on the boat, she kind of kept us boys under control. I didn't have any money to hit the hill with anyway. Old Captain Banta was a good ole man. Dead and gone now. I worked hard for him, but he was good to me. I got to ride the boat with him and George W. Banta. Me and him rode together. I was pilot, and he was the captain. We had some interesting conversations. Some of this came up about us staying here these fourteen days and nights, and he said, "Louis, that was hard days," he said, "than what it is now." He

said, "We got air conditioning now. We got power steering." He said, "Big lights. We got radios. We got radars." He said, "That's wonderful, ain't it?" I said, "Well, we come a long ways, I guess." "Yeah," he said, "we sure have." I just wonder sometimes if they got a towboat place up there in heaven. I'm sure they have.

FRANK WILLIAM BANTA SR.

– b. 1931 –

My name is Frank William Banta. My first pilot's job was in 1946, but I was on the river before that. The way I got on the river was following my father. He brought me with him. He brought both my brother George and I in 1934 on a boat that he had just finished buying, and it was a ferryboat at Plaquemine. The name of it was the *Polly S*. The first thing he did was he took a saw and sawed the cabin all around even with the deck. Somebody called him and had a job for it. They wanted to move some logs from Hog Point, which is right across the river from Angola, to the Bayou Plaquemine. And he took that job. We went to Hog Point, and they rafted timber. I was only about three or four, maybe five years old. I don't know how old I was. But we stayed up there and rafted that timber and floated it down the river to the locks and pulled it in the locks and put it in the bayou. They used chain dogs and a willow pole, and they drove a spike through them and put each log together that way. We floated in the daylight. At night time they'd push it to the bank. It just floated. We came at night, and he'd push it to the bank, and one of us would jump off and put a line around a tree. We didn't have any electricity. We didn't have any ice. We had drinking water and canned food, something like Vienna sausages.

I can remember one time he got a job, and I wasn't in school, and he took me with him to the boat. That was early in the morning, and he put me downstairs in the engine room. I could pull the clutch, but I couldn't put it all the way in gear. I could just make the wheel turn both ways when he'd ring the bells for me. I could make it come ahead and back up. But all he wanted to do was cross the bayou, which wasn't very wise, and pick up the rest of the crew. I was only three or four years old. I couldn't put it in gear. If I would have put it gear, I probably wouldn't have been able to get it out of gear.

I started actually piloting before I got out of high school in 1947 or '48. I went to work for Baton Rouge Coal and Towing Company. I went to work for them, and they said, "You're a pilot." I was sixteen years old. We were grandfathered in as far as the license is concerned. I just renewed mine. It will be due again in 2019. When I first started out there, I knew that I was going to make a career on the river.

Once we were towing for Cargill. We had a J barge in tow. And a J barge was a barge that came off the New York Barge Canal and belonged to Cargill. They had a tank on top, copper. On the bottom

of it is liquid. It would be liquid fertilizer, molasses—molasses mostly. We had one loaded with molasses, and the top was empty. I put the crew out there, and I took a two-inch pump, and it pumped water into the hopper. We had a pirogue on there. And my wife was on there with all four of the children, and she used to take her folding-down chair and her book. She'd let them go in there and swim inside of the pirogue. Another time, we had another empty hopper, and it had coal in it. The children had to have somewhere to play. We put a ladder down there and let them go down the ladder and then took the ladder out. They couldn't get out. When they came out they were black everywhere. They had shorts on but were black all the way down. But they couldn't get out. There was no danger of them falling overboard or that kind of stuff. I don't know if anybody else ever did that.

Our kids rode with us until they started school. That was the way we'd be together instead of being apart. When we were on the boat, my wife kept up with them along with the deckhands and the crew. After the kids were gone, my wife rode with me and cooked because she didn't want to just ride because there was nothing to do. It was boring.

A friend of mine, Willie Rushingham, described how it is to be a pilot on the river. Willie said, "Well, 90 percent of the time you're bored to death. Ten percent of the time you're scared to death." I agree with it, yes. You can have some tense moments.

When I started out on the river you had light lists, channel reports, maps and that's what you referred to. I knew people that could draw the river for you. I never could do it. I had to look at my map or read my light list or channel report.

My daddy was a steamboat pilot and also my Uncle Sherman; he had a steamboat license. But my daddy taught me boat-handling skills when he had

the *Polly S.* He would get out on the barge and put me in the wheelhouse. He would motion to me. If he motioned another way, I'd stop. If he motioned another way, I rang one bell. So if he did his hand up and down, up and down, it would blow the whistle. In other words, one whistle was half head; two whistles was full head; and three whistles were everything you had. One bell was to come ahead; one bell was to stop; two bells was to back up. So he put me up there when I was little. I had to stand on the box, and I'd turn the wheel for him one way or the other, whichever way he told me, and we'd land the barge or put the barges together or whatever they did. And he let me. I was just what you call a remote control, I guess you'd call it. I had a wheel. I didn't have sticks. The wheel could be dangerous. Like one time, Frank Repp, we were coming up the bayou, and he had the wheel down hard, and a log hit the end of the rudder and broke it off. It pulled the wheel up and broke his arm. But the rudder, if he wanted or when you had it hard down and you were coming full ahead on it and you just let it go. . . the wheel wash would straighten it out. If you let it go the other way, well then you had to pull on it. You had to get out of the way while it was straightening out. When you let it go, you moved. We had some other ropes too that were tied to the side of the wheelhouse. We dropped that over the spokes if you wanted to leave it hard down for a while. So you were not standing over it. So I learned at a very early age.

I've had a fascinating life on the river so far. I'm still a pilot now, and this month I was running the fleet boat. My big job these days is to get on and off the boat. Once I get on it, I'm all right. And once I get off, I'm all right. On the river, you always have somewhere where you can go. You have food. You have a bed.

GENE NEAL

– b. 1931 –

My name is Gene Neal. My career started January of 1956. I caught the original *Betty Brent* here in Vicksburg. When I was a junior in high school, I spent that summer vacation working on a towboat. I was fifteen years old at that time. I worked on a little boat called the *Templeton*. It was bringing sand and gravel in to Lake Ferguson in Greenville to what was then McCorkle Wright Gravel Company. But this boat belonged to Captain Templeton. He was a tremendous size man. He was tall and wide and thick. He talked to me about going to work on the boat. Captain Templeton was so big that he couldn't get on the boat like other people. The last time I remember him getting on a boat, he went down on the old wharf barge there down at the Greenville waterfront. He was so big that they had a seat made for him on this crane, and it would pick him up and then sit him over on the front deck of the boat.

When I got off of that boat that summer, at that point I decided that I didn't want anything to do with boats. I didn't back off from anything, and that was just a hard job. But I made a mental note, "Well, that's not for me." I then went on and graduated from high school. I spent four years in the military and

came back home and was knocking around doing the same thing. I had an uncle that was in the towing business at that time, so I thought, well, I'll just catch a boat and get away from the bright lights and have some time to think and see if I can figure out what I wanted to do. I wound up catching the *Betty Brent* in January of '56 at Vicksburg. I finished my river career about forty-six years later.

I hadn't been on that boat long my first trip out. I was up in the pilothouse one day cleaning up. George Reed was the captain on the boat. He asked, "Do you think you can steer this boat?" I said, "Well, I think I can." And he said, "Well, sit down here and try." So I sat down, and it was a good river, and it was northbound and in the buoys. So there really wasn't much to do but just steer the boat. From that start, he started letting me steer a little more and a little more. It wasn't too long until somebody said, "Looks like you are George's pick for this year." I said, "What do you mean? What kind of pick?" And he said, "Well, he usually breaks in somebody every year where he'll be assured to have somebody where he can get off to go deer hunting." That's really simplifying it. But it turned out that it was pretty accurate.

One of the most interesting characters I ever met out on the river was Captain George Reed. George was a fellow that tooted his own horn, and I guess you could say he bragged a good bit. But they say when you can back it up, you are not bragging. And he could do it. I learned things from him that stood me well for all of my piloting career. And there was Cannonball, Jim Roebuck. Back in the '40s, when Jim came to Greenville, he would go to the police station. At that time, the police station had a jail there, and they'd let him sleep there. He was homeless, but he had a home wherever he went. George told me this about Jim Roebuck. Jim came on the *Betty Brent* one day there in the harbor in Lake Ferguson. While they were down there, Jim showed up, and he was asking Gilder McCool if he could ride the boat to Baton Rouge or somewhere, and he told him yeah. Back then you didn't have to worry about people suing you for this or that or the other. But Cannonball would just ride the boats. He'd just ride up and down the river. He would work, and he was capable. He'd go out there and deck and do whatever job needed to done. It was such a different world then.

I knew Wamp Poe for years. He was the captain on the *General Jackson* up there at Opryland. I also knew his father, old Wamp Poe. I was on a little boat that I was captain on one time. We were doing some work on the boat that needed to be done. This old fellow comes walking in and said "Hello" and first one thing to another making himself known—"Hello, how are you?" You know. And he was Wamp Poe, the older Wamp Poe. So he asked in a little bit, said, "Who is captain on this boat?" I said, "I am." And he said, "Oh." I don't know if I ever talked to him face to face again, but I talked to him a few times up and down the river. He was just an old river captain.

The river gets in your blood, but I think maybe there's more to it than just getting river water in your veins. One thing is you get out there, and you get removed from everything that's going on other than just what is going on out there. If you stay with it a while, you start making pretty good money. The longer you stay, the more money you make, and the harder it is to leave that job and go back maybe to a shore job making less money. So it's not just the muddy water in the veins, it's the checkbook running thin.

CHARLES F. LEHMAN

– b. 1932 –

The SS *Bennestvet Brovig*, a Norwegian flag cargo ship, introduced me to a maritime life when I shipped aboard her in 1950 as a deckhand. She was a small freighter engaged in shipping between ports in the United States and Mexico. My prior experience with life on the water was reading Moby Dick and swimming in a few lakes and Missouri's Meramec River. My experience at sea was thoroughly enjoyable. Although I was the only American of the crew on board, employed as a temporary during good weather to do chipping, scraping, painting, and other deck work, they wanted me to stay on as a regular hand, but the pay, only being fifty dollars a month, with 20 percent, or ten dollars, of that deducted for the Norwegian tax man, left me with the feeling that it probably wasn't the best career path to follow. So that fall I left, but apparently the attraction to nautical life was somewhat addictive as the thought occurred to me that perhaps working on riverboats might be interesting. My first job was a deckhand aboard the M/V *St. Paul Socony* that was pushing refined oil product barges on the Lower and Upper Mississippi. Later, the company sent me to take a test at the then Second District Coast Guard office,

and I became a tankerman. However, with the Korean War going full blast, the local draft board was casting its eye in my direction. With a merchant vessel–based background and skills gained working in the marine industry, my thought process decided that employment by the government might be best served in naval service, so I joined the USN and spent most of my four-year tour on the second USS *Juneau* (CLAA 119), a light cruiser.

Upon discharge in the spring of 1955, and having visited my folks, various relatives, and friends and running short with my mustering-out pay, I went to work for Commercial Petroleum and Transport Company, the predecessor of the "C" in, ACBL, American Commercial Barge Line. At that time, it was to be a temporary job prior to attending college in the fall of the G.I. bill with the thought of becoming a history teacher.

So much for career planning. When my time came to leave, the captain recommended me for a job as steersman, to learn the river and become a pilot. At the time, I didn't know much about what a "steersman" did. However, having worn out my pair of work boots, they were thrown overboard,

and I decided to give a shot at what became both my vocation and my avocation, the river industry.

The Western Rivers industry has been my career for over a half a century, first as a deckhand, then a tankerman, pilot, and master.

ALBERT L. WOLFE

– b. 1932 –

My name is Albert Wolfe. I've been on the river since 1946. I was about fourteen when I started. My dad was a river man, and I just kind of followed in his footsteps. I grew up on the river. I come from a long line of river men.

My first license was in 1951, but I let them expire, and I didn't renew them again until 1973, but I have every five years from that. I started piloting boats though at fourteen. If you could ride one, you could steer it.

I was kind of self-taught, but I worked for Elmer Vickers on my first boat that I operated, towing barges and pushing barges. That old boat that I was on was the *Frances K.* The captain on that boat was Iron Head Vickers. That's what they called him because he had a plate in his head. That was in about the late 1940s.

In my family there were seven of us boys. All of us were pilots. In the last forty years, a lot of things have changed on the river. There used to be a bar just about everywhere you had to stop. It was rough and tumble as usual. The river rat type thing. Of course, the people seemed to enjoy it. Nowadays, if you get off, you take your suitcase with you. But back then that was common. We used to make a stop down in Natchez every once in a while, when they had all the old saloons and joints Under the Hill down there where the gambling boats are now. Of course, I never did have any experiences down there, but we'd go in.

The longest hitch I ever did was ninety days, and that was on the Missouri River. You'd make a trip up the Missouri to Kansas City or Omaha. You turn and come back out, and you were expecting relief when you get back out of the Missouri back to St. Louis and then you didn't have any. That's the reason why I stayed on there for ninety days. We couldn't get any help. I was ready to get off, but the worst thing is, they let you get almost down there before they tell you, "Well, you don't have any relief. Everybody else is getting off but you."

The biggest tow I ever pushed was forty. I didn't do forty many times, but I can handle forty. All my brothers, that's what they do is the big tows. You have to have nerves of steel. I never did get nervous about big tows because I always knew what I was going to do. I learned how to steer a boat without all of the electronics. I don't have to tie the boat up because my radar goes out.

Back when I was a teenager, and on the boats, it was kind of miserable from the heat. We didn't have any trouble keeping warm. We just always had good heaters, but it was hard before they got air conditioning. We used to have DC current on all these old boats. The air conditioning was out, but you couldn't run it on a DC current. When they went to AC current, we got air conditioning. I've had some fans on those old boats that would pull the sheets off the bed just about. You slept pretty cool when you had one of those.

Life on the river, well, it's been good to me. It's hard on family life, but a lot of women can adjust to it, along with the man. And if they do, it's good. If they don't, then, I've seen a lot of them break up, and I've seen a lot of them make it all the way through.

I made a lot of pilots over the years. I broke in a lot of people. I might not be really good at giving lessons, but if you watch me, I'll explain things to you. For example, you can always tell what kind of current you have just about—if the buoys don't have much of a whisker around [them], if the current is not very strong. If the buoy is kind of laying over and the water is really rolling around it, you know, you got a strong river.

One time I went swimming in the river. But it wasn't for me. I never did fear the river, though. A lot of times I might should have, but I didn't. I respect it, but I don't have any fear of it. I know what it can do. One time me and a friend of mine we were working a logging job with a logging company. There were some boats and barges and everything. We were tied up, and it was up above Greenville. We decided to go out and go fishing about two miles up the river from where the boat was. We get up there, and we fished. We decided instead of walking back down the river bank to the boat where we would get back on, we just got in the river and got us a log. We were just floating down the river. Somebody saw us floating on this log, and they called the Coast Guard, and then they had an alert out. We had to get back on the

boat. I was about twenty, twenty-one, somewhere around there.

My old granddaddy, over on the St. Louis riverfront up there around Laclede's Landing, he was a lamp lighter back before they had the electric lights. They had kerosene lights or either gas lights. I think I have an old picture of him when he was doing that. He was all dressed up and everything. At dusk he would light the lamps in St. Louis. He was up and down the river on those boats. He just followed work.

When I was running the upper river for J. O. Smith, and I was on that old *Brimstone*, I was captain on that thing for a long time. And old J. O., I loved him like a brother, but he was an old rascal. He didn't want to spend any money. He'd tell me all the time, "I'd sure love to have you working for me all the time." Said, "You're a high-dollar pilot. I can't afford you." I said, "You can't afford to not have me, if you have something to do." He'd call on me.

Anyway, I'd be on a boat for him if I didn't have somebody else calling me. He'd call me up and say, "I sure wish you would see that that boat gets through that bridge." I say, "There we go talking about that. You talking about not wanting to pay me any money, but you don't want your other pilot to make the bridge." And I said, "Something ain't right with that story." And he said, "Just go ahead and get it through there for me. Call me as soon as you get through."

I knew Cannonball. In fact, I give him a ride quite a few times. He would ride most of the time from Memphis to Baton Rouge from boat store to boat store. It was his way of life. I never did know of him working. I know him riding. He hitchhiked. I think he had an old dog one time. People would just let him ride up and down the river. Everybody knew him. There was a guest room on most of the boats that I've ever been on. I know a little bit about old Cannonball. He had a brother-in-law in Greenville that ran a hotel and a laundry. Old George Leech was the guy's name. I don't know Cannonball's last name. That's all I ever knew him by was

Cannonball. But anyway, old George—Cannonball always came by the hotel and store . . . One day, Cannonball came by, and George asked him, said, "Will you run this money by the bank for me?" He gave it to old Cannonball, and Cannonball took off with the money. The next time George saw him, he asked Cannonball, he said, "Why did you do me that way? Why did you take my money?" He said, "You just asked me to run it by the bank." He said, "I did. I just kept going."

I started back while me and Lea Brent and Howard Brent and my brother John were the same age. I go way on back when Mr. Jesse Brent was around. They never did spend the time out there on the river that I did though because they never had to. Daddy took care of them, but they worked when they wanted to. I had to work all the time. I knew Jesse really well, the dad. I liked Jesse. He was a good man. He was a river man. He had people at heart too. He wasn't just all about Jesse. He'd take care of his people. I thought a lot of Jesse. Old George Reed, he started out with the Brents. That's where he started, and that's where he stopped.

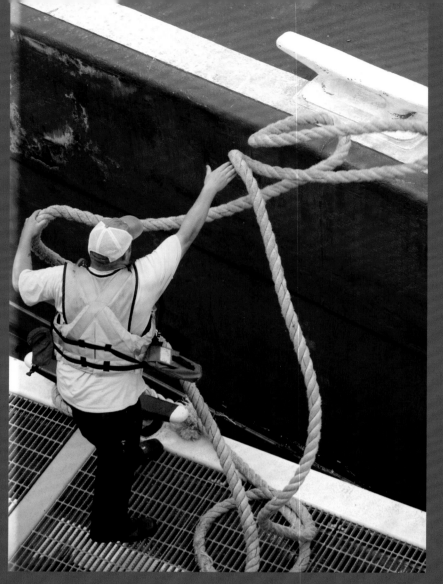
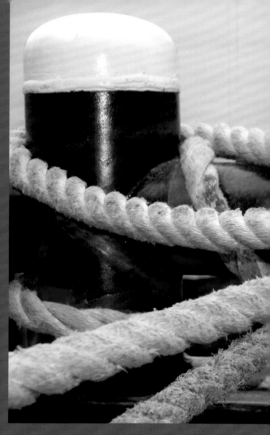

LEO J. BRAUN

– b. 1933 –

My name is Leo Braun. I got started in January of 1954. I've ridden over a hundred different vessels. I'm going to tell you two stories. The first story is, there was this green deckhand that caught the boat in Houston, and the boat was going to New Orleans. He had only been on a boat three days. This is in the 1950s. Back then, you had to tie your tow off and go to a refinery and get your bunkers, get your fuel and stuff like that. The boat left Houston and was going through Port Arthur. So they stopped at the West Port Arthur Bridge. They tied their tow off, and the captain told the green deckhands, he says, "Go out there to the deadman out there. We want to tie these barges off with a deadman." So that green deckhand got off and went out there and was stumbling around out there on the dirt and stuff and was thinking, What kind of people are these we're working for? We got to tie a barge off on a deadman. He was looking around for fifteen or twenty minutes, and finally the captain says, "Hey, there's a deadman right there." And he was talking about a cable coming out of the ground. So that poor dumb deckhand. See, that was me that was the deckhand.

Another story I have to tell you, there was a boat called the *Dolphin*. Well, back in the 1950s,

things were kind of sparse. The crew on the little *Dolphin*, it was a little four-hundred-horsepowered tugboat that carried a crew of four men on the boat. The crew was always complaining they didn't have milk, didn't have milk, didn't have milk. Well, the *Dolphin* would come into Port O'Connor. The dock man there, Ray Forbus, had a cow called Cindy. So Ray Forbus and Jeff Luber got together and said, "Hey, let's put Cindy on the barge, and I'll watch her, and we can milk the cow." They put some bales of hay on there, and they made a pen for Cindy, and the captain got up about four thirty every morning and milked the cow and got fresh milk. Things went along fairly good for a month or two, but wintertime came, and the days got rough. It was rough out there, and Cindy would get seasick. When Cindy got seasick, the milk went sour. So that would throw off the trip four or five days. So, finally, they put Cindy back ashore.

When I caught the boat in 1954, it was a little threeman boat with single screw, about forty-five by eighteen foot. There was just three of us on a boat—a captain and a pilot and a deckhand. The bunks were not big. There were three bunks that were stacked one on top of the other. The bottom bunk was just

right on the deck of the bunk room, and then the captain slept in the middle bunk, and the mate slept in the top bunk. The top bunk was bad in the summertime because you were real close to the ceiling, and it was so hot. But the bottom bunk, you were about twelve inches above the dang engine, so it was pretty warm too. But the thing about the bottom bunk was, I was the deckhand, and I'm not a particularly big person. But when I got in the bunk, I got in on my back or on my stomach because you had no room to turn over. It was like that. But we didn't know any difference. In the galley, you could take and put your hands and out and you could touch all four walls. You had no running water. If you wanted water, you had to go pump. We had an old water pump that you pumped the handle. There was no electricity. We were battery powered.

We had a water tank. But the way you get it out was with that hand pump. That little ole hand pump that you had, you'd get water up with that. We had no commodes with no shower system. It was crude, but we didn't know any better. We didn't have air conditioning. The fans were little Mickey Mouse DC fans, direct-current fans because we didn't have electricity on the boat, and no generators. We did a lot of work on a towline. We always towed everything. We didn't push it. We towed it.

A big change that I've seen in the industry is the fact that we had handheld radios. Before we had handheld radios, we stood on that tow that may be a thousand feet long while you were given hand directions, go to the right or go to the left or something. You couldn't talk to the wheelhouse, so it was all done by hand because the communications with the little handheld VHF radios made a world of difference. Of course, things have gotten a lot better.

When they started pushing the tow rather than towing it was in the late '50s. George Peterkin with Dixie Carriers started building push boats, and he started pushing barges around. Everything before then was tugboats, which was the model hull boats. It had a pointed bow on it. Pushing changed a lot of stuff too. It made it a lot safer.

Out on the river, it's either black or white. You love it, or you hate it. What happens to a lot of people, they get out here, and they get in the wheelhouse and start making good money and they don't like it, but they can't quit because they're tied up into it. I know a lot of people who went through college working on towboats, and when they got out of college, they were making 70 or $80,000 a year, and they could go work ashore for about 20. So they wind up on boats because they got in there and became proficient and moved up, and they got locked into it because that was good money. You have people that are college graduates out here on towboats, and that elevates the industry an awful lot. It's a very diverse group of people out there.

FRANKLIN E. "GENE" GOINS SR.

– b. 1934 –

My name is Gene Goins. I went on my first tugboat the nineteenth day of December in 1955 as a green deckhand. I was in the navy on what you call a kiddie cruise. I went in before I was eighteen, and they had to release me when I was twenty-one. They called it a kiddie cruise because I went in when I was seventeen. My grandmother had to sign for me to join the navy. I couldn't do it on my own. They had to let me out when I was twenty-one.

I've been on so many rivers that it would be easier for me to tell you the ones that I haven't been on rather the ones that I have been on. The Ohio River is my favorite river. That's a loafing river. My favorite thing about being out on the river is the food. My daddy was a sharecropper. I came up poor. I can write you a book on being poor. I couldn't believe all the food that they carried on these boats. I said, "I have found a home." I'm a finely tuned eating machine.

I broke into the pilothouse with Tiny Sanderson. They put me on a boat that he was relief captain on. I covered for two weeks, and I stood my first pilot watch in October of '57. Tiny, he was a good trainer because he didn't get excited about anything. He'd just let you run through a bridge and sit there and laugh about it. I always give him the credit for making a pilot out of me.

When I first started, there was radar, but all boats didn't have them. The best you could do was a carbon light. It's a search light. That was about the best piece of equipment that was on a boat at that time.

I met a lot of interesting people out on the river and a lot of old timers. I'm an old timer myself. George Reed would stick to my mind more than anybody would. George was an uneducated man, but he had the best understanding of floating equipment than anybody I have ever seen. If he told you it would work, it probably would. I think the towing industry is eat up with commonsense people if it's going to be a success. Education is not really necessary to run a towboat.

I didn't think I ever wanted to work on a boat where there wasn't any kind of camaraderie or joking. You have got to have a little laughter and a little morale on the boat. The biggest morale builder that I ever saw on my boat was *The Young and the Restless*, that soap opera that comes on at eleven o'clock in the morning. Everything shut down, so everybody could go watch *The Young and the Restless*. I'm talking about not tie the boat up, but the guys

could knock off and go down and watch *The Young and the Restless*. But those guys, they lived for that next day just to see what these characters that were on there, what they were going to do next.

One of my favorite cooks out there on the river was Bill Harris. He was an old hotel cook, chef type. He was sloppy as the devil, but he sure was a good cook. Another one of my favorites was a lady, and her name was Glennie Rose, and she was from Texas. She would cook anything except beans. She just couldn't cook beans, bless her heart, to save her soul. She was a good shipmate, too. She rode that *Margaret Brent* so long, and her cabin was right there off the galley. And *Margaret*, her engines, after she got a little age on her anyway, was bad to lose a turbocharger. Glennie could tell the sound of those engines. She could tell when a turbocharger was going out before the engineers could. Her room was between the galley and the engine room. She got along really well with the crew. She played with them and played parlor games with them and played poker with them. She was an older woman and in her fifties. Heck, she could stand on her head. She was a character. She really was a good person.

I stopped up there on the Upper one time. It was really, really cold, and we had picked up an old barge that was leaking really bad. I finally just ran into the bank. I wanted to see if I could do something about the leak. It was down like in the twenties. This water was about knee deep down in that barge, and it was ice cold. This boy that I was down there with, we stayed down there until we were making headway and kind of got things slowed down where we could pump it out. We came out of that barge, and Glennie was there at the hatch with of all kinds of things to eat and a tray with ice tea on it. I could have seen if it would have been hot chocolate, but she just wanted to do something, you know. She was taking care of us guys. We were her family as far as she was concerned.

I met a lot of good men out there. I really did. And barring none, I never met one that I could recall, off of the top of my hat, that you could even come close to being called sophisticated. They had a commonsense talent. Common sense will do you a lot more good than a formal education during that time on the river, or at least that's the way I feel about it.

GARLAND SHEWMAKER

– b. 1934 –

I am Garland Shewmaker, and I was born around Livingston County, Kentucky. I grew up on the river. Before I got out of high school, I got a job and worked two years as a deckhand and mate and tankerman. I always wanted to be a pilot anyway. This is back before the Coast Guard had all these regulations. You didn't have to have a license to be a pilot unless you were on a steamboat or an inspected vessel. You had to have a license to draw the river when you became a pilot on a steamboat or a regulated towing vessel. Then, in 1975, they came along and started putting operator's stamps on a firstclass license and, of course, made it a requirement for everybody to have that whether you had a firstclass license or not.

I was fifteen years old when I knew I wanted to make a career out on the river. I went on the first boat at sixteen. I knew I wanted to do that all along. I kept arguing with my parents about it. I read Mark Twain and all that stuff, and just the adventure of the river I think is what drew me to it. My step-dad had told me that I would make a pilot because I had a good memory. That stuck with me. In those days, you didn't have radar. You didn't have sounding machines and electronic charts. The Coast Guard wasn't on you every few minutes. You were

pretty much your own boss as long as your employer decided you were capable and you were a good pilot and you weren't tearing things up, you had a job. Once they came along with the operator's license in the '70s it got more hazardous out there than ever because these guys would get an operator's ticket and were supposed to be a pilot. A bunch of them got on boats and didn't know what they were doing. It was more unsafe than it was before they got license because it doesn't take a license to drive a boat.

In bad economies and bad times, old President Dwight Eisenhower put barrels out for buoys. We didn't have buoys. When Eisenhower was president, we were running with just plain old barrels for buoys. They were too cheap to buy buoys. In Eisenhower's time, they had old buoys floating out there. No paint on them. You couldn't tell what color it was or what size. But the only thing that saved us was the Corps of Engineers published a channel report every other week or so. It would tell you there's a buoy over here in so many feet of water, low water or high water buoy. There may not be any color on it, but it's on this side. We knew where it was supposed to be. So that was one of the things that's changed considerably.

In '85, old Harold DeMarrero called me and wanted to know if I'd like to have a job as a captain on the *Delta Queen*. Of course, that was my dream when I got my first set of license. He said, "Well, come on up here and get on. I'll just pay you to ride a few days, see if you like it." I got on at Huntington, West Virginia, and rode to Pittsburgh and then back down to Gallipolis, Ohio. Then Harold said, "Now, look, man, you got to let me know something. I can't just pay you to ride." So I said, "Well, okay. So I'll be hollering at you when I get home." I called, and I said, "Harold, I'm ready." So that's when I went to work. That was the greatest experience of my life really because you meet a lot of nice people from everywhere. You'd be sitting there talking to somebody like Helen Hayes, a fine old lady, Bing Crosby, those people like that. I was on the *Delta Queen* for about a year. Then I went on the *Mississippi Queen* and rode it for quite a while. I was on the *Mississippi Queen* in 1997 or '8. About '98 I guess Captain Keyton passed away, and so they sent me over there to replace him on the *American Queen*. So I stayed there a couple of years. The difference between the excursion paddle-wheel boat and a tow-boating pushing freight, well, it's not much of a job to it on the paddle wheels. It takes some ingenuity. It takes a little expertise because that thing is an eight-story building. And the wind blows, and when it gets to blowing pretty hard, it will blow you into something. So you have to make a wide sweep. But on a towboat, it's a lot different. That's some hard work. You get thirty or thirty-five, forty barges—I mean you're going to have to be on your toes.

Thinking back on my own career, I think that it's the best thing I could have done. I think it still is because there is always a job of some kind on the river. No matter how bad the economy is, somewhere there's a job on a riverboat.

I tell you what, I like a guy that don't blow smoke up your butt about how good he is. You know what I mean. You get a lot of those kind of guys, and they'll come out there and, man, tell you what all they've done and how good they are. If you don't believe them, just ask them. I don't really care for those kind. But if somebody gets up there and is doing his job, and he doesn't really impose on anybody, that's who I look up to. There are several guys that I've really respected over the years. Of course, Earl Basham. He said, "Hold that pier there until you feel something run down your leg." He said, "You always will find a lot of good pilots in the galley and then on the lock walls." He said, "Let them get up here and get between the sticks."

I've been on some real good boats. I've been on some dogs too. That's the thing that's changed over the years is the boats. The good boats now—you used to couldn't even stop when you were headed southbound. The only way you could stop was just drag down the bank—you weren't going to stop—or go aground.

I think today is as good a time as any to make a career out on the river because they've got the means and the equipment and the safety rules to take care of you. Anybody that really wants to go out there and make a pretty good living on the river, and maybe build a nest egg, the opportunity is there.

JERALD "JERRY" TINKEY

– b. 1934 –

My name is Jerald Tinkey, but I've always gone by "Jerry." I got started on the river when I got out of high school, and jobs were really hard to find. I was just eighteen. I came down to Wood River. I had heard about the Economy Boat Store. On the river, they had, I think, a Tri-Cities Grocery Store on Third and Penning Avenue. They told me you could go there and sign up. If a boat came by and needed a deckhand along with the grocery order, you could get a job. They had a warehouse back there. You could live back there. So I got to Wood River and signed my name. I was on the list, and it didn't take long at all. An Ingram boat was coming by and had ordered groceries and needed a deckhand. That's the way they did it back then. There weren't any physicals or anything like that. They just sent me out. So I went out. It was either late March or early April, but it was snowing, and I didn't know what was going on. But I went out there. They took me out, and I'd stand on the front deck area making tow. They were getting ready to go to Bettendorf and were putting a tow together. I didn't know a thing that was going on. I was just standing there. I saw this guy dragging what I thought was a rope. He was dragging it across the deck, and I was watching

him. And he put it down, and he came back. He saw me there. This is absolutely the truth. This was my orientation into the work force. He said, "Who are you?" I said, "Well, they brought me out here. Said you had a job opening out here." He said, "Yeah." I said, "I don't know what to do." He said, "Well," he said, "you see me dragging that line?" I said, "Yeah." He said "Well, any time you see me dragging or lifting or carrying anything," he said, "you just grab a handful and help out because," said, "I'm your mate, and I'm your boss, and that's all you need to know for a while." So that was my job orientation, just grab a handful and help out. That kind of worked pretty well the rest of my career, just kind of get a little bit of it and help out. Well, I helped put tow together. This was right after the war, right after the Depression. My dad died when I was seven, so my mom was raising us, and we didn't have anything really. So that was the best living I ever had. It had an inside bathroom and good food and a good bed. So I figured it was going to work out for me. I thought this was going to be okay. But I didn't stay there long because I'd heard about this company that was just starting, and it was called Nashville Coal Company. They had a towing subsidiary called Potter Towing.

That was Noble Gordon. Noble Gordon started that company for Nashville Coal Company. They were paying $255 a month, and I was making like $210. So 45 bucks a month difference, I can tell you, I was ready to move. So I called them when I got off to see if they had any openings and I got hired on, and I was with that company until we sold it and I was the president of that company when we sold. But that was my career.

The other part of that job orientation that I had, after we got our tow made up and started up the river, it was daylight then, and in the morning. Everybody else kind of went to bed. It was the *EB Ingram.* It was a little bitty boat. They're all in the same room and I thought, well, I'd just go there too because I'm tired. I'd been in that warehouse. Well, that mate came in, shook me a lit bit and he said, "You're on watch." I said, "What does that mean?" He says, "That means you're not supposed to be in this bed. That's what it means." But he was one of those colorful old guys and I'll never forget his name. His name was Harry Underwood. He was a tough old steamboat mate, and he was just working there long enough to get him a tavern. That's what he wanted. But that's the first time I heard that phrase. He said, "You know," he said, "We work six days a week helping that captain get this boat up and down the river," he said. But he said, "Come Sunday," he said, "if we don't have anything else to do," he said "all you're going to have to do is eat chicken and ride." And so that was my benefit program and my job orientation there and a couple of small lines.

Well, the real character that I worked the longest for was Captain Shorty Williams and another colorful old guy was Ray Prichard. These were guys that came off of the government steamboats and things and the dredge boats. They all came up through, when we were young, back in the 30s when they were canalizing the river. They were old steamboat pilots, and they were pretty colorful. But Shorty he kind of took me under his wing and he real early on he let me do a lot of steering. I rode for first license

in '55 under the Steamboat Inspection Service in St. Louis. My original pilot's license was in '57. I spent about 20 years on the boats. Then about six years on deck as a deckhand and a mate and second mate and a mate. Then about 14 years in the pilothouse in different boats for MidAmerica. I moved in the office in 1971 as a port captain. I kind of rose up the ranks there. I hit every base. In 1985 I was named president of the company, and so the rest is history.

The first involvement I had with rules was whistle signals and things like that was when I was just a kid. We were all raised in a little old town on the Upper Mississippi River, a town of about three hundred. There were really only about ten or twelve boys in that town—Hamburg, Illinois. And, of course, this was during the war years, and so we had the river in the summer and the hills in the winter, but we were in the water all the time.

One of our trips that we just had a lot of fun with was, back in the war years, they were running a lot of stern-wheel steamboats up there, the *Patrick Hurley* and the *Alexander MacKenzie* and some of those big ole stern-wheel steamboats because they kind of had to put them back in operation because they needed to move a lot of product. Those things would roll a big swell behind them when they were northbound. In this little town we had a town jon boat. A jon boat is just a wooden-hull boat, just a flat wooden boat. But as far as we know it, it just belonged to the town. It was just always tied up down there. Well, we'd take that boat out and get behind the *MacKenzie* or one of those when they came back and sink it on purpose just to hear them blow those whistles. And this is true; we'd hear them blowing the four whistles. They'd stop that big ole wheel and start it backwards, and then they'd blow another whistle. Well, hell, we just thought that meant that four or five idiots were in the river. But it was a danger signal, but we did that several times. There's a bend right below town where you could see the smoke coming, so you knew that one of them was coming by. We'd get all ready. But that was fun. You know, we would just swim the boat to

shore and dump it out and be ready to do it again. It was dangerous, but actually we swam back and forth across that river all the time, back when we were kids. I had a relationship with the river at an early age.

The other thing we'd do, there was a red buoy right out from town. Actually, the black buoys were black instead of dark green. We'd swim out and when the boat came, and we would get behind that buoy. Then when that boat got alongside, we'd jump up in. Now I can't tell you how many buoys I've run over coming out of there with empties but didn't even think of that. But that was part of our play time. This was in the 1940s.

When I first started on the boats, there was a boat named the *Mama Lere*. It was named after a lady named Valerie. Her grandkids called her Mama Lere. But that was kind of famous. That was a big boat for its time. It was thirty-two horsepower and back in the early '50s. It was '53, '54 when I went with that company. That was a pretty good size boat. But we had up to seventeen people on board that thirty-two-horsepower boat. There were four on each watch, a second mate and three deckhands on the following watch, and a first mate and three deckhands on the after watch. So it was a man and a wife in the galley, and it was four people in the engine room. There was an engineer and an assistant engineer and two oilers. And usually we had the steersman in the pilot house. So there were three up there. We had right up to seventeen people on that little boat. But it was really kind of family oriented. It was nice. It was good.

I have a lot of stories about Noble Gordon because when he first started he was on the boats all the time. He lived there in Uniontown, Kentucky. We were running from Uniontown to the Upper Mississippi or on the Tennessee River in the winter. But he was down on the boats all the time. He was a stickler for doing it right. The winter back in those days on the river, it was cold. It was really cold. Back then, we really didn't have the warm clothes that they have now. Wool was the best you could get

until after the Korean War when they learned from the Chinese how to make quilted clothes and stuff to get them a little warmer. But before then, what we had was wool, wool mackinaw, and they'd get wet and smell like a wet dog. And we didn't have the synthetic lines in there, and a two-inch line would swell up to be about a four-inch line when it'd get wet. And then when it would freeze, it would be stiff as a pole. And you would have to drag those all over the place because we didn't have a lot of lines. Your head lines and your lock lines and stuff like that, you had to use the same ones. So the equipment was tough. We were still using bull chains when I was out on the boat. They were fifteen feet long, and they weighed 180 pounds.

It's a bull chain because it didn't have any give to them. When you tightened it up, it was there. Well, we used them for jockeys on our barge-line tows on the Upper Mississippi because you land on the lock wall. If you didn't have good jockey wires or bull chains, it'd slide over, and you'd create a notch there. They'd get those notches hung on those ladder wells and stuff like that. But Noble insisted we use bull chains on those, and they were heavy. You had to be strong. We spliced our own rigging back then. So you had to learn how to splice wire. When you traded tows, you made a good exchange because it was hard work.

Back when I first started, you had to chart every inch of the river. During the second World War, you just had to chart a mile above and a mile below the bridges. But, after the war, then you had to start charting the whole thing again. But all the testing and all the examinations were really based on wooden-hull steamboats back then because there weren't any license requirements for diesel boats. It was license requirements for steamboats. You had to learn everything either from one of the old pilots that you were working with and you sit up at the pilothouse and talk to him all night and try to inquire what's a rose box and stuff. A rose box is kind of a sanitary device that they used to collect stuff in and they call it a rose box. It was in the

piping. It really wasn't a box. But actually, a lot of the questions were on wooden-hull steamboats, carpentry and stuff like that. But all the licensing questions were done in presumption that you were going to be working on a wooden-hull steamboat.

In 1954, something like that, and we didn't have air conditioners on the boat then. At night in hot weather, we spent a lot of time out on the head of the boat. You'd sleep wherever it was cool because in the rooms at night it was very difficult. At night, we would usually sleep out on the barge because it's quieter out there, and we would just get out on the end of the barge that the boat was faced to. It was pretty uncomfortable because it was hot from the sun shining on it all day long and no air, you know. It was just hot, but it was nice out on the barges.

I remember a story told to me about when Anheuser-Busch decided they were going to try to get in the wine business a little bit. They had a naval architect design a tank barge for them. They had a stainless-steel tank. They were going to haul wine from some place down south and bring it into their place there in St. Louis. Well, Federal Barge Line took the contract to move the barge. They assured the captain that there was no way that the guys working on the boat would figure out how to tap the tank and get the wine out of there. But sure enough, the first trip up the river with that wine, the captain got a call, and it woke him up about two or three o'clock in the morning. Said, "Captain, you better get down here. We got a problem on the boat." Captain said, "What's the matter?" He said, "The crew is drunk." So he said he went in the galley, and he talked to the cook. He said, "Now, what time did you get up?" She said, "Well, I get up around four." Said, "Did you notice anything different," he said, "like somebody was drinking or something?" "Well," she said, "I can't say that anybody was drinking, but when I came into the galley, the mate was standing up on the table. He slammed a bottle of ketchup against the wall and said, 'LET THE GOOD TIMES ROLL!'" She said, "So, I suspected he was drinking a little bit because he said he never did that before."

One of the old timers that I really was fortunate in getting to know and having some involvement with was Gene Hampton, the last active captain on the *Sprague.* This was when I was still with Potter Towing.

When you are on a boat, it is like family. One of the things that really made it nice was in the galley was a husband and a wife, and the husband, we called him Sailor Boy. They did all the rooms, or he did, and even cleaned the deckhands' rooms and then helped his wife in the galley. But that was a nice family-type atmosphere where everybody cleaned up for meal time. You wouldn't come to meal time with a sweaty or dirty T-shirt on or anything back then. You went in kind of cleaned up before you came to the meals.

The pilots and captains that are out there nowadays are pretty attuned on anywhere you need to go. Back in my day, an Upper river pilot probably wouldn't go to the Lower river. He'd go to the Tennessee River or go to the Illinois River or go somewhere it's a locking river, but certainly wouldn't be comfortable at all down on the big river. In the same sense, the guys that were running the rivers below Cairo, the Lower Mississippi that's big and fast, they wouldn't be very comfortable on the Upper river back in those days.

Noble Gordon hated the unions. Noble was a union hater. Actually, and this is the truth, too, at Uniontown, there was a nonunion operation. National Coal was nonunion, but that was the heart of union country and coal miners. They were always threatening us down there at the coal dock. Noble had you wear a pistol in a holster when we were out spotting barges. Didn't have any shells in it or anything, but he wanted that for show, and he had us all wearing those things. If we had fallen in the river, we would have drowned sure as hell. But he did. When we tied off up in Saint Paul, we tied off at Lambert Landing waiting for barges all the time. Well, that was big union country up there, too, and Northern States Power was our customer there or National Coal's customer. And, of course,

they were a union company, and so every now and then they'd have pickets where we were tied off, picketers picketing the boat. Well, when they did that, we had two carbine rifles in the pilothouse. Noble had those put up there and bulletproof glass. He wanted all that stuff. He set those rifles out on the bridge there.

A towboat captain should be a good manager who respects himself and respects his crew. They're a pretty rugged bunch actually. Generally, they don't have a lot of formal education, but they have an awful lot of intelligence. They have to make decisions on just split timing. A towboat captain has to be a babysitter and they have to be a manager and they have to be talented.

CLARKE C. "DOC" HAWLEY

– b. 1935 –

My name is Captain Clarke "Doc" Hawley. I was born in 1935 in Charleston, West Virginia, on the Kanawha River. I'm going to tell you about my life on the passenger boats because I spent just about all my time on excursion boats or overnight passenger boats like the *Delta Queen* and *American Queen* and *Mississippi Queen*. My family worked on the river. My grandfather and my great uncle were river pilots on the Upper Kanawha, and they owned little packet boats that delivered the mail and took goods up and down the river. They didn't push barges; they just carted people around. They were little paddle wheelers.

I was always interested in the river. Every time a showboat would come to town or an excursion boat, they would usually play the calliope. I could play the piano by ear. I'd go home, and I'd play calliope songs on our little pump organ. My brother's class went on the *Avalon* boat, a steam paddle wheeler. I was sixteen years old. They needed some chaperones, some older kids, to go with them to keep the little kids from running around. So, I went, and I went up to the watchman and I asked him, I said, "Why didn't they play the calliope today?" And he said, "The calliope player quit down in Huntington,

West Virginia." Then I said, "Well, I think I can play it. Would you take me up there and let me try?" He said, "Oh, I'd have to check with the captain first." So, he came up and got the captain. Here comes the captain, a six foot four, big, huge man. I said, "I want to play the calliope and just want to give it a try." He says, "Let me tell you one thing young man." He says, "Everybody thinks they can play that thing if they play the piano." But I said, "Well, I don't need music. I can play by ear, and I can play calliope-type songs." He said, "Now, I'm going to let you go up and try it. But if I give you timeout signal, stop playing because you'll run away more people than you'll bring down here. The reason we play the thing is to bring people to the boat and so they will follow the sound." So I went up there, and I started playing. He said, "That's pretty good." I said, "Well, I've been listening to the *Majestic Showboat* and to this boat." And he said, "Well, do you know a song called 'Down Yonder'?" So I played that song, and it just so happened that that was his favorite song. I just knocked that out perfect. So he said, "Young man, what are you doing for the rest of the summer?"

The captain said, "I can pay you thirty-five dollars a week if you'll pop popcorn on the side." I said,

"I can do that." So there I went. My first season, I worked with all these wonderful old captains and pilots, and I just fell in love with the business. The boat was almost as big as the *Natchez* boat. It carried thirteen hundred people. It was a paddle wheeler. I had a lot of good experiences, and I got to see how people in other places acted and responded. And we did have fights. The boat had a little jail on there to put any rough folks that wanted to fight. You get a thousand people, and there's a rotten apple in every bushel. There were different towns and different people, and by the time I had worked two summers on that boat, I had been on eight rivers in seventeen states.

It was like another education. I had graduated from high school. The captain had only graduated from the sixth grade. He thought I was a whiz bang because I had graduated from high school, see. In those days, if a person was bona fide not able to read or write, or if they were Native American, they could take an oral examination for their captain's license or pilot's license. You could sit down to an inspector, and he would say, "How do you run such and such a bend? How would you set up for the Vicksburg bridge?"

On my twenty-first birthday, I got my mate's license and just kept on getting experience. Then one of our pilots was the captain of the *Delta Queen*, and he talked me into coming over there as the mate. The *Delta Queen* was the biggest tonnage boat on the river at that time. I could go work on the *Delta Queen*, and I'd get all of gross ton license. So then I got my captain's license, all gross tons, and went back to work on the old *Avalon* for a couple more years. Then I got off and went back on the *Delta Queen*. I worked on there nine years and got off the *Delta Queen* and went back on my original boat, the *Belle of Louisville*. The old *Avalon* had been renamed the *Belle of Louisville*. And here I was captain of that *Belle of Louisville*. I was young. I got my captain license at twenty-one.

I remember Captain Edginton, who was an Ohio River pilot, he was in his eighties. He was on the boats that ran Pittsburgh to Cincinnati, and he had worked for my great grandfather. He worked till he was ninety-four. He got licensed in 1880. He worked till 1960. He died in 1961. He was on the river for seventy-something years. One time I said, "Captain Edginton, do you ever remember Captain Calvert of Charleston, West Virginia?" And he said, "I surely do. I worked for him on the *Kanawha Belle*." And so we became really good buddies. Here I was working with this man who had gotten his license in 1880, and I'm working with him in 1950. I worked with many, many guys who had worked on towboats and passenger boats before 1900. They were still working on that boat I was working on in the early '50s. So I'm listening to their adventures getting aground in the days before any radar when you couldn't run, and you'd miss the next town because you didn't get there on time, stuff like that. So I'm figuring these guys are pretty high class. Most of them weren't college educated but were wise to the ways of the world. They were river people.

Some really interesting people got on my boat stand out, [such as] Gerald Ford, president of the United States. We had George Bush Sr. on the boat. I remember he announced on the boat who his vice president was—Dan Quail. Reagan came. Helen Hayes made at least ten trips on the *Delta Queen*, maybe more. They even named a room after her on there.

I don't think I'm going to get my license renewed. The Coast Guard asks too many deep-sea questions for the river. I'm a brown-water person. I'm not a blue-water person. I get mad because the Coast Guard makes you do a compass course now, especially if you're on a passenger boat. I worked twenty-five years on the river before I got on a boat that had a compass. What do you use it for, you know? And here's the Coast Guard telling me I have to have this compass course if I want to keep working. So, you know, thanks but no thanks. I'm seventy-eight years old, so no thanks.

About my early days on the steamboat; the steamboat either burned wood or coal or oil. That

first one I worked on, the *Avalon*, had been a coal burner, and then they converted it into oil. The big boilers boiled the water to make steam. Steam goes through a pipe back in the engine room and turns the paddle wheel and turns the rudders. The steering gear and everything is powered by steam. It's interesting because for years, up until 1974, you had to have a license to run a steamboat, but you didn't have to have any license at all to run a diesel boat. Nothing. But the Coast Guard made the diesel people start licensing. If you had worked on a boat for twenty, twenty-five, thirty years and had a pretty good record, they'd give you a Coast Guard license. But all the new fellows coming up had to go the Coast Guard route. Another thing, passenger boats were carrying lives, you know, people; especially the *Delta Queen* and those boats were just floating hotels. They ran night and day. You had to have the best licensed crew to run that boat because you had human lives instead of lumps of coal. That crew became like your family. I was just a little kid when I first started. They took a liking to me because I was young, and I was a good calliope player. The old timers took me under their wing, and I would love to hear them tell their stories about their adventures. Most of the stories were about boats that caught on fire and burned, and they barely got off. Some boats got hung up on sandbars and ended up being aground all summer. They told about river adventures and about getting down the channel on foggy nights and trying to run in the fog in the days before radar. I got interested in steamboats in general back in the days when those big boats like the *Robert E. Lee* and the *Natchez* and those big giant white great big boats ran. They didn't have any refrigerators on those boats. Back in those days, there wasn't any such thing as a refrigerator. They had the animals on the boat. Those great big boats were side-wheel boats. They never carried roosters because roosters made too much noise, but they had hens. They would defeather the chickens and chop them up and fry them right there on the boat. I have menus off of some of those old boats. They never had less than three or four choices of meats. They would get their vegetables from the plantations and would buy their vegetables from plantations where they were loading sugar or cotton. They'd make a deal with the overseer of plantation—"Look, I need a bushel of beans," etc. That was way back when.

People always are asking me, "How do you know where the water is and where the water isn't? How do you know the channel?" I say, "Well, okay. Say you go from your house to your job five days a week. You know where all the potholes are, the bad ones, and you dodge them. You know where the streetlights or stoplights are. You know where the cops are hiding behind the tree trying to catch you on running the red light. That's the way we are on the river." That's why we have to make ten round trips, to get a pilot license. You have to certify that you've made ten round trips, half of them in the day and half of them at night because the river is as different as day and night. From sunup to sundown, it's one way. After the night falls, if you didn't have that big carbon arc light to swing back and forth and hit those buoy reflectors and a good radar, you could get around really easy. That's what it was back in the old days. I was working with and coming up with guys who never had radar. Anyway, you memorize. Mark Twain talked about learning the river, and that's how you do it.

If I had it to do all over again, I would do the very same thing.

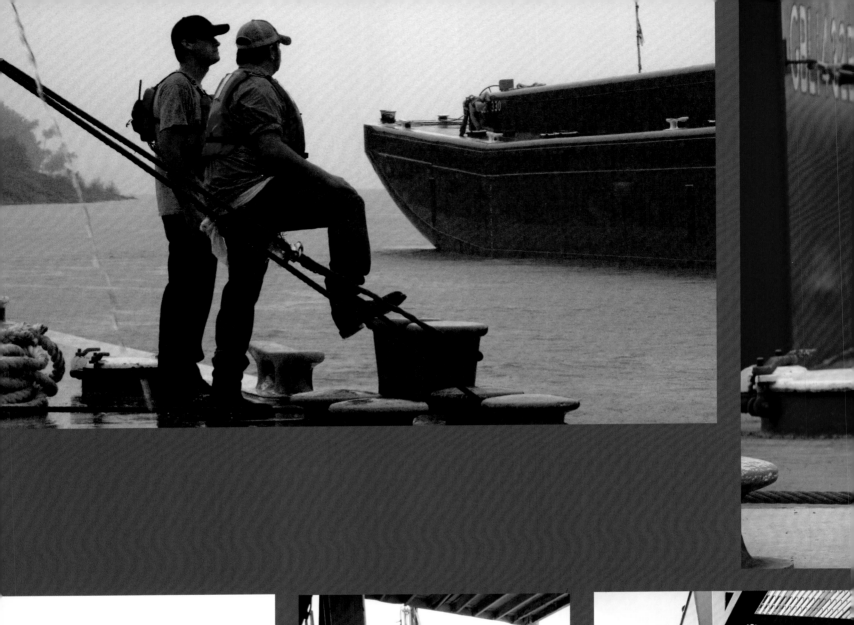

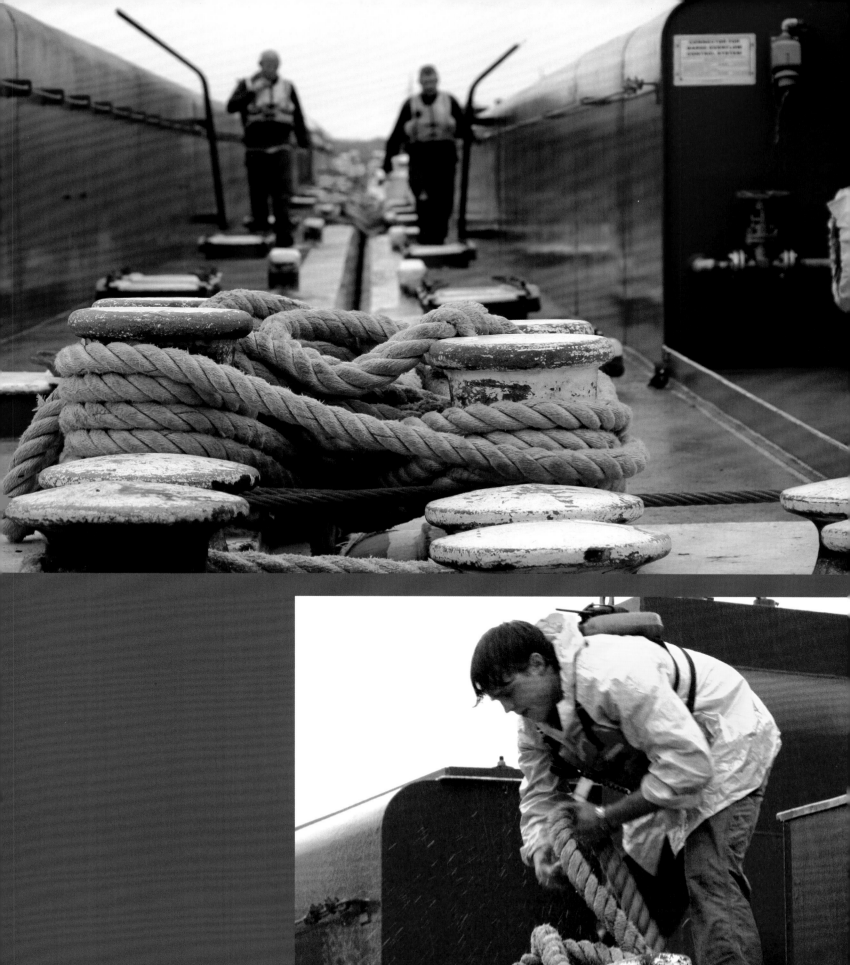

JAMES BERNARD "SUITCASE" SIMPSON

– b. 1935 –

My name is James Simpson. I'm called on the river "Suitcase Simpson." I started on the river, July '55. I never did have anybody to break me in after I moved up on bigger boats. I just got hired on a boat as a pilot. If you hired on as a pilot back in those days, you went along till you were captain.

I'll tell you a little story. While working on the *Polliwog*, I had an engineer on there by the name of Ira Frogget. We were up the Arkansas River on it. Marine operator called me. That's when they had the old Channel 4 radio. He said, "The motor vessel *Polliwog*?" I said, "This is the *Polliwog*. Go ahead." She said, "I have a call for Ira Frogget." I said, "Okay. Hold on a minute. Let me get him up here." Well, while he was getting up here, I told her, I said, "I got him coming. Hold on." She said, "I can't believe that Ira Frogget is on a *Polliwog*." They got a lock on the Arkansas River named Toad Suck Ferry. Now, it's still up there. I wasn't there, but to make the story interesting I said, "Hon, that ain't all. I been to Toad Suck Ferry." She said, "I can't believe all of that. I don't believe it."

I had six issues of my license. I actually had a hundred-ton license, before they issued the grandfather license. Well, that's a little something there that I sort of like to put in how I got my name "Suitcase." I did not have [a] license, and I was working for Mr. Charlie King. He had an old man in Greenville that couldn't get around. Couldn't see. Couldn't hear. They'd send him down there, and he'd run over everything they had. They'd call Mr. Charlie and tell him to get him off. But Charlie said, "We'll have to send Simpson back down there then." "Well send him." So here I'd go. I'd go back down there. And they got to say, "Here comes old Suitcase. There's goes old Suitcase," because I was coming and going all the time. Well, one of the guys got to calling me Suitcase, and it just stuck. That's what I've been known as my whole life. For decades.

There were shanty boats on the river back when I first started. The White River had a lot of them on it when I was running it. That's just where they lived as fishermen. That's the way they made their living. There was a guy by the name of Wayne Wilcox. He died this year on a Marquette boat. Died at the wheel. Died on a boat, but he was born on a shanty boat, and he died on a boat. He rode them day in and day out. He didn't take a lot of time off. His daddy run an old crane loading logs off the bank to a barge for Chicago Mill there in Greenville, and

they lived in it, just kept that old shanty boat wherever you loaded logs. Well, he'd go to town on Saturday evening. Come back, they'd take the front door down. They used it for a gangplank because they knew he was going to be drunk, so he wouldn't fall.

When I went on bigger boats, you just had a set of rules you went by, and that's pretty well it. We didn't ever put up with having to call a man two or three times when it came time for him to get up. We expected him to get up. We had a little rule. If you don't get up, we'd put the firehose in the room with you and then run it. The next time you call, they'd come out. They'd come right on up. We did that a few times. Sort of had a mess in the bedroom for a few days, but.

I finally did go get me some license way back when. They turned me down on account of my eyesight, the Coast Guard. So I came back and told Mr. Charlie King about it. Working for him. He said, "We probably can take care of that. We might can get that changed." He said, "We'll go to Greenville here in a few days to get things taken care of." In a few days, he said, "Come on. Let's go to Greenville." We went to Greenville and stopped in there to see Bilbo Williamson, go there and talk to him a while. And Mr. Charlie told him, he said, "This boy here went for his license, and they won't give it to him on account of his eyes. Said he hasn't got enough eyesight without his glasses." Bilbo said, "Charlie, I'm a Democrat. Hell, you need to be talking to Jesse Brent. He's a Republican." He said, "Yeah, you're right." Nixon was president back in those days. And Charlie reached in his drawer and had another snort or two, you know, and we went on down to Jesse's. We went in to see Jesse, and he opened the drawer and had another snort or two also. By that time, I didn't care whether I had license or not. You know, I had a little snort too. But Jesse said, "Well, let me see. Get ahold to Clark Reed. I'll let you talk to him. You can tell him what you want." He called Clark on the phone. Clark, after talking to him, he got it. Jesse told him, he said, "Got a guy here. I want you

to talk to him. He'll tell you what he wants." And he gave me Clark. I told him, I said, "I want some towboat license, and I went up to Memphis to get them, and the Coast Guard turned me down on account of my eyesight. Said without glasses I couldn't see well enough. I had to have so much without them." He said, "Well, I don't know what I can do, but give me a few days, and I'll let you know." He got my address. Well, in about ten days, I had a license. It was signed by President Nixon void without corrective eyeglasses. I still got it today. Hundred-ton license. Jesse Brent, he helped people. Well, people can say what they want to about Greenville, but those people around there put a lot of people to work that needed to work. They put people to work like me that didn't have a great education. They let them make something out of themselves.

I helped raise the gunboat *Cairo* out of the Yazoo River years ago. We brought a gravel digger in there and pumped the mud off the top of it, so they could get to it. We didn't raise it, but we got a lot of stuff that was on that old boat. We got a few pistols, bayonets, that kind of stuff. And all kind of army buttons were on there that we popped up then let them land on the gravel barge, and we'd sort of sift through it. We got so much junk off of it, they brought the navy in there, and the navy confiscated it all. We just pumped the mud off. It was still sunk when we left. I'm not sure just how they did raise it, but it was raised. But I was having a good time. Ken Parks was doing the diving. He'd go down and got the pipe hung on a gun barrel up in your pipe there. But there was live powder on that boat. We dug up some kegs of dry powder that had been sunk over a hundred years. They dug a hole out there with a dozer and put that stuff out there and set it off. They got rid of that powder right out there. Sure did. It was very dangerous. We got a call one day, and they told us there were live torpedoes on there. But if we had circled through that pipe that had got up there in that pump it might have lifted us out of the Yazoo.

HOWARD HAYES BRENT

– b. 1937 –

My name is Howard Hayes Brent. I was born in Vicksburg in 1937, and we lived in Redwood. My father, Jesse Brent, had a little farm out there. He was working for the Corps of Engineers at the time. Daddy left the Corps of Engineers. He bought a wooden-hull boat in Vicksburg. It was right on the Yazoo canal. He and Gilder McCool and Percy LeMay went in together and bought this boat, and they had about $2,000 together—they gathered up groceries and everything. He had come to Greenville and got a job on one of the oil company barges. They had two little ole small barges. And so Daddy quit the Corps of Engineers. Percy and Gilder McCool kept working for them, and Daddy was going to run the boat.

But my daddy started off early on. His granddaddy was Wilson Hemingway, and he ran the Yazoo River. In fact, he had a boat and barges and during the '27 flood he was going out and saving people, pulling them out of the high water and taking them to Vicksburg and up the Sunflower and the Yazoo and all up there. Daddy was an Eagle Scout then, so he was helping down there too. Then he worked some on his granddaddy's boat. He and his daddy had a boat running the Yazoo River for a while. But then the '30s crash happened, and hell,

everybody went out of business. Shoot, Daddy got one of those WPA jobs working on Highway 61. He was making $70 a month. He came home, and he had Mama and Betty Joe and Lea [my sister and brother] there. He had grocery bills and everything to pay, and he went to the First National Bank in Vicksburg to cash his check. The banker said, "We can't cash it. The state is broke." Daddy said, "Man, I owe money. What am I going to do?" And the banker said, "Well, they got a dice game up there at the Vicksburg Hotel." Said, "Up there on the second floor." Said, "You can go up there. Now they'll cash your check, but they are going to take 10 percent, you know." And daddy said, "Well, I got to pay some folks off." Said, "I'm going to go up there." Well, he went up there, and they said, "Well if you want to get in the game, now we won't take 10 percent. We'll just cash the check if you want to get in the game." He got in the game and came home with $380. That was in '32. Daddy, he was a gambler now. He would roll the dice every now and then. He started out working with the Corps of Engineers. Then he got a boat, and he had a job lined up for it with the Corps of Engineers down on the Atchafalaya River. Well, they had put an old World War I surplus engine in this son of a

gun. So he was going to try it out. He had a couple of friends on there with him, and they are the ones that had that ferry. They didn't even have the bridge there at Vicksburg then. They had the ferry, the *Pelican*, running across there. Well, he turned it loose in the dock, put it in gear and went out in the river. And then when he went to shift it, he tried to shift that son of a gun, and it hung up and it wouldn't shift, and that ferry ran over him. Well, when that ferry hit, the two of the guys that were on there, jumped off. Daddy was still in the boat and went under it. He somehow got out back there at the paddle wheel, and he grabbed a hold, and they pulled him up on the boat. He got on another boat when they got off and went down there looking because that's all he had; everything was on that. So that was the end of that.

I started out working when I was about fourteen years old in the summertime. I'd go out there on the boat and Captain Carl Rusk was the captain on the *Ruth Brent* at that time. We had a run all the way to Pittsburgh, but I went back and finished high school. Daddy wanted to straighten me out. You know I was kind of wild, so he sent me to Texas A&M to try to straighten me out. I get out there at Texas A&M. Man, that was rough. That son of a gun was rough, and it was just like boot camp. But anyway, I finished one year, and I came back home because Daddy was in with Bilbo. There were five of them in together, Bilbo Williamson, Bill Williamson, Gilder McCool, Edmond Metcalf, and daddy. Lea had just graduated from Mississippi State, and Daddy had decided he was going to start a family business. So he took the boat and two barges and started Brent Towing Company in 1956. That's when I left Texas A&M and came and worked on the river. George Reed was the captain on the boat at that time. He would let me steer some, but I already had a tankerman's license by then. George Reed was the one who broke me in.

In '60, I was on the boat in St. Louis, and Thomas Golding and Daddy bought a ship, a freight-and-supply vessel, that used to supply the big aircraft carriers and stuff. It was called a freight-and-supply during World War II. It was in Charleston, South Carolina, in a bone yard. They went over there and bid on it. Daddy called me, and I went over there, and Lea was over there. And Lea hired this sea captain to help us get around. That was during the Cuban crisis. So we went around Florida dodging Cuba, and we came into Gulfport because when you come into the Mississippi River, you're going to have to pay the ship pilots—you know, the bar pilot in the New Orleans Pilot Association up to Baton Rouge. So we came, and we were able to go through the industrial canal. We came in from Gulfport and ran the canal all the way to New Orleans and then came on up the river. They refrigerated that boat and started running it to Central America.

Oh, Lord. I knew some of the old timers out on that river. I'm telling you, we had some old timers that worked for us, some of them that only had about a third-grade education, but they knew that river like the back of their hand. The river is a different place now though. Oh, Lord, yeah. Shoot, man, we'd go down the Atchafalaya, and there were people down there that were fishermen that couldn't speak a word of English. I mean they were all talking French, Cajun French, you know.

I was about seventeen years old. Of course, walking around in that diesel fuel, my dang sole had come loose on my shoe. And I'm walking around there flip flapping. And boy, my daddy gave me, I think it was fifteen or twenty dollars. Said, "Go buy you some work boots, boy, dang." Man, I went and got cleaned up. Got that twenty dollars and headed to town. Of course, he left about six o'clock that evening. They were driving back to Greenville. We were in Port Arthur, and Port Arthur was a wide-open town. I came back about one o'clock in the morning, flip flap, flip flap . . . coming back on the boat. I was broke, but man I had me a hell of a time. But, no, no, I didn't have any new work boots.

In the early days, my wife, Carole, would come out there and cook where she could ride with me. And, man, those old cooks that left grease out

there—Clyde Rogers was on the boat. And she was down there in the kitchen. I was on the first watch. At about two o'clock, she was down there in the kitchen getting stuff ready, and he runs aground, and the old cooks had been saving that grease. That son of a gun spilled out from under the cabinet, all that old bacon grease and stuff, man, that they had been saving went all over the floor, man. I felt so sorry for her. But she couldn't cook to start with. She learned, though, pretty fast.

My daddy was the first one to go in the towboat business in Greenville. And, man, it got to be one heck of a towboat town. You know, there were thirty family-owned companies that were here, and old Colonel Barstoff, he was head of the Vicksburg Corps of Engineers for a long time, and then he moved here and was head of the port terminal. And he wrote a book about the million-dollar mile and had about six shipyards and had thirty towing companies back then. It's all gone. I hate it, but Washington called Greenville the towboat capital of the world back then.

That boat, the *Carole Brent*—I'd ride that son of a gun. And of course, it had the *e* on it, see, *Carole* with an *e*. You got the *Creole Brent* coming at you with four on the nose down there in the canal. The Cajuns called it the *Creole Brent* because they'd see that *Carole* with an *e* on the end of it. *Creole Brent* coming. Hot dang.

The *Sprague*. When I was about twelve years old, we made a trip on the *Ruth Brent*, and we passed the *Sprague*. They were working for Standard Oil Company out of Baton Rouge towing oil barges then. That son of gun, I mean it almost broke us out of tow because of the wake that had rolled behind that *Sprague*. But the *Sprague* in 1907 brought sixty-seven-thousand tons of coal from Louisville, Kentucky all the way to New Orleans. They had a tug out on the front to where they could help steer but it was 5,000 steam horsepower but that's sixty-seven-thousand tons. It set the record that will never be broken too. Man, I think it was like twelve acres of barges. Twelve acres of barges is what they had out in front of them.

And then they had those whiskey stills all over the place. You could pass up there at Big Island, and you could see the smoke coming out over there, and them dang whiskey stills were over there on Big Island. Man, they were making that moonshine up there back in the old days. That old barge line ran aground up there at Victoria Bend, and they had some barges tied off, and they had sugar seals. They sealed those sugar barges back then, see. They had a whole barge load of sugar, and they had it tied off and were getting the barges off ground. That son of a gun had been half unloaded, and those whiskey guys had broken the seals. Man, they had a hell of a time. They never did find out who did it. Yeah, making that whiskey.

So, like I said, I really miss the river. Everybody says it gets in your blood, and then you are going to be a river rat from then on, baby.

WILLIAM ALFRED "PEANUT" HOLLINGER

– b. 1937 –

My name is William Alfred Hollinger from Luxora, Arkansas, which is right on the Mississippi River. When I was a little kid, we'd lay on the side of the levee, and during high water some of the barge lines would come up through that chute and go out at Island 27. We'd lie on the side of that riverbank thinking, "Goodness, gracious, we need to get us a job like that." We were making a dollar for ten hours chopping cotton. That gives you a lot of incentive to go make a hundred a month and groceries and get all you could eat for free. Sure enough, we took off.

I walked away from home in 1950. I had a great home. I just wanted to see the world, and I didn't like taking orders. I was thirteen. I went to work about two months before I was fourteen and been doing it ever since. I never had any sense to leave the river, but it's always been awful kind to me. I never got a check from anywhere else until I started getting the Social Security checks. My family had always worked, plumb back to my granddaddy Hollinger for Anderson-Tully Company building dikes and either be in logging or construction part of it. But we all really come from Anderson-Tully, Patton-Tully. I come from the Patton-Tully Construction side. I got a job, and I believe they had forty blacks that were cutting timber. My job was—and another little boy, his job was—to keep the beds made, keep the floors clean, and help the cook. I think you'd call him "galley boy" later on, but that's the way we got started.

I knew that this was what I was going to do for a career the first time I got my check. The first check I got was thirty-seven dollar and a half. I'm talking about in money. It was the most money I had ever seen. I went uptown. I drank chocolate milkshakes until I was about to throw them up. I went to the picture show. I came back down. I bought a stack of funny books and a whole box of almond Hershey bars. I remember I was sitting on the head of that boat eating those almond Hershey bars and reading those funny books, and I had money sticking out of every pocket. I knew right then you couldn't get any closer to heaven than that, and I've always since then had a pocket full of money. If I wanted a Hershey bar, I could get it. That's just all I can tell you. It just kept getting better and better and better.

I remember my daddy and all of them were working. Every time I'd get off on days I'd go down there and weld. We never did take much time off. I was always scared I was going to go back to that cotton patch. I still am.

I was coming down the river above Mt. Vernon after I had been there about a year, and it was a nice night. I thought I could see something in the water just above Mt. Vernon, Indiana. I turned the search light on, and there was a boat sideways with one barge empty floating down the river. I thought, Well, I'll be damn. And the folks out there were just waving. No lights. Not a single light of any kind. I backed around there and got ahold of him. I thought he was kind of an old guy. He was probably fifteen years older than me. Kind of a rogue kind of guy but a master boatman and a master engineer. You never passed anybody aground. You just didn't do it. You helped.

Hell yes, we helped one another before all of these phony ass lawsuits and crap like you have today. So the guy told me, he said, "Damn." Said, "Boy you pilot the hell out of this boat. He said, "You don't know how much I appreciate this." I said, "All right." Well, that ended up being John Ritchie. He called me about two months later, and he says, "I want you to come and work over at Mississippi Valley Barge Line." He said, "I'm going to put you on one of those Lower riverboats." By then I wasn't even seventeen yet. I said, "You better get you a job yourself. Last time I saw you, I couldn't even tell what color your hide was floating down the river, and you are going to give me some job on those big ole boats over there at Mississippi Valley Barge Line." I said, "Appears to me you ought to be trying to find yourself a job." He said, "No, I'm not shitting you." He said, "They've hired me as the new vice president of operations of the barge lines."

Used to be the way all pilots had to start off or anything in the old school is they thought you didn't have a brain until you were about seventy, with a big beard and long hair. You had to work your way through ass kissing and muscle and everything else to kind of get there.

I have never seen a bad boat in my life. We made a lot of money buying what everybody called bad boats. A boat is only as good as the crew that rides it. You got a brand-new boat with a lousy ass crew, you got a lousy ass boat and a crew.

I had some great pilots, but any time they'd feel a little bit afraid, well, I'd just get on the damn boat because I wasn't about to let them have an accident. Anyway, I decided to go from sixteen to twenty barges. You would have thought the world was coming to an end they were so scared. I told them, I said, "Put the motorboat in. I'll get up to Arkansas City. Get on the Arkansas, and we'll take her on down. I'll just run Vicksburg for you, too, while I'm at it." I said, "We'll be down there as fast as this river is in no time to get to Vicksburg." Anyway, I carried Russell with me, my son. Russell was probably ten, eleven years old. I said, "You want to catch the boat?" "Yes, sir, Daddy, sure do." I said, "Great." We went up the Arkansas River, and they cranked up the outboard and came and got me. I said, "What's going on?" He said, "Captain, I don't know what we are going to do around that bridge." I said, "Well, I'm going to tell you what I think you ought to do. You ought to sit back there and learn how to pilot a boat is what you ought to do." So I just told Russell, I said, "Get over to the sticks." Russell had to be about eleven years old I guess. So, all I did was the same thing anybody does on a ship or anything else. I sat back there with them to humiliate them. I'd tell Russell, I said, "Give her a little rudder over there, son." So I just let him go on and run the bridges. Run Vicksburg also. And they said, "Damn." Said, "We could have done that." I said, "That's what I was telling you. You guys, I don't know how you ever get any snookum from them gals. You ain't got no self-confidence." I said, "Use the abilities you have."

In the early '80s, I'd just bought sixteen new barges, hopper barges, grain barges. I'd had them out working probably two years when that crash hit. Luckily, I hadn't spent my money and rode through it. When the smoke cleared, there were three of us left, Bunge Grain, Brent Towing Company, and myself. The industry was so bad you could walk from boat to boat, barge to barge. I'd used up all

the money that I had hid and one thing or another. So all I had was a water bucket full of that stock at $46 when I got out. I went in at .80, and I sold out at $46. But anyhow, I went up there to the corner by the post office in Greenville. You had an Edwards, like a stock thing. I went in there, and I gave him a tub full of that stock, and I said, "You convert this to money. I'm going to save this company." And I did. And I thought, Well, by next spring, this thing will turn around. By God, it didn't. Then I got caught, by golly, for filing a false income tax statement. Now, had I fought that out, even back then if you would do over $10,000 it makes a red light. Well, mine was a hell of a lot more than $10,000. So, I had a siren going on down there in Georgia with the tax people. They were just waiting, huffing and puffing.

I was in my office one day . . . I always kept me two beautiful gals up front but with beautiful brains. First impressions make a difference. For me to show up first, that doesn't necessarily make the best impression because if I'm in a bad mood I say, "What do you want?" and that's not conducive to good business. So anyway, I need a shield. And still do between me and the world because I don't much care what somebody thinks about what I do. I'm back there listening to this IRS guy, and he's flirting with these girls, which they had told him I was gone; they didn't know where I was. But, anyhow, the guy kept talking about me to them gals. I lost what little cool I had. I came down that hall. I don't know if the guy could see it on my face or not, but like all inexperienced guys about beatings, had a tie on. It was knotted. I threw my hand inside that knot and gave him a half turn on that knot. Slapped him upside that right ear really hard. He had a little old pistol. If he had of shot me in the eye, it would have hurt me. I told him, I said, "Show these gals how tough you are." I slapped him again. I said, "Get your gun out. You got back there telling them wasn't for guys like me how would guys like you do, how would the world go around or some shit." I carried him across to the jail. Had a black jailer there

in Greenville. I walked in, and I told him, "Lock this SOB up." He said, "Okay, Captain." Say, "I got him." Said, "What does he do?" I said, "He's with the IRS." And he threw his hands straight up in the air. Said, "My God that's like a highway patrolman. Everybody in Mississippi is terrified of a highway patrolman." I'm just going to tell you right now if it was the devil stepped out of a car or a highway patrolman, they say come on devil.

But anyhow, I had a violent nature because I attacked a federal officer. But the judge when he gave me the 108 days, he said, "You can plead nolo contendere," and I did because [like] a fool, I didn't try to hide anything I did. I just forgot to add that to my income that year. This was in the early '80s. But I went down to FCI, Fort Worth, Texas. I never slept or lived in a cleaner place. I never been to a place where everybody called you Mister. There weren't any fences. Right in the middle of Fort Worth. I think any businessman that works as hard as I used to, every five years it ought to be mandatory you go to federal prison for 108 days. I can't tell you longer than that, but everything was broiled, baked. Nothing was fried. But really the 108 days, I used to ride a boat 120 days feeding my family.

So the judge asked me over in Starkville, Mississippi, where the northern district was. He said, "Mr. Hollinger, you ever going to be here again?" I said, "Mister, to save my company, you better keep a bed ready. I ain't going to fail. Fail is not an option for me. I ain't never failed, and I ain't going to, period." But you got to have that attitude during these times or all kind of times. You never know.

I can only tell you the stories that are true from 1950. Back in the 1950s there was the Wilcox family in Greenville. When I was a young man working for Mr. Tully, all the Wilcox family lived on a derrick boat. They had a steam derrick boat that was self-propelled. They used to chain the kids. I asked Paul one time. I said, "Paul how did y'all keep from getting drowned?" He told me they had the chickens on the boat running around and the damn dogs

and little ole kids crawling around. But they had a chain around their ankle. It sounds cruel, but they could play and everything, but they couldn't get any closer to the water than the chain would let them. Now, that was just a way of life back then. It wasn't they were being mistreated. They all lived there. That was their permanent home was on that two-story derrick boat. Hell, they had to be chained, or they'd fall overboard, and they'd drowned. You can't watch five or six children and run a boat at the same time.

The thing that always drove me—I'm terrified if I'm not going ahead, I'm going backwards. I don't want to go back to Arkansas and chop that cotton because they don't do it anymore. But if anybody in this world has been blessed, the good Lord has blessed me more than anybody. But if I had it all to go over with in the morning, or if I picked up some boy hitchhiking down the road, I'd say, "Son, I ain't going to give you money. I'm fixing to carry and get you a job on a boat." I've always felt sorry for

anybody who wasn't involved in the river industry because the only thing holding you back is yourself. If you ain't got no zip in your britches, shit you ought to go backwards. Simple and easy. All you got to do is work a little. I'm going to die, I hope, getting drowned somewhere getting on or off an old boat. I'll just tell you now because it would be a better way to go for a river rat.

I love to talk about the river because I love the river. I don't know anything but good things about it. I know some of this was kind of tiresome, and a few were kind of embarrassing, but most of it has been terrific. The good Lord knows everything I've done. I don't much care if the rest knows it, but it sure is funny, some of it. All them fights and all them gals and stuff—they weren't always winners, but it was a lot of fun. It's about time to get some of that stuff written down I guess before we all die out and know what the true river rat was and what today's river rat is.

JOHN S. "SMITTY" SMITH

– b. 1937 –

My name is John "Smitty" Smith. I am one of eleven children. There are no other children left but me. They're all dead. I am seventy-nine years old. I have a great career. I had a great life. I was never hungry, and I was never cold. I don't have any formal education at all. I grew up in Plaquemine, Louisiana, along with the Banta family.

I went to work full time on the boats. It was 1950, and I was thirteen years old. I went to work as a gopher working. You did anything that you were told to do. If you could take orders, you could be a gopher. And I could take orders. Captain Franco, he was taking on groceries. He sent me home to get my clothes, and I caught the boat that night. Stayed on I think around seventy-five days. I had two pair of blue jeans and one shirt. I didn't have any shoes. I didn't want to wear shoes. I used to be able to run across a marble ring and come out with three marbles with my bare feet. Kids playing marbles. We couldn't afford to buy any marbles. I'd run across the marble ring and get two or three of them in between my toes. It's the truth. Mama couldn't buy us things like that. She just couldn't.

I went to work for Captain Franco as a deckhand, and my first trip I made seventy or seventy-five days. We were only getting three hours a day, if I remember right. Not to put into perspective that the Bantas were people that didn't pay a lot of money, but you had a job, and you had a place to eat. You can take the river on as your life, and I did. It's been good to me. You can be a gambler. You can be a drunk. You can be a doper, which I never did dope or anything at all, or the ladies of the night. You don't know how many times I got off the boat when I was fourteen, fifteen, sixteen years old and had a little money left. As I get to town after being on the boat that many days, I'd blow it in one night, spend it gambling or whatever on the three I told you. But there's something that the river gave to everybody, and I tried to teach the river people, was that you always got a home to come to. You always got a warm bed. You got a cook to cook your food for you. I mean air conditioning. I didn't have any of those things. Goodness gracious, I was going on vacation when I went to work. So, after that first trip, I knew that I loved it. I fell in love with Captain Franco and the Banta family. Well, everybody who respects him calls him Captain Franco.

I worked for him for the whole summer, which was about ninety days, close to it, two dollars a day. I was just thirteen years old. That was good money.

When it was the end of the summer, I went to Captain J. W., and I said, "Captain J. W., my mama wants to know if I can get some of my money?" He said, "What money?" I said, "I been working the whole summer, Cap." He said, "Who told you you had a job?" I said, "Merlin did. Merlin told me I could come to work, and I could get paid two dollars a day." He said, "Merlin don't run this company. I do." I'm a boy. I started crying. I ran home. I went home, and I went in the back. I was crying. My mama wanted to know why I was crying. I said, "I don't have no money, Mama." And about that time, there was a knock on my front porch, and my mama answered. She came back. She said, "Captain J. W. Banta wants to talk to you." I said, "Okay. Whatever." I went out there. I said, "Yes, sir." He said, "Where did you go, boy?" I said, "But you told me I wasn't gone get paid, Cap." I said, "I don't know what to say." He said, "What you mean you ain't gone get paid? You don't know how to take a joke?" And he reached in his wallet, and he got three brand new twenty-dollar bills and gave them to me. Lord, I was filthy rich that day. Of course, I gave it to my mama. But that's the kind of man he was. He walked all the way over himself, and nobody came into that part of town. Trust me. But he was a good man. He really was.

I answered bells for Captain. The terminology is when you answer bells. The bell system is really simple. But, again, they could be complicated. The man in the pilothouse had a bell and a whistle to his disposal, to his reach. If he wanted you to stop the engine, he'd ring one bell, and you shut the engine down. Had no clutch in the boat, direct reversible. If he wanted you to come ahead on the engine, he'd ring a bell again, and then you'd start the engine coming ahead. Then if he wanted you to go backwards, he would stop the engine with one bell. Hit two bells, and that would be telling you to put it in reverse; then you would be backing up. That took care of how the engine could go. There was no reduction gear. The speed of the engine was over the man in the engine room, which was me at that time. One long whistle was dead slow. One short

whistle was half head. Two whistles was give it all. That's what you did. You changed the cam from reverse to backward or whatever. Used to work an engineer to death. In fact, he worked me to death. It was probably '59.

I did a lot of reading. Seminole Indians had never signed a peace treaty, so technically they are still, well, at odds with us. I was on the boat with two other guys, but old guys. He calls me up to the pilothouse. It's nightfall again, and these guys told me about these Indians scalping these deckhands and all this, and I'm believing it all. I'm listening to it all, and I'm scared. He called me up. He said, "Get out there and put a water tie on them barges. Get around a tree and come back to the barges." I said, "Okay, Cap." I get the other man up. "You don't need the other man." I said, "Cap"—I didn't want to tell him I was scared. I said, "Cap, I need some help out there." He said, "You want your job, boy?" I said, "Yeah, I need my job, Cap." "Get out there and get that thing tied up."

Well, I went out there. I did, and night had come upon me, and I'm walking out there, and I got out there and threw the lines on the bank. Then I jumped over on the bank, and I started pulling that line. I guarantee I saw fifty Indians. I know I saw fifty Indians. I know I saw them, but I didn't. I was so scared. God damn I was scared. I got the line around the tree. I got back to the water. I'm glad that was over with, and I come on back to the boat.

The next morning, day is breaking. Captain J. W. again. The pilot was on watch. He said, "Go out there and turn that line loose, boy." I know it wasn't any sense in me asking for some help. He said, "I'll go with you. You scared?" I said, "No, sir, I'm not scared." He said, "I'll go with you." So, he came with me. This is the funniest part of the story. So, he came with me. Now we have four barges out there, landing boats. We get out there, and I'm fixing to turn the line loose. I got down to the last line to throw it off. He looked out in the woods and saw a cute little bear cub. Just as cute as can be. It's just so cute. He said, "Pull that God damn line, boy." "I got it, Cap.

Don't worry about it." So, he eased off into the bank and he got to this bunch of thistles and stickers and he pussy-footing his way through that to get to the little bear cub. And he had something in his hand for breakfast. And whatever it was he offered that little bear cub, and the little bear cub was eating. About that time, this huge bear was coming running through the thicket—I said, "Oh Lord!" Captain come through that briar patch. Never slowed down. He said, "Turn that God Damn line loose!" I said, "Captain, I turned that line loose." We were floating off, and he took a jumping dive. He caught on, and I reached up and got him and helped him get up on the barge. He said, "Don't you laugh." I said, "I ain't said a word, Captain." I pulled stickers out him all day long. He was something else. That bear cub made a hole through that briar patch.

I was a pilot at sixteen or seventeen. As soon as I left school, I spent a few years on the deck and progressed real quick. Worked real hard at it, and I became a harbor pilot. Many people don't have a good definition of what pilots are. You have a harbor pilot. You had heavy-tow pilot. You had lineboat pilots. You got canal pilots. You got towline pilots. You can go on and on and on with it. Each one has the expertise in their field.

I stopped working for Captain J. W. because he died. I miss him till today. Yeah, he never forgot me. Never. "Black boy" is what he called me. You didn't take that to your heart, but in my day that was a fine name for me. Called me "black boy" from the day he met me. "Come here black boy." I could never say anything bad about him.

What makes a riverman? When you meet a man on the river, and he's coming down the river in a bad place, and you don't know the man, but you know his voice. You respect his voice, and you talk with him and hear him. I can name you a jillion places, Thompson's Point, Free Nigger Point; up the Upper river up there, there's a thousand places that's like the river is so tight that you don't have the passing safety. It's not safe to pass. It really isn't, but the rules of the river, they're very simple. The downstream tow is the burden vessel. He determines whether you're going to come into a hole or not. He determines that. If he tells you no, then it's no. If you meet someone, you better know what you're doing. But when you hear that voice, and he knows you, and you know him from the voice and only the voice, he tells you to "Come on in there, Smitty. If it gets a little tight, lay her against the bank. I'll get by you."

Back in the day when I came up making the kind of money I made—hell, the last job I had was $700 a day, of course as a pilot. You can demand as much as $950 a day. Well, you got to get there, if it gets in your blood, and you like it. Your deckhands now, the tankermen, they are getting $ 250, $280, $300 a day. I mean, it's a wonderful, wonderful life, but you got to resolve your mind to one of the biggest problems of man: Who's dancing with my wife tonight? I know that's cruel, of course, and I apologize for it, but it's true. You got to be able to leave that lady, and you got to leave it behind you. You have to leave it behind you, or it will run you crazy.

MALCOLM GUNTER

– b. 1939 –

My name is Malcolm Gunter.
I've been on the river since 1958.
I started off on a boat out of Lake Providence. The name of the little boat was the *Mack*. It was a 380 horsepower boat. I spent ten months on the boat as a deckhand. We were in Arkansas City on a Sunday, and the captain on the boat went uptown and got to drinking and decided the smart thing for him to do was to quit. So, the next morning when the dredge crew came out, they brought a guy out, they told us, said, "Where's your deckhand?" I said, "I am the deckhand." They said, "No not anymore because they want you to start running the boat." They brought me out a deckhand. He was about as tall as he was wide. He couldn't even climb on the barge. It was his first day ever on the river. So, I'm heading out southbound not knowing where I was going or what I was doing but coming through the Greenville bridge with those three loads of gravel headed to Lake Providence. That was a hairy experience. I was nineteen years old.

The way I got started on the river, I went over to Lake Providence and put in an application for Mr. Charlie King for a deckhand. When I got back home and had been home about two weeks, Barry Meadows called me and asked me did I still want that job on the boat. I told him I did.

At the time, James Turnage was pilot on the boat. I worked on there with him for about ten months, and Hub Jones was on there as a pilot. It was November of 1958. I was pilot on there, and Mr. King told me, he said, "I promise as soon as you get down here, I'll have you some relief." Sure enough, he didn't. Because I got down there, and he said, "Homeboy, you made it southbound. Surely you can make it back northbound, can't you?" I said, "I guess I can." So, I took off and went back up the dredge, and he said, "I promise I'll have somebody when you get up there," and he didn't. I turned around and got back south again, and you know what he said when I got down there? "Homeboy, you don't need nobody now. You got it made, ain't you?" That was before we had to have a license. You didn't have to have a license to be a pilot. All you had to have was the trust. From that time, I've been a pilot ever since. You just had to have guts and glory, I guess, and know where you were going. When you headed southbound, we ran at night with an electric spotlight. We didn't even have a generator on the boat. We had a twelve-volt battery system. That was all

we had. We had a Channel 4 radio, which operated off of the batteries. That was all. You know, we didn't have anything. We headed southbound.

Each day out on the river, you wondered where you were going to be the next day. I think it was more or less a challenge to get through with where you were going. It was just a day-to-day challenge out there. Of course, after I went to work for Brent, and we got a radar on the boat, that was the first time I ever had a radar. I had never been further south than Natchez and had never been further north than Memphis at that time. So I had to learn in a hurry.

It's been a fascinating life. I have seen a lot of things. But anyway, back to when I was in nineteen. I'm going to go back to tell you one more tale. When me and Howard were in business together, we had a boat named the *Carole Brent*, and we sold it to Thomas Golding. Thomas asked us to keep operating the boat. Paraguay was where he was going to send the boat—down there, somewhere in South America. He asked me and Howard could we keep operating the boat until he got ready to use it, and we told him it wasn't going to be a problem. So he said, "Well I want to do one thing." He said, "I want to send my son Steve up there and put him on the boat and let him ride the boat for about thirty days until he learns how to operate. When it goes to Paraguay or wherever it was at." So, he sent Steve up there. Steve was working for me and Howard, on the *Carole Brent*. They stayed on there for like thirty days or something like that. Then he got off, and then in the meantime the deal that Thomas had fell through. So me and Howard bought the boat back from Thomas. It was the *Opal Lensing*. That was the *Carole Brent*.

Once we went to Pittsburgh, we got up there and got on a coal tow. We were headed up the river,

and these dang folks were shooting at us. We didn't know it, but we were breaking the strike. We were in the middle of a dang strike. They were all the coal workers. Most of them were on strike, and that's why they hired us to come up there and push the coal barges. I didn't know what we were up there for. We were too damn broke and too poor to come home, so we had to stay. After about a week, they quit shooting at us. That was an experience. We had to make sure we didn't get outside anywhere. We didn't want them to shoot us. They were shooting at the boat, but they never hit it, though. They were just shooting. They knew better than to hit the boat. They were just trying to scare us. But we were too poor to be scared. We had a job to do.

I caught the boat for Patrick once. I don't know what boat it was on. It might have been the *Brimstone*, but they put a deckhand on there with me, and he rode south. He told me, "I just got out of the penitentiary last month." So, we went south and dropped the tow and picked up a tow and headed back northbound, and we were coming up. He said, "I'm going to get off when I get up here to Vidalia." And this is midnight. I said, "You can't get off at midnight. You got anybody to come pick you up?" "No, but I'll get somebody." I said, "Why are you going to get off?" He said, "Just push this thing into the bank, and I'll get off." He said, "Man this is too much like being in jail." I said, "Well, whatever," and I pushed it into the hill. I went into the bank, and he jumped off in the bushes, and I backed off. I left him there. I guess somebody came and got him. I don't know. Some folks like it on the river, and some folks don't. You just never know how they are going to take it. I just knew he wasn't going to like it.

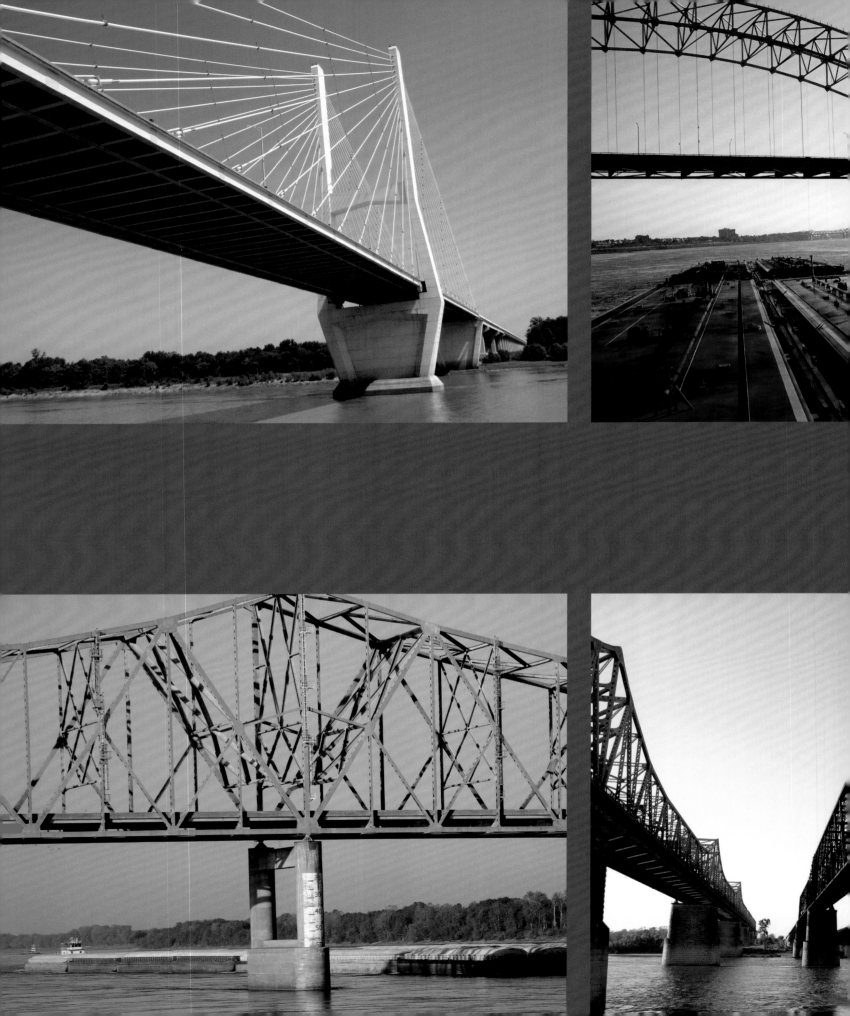

JOSEPH V. GALE JR.

– b. 1940 –

I tell everyone that I am not a blue- or green-water mariner, only a brown-water mariner. My license reads: "Master and First-Class Pilot, all gross tons, upon rivers." I am a product of the Ninth Ward of New Orleans; Holy Cross Tigers 1958; St. Edward University, Austin, Texas 1962; and boats on the river for the rest of my professional career—a river rat! I got my first paycheck at age fifteen as a deckhand and was forced to retire at age seventy by the state of Louisiana. That's fifty-five years being paid and ten years before that, as a young kid riding the Chotin towboats with my dad. I came along December 28, 1940. Again, boats were involved. When Mom was in the Baptist Hospital doing her best to bring me into this world, Dad was on a boat, the tug *J-Gee*, inside the Harvey Lock. Mom and Dad would bring me on board the boat in a basket, a forerunner of today's carry around baby car seat. My time started on the boats at age six to eight months.

I think that because of my dad's many years of faithful, loyal, and quality service to the Chotin Company and excellent work ethic, Captain Scott rewarded him by giving his son, me, the opportunity of a lifetime. I took this gift as an opportunity and ran with it and made the best of it. Thank you, Joseph Gale and Scott Chotin.

Every summer vacation from school, Ole Man River and Van spent time together. The mates and deckhands put up with it because I was the captain's boy. The cook hated it for obvious reasons. Between ages seven and fifteen, during summer trips, the deckhands' job became a part of my early education. I learned all kinds of things but most important, don't fall into the river. Proper shoes, gloves, and don't forget your life jacket. Again, don't fall overboard.

One time we were in a very hard rainsquall as we were northbound at Rosedale, Mississippi. At this time, I had made pilot, and from experience, I stopped the tow close to the bank where I could see something and hold up in the current. The next thing I see is a small flat boat coming down the port side of our barges with two men in it. Both men had rain gear on but no life vests. In the middle of the small boat they had what looked to me to be a child bundled down under a tarp to protect it from the rain. This fact really irritated me because where they were and what they were doing in only 10 percent visibility was extremely dangerous. When I related this to Captain Jules, he pointed to the map of the area. He pointed out the islands just below

66

the mouth of the White River on the right bank. He said, "Van, that was not a child you saw. It was a keg of moonshine being moved from still to market when the feds are not out looking." I simply said, "Oh, you learn something new every day."

Along the riverbanks were people living and rearing children in the wild of the river valley. One was Sid Jolley. Sid and his family lived on the back of a cigarette sand bar between island[s] 39 and 40. Sid had a Hallicrafter radio set to the marine navigation frequency, 2738kHz. He and his family would monitor this radio twenty-four hours a day. When we were thirty minutes away from his landing at Cigarette Bar, we would transmit our position and direction. Sid would come out in his outboard skiff and come aboard and barter. He needed kerosene, diesel, sugar, coffee, spices, and flour, and in return he would bring fresh vegetables, deer, catfish, or squirrel. We would put in our order on the northbound trip with an ETA for southbound. He would have our order ready when we came south. A loaded fifty-five-gallon drum will float very low in the water. When we stripped the barges, after discharging, there was enough to fill a few fifty-five-gallon drums. The pilot would stop the empty barges as close as possible to Sid's landing and roll the drums into the river. Sid would not take money. If he needed cash, he would go downriver twelve miles to Frankie and Johnny's Boat Store in Memphis. His call sign was the "Greenhead." God bless Sid Jolley, wherever he is now.

I must give due credit to as many great towboat river pilots that had anything to do with learning me the river and profession. Other than this minor recognition, it's a travesty that history does not have a list of names and accomplishments.

Only six months into my pilotage, on Christmas Eve, 12/24/67, I got orders on the SS *Manhattan* for the *Point* to anchor in Baton Rouge. At the time, the SS *Manhattan* was America's largest vessel, merchant or navy. She was 943 feet long, 134 feet wide, with a draft of 49 feet; she was 114,000 deadweight tons. When I got off the pilot ladder on the deck, the pilot Captain Kenny Scarbrough was waiting for me, and he said, "Watch her, she carries her way." When I got to the bridge, the master, Captain Redden, greets me with "Merry Christmas. I am your Christmas present." I didn't know anything about this ship. I found out, only after I got to the bridge, that she was a twin screw with two rudders. Naturally, I had reservations about all of this. This was America's largest vessel with a draft of 40 feet on a rising river, all night long with no chance to change pilots. Captain Redden watches me go around Algiers Point, is convinced I know what I'm doing, that I am sober, and says, "Call me thirty minutes before you anchor." He goes below, and I don't see him for another twelve hours. Merry Christmas!

The *Manhattan* was a midship house vessel, which was good because you could only see forward. Captain Bud, NOBRA [New Orleans Baton Rouge Steamship Pilots Association] number 3, said, "Just look forward and put that end where it is supposed to be. The back end will follow." In other words, don't look back—the thing is so large it will scare the heck out of you. She also had quite a history. She was the first tanker to go across the Northwest Passage from Alaska to the Atlantic Ocean north of Canada.

On June 21, 1968, I was ordered to sail the sixty-thousand-ton German bulk carrier *Strassburg* from Cargill Grain Dock, Baton Rouge, to New Orleans. At 1245 this was turn number 179. I remember this was a big, beautiful, green-hull, new ship, with a draft of forty feet. After three hours of sitting in the pilot chair, you get a little stiff. In an effort to get a little exercise, I would walk outside on the bridge. If the ship had steps outside leading up to the flying ridge, I would go up because most all ships had a speaking tube down to the quartermaster. Much to my surprise, the female radio operator was laying on a cot face up, letting the sun shine where it usually doesn't. She looked at me and smiled. I looked at her, my face got as red as my hair, and I ran down back to my pilot chair

ASAP. The captain asked, "Pilot, what's wrong?" All I could do is point up and say, "Girl; no clothes." He started to laugh and said, "I forgot to tell you, Pilot, the upper deck is off limits from 1300 to 1700 for us." Around 1900, that same smile came up to me and said, "Hello, would you like some coffee?" She had her full uniform on. As a young pilot, I was not ready for this!

Technology is only an aid to navigation. If you ever lose or for some reason don't pay attention to the three basic fundamentals of piloting, you will be in extremely bad shape and won't even know it. Just think about Captain Sully that landed that jet passenger plane in the Hudson River. At that moment in time, he had zero modern technology going for him. What he had was years of experience, knowledge, and intestinal fortitude—balls.

So many changes over the decades have taken place. For thousands of years, the valley would flood every spring. It was not until 1927 that the Army Corps of Engineers started a flood and navigation project. Still, to this day, this project is underway, only it costs many millions more per mile. Locks and dams have resulted in more miles of navigable channels. Dykes and revetments have stabilized the channel and made it much better. Fifty years ago, in normal river, you could not bring over twenty-five loads south and steer most places. Today the big fifteen-hundred-horsepower powered boats are bringing as many as forty downriver at one time and are steering most places.

Every generation has different mores, standards, and work ethics. What was important to the greatest generation means little or nothing today. When I was a deckhand, what was important was a good pair of gloves and work shoes. During the love-child generation, going to work with a guitar was important. Today, the iPad, or whatever you call those things, is most important, not shoes and gloves.

And one more thing. You can't learn this profession in a book. There are three basic fundamentals that pilots must know. They are, headway, foresight, and straightaway with the current.

HAROLD SCHULTZ

– b. 1940 –

My name is Harold Schultz. I grew up on a bayou in Louisiana—little place called Lafitte. My grandfather, when he was alive, and my grandmother, they had a houseboat right there on the bayou. That's where I grew up. I was three, four years old driving boats. They were shrimpers and trappers. I'd sit on my daddy's lap or my granddaddy's lap and drive the boat. Then when I was thirteen, of course I'd do boats all from there. I had my own boat, a pirogue. But when I was thirteen, I began my official role as a deckhand on a boat. It was a model bow tug, a wooden hull, a boat called the *Denver*. It had a GM engine in it. I quit school in the eighth grade about two weeks before graduation and started decking. Steve Zar, my mama's cousin, when he was training me, he said one of the things I'll never forget. He told me, he said, "Don't get mad at me, cuz." He said, "I'm going to be hard on you." But he said, "If you want to be a good captain one day," he said, "I'm going to train you," he said, "to run anywhere, you know." He said, "I'm going to teach you how to navigate." He said, "A lot of people can steer a boat, but not many people can navigate." He said, "If you can navigate, you can go anywhere that you've never been before."

But in '55 we built this tow to go to Greens Bayou. It was three of us on the boat, a captain, a mate, a wheelman and a deckhand. The captain was trying to get a raise from the company. After we built the tow, he left the deck. Tied on the side of the canal and went right across the bayou to the office. He told the boss man, he said, "I want a raise, or I'm going home," and the boss man said "Go home." So, the port captain was at lunch, and he came back after lunch, and the boss told him, he said, "Hey, so and so quit because he wanted a raise." He said, "We got to get this tow moving to Houston for Brown and Root." He says, "Who are you going to put captain?" The port captain said make Harold captain. I was fifteen years old. And the boss man said, "You got to be crazy. He's just a kid." He said, "I don't care. He can run a boat." At that time, you had to have a license to run a boat. So they put a man under me. They called this guy up to come out and catch the boat as my wheelman that was thirty-seven years old. He was old enough to be my dad, but he didn't have what they call the sticking power. My philosophy was this: Nobody's ever been born with the knowledge of how to make that first trip over that body of water. They have to make the first trip to

learn. I never faced a challenge that I was afraid of. I always knew I could navigate.

In '75, I moved to Wood River, Illinois, and I went to Sioux City, New Orleans Barge Line, and I saw the port captain there. A friend of mine was a good friend with the port engineer. He had introduced me years before. And so he told me, he says, "Go see this port captain and talk to him." He said, "See if you can get a job." So I went over and talked to him for the interview, and he says, "You ever run the Upper Mississippi?" I said, "No, sir." He said, "You run the Illinois?" I said, "No, sir." He said, "You ever run the Ohio?" I said, "One trip." And he says, "Well, coon ass, you got a lot of nerve coming up here wanting a job, and you ain't never run nowhere." So I figured I'd play the same game. I said, "Well, let me ask you something." I said, "You ever run the Intracoastal Canal?" He said, "No." I said, "You ever run the war zone," I said, "the combat zone we call it from Baton Rouge to New Orleans with no radar and no flanking rudder, no swing meter?" He said, "No." I said, "Well, I figure if you could run down there you could run anywhere." So he got quiet for a minute. He says, "Well, I tell you what I'm going to do." He said, "I'm going to give you one shot." He said, "I'm going to put you on the worst boat I got." And he said, "If you can make it," he said, "you got a job." I said, "Okay." I said, "What's the boat?" He said, "*Crescent City.*" I started laughing. He said, "What are you laughing at?" I said, "*Crescent City* is not a bad boat." I said, "I know boats." I said, "and the Crescent City is a Dravo hull." I said, "She's thirty-two hundred. I've seen that boat come down the river many times with twenty, twenty-five loads on it." "Okay," he said, "we'll see what you got." So I got on the *Crescent City*, and they had a little Cajun engineer. He's about maybe five foot tall. The first watch I stood at night, he come up there, and he walks up in the pilothouse and walks around this side of the console and looks at me. Walked around behind me. Walked on the other side and looks at me. Then he sat down behind me. I said, "Can I help you, Chief?" "No," he said, "I'm all right." He said,

"I'm just here checking you out." I said, "What do you mean 'checking me out'?" He said, "Well, I'm going to find out if you're going to make it or not." I said, "How are you going to do that watching me up here?" He said, "You burn my clutch gears down there," he said, "I'll know whether you're going to make it or not." So I stayed there with them, oh, I don't know, year or two.

I then went to work for Apex, and I worked for Captain W. P. Jackson. He was an ornery old fellow. When the guy that I had been riding with told me when I was going over to catch his boat, he said, "Man, you a Christian. You ain't going to like riding with him." He said, "He cusses a lot and tells a lot of foul stories and stuff," And he said, "What are you going to do?" I said, "I'll just pray about it." Sure enough, I got over there, and I bring my Bible on watch with me and take it down whenever I get off. He would tell a lot of stories and stuff and use foul language a lot. That day I had been reading my Bible, and there was a section—I want to say it's in Timothy. It's in the Epistles where Paul is describing two types of profanity. One is Godly, and one is common. I can't quote it word for word, but he was talking about an old wives' fable, and godliness is under everything. We worked six and six, sometimes more, sometimes less, but it wasn't a regular six in the evening or six o'clock in the morning or twelve noon or twelve midnight. If he couldn't sleep, he'd come up and see about you, and he'd go on to bed, and I'd do the same thing with him. So, that night, I went on watch about ten o'clock. There's one of the deckhands by the name of George that was up there. Captain Jackson turned around, and he says, "Captain Schultz," said, "you ever talk to George here about the good Book?" And I told him, I said, "No, Captain Jackson, wouldn't do any good." He said, "What do you mean it wouldn't do any good?" I said, "Well, not for the example you're setting around him." Boy, when I said that, he sat up, and he was a big man. I mean, he made me look like a baby, and I was a lot smaller then. He sat on the sofa in the pilothouse, sit right in the middle,

and with a six-foot sofa his wrist would hang over the end of it. He was a big guy. When I said that, he jumped up, boy, and he kicked that pilothouse chair back. I mean, I could see fire in his eyes. He said, "What do you mean," he says, "that I'm not setting a good example?" I said, "Well, all them dirty stories you tell," I said, "all the cuss words and profanity you use." He says, "You mean that religion you belong to." I said, "Captain, I don't believe in religion." I said, "I believe in God." I said, "I believe in the Word of God." And I read it to him. I had my Bible. I opened the scripture, and I read it to him what it says about refusing old wives' tales and stuff. So he left. Didn't say another word. Took off. Came back the next morning. He walks up there, and he told me the same thing. He said, "Captain Schultz, that religion you belong to," he said, "believes all this stuff I'm saying is wrong and sin?" I said, "I told you last night, Captain, it's not a religion." I said, "It's the Word of God." I read it to him again, and he shut up, and I left. I went on to bed. When I come back on watch that day, he told me, he said, "Captain," he said, "I want to apologize to you." He said, "If I've offended you in any way," he said, "I'm going to apologize." Said, "I'm going to try to do the best that I can not to do it again." And when he died, his grandson, W. P. III, told me, he said, "Captain," he said, "you don't know the affect you had on my granddaddy." He said it changed his life. He said he didn't cuss as much [as] before. He wasn't as mean to people as he was.

To show you the difference in captains, every one of them does the same job. That's the thing about us. That's what's so great about the river. We all get the same job done; we just do it different ways. After that, even with the being ornery and stuff, he changed so much. When anytime he'd hear me on the radio, "Captain, how you doing? How's your family?" and all this stuff. I mean, he just became a gentleman to me. Sometime we can have a way of witnessing to people and not realize that we're doing it. There's a saying that sometime we're the only Bible that people will see, you know.

They might not go to church. But you know you live the life and try to be a witness for Jesus.

David Kesh calls me. He says, "What are you doing," he said, "March 1st?" I said, "Nothing really." I said "Why?" He said, "Well," he said, "I'll have that *American Queen* in Memphis." He said, "You come on down and get on it, ride down to New Orleans for seven days. Take a look at us. We'll take a look at you." He said, "When you get down there we'll talk." I said okay. So I got on the *American Queen* and rode it to New Orleans. From there I worked from March 1st, '96 all the way through 2008. November 2008, I got off in Baton Rouge. The company was going bankrupt.

The last towboat I got off August 15th, 2009, from Magnolia Marine boat in Greenville. Came home, and I told my wife, I said, "That's the last towboat I'm riding." I said at least with a steamboat I knew a year in advance my whole schedule, where I was getting on, where I was getting off. You walked off a stage, got a ride in a taxi cab, and go to an airport or rent a car or whatever, so it was a whole different ball game.

I miss the food, the friends, and the family in south Louisiana. When I was a little boy, I rode around in the pirogues. I can understand French better than I can talk it. It's sad to say when I was going to school we weren't allowed to speak French because they wanted us to learn English. I'm also what they call a Houmas Indian. I am a natural Louisiana Indian. My great-great-grandmother was fullblooded. Her name was Rosalie Courteau, and she was an Indian princess. She was the chief's daughter, and she eventually became the first woman chief.

'Twas the Night Before Christmas 2004

The *American Queen* was "head up some more"
We were tied up in Vicksburg, As I look out the door
The smokestacks were up, the passengers in bed
The tow boats were meeting coming 'round the bend

I look at my wife on the bed fast asleep
And knew that my crew was in dreamland so deep

Except for the ones standing watch, sharp and keen
Keeping us safe and secure as we dream

Tomorrow's the big day, full of activities
My first cruise as Master of the *American Queen*
I've met lots of nice people, I shook lots of hands
Smiled and took pictures, listened to the band

But tomorrow is different, I'll tell you about
PSSOA meeting, then wedding vows
And then Captain's dinner, We'll dine and we'll dance
At the end of the evening, hit the buffet (perchance)
By this time, it's late, it's time for some rest
Sweet dreams and sweet sailing, steamboatin' the best!

Captain Harold A. Schultz, master *American Queen*

Captains toast:

Here's to y'all, y'all!
That our sentiments are honest and real.
May your days be bright
And your cares be as light
As the spray from our ol' paddle wheel! Cheers!

WILLIAM "MURRY" COUEY

– b. 1941 –

William is my first name. I go by "Murry." Couey is my last name. I've been on the river fifty-four years. I come from a long line of riverboat people. My dad, uncles, cousins, they were all riverboat captains at one time. Most of them have passed away.

When I was a child, I was thinking about a career on the river as being my last choice of careers. I remember how long my dad was gone at a time, working on the boats, and I didn't want to do that. But, yeah, I wound up doing it. My dad was a captain. His name was Walter Couey, and he was born in 1905. He worked on the *Sprague* in the '20s. He was a deckhand. My dad was like eighteen or so when he worked on it, just a kid. He would tell me about a lot of barges they pushed for the boat, and they never knew how much power that boat had. It had awesome power. Had some big steam boilers in it, but they never knew how much power. But he told me about another steamboat he worked on and it was during the '27 flood, and they were going out in the fields in Mississippi. That's before they put the levee in. They were going out in the fields and farms and picking people up off the top of their houses with that steamboat going right up beside the houses.

A lot of my people made whiskey. Daddy and his brothers, some of them made whiskey. Uncle Tom, one of his brothers, made some really good whiskey. Perry Martin was famous for making whiskey. He'd run whiskey from Chicago to New Orleans, and he lived in Rosedale. There was an old guy named Warner Tamble here in Memphis. He used to run whiskey from here to Island 40. He had a harbor service for years and years. He ran the whiskey before he had the harbor service. That's how he got started. He was running that whiskey with a little old boat. He had a boat store down there one time.

When I started working on a boat in 1959, I was still in high school. After that summer on that boat, I said, "This will be the last thing I do before I go back on a towboat." I was used to work. I worked hard all my life when I was young. We'd work in the cotton fields. Blacks hadn't got anything on us. We were working right alongside of them in the cotton fields. We picked cotton, chopped cotton, and pulled corn. I was doing that when I was nine, ten years old. They would teach us children how to do it. Everybody worked back then in the family when we were on the farm, though. When Dad was on the river, we didn't have to do that. When he

went out on the river, he made enough money so that us kids didn't have to get out and pick cotton.

My brother Grammel was born on a houseboat right there under that old Vicksburg Bridge. We lived on a houseboat. My other brother was born at Three Rivers, Louisiana, on that same houseboat a year later. My sister was born in Rosedale. We got back on that houseboat. We were living down there around Vidalia and Natchez. Three Rivers, Louisiana, at the time wasn't anything but a fishing camp. That's where my middle brother was born. We were on that houseboat, a shanty boat, we called it. Had to pull it around with an outboard. My dad was fishing for a living, catching timber in the spring. The timber was floating down the Mississippi River. They did that a lot. They would catch the logs—drift. There were a lot of old cypress trees that would wash up out of the banks—mud banks and riverbanks—back when there wasn't a whole lot of revetment on the river. That was going on a long time after I started on the river. But they were rafting the timber. What they would do, I saw my dad stand out in the water with a crosscut saw root wading and cutting the root wad off of the trees. He had to use what they called chain dogs. It had a spike on each end of a chain. They would drive that chain dog, that spike, in one log, fetch a chain over to the next one, and drive it in that log there. They do it on each end of the log. That's where they rafted that timber up. They'd raft it down the river. But I saw him stand out in waist-deep water with a two-man saw by himself. Dad was strong. He and a couple of brothers and Uncle Bob Samuel, Aunt Pearl's husband, they'd raft them all up, and they would take them down to the paper mill there in Gypsum Mill in Greenville. Last time I saw that was on the Illinois River in high water when water got over the banks in the Illinois River twenty feet deep. I saw them do it up there in '70. That was the last time I saw that. Down here since probably early 60s.

Back in 1974, I met a man named Edgar Allen Poe. Not the poet. Captain Poe, he would have been born like in 1934. He died young. But his father I was telling the story about, he was a captain as well. His nickname was "Wamp," just like little Wamp. And when Captain Poe is there we called him Wamp. That old man was something. But anyway, the old man Captain Poe got on the boat with little Wamp, and they rode from Cape Girardeau up to St. Louis with us when we came out of the shipyard up there. The old man, he was like in his eighties then. He was in good health, though, good shape. I think he was in his nineties when he died. But anyway, in '75 he was in his eighties, so he was probably born 1890 something like that.

Me and Wamp were sitting at the table one day eating. Everybody else was finished eating. We were sitting there talking. He said, "Murry, you know what?" Said, "If there's such a thing as reincarnation"—he was always coming up with stuff like this too—said, "I want to either come back as a rich woman's poodle or a riverboat captain's wife." Said, "They both got it made." Come up with stuff like that just off the top of his head.

I did things after I got in the pilothouse. Unless another pilot saw me do it, they wouldn't believe what I did. I put forty barges down through that Arkansas side of the old Greenville Bridge several times. It filled the whole thing up. I mean, you have got to hit it just right. You have got to know what you're doing. Forty loaded barges southbound in the old bridge. I have floated down through every bridge on this Lower river. Nobody's ever done that I know. I used to try to do things that I knew nobody else had done with a big tow.

You didn't have to have a license to run a boat. I'd been in the pilothouse four years before I got a license. And then I got one because I wanted to. I didn't have to get one until '73. In the beginning, I just worked my way up from a one-barge tow to a forty-five-barge tow. Most of what I've learned, I learned on my own and by listening on the radio to the older heads. I started heavy. What I called a heavy tow is when I have got over fifteen barges off in the locking rivers. Started working down

here. But mostly what I did was heavy tow. I hadn't hardly worked on a boat less than six thousand horsepower in the last thirty-something years.

Old Mike Thompson out of Greenville down there, he rode the boat with me some, a pilot. I was naming all the lights on the river and giving the miles right down to the tenths. He couldn't believe it. He said, "How you remember all that?" I said, "From running down here so long." I said, "I ain't run down here but about a year with that river chart, and I threw that thing away." I kept what you call a bar book. Keep it up to where I could run on certain levels of water. I did that for a long time. But then it was about '96, I did away with it, or I lost it. I left it on that *J. S. McDermott* boat, one of the ten fives. I left it on there, and somebody got it. They wouldn't give that back to me because it had too much information in it, but I remembered most of it anyway, what stages I could run different places, where I could run over sandbars and dikes and all that stuff when the water got up high."

In September 1961 is when I started working for Brent Towing Company. I went for decking in 1964. That's three years to the date that I went in the pilothouse. At that time, I had cousins that were already in the pilothouse. My dad had been in the pilothouse for years, and captain on the boat. I said, "Well, if I'm going to be out here, I want to go to the top." I worked on the boat with Howard Brent. He was pilot on there. I helped Howard do stuff that nobody else would do. I liked Howard. Howard liked me.

I worked with Howard Brent some when he was a pilot. The first year I was with them, Howard was on the boat. We were down in Texas City, Texas. We had those old single-skin oil barges back then, and then most of them, they had leaks in them. We had gas-freed this barge. We had to gas-free it before we could reload it down there. We had to gas-free that one tank because it had a pretty good hole in it. Me and Howard were going to have to get underneath the barge to patch that hole. We did what we could inside, and we couldn't stop it. We'd put a jack on

it and all, jack patch on it. We were running out on that Rattlesnake Island. We were running the bow of it and run that thing up there just as far as you could with a boat and got that hole up out of the water. He couldn't get anybody to go under there with him, underneath that barge. I said, "I'll go under there." He said, "Well, those other guys won't go because they think there's rattlesnakes all over this island." I said, "They probably are out there, but they aren't going be around this water." He said, "Well, that's the way I see it." "They are probably gone back out on the island, you know. We will just look for them before we go under there." So anyway, old Howard really liked me because I worked hard. I tried to learn quick as I could and move up quick as I could. He had seen that. I hadn't worked with him very long. But anyway, we went under and patched that barge. After that, I'd do anything he wanted to do. It didn't make me any difference. I had to work anyway. But I was used to hard work. That work out there was easy to me compared to the way I grew up. That was easy. I'd worked pulpwood camps and everything else. That's hard work—mosquitos and hot weather, cotton fields.

Working on the boats when I first started as compared to now, there is no comparison. Back then, you either had to quit or ride long as they wanted you to or until they got you a relief. I rode the boat a lot of time forty-five, fifty days when I was single. The longest I ever rode one was fifty-six days.

I remember the river being a lot like it was when I started where the Corps of Engineers kept the lights and the buoys and all that. And back then, they still had some kerosene lights on the river when I started working. It wasn't battery powered and all. Had fishermen take care of the lights back in the '40s. I remember in the late '40s, my Uncle Bob, Aunt Pearl's husband, he tended a lot of lights like from Dennis Landing down to Rosedale. To tend the lights, they had to run them every day or so. They had to run the lights that were out there. They were kerosene lights. You had to refill the kerosene, make sure the wick is trimmed and lights are

burning. That was his job. Corps of Engineers paid him so much to do that.

That old Perry Wolfe was telling me, I don't know whether it was on that *Double D* or which boat it was on, but it had an old captain on there that had been working on there, and he died on that boat. And old Perry said, "Murry, I'm going to tell you this. Don't tell anybody else. I ain't told nobody about this." But he had gotten off on another boat then. We were talking about stuff, you know, things that happened out there. And Perry said, "Let me tell you one, but promise me right now you won't mention this. People will think I'm crazy, you know." I said, "I won't tell nobody." That's been a long time ago. But anyway, old Perry said, "Yeah, I was working on that boat. I was just tripping on there." Went on to make a trip and said that guy that was riding that boat, the captain was on there. He warned me. He said, "This boat is haunted." Perry said he passed it off. Laughed about it. Said, "That old captain so-and-so died on it." He said, "He talks to some people that come on this boat." Captain said, "He has never bothered me. I'm just telling you ahead of time. I never had no dealings with him." Old Perry said he was sitting up there, and he said he thought this captain had set it up with some

deckhand to do this. Said he was sitting up there one morning about five o'clock. Wasn't daylight or anything. It was dark. He said he's just sitting there in the chair and looking out the front window and that he felt someone tap him on the shoulder. Perry say he didn't look back or nothing. He said that guy said, "Well, I got you. You ready to go." Said, "I got you." Perry said, "Okay," you know and told him where he was. He turned around, and there wasn't anybody there. He said he ran over to the stairwell. Looked down the stairwell to see if his deckhand or somebody was hiding over there. And he said this was the first morning he was on there, the next morning after he got on there. And he said, "Well, that's just the deckhand." He didn't think anything about it. He said about two mornings later, it happened again. Said, "I got you." Old Perry looked around real quick, and there wasn't anyone there. Said he got scared then. Said that scared him. Perry was still young, and I was pretty young when he was telling me about it. He told me about that, and he said, "Murry, don't tell nobody about that." I said, "I ain't going to tell nobody." But Perry, he'll know who told now probably. If he's reading this book he'll say, "Murry done told my story."

DELFRED J. ROMERO

– b. 1942 –

My name is Delfred Romero, and I'm from Iberville, Louisiana. I've been on the river since 1962. I went to work for Marine Towing Company. And Marine Towing Company was working for Ratcliff out of New Orleans. And we were hauling clamshells all over the mud holes and Vermilion River and New Iberia. And everywhere they had a mud hole we'd go bring some clamshells. A clamshell is [a] little bitty shell. The only place you find that is in Lake Pontchartrain. They were getting the clamshells to put on the road, put in your driveway. I worked for him a long time. That was in 1962, '63, '64 probably. And from there, I moved on. I sought oil towing. I liked the oil tows because they were clean, because all those clamshells would stink.

So, I went to work for a company, 3R Towing. This man at LaBeouf Bros., the dispatcher was Peter Russo. So he hired me, and by then I was already at the wheel. Probably about two years after I started on the boat, I was in the wheelhouse. I wanted to be in the wheelhouse. I could taste it. I wanted it so bad. And the captain that trained me, his name is Sonny Parfait, he was from Dulac. Good fellow. He took care of me just like I was his son.

With that first old captain at Guarisco, he was a mean old man. Oh, he was mean. The only time I had the right to go in the wheelhouse was to sweep, mop, and clean. But then when Sonny would come on, Sonny was working as a wheelman. He'd call me up to the wheelhouse, and he'd talk to me and he'd tell me, "Look, I want you to learn your mile board." He said, "Every time we pass by a mile board, I want you to look at it and remember it." And that's how I remembered all my mile boards.

I think I was a natural at being a pilot. I think I was born for that because I love it. And I'm seventy-four years old, and I still like it. Well, I must have had it because I've never had a major accident in all these years.

My grandfather was a foreman on a big plantation. He farmed sugar cane and dairy cows. He was the foreman then, and that's what he did all his life is push a crew. You know, work in the field. He had mules, and I guess that's why I want to push a crew. I was always able to push a crew and get along with my crew.

When I started at eighteen on the clam boat, my pay was $200 a month, and I had a wife and a kid.

We thought we were rich. We thought we really had it. Then it wasn't long I got a raise because I was a hard worker. I wasn't very big, but, boy, I tell you what, I'd hang in there. Ratchets were bigger than me, those old steamboat ratchets. There was no such thing as winches. Everything was hard rigging. When I first started out, we had no air conditioner, we had thirty-two-volt fans, thirty-two-volt icebox. Had a line of batteries. That was our refrigeration. And the hot water heater was in the smokestack. They'd take a big pipe, and they'd cut it, and that's what our hot water heater was. We slept in the bunk room, and it was hot in the bunk room. It was a nice bunk room—our beds—but it was no air conditioning. It had screens. You had the windows. You put a window down and a screen. You put that thirty-two-volt fan on you.

When I was really young, we would pull in, and the crew would go to town. I'd stay on the boat. I was always afraid, the captain . . . took care of me, and a couple of times I went with him, and he protected me. He wouldn't let anybody come around. But it was pretty wild back then. Just like we would be hauling out at Mississippi River outlet back in there. We'd be coming down, and my crew would get hot. They wanted to take a swim. We would stop the boat, jump in, go swimming twenty-five, thirty minutes, and we get up, dry off, and take off again. Can't do that today. Today, if you stop for traffic, they call and want to know why you stopped. What are you doing stopped? Well, what's the problem? The eye in the sky watches you all the time now. Things have changed a lot. Oh, you can't imagine how much.

I have a picture of the first wheel that tore me quite a few shirts. The spokes would catch me. It was a little tug, six hundred, and we were pushing a little unit tow, oil tow. So, the spokes, well, you'd hard it over, and then you'd tie it with a rope, and when you'd untighten, you had to watch it because when that the thing was coming back, it was spinning. And if it

happened to catch you, oh, it would undress you. A few times we were stuck, and I was pulling on towline. And, man, hard over, and you tie it. Then when you turn it loose, you had to back away from it because that thing would catch your shirt and undress you. Boats are not made like that now. Now it's all hydraulic. Everything is push-button, hydraulic.

I was privileged enough to break in my oldest boy and my youngest son. I was able to give them what I knew. And I think they're even way better captains than what I am today. I have two sons that are captains. The oldest one is Fred Reid Romero. And the youngest one is Frederick Shawn Romero.

The river is very beautiful, especially in the spring. You have to watch your currents. You watch how your currents are coming down, so when you get in a bend or somewhere you are going to know what you have to do. And that's what these young men don't know how to do any more. They don't watch. They have no idea what the river is doing. Reading the water—that's exactly what you'd call it. I tell you watch your drift, how your drift is going down. Watch when you pass by a buoy, watch how your water is coming down. People are scared of the river. And the river is very easy to work with if you let the water work with you instead of work against it.

To be a true river man, it takes somebody that's got a lot of patience, a lot of understanding. You need a lot of wisdom. You can become a real good river man if you have those qualities. You have to have trust, love at home, and have God in your life always. If you have that, you can make it, and life is very easy. If you don't have trust and God in your life, you always have difficulty.

People have to like what they doing. If you don't like what you're doing, you have no business on a boat. If you like what you doing, use common sense and let the waters work with you, not against you. You'll be all right. Like I say, I'd do it all over again because I enjoyed what I did.

CHARLES TURNER

– b. 1942 –

My name is Charles Turner, and I've been on the river since I was sixteen. I was born in 1942. I got on the river because Albert Wolfe gave me a job. He carried me to the boat. It was just a job at the time, something to do. After the first thirty days on deck, I knew then that I wanted to go to the pilothouse.

Back then the boats they weren't very good. You had old fans. There weren't any air conditioners. No telephones. No TVs. No radios. Just work. But everybody had a cook. That was the main thing, and they were all good back in the day.

Albert Wolfe broke me in. Back in those days, you had to learn to towboat. Now you don't. Albert wouldn't let me steer unless I drew the part of the river I was going to steer on.

When I first started, I said, "Captain, I might hit the bank." He said, "Well, it'll stop if you do." Said, "But you better not hit the bank." I took Cap for granted. Those old boats back in the day didn't have the power they have now. Sometimes if you hit the ground you didn't even know it for thirty minutes. You would look out, and you weren't moving. Then you'd back up and move over and go on so. Now, if you just touch the ground, you can tie it up for two weeks doing reports and all this. So, it's a lot different.

There were some interesting characters out on that river. We had singers. You had story tellers, and you had artists.

Back in the day, if you were tied off, you could go into town. Some of the times I don't want to remember because you had to get up and work the next day sick and hungover. But if you did your job good, well that was the only benefit we had is when we'd be there two or three days. If you do right, captain would let you go uptown. But that's only what we call "fun" then you had.

Rule of thumb was, if you weren't below Lock 2 on Thanksgiving, and if you eat Thanksgiving dinner above Lock 2, you were frozen in for the winter. And then we were up there one year on an old boat, *Albert Wolfe*. We were there at Hastings, Minnesota, and we couldn't get under that bridge. And we sat there and fooled around and got frozen in, and we spent the winter there. That was when we could go to town. And then one year I was working for Red Harvey. It was on the old *Ouachita*. We had six loads working for Cargill. It was on the Illinois River, and we got right below New York Central

Bridge, and we got frozen in. Red come down to dinner that day and told us, said, "Well, boys, I'm going to have to fire all of y'all." He said, "I just got fired." Cargill fired us because we couldn't move the barges, so then we sat there a month or so waiting for it to thaw out. And then the day it thawed out, we could move. Cargill put him back on the payroll, and he put us back on the payroll. So, in the time that they fired us, we just stayed on the boat with no pay. Back in those days, we bought the barrels of flour and all and a five-gallon can of lard. There wasn't any such thing as Crisco and stuff. We had plenty of lard. We had plenty of flour and corn meal. I had a frog grab on there we put on the end of the spike pole and caught those geese with it on the ice. We ate that. Then we had that old bacon and stuff, that smoke and salt and all that. We were there thirty days. The boat and everything was frozen up. Couldn't run the boat. We could run the main engine, but we happened to have plenty of fuel and had old diesel stoves and heaters and things, so we were warm—well, what could get warm on those old boats, no insulation or anything on them. But that was the way of life back then. You didn't have a problem sleeping because you were tired when you went to bed.

The only swimming story I remember, we were up some little old river, and Jackie Neal was decking for us. Albert was captain. I was pilot. And we had gone to town. Some kind of way Jackie got ahold of a bottle, which that wasn't hard for Jackie Neal. We were fixing to go. And Jackie hid the bottle in the kitchen cabinet. Had a pair of old cutoff pants on. He didn't have a shirt on. That sucker is hairy as a bear anyway. So I found his bottle. I walked out there and threw it in the river. Jackie went in the river right behind it. He came up with that bottle. We pulled him up on the side of the boat, and it just tore all the hide off his chest. We were pulling him up. I grabbed the bottle and was going to throw it back in. He turned. Albert said, "Hell, no, give it to him." Jackie was going to follow that bottle till it was empty.

Back in those days, you could wear whatever you wanted to. Half the time in the wintertime, we'd take an old garbage sack and cut holes in it, put it on up under our coats, and it would stop that wind. But you just made do.

Taking shortcuts on the river, I still do. I'm not supposed to, but I still do. We didn't stop for anything. You did it because you had to. You had to learn where you were. Back in those days, just like Captain Jesse Brent taught us—he'd beat it in our head—"The shortest, slackest mile is your money mile." If we could run across out through the woods or something come out over there. We didn't tear up anything. We made some money, see.

I used to work for Captain Frank Banta with he and Mrs. Dorella. His wife, Mrs. Dorella, always rode with me. But we'd ride till we got tired back then, and then he'd come ride. I'd take off as long as I wanted to. We used to ride when I worked for Brent. A lot of times, we'd ride ninety days at a time. I mean, things were short. We would just ride. But, then, like Gene Goins—I was on the boat when me and Gene rode the boat ten years together. And I'd let him off right here, and I'd pick him back up again at Lake Providence six hours, eight hours. I'd jump off at Greenville, and he'd pick me back up eight or ten hours later.

The story Albert Wolfe used to tell, he said his daddy he worked on the old *Sprague*. He never did try to get ahead. He said in those days his daddy, Captain Clyde, said he didn't really try to put a lot of effort into his job because he was pushing coal in a wheelbarrow. And he said the only thing you got out of it: The quicker you did it is the quicker you brought back another wheelbarrow full of coals.

Captain Frank Banta is one of the finest human beings I ever been around. He's like Jesse Brent. They were not only interested in what you could do for them; they were interested in what they could do for you and your family.

Back when I first started, people had guitars for entertainment on the boats. That was it. No radios. No TVs. Had an old Hallicrafter radio in the pilothouse. We had two big things, boxing on Friday night—we would listen on the old radio—and then

the *Grand Ole Opry* on Saturday night. It depended on what kind of captain you had, but most time, they let us come sit around in the pilothouse and listen to the radio till nine or ten o'clock.

Probably from the time I went in the wheelhouse fifty-something years ago to now, the river is probably a hundred miles shorter than it was then.

We used to wash our clothes in the wheel wash because we didn't have a washing machine. We had a damn rub board and we'd take and throw them in that wheel wash. Tie a handy line on them, and that wheel wash would wash them, or either if we weren't like up on the Illinois River, you don't throw clothes in that thing because all that sewer and stuff comes out of Chicago. But we'd take a fivegallon bucket and then run water in it and then take a commode plunger and beat the clothes up and down, and we'd wash them like that because very few boats had washing machines on them.

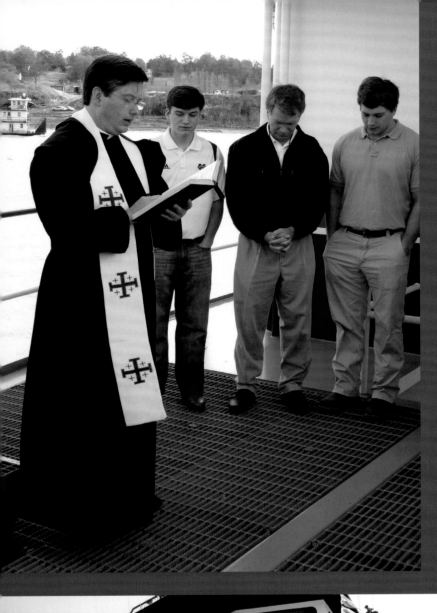

SCI
CHAPLAIN

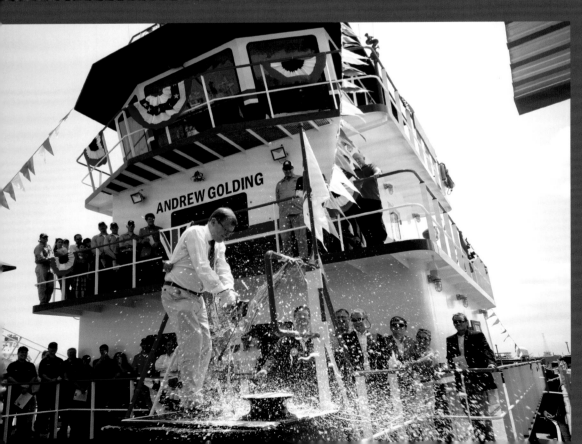

ANDREW GOLDING

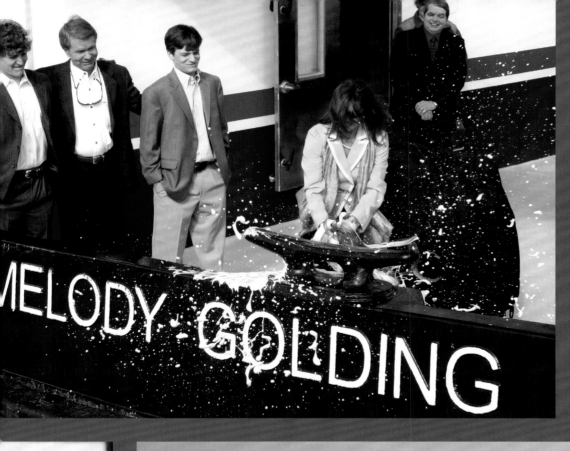

MELODY GOLDING

JIMMY F. SHARP

– b. 1943 –

My name is Jimmy F. Sharp. I'm from Paducah, Kentucky. I've been on the river since 1965. I got an academic scholarship to go to college, but I didn't want to go. I wanted to go to the river because there was money being made back in those days.

I'm a heavy-tow pilot. Forty is the biggest I've pushed. It's seven and a half acres out in front of you. But if you've got a nine-thousand- or ten-thousand-horsepower boat, you can do it, but you have got to know the river. We push grain, and we push some petroleum products. We push a lot of coal and grain. I can run any river. I'm posted on all of them. Where one barge is drawing ninefoot, it is probably anywhere from fifteen hundred to sixteen hundred tons. But now the new barges they've got are twelvefoot, thirteen and fourteenfoot barges, and they're putting anywhere from twenty-one hundred to twenty-two hundred tons in those barges when they're drawing eleven and a half, twelve foot. They do that a lot now to get the tonnage in there on these barges.

When I was coming up, there were a lot of older guys that were pilots and captains out there then. John Ritchie was one. All those Ritchie boys ran the steamboats back then—the *Delta Queen,* and then

I think they made the *Mississippi Queen* and then the *American Queen.*

I never did run the steamboats. I just didn't want to. I just didn't care for it.

I know that river like the back of my hand, the Mississippi River from St. Louis down. I don't need the electronic chart to tell me where I'm at. I used to have bar books and everything, but I don't use them anymore. What we try to teach these younger people is, learn the river and keep it up there in your head. Of course, it's a lot to learn, but you can still do it. I did it, so I know they can do it too. If they're going to be a pilot, learn it.

People would be shocked if they knew what we actually did out on that river. If it's soybeans, corn, or whatever, you've probably got a million dollars' worth of cargo in a barge, and in liquid barges, you have a lot more than that. But, the revenue, you can move so much in a barge. One barge will hold approximately 250 trailer trucks. And, train boxcars, I think one barge with just fifteen hundred ton will probably hold sixteen boxcars, just one barge. So it's so much cheaper for people [to] ship their products on the river. Some of the larger boats—I know ARTCO, they come down with forty-eight. They go six long and eight wide. You've got eight

acres ahead of them. Just think of six, seven, eight acres out in front of you that you have got to move. The key is to have a good boat.

I've seen a lot of Tom Sawyer types that they'll build their own raft and come down the Mississippi River. They don't really know how dangerous it is. I don't recommend it.

If you're running full ahead, and it's according to like the river stage, how high the river is or if you've got a lot more current, you're running anywhere from 10 to 12 mile an hour with forty loads. In a deal like that, 10 or 12 mile an hour with forty loads, you're moving. That's kind of like doing 150 in a car. You better know what you're doing because it takes a while to get them stopped. You just don't put the brakes on. Oh, surely it will take within a mile or half a mile to get them stopped.

You can get shutout fog or a shutout rainstorm. Then you have to do it by all your electronic equipment to get to the bank. If you have seven acres of barges in front of you and fog moves in, and if you are headed southbound, absolutely. A lot of times northbound you stop, too, because a lot of Coast Guard rules and regulations, they say this electronic equipment is put on here to get you to the bank when you do get shut out, either north or southbound. I have run from New Orleans, back in the older days, for four or five days and never even saw the tow because of fog. Now we have depth finders and everything out on the head that shows us how much water we have in front of us. You pretty well know. If you've been running it like me, you know where the slack water is and where you can run faster northbound. I know the river like the back of my hand.

I read the water. You can see you'll have reefs, and you'll have a deep-water reef, or you'll have a shallow-water reef, and you can read the water because it will be a difference in the ripples of the water. Especially, you can see stuff going over the dikes and stuff on the Mississippi River. But if you know the river well, and you know where the bars are going to build up, if you have got a fast-falling river, it will leave sandbars. But the Lower Mississippi has no locks on it from St. Louis down. It takes the dikes to cut the sandbars out. But if it falls too quick, it doesn't have time enough to get out. But if you have a small falling river like falling two- and three-tenths a day, the current down there will cut the channel back out because the dikes will do their work. Now we've got a lot of weir dikes that are made in underneath the water that we run over top. A weir dike is made to move the sand. They'll put weir dikes in the bends to keep the sand moving. It will move the sand like a dredge, weir dikes will. Now they've got some of the new Chevron dikes they're called. They're like a horseshoe. They put them in for a lot of the environmentalists to where the fish won't have to swim all the way around the end of a turn and everything. But they have different styles of dikes, and weir dikes have really helped the river industry.

The Lower Mississippi River, you'll get 65 percent of your water coming out of the Ohio to the Lower, and you'll get 35 percent coming out of the Upper to the Lower. But if you have got both of those river risings, you're going to get a quick rise in the Lower. But if you haven't got both of them rising, your gauge at Memphis can go from five foot to twenty foot in a couple of days if you get a lot of it coming out of both of them.

There's a lot of difference from what I make now than when I first started. Right now, they pay me a thousand a day. All these companies, they want us older guys because they know we can teach it, and they know we're going to get their boat from point A to point B without incident.

JERRY FAULKNER

– b. 1944 –

My name is Jerry Faulkner, and all together I've been on the river about forty-three years. I'd always wanted to work on the river since I was a little boy because I loved the river.

I broke in on the Missouri River in 1968 in the pilothouse. That's some river to break in on. Up there, they had mailboxes for channel reports or used to back in the day. They'd put a boat in, and you'd run down there and get it, or sometimes they'd back into the bank, and you get off and get them. It was two of us. We were going to go get some channel reports. We put the boat in and got in it. He backed up. You know what that did. Under the barges we went. I think I still have got knots on my head. We sunk the boat. We went under the barges. It was one string of empties there on that side and then another string of loads. Anyway, the life jacket was holding me up against the barges, and my head was beating against the bottom of the barge. It wasn't good. So I had on my life jacket, and I popped up out there at the first coupling. The other guy, he popped up about halfway out. That hurt.

One time we were playing cards on the boat. But we were all in there gambling. We had been gambling quite a while, and there was a guy from

Mississippi. His name was Moss. There was another guy from Picayune, Mississippi, I believe it was. He was winning pretty regular, more so than we thought he ought to. But anyway, Moss come out with a knife, and Woody run that a way, and Moss was right behind him. Me and Sal were sitting over on the side from the door. We couldn't get to the door. We were crawling trying to get to the door. But anyway, he was cheating the guy from Picayune, Woody. He wore great big thick glasses. And I said, "How does he cheat?" Moss said, "He's cheating." And, boy, that's when the table come up and the knife come out. Me and Sal was trying to get out the door, and we were down crawling. Money was all over the floor and cards too. Everything that had been on the table was on the floor. Woody was running for the door, and Moss was right behind him, swiping at him with that knife. I'll never will forget that as long as I live. Captain Carol, he run them all off— not all of them, but supposedly the ones that were cheating and causing the trouble. That was something else.

Some of the early people I worked with had a history of having been all the way back into the steamboat era and before diesel engines. Captain

Riley use to bring those DPC boats down. They were named after islands in the Pacific. Captain Stewart Riley, he was from Ohio at mile 535. He was a steamboat captain.

How I would prepare myself for being out in that cold weather on these rivers is when I was on the boat I carried an electric blanket with me, and everybody called me sissy. But they were all wanting to borrow it by time the trip was over. So it was always cold and always hot. There wasn't any in between. The Illinois was the coldest to me. I've been out there when it has been frozen over. You put the barges on what they call mule train. Put the boat up there with a square—not against the boat but thirty-five-foot wires, or we had lock lines, big lock lines, or Hauser lines. You put the barges like that and put wires loose, real loose, and the barges follow you right down that river in that ice—you will go through bridges and everything—so the barges are behind. They took a certain kind of boat that was real good at that, the mule train. The rudders where you pull from, the H bits had to be forward of the rudders for it to pull good. If the H bit was behind the rudders, it didn't pull. It didn't do good. The deck was very, very slippery. That *Waverly* was a tug, a model bow V. It would pull the barges you wouldn't believe. It had a great big ole winch back there on the back of it—I mean just something awful. It would mule train the barges better than any boat I was ever on. It was really something.

The Missouri River would just shut down completely in the winter. Down there below Cape Girardeau, Gray's Point, Thebes Bridge, I have seen that shut down in there, and Corps of Engineers went in there and dredged that, cut the rock. It was rock. The river would get down so low you go down there, and you bump, and you knock holes in your barges.

Talking about those rivers freezing over, when my wife and I first married and from between Thanksgiving and Christmas until March, I would be off because the rivers would be frozen, so we just learned to save those other months of the year because I knew I was going to be off, and we had to have money in reserve. So I worked more when I came back on. I knew I was going to have the winter months off. We'd ride through the summer a lot. I rode as high as eighty-nine days. What's that like? Well, you learn not to gamble. That was something else, but you knew you had to do it if you wanted to eat.

It's a good life if you like the river. But if you don't like it, it's the worst place in the world to be. It's a good life because you never wake up in the same place twice. And the bad part of it is you're away from home, away from your family. That's the only bad part of it I can say was bad.

Sure, you have breakups and everything, but the money is good. I had a high school education. Where else could you go and make that kind of money? Now they're making a thousand dollars a day. It's a good, honest living. You work hard, play hard, spend your money.

But the river has been good to me. I can't complain. It's been good to my family. Don't owe a dime for nothing or nobody. But, yeah, the river has been real good to me.

MENVILLE TROSCLAIR SR.

- b. 1944 -

My name is Menville Trosclair Sr. I grew up in Houma, Louisiana. My name is French Indian, yeah. I'm a Chitimacha Indian. It's pretty much a lot out of Biloxi, Mississippi.

From my daddy's shrimp boats, I went to work on an oyster boat. When I was fifteen years old, I was running a fleet of oyster boats, fishing boats. Had about five, six boats I ran like a foreman, yeah. Fifteen years old, captain on a boat, and running the whole fleet, operate the whole fleet in Grand Isle, Louisiana. I was thirteen years old when I first ran my own oyster boat getting eight dollars a day. We worked three o'clock in the morning till ten o'clock at night and one meal a day in the morning—pot of beans, a plate of beans at nine o'clock in the morning. In the afternoon, on your break, you had a cup of the green bean can. Had one cup a break for wine at two o'clock in the afternoon. That was your break. At two o'clock in the afternoon. The bean can, that was your glass. That was a drink of wine. You drank that in about three gulps. That was it. Go back to work. You had beans in the morning or oysters in the morning; whatever you peel at night. That was harder work. So I decided, well, I'm lazy, and I'm going to go work for a tugboat company in New Orleans.

We bought a tugboat from Joe Angich and worked for Joe Domino in New Orleans, towing service, in the harbor for the Valley Line Company, Valley fleet back in New Orleans, and we'd haul sugar. We had an old wooden tugboat. We'd get some sugar barges for the Valley Line Company in Jeanerette, Louisiana, and Franklin, Louisiana, which I had kinfolks working at the sugar plant there. We got in with them and hauled the sugar out for Valley Line. We'd take it to the river, and we'd go back in the ICW [Intracoastal Waterway] in slack water at night, so our boat wouldn't sink. Had a wooden tug. The boat could sink because the current shakes the boat and made the cotton come out. On the planks of a boat when they're spliced together, you had cotton hair. They just packed cotton in there. It was an old boat, but they did that back then. They use silicon now I guess. It's not real cotton. It's a brown thing. You got to know what you're doing with a chisel and a little bit at a time.

That boat was old because when you knew you sit them in the water, and it swells up. So that tightened all the wood and the cotton. If you took it out of the water for any amount of time, they'll dry up and unswell. You need to put it back in the water. It would leak, leak, leak. Then when it swells up,

no more leaks. But you stay in the river, and the river is always running, and you would bump the barges. So we take it in the canal. Tie it to the dock. No movement. It was a big tugboat, a hundred and something foot long. It was a model bow boat—a steering big tug. It had three or four cabins on it. But we hauled five sugar barges at a time, and that's whatever ton it was back then. That was off of those sugar cane plantations in Sheridan, Louisiana. Some of it was raw sugar. Some of it was bag sugar, raw sugar. It was ready for the market. Just pour it in a barge and take it to Chicago and whatever they did. At that time, I was a deckhand and driver. I was about sixteen. At sixteen years old, I was driving five barges down the ICW canal going to New Orleans, to Houston and to Florida and Panama City and all. We'd towline. I'd pull the barges behind a lot.

I just tried to stay in the river and learn it. I learned that light list book. At nighttime, when I'd go to bed, I'd study because we were making four miles an hour. When I go off watch and I'd come back on about thirty miles up, twenty-five. So I'd study from that thirty to twenty-five, thirty miles up. I studied my part. I remembered some of the lights, and then the same thing next time. I put my *Playboy* book down and look at the light list book. Yeah, that's how I learned it. I went from *Playboy* to the light book. Yep, that's it. And I made it.

I dated a few cooks. And I worked with Valley [Line]. We had some young cooks back then. Out of union hall was nineteen-, twenty-year-old cook, twenty-five. Foxy girls. We had no more problems then than we have with the fifty-year-old cooks today. Never want to get off the boat. We had whiskey and girls. What the hell. What you want to get off for? Decent cooks. Several captain friends had their daughters and wives working out there also.

My buddy on the Valley Line, A. D. Haynes the II—we made a few tapes up there on the Ohio River singing. And the cook from Indiana, young cook, she was like maybe twenty-one at the time, and we made a little cassette tape up there playing the guitar going up the river.

We just pick the guitar, and he was a mate. Toby Greenleaf was his name. He was from Point Pleasant, West Virginia. That was back in maybe '75, '74, did that little tape. And she came up there with a negligee on, and Toby had a guitar, and we tried to pick it, about two, three o'clock in the morning. Back then, there used to be a lot of music on the river. Not so much now.

It's kind of faded away. Everybody is on their cell phone now. You don't talk on the boats any more. You can't go down in the lounge and have a conversation because the guy is on his cell phone. You don't play cards anymore. You'd have a little poker game. No more. Cell phones. They do their cleanup work, and they go talk on the cell phone. But that's all right. I know he wants to talk to his family.

When I'm not on the river, I don't miss it, not a whole lot, but I miss it. Miss my friends out there. Miss my people. That's my people. Bunch of family. Miss that.

To be a river man, you have got to be strong. You have to be determined to go forward. You got to have a strong wife at home, understanding wife or girlfriend or whatever. She's got to be riverboat people too, understanding lady about being gone. Life is life. Riverboat man doesn't raise kids, doesn't know his kids. The wife raises the kids. She got to learn how to babysit, take care of the kids, pay the bills, fix the tires, fix the plumbing, tell the lie to the bill collector. First thing she has got to do is learn how to tell lies because you never have enough money. Tell, "Well, I'll pay you next week," stuff like that.

I recall Luther Brooks out of Paducah, Kentucky. We called him, "Paw Paw." He worked for Valley for years, and he lived in Paducah. He stayed drunk. He come up in the afternoon. We had a big tow all the time with Valley. He'd come up there, and see, we were flanking, say, Victoria Bend. That would be to the right at that time. He'd flank to the right. We did bad in that back yonder in the early '70s. He said he felt he needed a drink. So he would stand on my righthand side, on my starboard side, see. He need a drink—bottle of vodka and gin. That was the

big thing, gin with Valley. We'd drink probably five or six good drinks, and I'm not talking a swallow. We're talking drink. We flank around there. He was an old timer. He'd tell me some stories from way back in the steamboat days.

I had a friend running captain from Lake Charles, Louisiana. The pilot on there didn't know how to get across the Mississippi sound, so they called me. I went over there. So, while we were sitting at the dock, sitting in the galley, here comes the deckhand. "Hey, man, there's some alligators behind the dock." No problem. I'm a Louisiana man. I'm Mr. Macho guy. I take off out there with a sledgehammer going to kill the alligator. All right. So I left the galley table. So I go out there and got in the dock. Here comes the alligator, and there were two, three of them. Everybody says "Kill him, man. Kill him, man." So I get in the water. I took my shoes off. When I'd move, the alligator would run off. So I walked back to the dock. Got one of them pipe wrenches what you tighten the hoses with, stainless steel. I had my wrench cocked, but I didn't know that the alligator, he was cocked too. I reached for him. I got him behind the neck where the soft spot. He knocked me down. I got to swinging, and I beat that alligator, and he beat me. We went round and round and round in the water. He was turning and turning dragging me into the deep water, deep water. He was ready, more ready than I was. I was screaming. My wife and the people on top of the head of the stern screaming, "Turn him loose. Turn him loose." I couldn't turn him loose. He was dragging me to the deep water where he could drown me. Finally, I hit him. He slowed down, and I got myself back. I got him to the beach, and I beat him some more. I finally killed him, and I was beat up for days. He was my size. He was five foot. And [I] carried him to the boat and put him in the galley. The cooks all got excited.

Another time I worked for Sioux City New Orleans Barge Line on the *Robert Crown*. Seventy-two-hundred-horsepower boat coming up the river below Natchez, and the generators went out. Call

the electrician. So we going to go up the bayou and pick up the electrician, Highway 61. I never been up that canal. Me and the mate took off in the skiff. We found a big old loggerhead turtle. Put him in the skiff. The mate was sitting in the bottom of the boat. I was driving, messing with the big turtle, poking the turtle, big old loggerhead. And all of a sudden, the damn turtle got me on my leg. I was screaming. Mate was screaming. I think the turtle was screaming too. Turn me loose. So we beating the turtle but couldn't hurt the turtle. I got the turtle's tail. It's about sixinch tail, and I pulled him off my leg. Mate was right there. Well, look, the turtle got me. "Oh, man, you're going to die." Blood was just rolling out my leg. The turtle, he still trying to bite me. So he grabbed a bandana he had, and he tied my leg and stopped the bleeding some. Got rid of the turtle. One captain on the boat, not the turtle. And I'm kind of lost. We don't know where we are going. So we found a beach. Seen a bridge. Figured that was 61 Highway. We run the boat up on the bank, jumped out, jumped in the mud. The river had been up and down. We sank to our waist. So we drug one another out of there. So the bandanna was gone. "Oh, man, you're gonna die." He drug me up to the top of the hill. We washed ourselves best we could with the mud—blood and mud and water. "Oh, man, you're gonna die." I said, "Man, be quiet." We get to the top of the hill Highway 61. As far as you can look, man, but field, field, field both ways all around, up and down, nothing. "Well, man," I said, "I guess Natchez is this way." During the while, he'd check my leg. Still bleeding. "Oh, man, you're gonna die." We're walking down the road still trying to find Natchez. We look back. There's a big old log truck. So we flagged the guy down. He stopped. I told him what happened, He said, "Oh, man, you're gonna die." We're out in the middle of nowhere. "Can you get us to town?" "Well, you're gonna die, man. You're gonna bleed to death. No telling what that turtle got, what kind of poison. A loggerhead." So, he took us to Twelve Mile Store somewhere below Natchez. So, we get

in that old little store here. They had a pool table and a few pieces of groceries and an old, old lady. Tell [her] what happened. She said, "Oh, boy, you're gonna die, boy." Man, quit telling me this. Well, if I'm gonna die, I'm gonna die drunk. Give me a beer. So, we started drinking. We played a game of pool. The lady say, "I ain't gone charge you for the pool because you're gonna die right there." Said okay. I'm hobbling around still bleeding. She patched my leg some more. Put some first aid and stuff on it. Put me on the pool table. Packed me with all kind of alcohol, burning stuff. Here comes a bread truck, Holsum bread truck, panel truck. Told the guy what happened. He said, "Oh, boy, you're gonna die." I said man. "Okay. Well, get me to the doctor. Well, how far am I?" "You twelve miles. The Twelve Mile store, right? Where you think you at?" I don't know. He took us to the hospital. Rode me up in a bread truck.

So, we get to the hospital. Took us in there and told what happened. The nurse said, "Oh, my God. It's a wonder you not dead already. You lost so much blood." Here come the doctor, "What had happened?" She said, "Oh, my God. You're lucky you're alive, boy. We're lucky you're not dead." Man, fix me up. Fix me up, man. I had a piece of meat hanging. She just grabbed it and pulled it off. "Awww, man, now y'all killing me." But they patched me up. Of course, they couldn't sew nothing. They had nothing there. They packed it up and wrapped me up. "No drinking." I called Mr. Law, the port captain, port superintendent, for Canal. I said, "Man, I need a couple of dollars." Told him where I was. "Sioux City will pay you back, or I'll pay you back." "Oh, yeah, no problem. How much you need?" "Oh, it's about $30." That was quite a bit of money back in the '70s. So he sends somebody to brought me the money, and we took off. We went to the Princess Motel Bar in Natchez at a hotel. So we drove in there, and there's all kind of doctors and nurses in suits and all clean clothes. Here we are all bloody and muddy. So we left. We went to downtown Natchez to an old wooden bar. We didn't fit there, but we went in there and people sitting at around tables playing Dominos, cards, whatever, old water people. Went to the bar. Ordered a beer. Took me some bottle beer. Had some people in the back. Pretty good crowd but old timers. The old bartender there, tall skinny guy, "Where y'all from, son?" The mate say, "I'm from Michigan." No, man. The place stopped all right. The place stopped. These guys are Civil War people here. He's a Yankee. Say, "Wait a minute. He lives in Oklahoma. I'm from Louisiana. We not Yankees." "He said Michigan." I said, "No, no, he lives in Michigan. Right now, he's from down south." We drank two beers, and we left. Had to hitchhike a ride back to the skiff. We finally got back to the boat way after midnight, but in that little bar, those people are still fighting the war. I called my wife. Didn't believe it either. "Well, you might die after all this." I'm still here. It was 1973.

They made me master on the *Valley Voyager*. Me and my deckhand out of Pittsburgh, we got off the boat in Chester. We put our clothes in a Ziploc bag and jumped off the Chester Bridge. Floated down the river a while, just for fun. We jumped off the Cape bridge. Cape Girardeau. We floated down the river into that with our clothes in a Ziploc bag. We didn't get arrested or anything. Just got naked and jumped off. Floated down the river and got on the little sandbar. The Chester Bridge is about fifty, sixty feet. About all it is. Pretty good dive. We did that in the Gulf. You know, shrimp boat, the masts and all. The masts are pretty tall. The shrimp boat mast is pretty tall. There's no problem. Just water. We made some booze with Sioux City. We call it Buck whiskey. With strawberries. Got one of the cooks with the Sioux City New Orleans Barge Line boat. Had a big old stove in it. We'd make a five-gallon bucket of moonshine—whiskey or whatever you want to call it. Fill it almost to the top, and we'd put it in there to ferment alongside the stove. It would take it a week or so. So by the end of the trip, we drank the whole five gallons. Everybody had a drink. It was strong. Taste bad, but it was all right. Cheaper than going to town. Yeah, we drank. Just

for fun, you know. My wife, when she used to come to the boat, she'd bring some rubbers. Sex rubbers, and just put it on the cap to when it ballooned up it was ready. When it would blow up like a balloon, it was ready. On a five-gallon bucket top like the pour top. When it ballooned up, it was ready. Time to drink, yeah. Threw the rubber away.

PERRY WOLFE

– b. 1944 –

My name is Perry Wolfe, and my first trip on the river I was eight years old. I rode with my dad on a construction boat going up to Fort Smith, Arkansas. I had to sleep on mosquito bars and sleep on the sandbars. My dad called me his mate, so I considered that my first trip. The boat didn't have sleeping quarters on it, and there were no air conditioners or anything. That was way back in 1950. I thought I was doing a real big job at six years old. My dad's name was Clyde Luther Wolfe. My dad picked me to go with him on that trip because I was the oldest one out of my brothers and sisters at home right then, so I got to go. I realized that I was going to make a life on the river probably when I drew that first paycheck after riding when I was just a boy. I wanted to be like my dad.

When I was sixteen, I started working for Brent Towing Company. I was a deckhand. I knew that I wanted to be the captain and be in the pilothouse before I ever even got to be a deckhand.

I've been on all the rivers in the Western Waterways. My favorite is the Upper, and I like it because the scenery is better.

In the early days, the river was wilder in a lot of different ways. The river was wilder, and the people were louder. Back then, you didn't have all these dikes, so you have a swifter river now. The river is swifter because of all the dikes, but now it's all a channel. You come down and every trip you don't have to guess where the channel is going to be.

Actually, up there at Lock 26, it was more wild than Natchez Under the Hill. Used to, guys would swap boats there pretty regularly. They would come down, and there was a lot of lock delay, and they would go up there and get to drinking too much and come back, and the boat will be done gone, or they'd come back and tear up stuff, and they would get fired. Anyway, they just jump off one boat and go on to the next boat. That's one of the things that's better now. You don't have to contend with that stuff anymore. Being a captain back then was a lot harder because you had to referee all the fights, and now you don't hardly have any of that stuff now.

Percy LeMay there in Greenville, that's the way he used to hire his guys. They would come down there, and he'd asked them for an interview, and he'd asked them if they had ever been to jail. If they said no, he said, "Well, I don't need you." I guess if they'd been in jail, he'd usually hire them because he knew he was going to eventually have to pay to

get them out of jail. And that's like captured labor, and then you got the guy, and he was going to stay with you.

My dad, he used to go out and raft logs and all that kind of stuff. You learn the flow of the river doing that, rafting the logs together, and he'd bring all the rafted logs down and turn them up in Lake Ferguson there. The logs they call them big blues. That's drift, the big trees coming down the river. He'd go out there and spike them and rope them together, throw them to the bank, and then tie them off. He'd put spikes on them and tie them together, and he'd bring them all down. He sold them to Chicago Mill there in Greenville. So, it was all kinds of trees, but most of them were the big ones and they called them big blues. They had been in the water so long they look kind of blue looking. You still see them, but you don't see many people rafting them like that anymore. The last time I saw a big rafter log was, I'll bet, it's been fifteen, twenty years ago. It may be even longer than that. Now, they'll go on downriver, or they get hung up.

My dad worked on the *Sprague*. He wasn't a pilot, but he worked on there. He was throwing the wood on the fire. He stayed on the *Sprague* when he was on there working. They stoked the fire for the engines. My dad he was from up around St. Louis, his family was. My grandfather, he was a fisherman, and when he lived in St. Louis he was a lamp lighter. He lit the lamps on the streets, but I know he did some fishing. I have seven brothers. There's seven of us children, but there were six brothers. We were all captains. My brother Albert had five sons that were all pilots. My son Scott is a captain. And my son Steve, he works on the river.

I can tell more barroom tales than I can riverboat tales. If you got through and stopped loading, or if you stop because of lock delay or things, I guess people used to make those little trips uptown all the time. We were allowed to get off the boat. Sometimes when you came back to the boat, if you didn't have a sore head, it was hungover the next day. I'd rather them get the sore head uptown, though, than

come back to the boat and get it, because if they got to fighting on the boat, it was kind of rough. I was tougher than most of them, though, so I didn't have too much trouble. I believe the river gets in your blood. I quit the river a couple of times, but I heard them ole boat whistles start blowing, and I had to go back to the boat.

I would say that life on the river, it's good for some people, and for other people it's not very good. Personally, I like to go out there. I can just relax, and whenever I'm off, I'm off. Nobody bugs me unless they have a problem. But it's real peaceful. You don't have that stress. But for some people, it's not that way. They just need to be home where they can go home every night. But if you are out there, and you use your time right, you got a lot of prime time off.

I worked with a couple of captains that couldn't read or write. George Reed was one. You come up in the wheelhouse, and he'd tell you right where you're at on the river. He would just look at the radar or look out there, and he would know exactly where he was. We had to fill out his log for him because he just could not read. I go back to the river getting in your blood. It has to be in your blood. If you like it, you like it. If you don't, you don't.

I worked with a couple of ladies who one was a mate, and one was an engineer, but I didn't work with any in the wheelhouse. A friend of mine, his wife is a pilot. He broke her in. I don't see anything wrong with it. If they have got the nerve to do it, let them do it. I don't have any problem with it at all. I think there are probably some women that can make better captains than men because some women will take control, and that's good. That's what they're hired to do. That's what they need to do.

I would recommend a career on the river for a young person. It's been pretty good for me and especially for people that don't have a real good education. I mean, it's good for some people that do have a good education too. But it's an education in itself. Ninety percent of this river work is judgment.

The buoys can tell you a lot. You look at the whiskers running on bridge piers and anything that's making a whisker where it's running around. An eddy, that's not good. If you get around on these big eddies, or if you run into a big eddy down there southbound, or if you get your tow over in any eddy, it will flatten you out. It won't let you make your steer. You can't steer out as quick. You have got to know the difference in what those eddies are doing.

Whenever they are loading up, you will get a bigger swirl out of them. Whenever they're dumping, then it dumps. It'll push you away from them. When it's loading up, it's going to pull you to them. They work in two different directions. You have to make young pilots aware of all that stuff. That's when experience comes in. You will know where it's going to happen to you, and you know where they are, and you try to get your guys to know where they are too.

JOE ZEICZAK

– b. 1944 –

My name is Joe Zeiczak. My family is in the pilot business, so I have been riding the boats, my God, since I was knee high to a grasshopper. I was riding boats like these crew boats in the Gulf when I was just seven years old. So I had a lot of experience. I learned to tie off boats and how to run a boat and to go get coffee. But when I was thirteen, I went with my uncle. He was a bar pilot, and I went on the ship with him, the NSS *Savannah*, the first nuclear-powered cargo ship there ever was. After high school, I ran the pilot boat for the bar pilots in Savannah. Then I went to the Gulf because I found out I'm going to be a river pilot. I went and got my license and started working for Cenac Towing, which pushed barges up the Intracoastal Waterway.

I was working for Crescent Towing Company in docking the ships. I worked for them as a deckhand. This was in March. They made me captain in May docking ships because I had the license. I was in the operation with Desert Storm. All of those ships that went to Savannah were led by those big cargo ships. I helped dock and sail every one of them. Those big ships, I would say, were a thousand foot long, and they ran about forty knots. They were big. We had to get special lines to dock those ships.

I was in Hurricane Bob. That was around in the '80s, and I drove right through the middle of it. The size of the boat was like what you saw in *Titanic*, with a helicopter pad and everything else. It was a vessel about three hundred feet long. I had no choice. It was not what I wanted, to be in Hurricane Bob. But the hurricane all of the sudden made a complete 380 and came back east and caught us. I can tell you this much, the movie *Perfect Storm*, that was exactly what it looked like. We had fortyfoot waves. And the movie, that gigantic wave they showed, that's for real. That's called a rogue wave, and that happens when the currents changes. You don't go straight on top of a wave like they showed in the movie. You have to keep your props in the water. Sometimes you have to maneuver that boat like a surfboard and glide over it. But you never take one head on. That's a bunch of crap there.

Another time, there was a big oil fire. This was when I was running the cargo vessels in Mexico. It was years ago. It was a big double rig. That was quite an experience. The fire happened because there was an explosion, and because of the explosion, it burned. There was a malfunction or something, and it just went up. These people got a chance to get off

the rig before it went up. They were on the lifeboats, and I was about six miles from them. We got a mayday from the Coast Guard, so I untied from the rig where I was and went to their aid. It was about eight- or ten-foot seas then. When that thing went up, it just pushed oil and everything all over the water, and it looked like a lake of fire. The heat from that was awful. I went right through it and saved a bunch of lives. The thing about this, you don't think about things because you don't have time to get scared. You react. To be able to save somebody's life, I would do it again. I wouldn't want the experience again, but I would do it again.

I've been overseas and everywhere else working, not just the Gulf of Mexico. I've been to Brazil, Jamaica, Mexico. I made some runs. I've had quite a life on the water. My favorite place was Jamaica. We had it made in Jamaica because we had our own office there, and I was more or less in charge. The mate I had on my boat could fly airplanes, so we had our own airplanes. We had the people picking us up in Mercedes and all that when we'd go to town. We were set. That was the life, man, I'm telling you. It's not like that anymore, though, with what is happening and the restrictions and all that. They don't let you go to shore anymore. You have so many rules and regulations now it's unreal.

The best thing about being out on the water is the freedom. It's a different world. You're away from reality except for Mother Nature. I never got sick when I was on the water. The worst thing about being on the water is the seas; when you're in those storms and the treacherous seas, that's no picnic, I can tell you. You are actually fighting for your life. Everything you do is critical. You don't make any mistakes. If you make a mistake, you will die. You better know what you're doing. You don't try to fight a storm enough to go through it. Get away from it. With this modern technology now, you know well in advance that it's coming. Now, if you go through a hurricane, I'd rather be at sea than land because land can be more treacherous. If I was stuck in my house, and we had a category 3 or 4 hurricane, I couldn't get out. My

chance of survival would be slim. You get me on a vessel, I know I have a chance.

Experience helps when you are out on the water. You can go to all the schools you want to, but you aren't going to know what you're doing until you get behind the wheel. The only way you are going to learn is by doing things and experience. You have to learn your boat. You have to know the currents and all that's going to set you adrift and whatever. Once I came all the way from Brazil, and everything went out. My radar went out. Everything went out. I didn't have anything to go by but the sun and the stars.

I don't really have any funny stories. We all joke and all that. I mean, we fished and had a lot of good times, but it's all serious. It's not a joking matter out there. Everybody's serious about what they do. It's teamwork. It isn't like running a cruise ship or something like that. Everybody depends on everybody. My hours were twenty on and four off, and you have paperwork to do. You have logs to fill out. I had to go through a medical school where I could learn to set broken legs and give stitches and all that because aren't any doctors out there. If you get somebody sick out there, you have to learn how to do CPR and everything. There is no doctor. There is no telling when a doctor is going to be there. You have to take care of people. In this day and time, if you contact the Coast Guard, they can come out there with a helicopter.

I'll tell you, being out on that water, you just miss everybody. You're away from home, and it takes time from your family. Also, it's treacherous; you don't know from one day to the next what will happen. You have to have respect, and don't ever think you are too good and that it won't conquer you. You almost have to think ahead of it. You have to be thinking "What I'm going to do in this situation? "How am I going to tackle this?" It's not an easy job. It's very stressful, very stressful.

I am a towboat captain and a ship captain both. I did it all. I'm retired now. I ended my streak in 1999 because the Coast Guard wouldn't renew my license because I ended up with triple vision, diabetes, and heart trouble. So that ended that. I wish I was back.

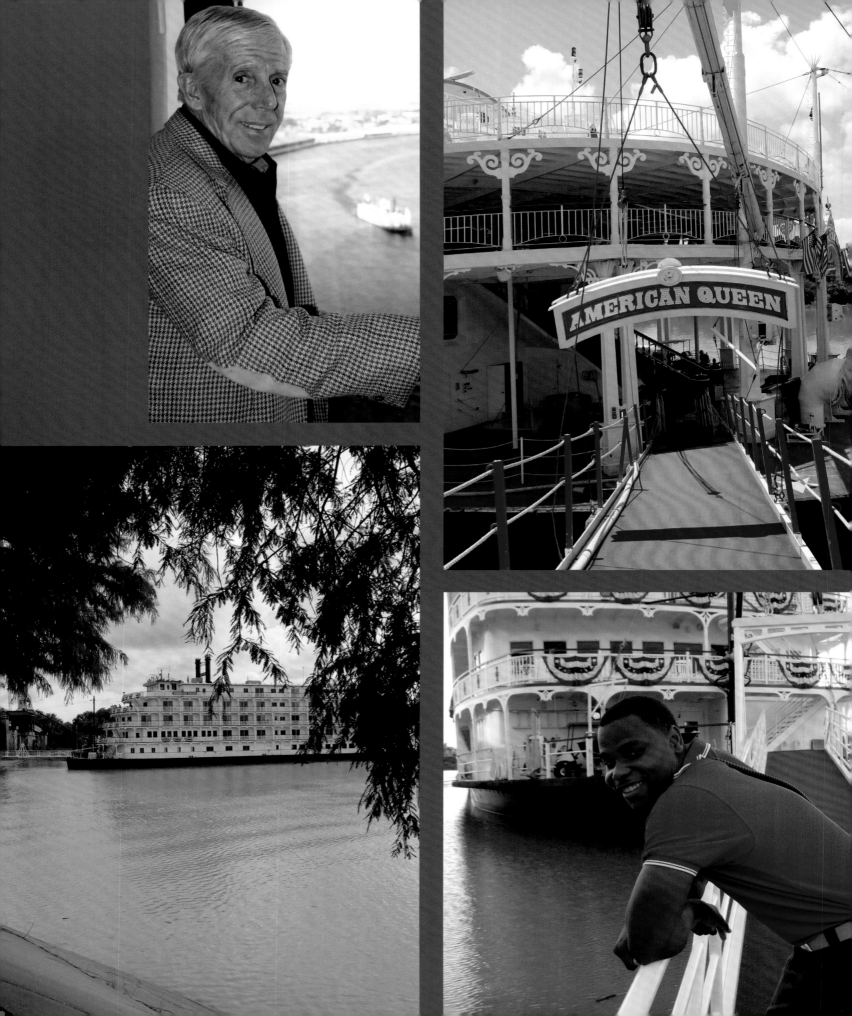

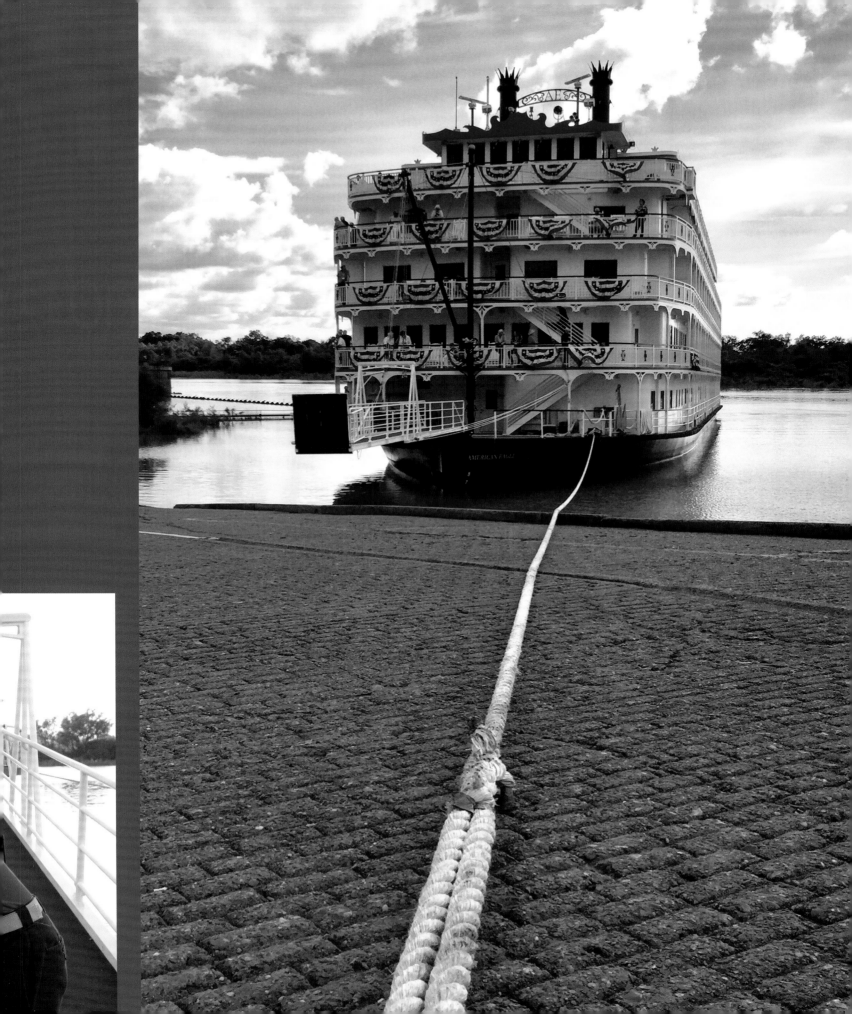

RICHARD "DICKEY" MATHES

– b. 1945 –

My name is Richard Mathes. Most of the people on the river knew me as "Dickey." I started in 1959 when I was going to Greenville High School when I would be out for the summer. My dad owned a company in Greenville, Mississippi, and I worked for him those three months. I did that three years, but I wound up being a pilot in 1970. I've been a pilot for forty-five years, but I started long before that decking. My career started in 1959, and now I'm retired. So, fifty-six years on the river.

When I first started out, I knew I would be affiliated with the industry some kind of way because my dad was a pilot and captain and also an owner for a while. I didn't decide that I wanted to do it for a career till I came back from Vietnam in 1964. Matter of fact, they used to come to the jailhouse and look for us. If you were in jail, and you wanted to go to work, they'd pay your fine and put you on a boat. So, I guess 1964 is when I decided I wanted to make a career out of it.

My dad was a pilot and was from Greenville. His name was Ernest Mathes, and most people called him Captain Ernie. He came up with Jesse Brent and Gilder McCool and all the original towboat people from Greenville. My grandfather was an engineer. He wasn't a pilot, but he was a river man.

I did have three brothers, and three of us boys were pilots. My mother was a cook on a boat. So we were just a river family or at least waterway family.

My dad helped break me in, and my brother helped. But the guy that really stands out is Albert Wolfe. He's the one that really taught me what I know. He's a legend.

There is one story that's been hard for me to live down because I never thought that I was a great pilot, but I was a decent pilot. I could do my job. When I had only been a pilot for about a year, and it was 1970, and I moved to Saint Paul, Minnesota, because Albert Wolfe was running a harbor service up there, him and Captain Jim Weeks. And he put me on a boat that was an old, old boat and just didn't operate like these nowadays. People would call it a nightmare now from what we have now, the conveniences and how they handle and things. It was a towboat, and it was a small boat. I think a twelve-hundred-horsepower boat. But the part I had to really live down is I was real scared. I was just starting out, and I'm coming out of the Minnesota River, and I couldn't stop the tow I had. It

just wouldn't stop. So I called the office, and I was talking to Albert. I said, "Captain Albert, I don't want to come down through the bridges at Saint Paul, Minneapolis. I can't stop this thing." He said, "Well, you don't stop to come through them bridges anyway." I said, "Yeah, but it's not happening right." He said, "Well, there's a railroad bridge up above all these other bridges." He said, "When you clear that, just start backing and drag down the bank. It will slow you down. I'll come out there and get on there with you." I said, "All right." I didn't know how he was going to do it, but I did. I got it slowed down to maybe a half mile an hour, and here he came. And he took off most of his clothes and swam out to the tow. Just swam right out to the barges. Got on, and here I'm breathing a sigh of relief now. Big captain is on here now. He'll take them down through there. He come up. He said, "All right, let's go." I started to back out from between the sticks. He said, "No, no, no. You gonna take it down through there. That's what we pay you for." And, oh brother, he was also a tough guy. I mean, he whipped a lot of folks in them barrooms and stuff, and I wasn't going to mess with him there. So I backed it out. The long story short of it is I made it down through the bridges. We got down below, and they had another boat help us get topped around into the fleet and stopped. I made it through those bridges better than I ever had before. He said, "You did a fine job. Now, don't you ever make me swim out to you again. From this day on, you do whatever falls on your watch. You are a pilot, and don't you ever forget it. Now, that wasn't so hard. Was it worth me having to get wet and swim out to you?" From this day on, I like to believe that I kept his advice.

But there's one story that I remember really well. Everybody called him Hootenanny, but his name was Wayne Wilcox. He was on the M/V *Lady Ree* with me and my dad and some other guys. I was decking. We tied up in St. Louis, and Daddy called the owner and said, "Look, we're going to be here all night. Not going to do anything. I'm going to take the guys to town and let them blow off a little

steam." So they said okay. It was cold. There was snow on the barges. We all started out across there, and I was just to put the ladder down for them. I couldn't go. I was too young, but I was going to watch everything. It was probably '60 or '61. I was just a kid, and it was late summer, but they already had ice and snow up there in Saint Paul and St. Louis. But Daddy got to looking behind him. It was like little ducks following him down through there. The funny part was—of course all of them got put in jail that night for fighting and drinking—Hootenanny didn't have any shoes on. He didn't wear shoes hardly ever. Decking and all that on those old barges, he just was barefoot. I guess the bottom of his feet were tough as a deck. But he was going to town, and Dad said, "Hootenanny, you got to wear some shoes if you are going to go to town." And they sent him back. He borrowed a pair of work boots from somebody and come back and went to town.

When I was a young boy, I'm talking about maybe twelve, thirteen years old, we'd ride the boat with Daddy once in a while. We didn't have a washing machine on the boat, and I remember how the guys would wash their clothes. They would tie their clothes to a small line, not the big line like you tie off with, but a strong rope and hang them over the stern of the boat in the wheel wash to wash their clothes.

My brother was on a boat, and they were doing tow work at Rosedale, Mississippi. This was after the safety-conscious thing really came in, and they were picking up an empty barge, and it was going to be made up to another empty barge. The rake of the empty barge was there, and this is a square end on the other barge come against it. They were out there like one, two o'clock in the morning. The deckhand had his foot hung over the front of that barge. When that barge come in, it mashed his foot. Now, that ain't humorous. I'm not trying to say that. But when they went to court, one of the attorneys said, "Do y'all furnish that man's steel toe boots?" He said, "Yes, sir, we do." Said, "What about flashlights?" "Yes, we do." He said, "Did he have his flashlight with him?" He said, "Now, I don't know that.

We tell them they are supposed to. That's a rule to carry it with them." he said, "Well, if he didn't have his flashlight with him, how would he know that his foot was hanging over that end of the barge? How would he know where his foot was?" trying to trap him up. He said, "Well, he didn't have his flashlight on, but he knew where his butt was. He'd know where that foot was too." So, he was just calm and quiet. My brother shot back at him on that when those lawyers tried to trip him up.

There was a lot of poker on the boat. I can truthfully say this; I never know of a thirty-day trip that my daddy made that he got off as a loser. He was a good poker player. Before that thirty days was up, he will win. When we were young kids, four of us boys, we lived in New Orleans. My daddy would take us down in Harvey, what they call Little Bourbon Street, where the rougher part of it was. And they'd play poker, and he let us watch. And we had to run to the beer joints. People let us in. They didn't bother us. But he taught us how to drink, how to gamble, how to cheat. Not so that we would cheat, but so we would know when we were cheated. But those old river people hung out down there too, and it was a rough crowd, but they never bothered us. A lot of boats don't even allow you to have a deck of playing cards out there anymore.

New Orleans was kind of like what you would see on the Barbary Coast or something. They talk about how the pirates were mean and fighting and drinking and one peg legged and patch over the eye. It was that kind of guys. I mean, just a rough, rough bunch. River rats is what they called us back then. It was just a rough crew.

There's a camaraderie out there that people on the river will stick together. They'll lie for each other. They'll fight for you. They'll fight with each other and lie to each other too. Well, that's the way it is with river people. They'll stick together.

There was this old captain he played a harmonica and a fiddle. There was another one that passed away about five or six years ago that played a mandolin. I don't know much difference between a fiddle and a mandolin but about the same thing. But, boy, he would make a hoedown with that music, and he'd pat that foot. We had a lot of good times with that music, but we don't stop like we used to. Back then you did have a lot of time stopping.

Now education is interpreted in different ways. We've always said ourselves we have a PhD in towboat. I mean, I wouldn't want to have a brain surgeon driving the boat, but I wouldn't want a towboat pilot operating on a brain either.

When I first started, my brother was a captain, and he had me on there as a pilot. He had me stopped in the fog in the canal. You had a tide back there where if it's a fair tide, the tide's coming in. If it's a head tide, the tide is going out. Well, it was a fair tide, so we just caught a line back on the stern, and the current kept you shoved that way. We were at a fog. And he went to bed. Well, it started clearing up a little bit. I hadn't even been a pilot for five days. On that trip, I was a deckhand, the cook, engineer, and pilot all in that one trip. I hadn't turned my line loose, and I took off. Well, it didn't go very far, and it got foggy again. So I called myself going to just keep going. He come up there and to relieve me in a few hours, and he said, "Where you at?" I told him. And he said, "Well, Dickey, you on ground." I said, "No, I ain't." I'm just steering away. I hadn't been going anywhere. I had hit bottom and thought I was still driving. So, yeah, I have run in quite a bit of fog.

One of the funniest things I heard about was my brother. Donnie Willingham ran a company here. My brother was going up on that old boat that Donnie bought, but he got to Cairo, and he tried turn up the Upper. Well, if you can get above that first bridge there, then the current slows down, and you can keep going. But it's hard to get through there when the current's really running. My brother tried. He stalled out. That meant he couldn't go, and it started pushing him backwards. So he called Donnie and he said, "Donnie, can I use one of these tugs here at Cairo to help me get through that bridge? If I can get through that bridge, I'll be able to keep going." Donnie said, "Yeah, if we have to, but let's

try this. How about you back up and get a running start at it." Junior said, "I can do that." He said, "Now you tell me how far to back up." He said, "This last running start I had started in New Orleans. I been shoving for nine hundred miles and got here and didn't slow down with my engines, but it wouldn't let me go. So how far would you suggest I back up and get a running start?" Donnie said, "You SOB" and hung that phone up.

My first piloting job my daddy didn't allow me to have the searchlight on or the radar. He put a blanket over the radar where I couldn't see it. And the searchlights back then were carbon lights too. The first Varo searchlight I ever used—that's that real strong powerful light—was for Steve Golding on his boats. They were expensive lights. They're a bulb, but they would reach out there for miles and let you see something. But my dad didn't let me have none of that when I first started. I had to drive using my eyes and what I learned, but it helped me become a better pilot. I can pilot the river without all the equipment. On a six-hour watch, I was allowed to turn the searchlight on for one minute every hour. And so I better make good use of it. But I knew where I was, and this wasn't my first time steering a boat. I also knew he was standing there to help me if I needed it. He would look out for me. He would help me out. We first started out with hand signals. We didn't have walkie-talkies or even speakers out there on the tow when you made those locks.

Years ago, I was northbound on the Upper Mississippi River near Red Wing, Minnesota, with four empty tank barges. Since they were empty, the draft was only about one foot. I was coming up on a bend in the river, and I knew there was a southbound fifteen-barge grain tow, but no one answered my call. The pilot on the other boat called me on the VHF radio and said the southbound boat I wanted to talk to had stopped at the fleet above me to do tow work. I decided to continue northbound. It was a narrow channel around this bend, and there was not enough room for two tows to meet if both tows stayed in the channel marked with red and black buoys. In modern times, the buoys are red and green. Back then, the red buoy was called a "nun" because it was shaped like a can. I got about half way around the bend, and I saw the other boat and tow coming downstream at me. The only way to avoid a collision was for me to move my empty tow out of the marked channel on the red buoy side and stop. The southbound tow cleared my tow, with only inches to spare, but at least I was able to avoid a collision. As I started getting back underway, I saw that my barges had been on top of a red buoy. I didn't harm the buoy, but the Coast Guard patrol boat saw all of this and boarded the boat I was out in. They wrote me up like a policeman writing a warning ticket because I had run on top of a buoy. About ten days later my wife, Mary, called me and told me I had been fined fifty-five dollars for "molesting a nun." Needless to say, Mary wanted an explanation. I explained what had happened when I ran over the red "nun" buoy, and we got a good laugh that day!

I want to say on the record that the river industry has been great to me. Overall, I made a good living for my family while I was working there. I was treated exceptionally well. Overall, I wouldn't change being out there. I would still work out there and be away, and I would have really coveted some time with my boys that are no longer with me, and they would have meant the world to me. But I still had a good life, and I gave my family a good life about living what we had. We didn't have anything special, but we did fine. I would change some things, my own actions mainly. And most of that's due to being a Christian. But I still think it's a great industry to be in.

LARRY RITCHIE

– b. 1945 –

My name is Larry Ritchie. On December 27th 2015, I will have been on the river for fifty years. I come from a long line of mariners. We are fifth-generation towboaters. My dad and us kids we were living up in Mount Vernon, Illinois, when I was eight years old. We didn't have any summer vacation when we were kids. Our time was spent on the boat. Every time we'd pass Mount Vernon, man, I'd get out there, and I'd start crying wanting to get off. My dad would pull his belt off and give me something to cry about. I swore up and down I'd never work on the river. I quit high school at seventeen and joined the navy. I got out of the navy on the 22nd of December of '64. On December 27th I caught a boat for Peanut Hollinger.

After I spent 120 days out there for Peanut, I knew I was going to be out there forever. I loved it. I never did want to be in the office. It's too boring.

My ancestor that I know about was the one in Mark Twain's book, and he was on the boat with Mark Twain. His last name was Ritchie. I guess we have a famous river name, but I'm home out there. Some of the people don't like us too much, but that's with everybody I guess. But the ones that do like us, they're real good friends. I think I have a lot of good friends out there on the river. It's a big river system, but it's really small in terms of everybody knowing everybody.

I've been on all of the rivers.

I was on the first ten five that came out, and it was the *Lily M. Friedman*. I caught it here in Paducah, and I rode it. Once old *W. A. Barta* come out, I got on it. The biggest tow we ever had on that was forty. That's well over six acres of barges. I've seen them out there pushing those seven wide and six long. That's forty-two. They say, "Aww, it's easy." No, it isn't easy. You say it's easy, but it isn't because you're in a knot all the time when you have that extra two hundred foot out there in front of you. It just takes up too much room. The way the river is nowadays, you don't have that much room to play with like down there at Victoria.

I have been on three boats that burned. One of them, I was only three and a half, four years old that time. My daddy had me out on that boat. He and my mother met on the *Jason*, the little old sternwheeler. She was laundress, and he was pilot, and they met on there. I think they were married for forty-something years. Anyway, I was three years old, and I was on there with my mother and my dad.

Once I had a cook on the boat, and I was on the *Old Lady Mignon*. Lee O'Conner was the captain

on there, and he was always late. He was never on time. So he came up to relieve me, and I went downstairs to eat. The cook set a bowl of scrambled eggs down that was just terrible looking, so I asked her to fry me some eggs. She said, "You eat what everybody else eats." I said, "No, I'm not eating mess like that." So I went up and told Leo. I said, "She won't fry me any eggs." He said, "Watch her for a minute." He was talking about the boat. But he went down there to the galley, and he gave her a chewing out that wouldn't quit.

So, I went back downstairs to the galley after he come back up to the pilothouse. I pulled a chair out. I sat down. It was a metal chair and had kind of a sway in the bottom. She had put water in it. I didn't say anything. I just went ahead and ate, and then I finished. A couple of days later I knew she was down in the galley, so I got some of that old fiberglass insulation. I went in her room and opened up her panty drawer and sprinkled it off in there. She did some itching and scratching. Payback. She didn't mention it, and I didn't either.

Well, about the rivers themselves, the Monongahela is narrow and actually shallow. They are a different breed of pilots up there. They're called "Hunkies." They have a different way of towboating up there. I was always taught that whenever you're down bound to take the point. Up there if you're down bound you go down in the bend. Now, I took a few of them off up there the first few trips I made up there because I'd always take the point. They kept telling me, "You don't take the point. You take the bend." I say, "No, I was taught to take the point; you get over in the bend, and I'll miss you."

Well, I had a captain on there that was from up there. He showed me one day how he did it. You put your ring on your radar—I think it was like a half a mile—and keep that little pie in there. Just as long as you didn't lose that pie, you were all right. After that, I started going down in the bends. It was easy. The name Hunkie is just something from Pittsburgh.

You give me a map, and I'll go, except to outer space. I would hate going there.

When I first started on the river, I made my own notes. Whenever I started down on the Lower, I used what you call a bar book. It tells you how much water you have in a certain spot, or a certain stage of the river, and what's on the dikes and sandbars before you'd run.

When I'm not on the river, I wouldn't say I missed it, but I was always glad to get back. People say the river gets in your blood. If you splice me open, you'll find muddy water in there.

When I was a boy, my dad only took me and John Jr. to the river because we were the oldest two. Charlie, he was too young to go out. Paul wasn't even thought of. And, like I say, I hated it. I swore up and down I never would work on the river. Now, I wouldn't do anything else. My dad worked out on the river up until he died. He was seventy-one I think. He was born on a shanty boat down there at the Duck's Nest here in Paducah. My dad was born up in that little slough up in there.

I always thought that the license didn't make the pilot, that the pilot made the license.

One time we had a bunch of kids that were on a boat or a raft. They called it a raft. They came all the way down to New Orleans. There were about eighteen or nineteen of them on there, and they were just having a good time. They had a motor on the back. I would never do that. You see people coming down, especially on kayaks and canoes, and they don't know what they're doing. They'll get right out in front of you, and you have to stop to let them get out of the way, unless they have somebody with them that is a pilot or someone that's been down there and knows what they're doing. There should be a law that they ought to have a course to take. You can go out there and buy a jon boat or a speed boat, and all you have to do is put a tag on it, and you're good to go. But you don't have to have a license to operate it, and that's usually the ones that get killed. They just don't realize how dangerous it is out there and how far it takes us on the towboats to get stopped.

I worked with Peanut when I first started out on the river, and the longest I ever rode was

153 straight days. That was up on the Missouri River. But when I worked for Peanut, I'd work anywhere from 90 to 120 days at a time. The best story I can tell about Peanut, the funniest thing, is about George Toussaint. We had a cook on the boat, a big heavy-set woman. Her husband was the engineer. The Coast Guard wouldn't come out and pick us up, and for what reason I don't know. But they had an air force station at the east end of Dauphin Island. They sent a helicopter up there to get us. Well, Peanut, being the gentleman he was, he helped that lady get into the harness and everything. They were picking her up, and he started wiping his face. He said, "Hell, it's raining." Her husband said, "No, she's pissing on you."

JOHN LOUIS "SONNY" CARLEY

– b. 1946 –

My name is John Louis Carley, and I have been on the river forty-eight years. I started out on the river when I was seventeen. Sometimes it wasn't all that much fun, but when you get on a towboat, you need to leave all your baggage right there on the bank. You don't need to take all that with you. You need to let that boat be your business. When I first started, we didn't have all this electronic equipment, stuff like that. I did get to used it in the last eight or ten years that I worked, but there was an old saying, "Know where you're going and remember where you been."

When we first started, you didn't have all these cell phones and all this stuff. All you had was a marine operator. I had been talking to this Paducah marine operator when we were running the *Ohio*. She just sounded just as sweet as she can be. It wasn't anything really, but I just wanted to invite her down. We were going down to the shipyard in Paducah. I was going to let her come down and eat dinner with us on the boat. And, you know, she sounded just sexy as hell. So I was going to give the crew a lift and me too. When she came down there, she weighed about 450 pounds, but I sent the deck crew out there and brought her on the boat and fed her supper. She had a great time, but you know,

people's voices, they can kind of throw you off a little bit, you know.

I had this pilot one time, and we were up at Thomas Point, and he came up there and relieved me. He got above that Baton Rouge bridge, and that eddy topped him around. Well, I got up at 5:30 a.m., and he was just shoved into the bank. I said, "What are you doing?" He said, "Call the boss and tell him that I got a job on the dairy truck. This is not for me." That is a tricky place when you have got eddies on both sides of the channel. But he said, "Call them and tell them I'm getting a job on a dairy truck. This is not for me."

I'll tell you the most peaceful thing I have ever seen in my life. We used to run out of Catoosa, Oklahoma, up there all the time on the Verdigris River. Well, I was coming down Verdigris River, and you would get to feeling a little low every once in a while. It was snowing, and there was a grey wolf out there howling at the moon. I opened the door to the wheelhouse. He was just howling at the moon, and that snow was coming down on him, and that moon was hitting him just right. The moon was shining, but it was still snowing. After that, when I ever thought of something that was really bothering me, I'd think about that wolf that was out there

baying at the moon by the river. It got me through a lot of hard times. So that was one of the nicest things that I've ever seen out there. It was beautiful. I still think about that wolf, and that's been forty years ago. That was the only time I ever saw a wolf. He just painted a picture for me.

How I really got started steering back when I was young was a lot of those old pilots couldn't read and write. They could read that river, but they couldn't read a lick on paper. That captain is one of the first people that let me start steering because I'd go up there and fill out his grocery order for him or fill out his logbooks and stuff for him, but back then a lot of riverboat pilots couldn't read or write, and that gave me one of my breaks.

We had one cook once . . . and my wife was coming down Baton Rouge to pick me up. I was getting off, and we were going on to New Orleans. She came on the boat, and she said, "Look," said, "there's a man down there laying in the middle of the galley floor." I said, "Well, that can't be nobody but the cook." So I walk down there, and I said, "Sam, what are you doing?" I can't tolerate ignorance. He was drunker than a roadrunner, but I'm getting ahead of myself. Eugene Head of HR had called me, and he said, "Captain, I just sent y'all a quart of lemon extract about a week ago." He said, "There's no way in the world y'all could have used a quart of lemon extract." Well, the cook couldn't get any alcohol, so

that's what he drank was that lemon extract. Sam Riley is who it was. Don't make no difference now knowing his name. He's dead now. Sam worked for us for a long time, and he was the kind of guy if he stayed on the boat thirty-five days, he was all right. He wasn't going to drink. But if he stayed over thirty-five days, he was going to get some alcohol somewhere. He was a heck of a cook. Another thing he did was the television kept going out. I said, "I can't understand that." It looked like we were putting a television off every week to get it fixed or getting a new one. So, one of the deckhands walked down there and caught Sam. The only place on that little old boat for the television to be was in the galley, and Sam hated television. He was pouring a glass of water down the back of the television, so it wouldn't work. So that's when he finally got fired. We had gone through about three televisions that way.

I just feel truly blessed that I got to stay out there and do what I did for a living in something I liked to do. Not many people get that opportunity.

I do and I don't miss the river since I retired. I spent more or less my whole life out there. I kind of find myself going up and watching the boats go under the bridge. When it's high water, I say, "I'm glad it's y'all and not me." But, no, I mean I loved it and truly did, but there comes a time you have to give it up.

JAMES W. "JIM" GHRIGSBY SR.

– b. 1946 –

My name is Jim Ghrigsby Sr. I've been on the river since 1968. Curiosity really is what got me out here. I had just come out of the army in 1967. Probably an hour after I got on the boat was when I decided to make a career out on the river.

The minute I stepped on that boat, I had to go to the pilothouse to meet the captain because that's the way you did it back then. You'd meet the captain and fill out all your papers in the pilothouse for your employment. I was studying him. I was watching him moving the rudders easing up the river, and I thought "That's the job I want right there," not knowing what it was going to take to get that kind of job. I fell in love with the river right then.

It took me overall about three years to achieve my goal of becoming a river pilot. That was not really typical back then. I was self-motivated and self-driven. I set my goal right that first night that I got on the boat. I said, "I'm going to be sitting in that seat one day." I don't know if it was the fresh air or the adventure. I had read all of the Tom Sawyer and Huckleberry Finn books and all of the stories about Mark Twain and his travels. I guess they lay dormant in the back of my head. That sort of probably ignited that thought.

The captain sat in a nice, comfortable pilothouse chair when he was working. When I was steering, that captain wouldn't allow me to sit in that chair. I had to stand up in place the whole hour that I was steering. That was another training method of the captain to say, "When you become worthy of this chair, then you'll appreciate this chair."

The tonnage that we handled in my last twenty years it was—the Mississippi River really—it was the only place you could run it with that kind of tonnage. We would leave St. Louis with thirty-six loads of dry cargo, grain products, soybean, and corn. Then we would get to Cairo, and we'd finish our tow out with the same product. At Cairo, we can make our tows bigger because the river would accommodate the bigger tows. Loaded it was eighty-six thousand tons. A typical loaded barge weighs sixteen hundred tons. Then of course we had 40, 42 and sometimes we had 46. So, you had around eighty-six thousand tons. They were basically all dry cargo. Each barge was 195 foot long by 35 foot wide. We were six long, which would be about 1195 feet long. And then the barge is 35 foot wide, and they're 8 wide, and you have eight pieces across, and they're 35,foot wide. So, it's 280 feet—it was a lot of tonnage.

We pushed coal. We pushed soybean. We pushed corn, rice, and sunflower oil. We'd have a few tank barges incorporated in the tow. We'd bring sunflower oil out of St. Louis and corn, and soybeans, milo, wheat, and rice out of the Delta. That's ADM's motto, "We feed the world." They take all this cargo down to the Gulf for exports into different countries. Basically, they did feed world. ADM developed a rice cake that was high in protein that they would send to Africa. That rice cake, it was so high in protein, you could give it to a starving person, and they could get the nutrition that they needed. I started working for them in 1997.

I didn't have all those forty-two years with one company. Sometimes you have to weigh out your options. Am I going to hurt myself for retirement to achieve my goal? As young as I was at the time, retirement was not my priority or my long-term goal. It was to be on the biggest boat and push the biggest tow. I achieved that goal.

The *American Pillar* was the last boat I rode when I retired. I was captain on it. It was two hundred foot long, and it was fifty-four and a half feet wide. It was forty-six feet tall, and it had an operating draft of ten foot. It would draw ten foot of water when it was loaded down with fuel and water. It had a 10,500 horsepower. It had triple-screw EMD engines that developed 10,500 horsepower, which at the time was the biggest there was on the river. We carried nine people. We carried a pilot, chief engineer, a system engineer, mate, watchman, three deckhands, and a cook. My cook probably knew as much about me and my eating habits as my wife did because I spent as much time with her as I did with my wife. Half of my life was on the river, and half of it was at home. My son made a comment one time that "Daddy was only around half my life." That was sad after you think about it. I provided a good living for my family; we all absorbed the sacrifices of me being gone.

Back in the '60s, when I started, there wasn't any such thing as retirement. Pilots just died on the boats. They may could have had a retirement, but they just chose to be there and spend their life out there. A lot of them did die on the boats. They just go to bed one night off watch and never wake up.

I had an old pilot tell me how to run this strip of river at Vicksburg in super high water without any electronics. See, today everything is electronics. Back then it was dead reckoning. You run on shoreline horizon and coonass compass. A coonass compass is a thirteen-foot aluminum spike pole with a blue light mounted on the head atop of it tied off on the bow of your tow, in the center of your tow. You could watch that at nighttime. You could watch that light move across the horizon, and it would tell you what angle you're in when you're lining up on something. We had all kinds of little tricks that we'd pull. Everything now is electronics.

Well, I'll tell you a story that happened to me. I came down on the Vicksburg bridge in low water. I had thirty-five loads. I had already been warned about the out draft on the Mississippi bank. Well, I didn't realize it was as strong as they were saying. I just thought they were overreacting. So I made my adjustments, but it wasn't enough, and the current set me out on that sandbar, and I grounded thirty-five loads. Well, in the process of grounding, I topped around, and I was pointing northbound. I had all these barges gathered up, and I was going to shove up the river and turn around and come back. When everybody that was stopped above me heard that I was ready to go, they started getting out in the river and were going to head this way. That would have caused me problems. So, what I did, I just called the boat store, and I said, "Bring me two bow boats." I said, "I'm backing through the bridge." They said, "Do what?" I said, "Yeah, I'm going to back this tow through this bridge," I said, "and then flip around and go south." Because with as much traffic as there was above me, I would have never gotten back through there, and it was just creating too much of a traffic jam. So I broadcasted on the channel that I was backing down through the bridge, which I found out later that there have only been two pilots to ever do that. There was

another pilot that backed a tow through the bridge by the name of Mickey Crutchfield back in the '60s, and then of course myself. It's not something you want to do all the time. It's not something you want to talk about a lot. But back then I had nerves of steel. When I think about it now, I get cold sweats. I backed through the bridge with twenty-five. Then I added another two strings after I got below the bridge which was thirty-five.

Let me tell you something. I would fight a circle saw back in those early days. I wasn't scared of anything. But I had no fear, which was kind of stupid, but I was lucky. But back then, let me tell you, pilots lived by reputation. There was a certain amount of reputation that went with being a good pilot. You didn't want to have a reputation of being a sissy pilot. You wanted a reputation of being a gut-wrenching pilot. Once you face up on a thirty-five, thirty-six-barge tow in St. Louis, you probably never unface until you get to New Orleans. You would be surprised at the heavy-tow pilots out there that have magnificent tow skills that can't hardly handle a boat when it's light. When I say "light," it's disconnected from the tow. They just run around bumping and bouncing into anything and everything.

There used to be a dog that would always catch a ride up on the Upper river. We called him a Hobo. He'd start out at Lock 15, and he'd meet you at the end of the lock wall, and he'd jump on the head of the tow. He would ride with you down to the next lock, and then he'd be out on the head of the tow when you approached the lock, and then he'd jump off. That's how he'd ride back and forth, and we'd feed them. He didn't do it for fun; he did it for eating. He was just a hobo. He was just a hitchhiker, and we'd let him do it because you don't have a lot of distance between the locks there. Everybody let him on their boat. Everyone would feed him table scraps. He would get on, and then he would ride to the next lock. He'd get on there, and you'd feed him, and he kind of would follow you around on the tow, and just sort of make friends. He was a smart dog. He was a big German Shepherd dog.

I've seen kayakers coming down the river. They put themselves and us in danger of trying to miss them. With the kind of tonnage we have, you just don't move it. Another thing about pushing heavy tows, everything has to be a mile in advance. You make your decision of what you're going to do a mile before you get there. You cannot make sudden moves.

Back in the big flood, and before I retired, and when it flooded everything out, my office called. The Coast Guard had shut the river down in '07 or '06. Several boats had hit the bridge back to back. There were a couple that hit it the on the same day. The Coast Guard shut the river down for nighttime navigation for southbound boats. Then they put out the word that they requested that they have an experienced pilot aboard that vessel that had the training to run this bridge in high water. So I was sitting up in the pilot house, and I was waiting on my relief here at Vicksburg. My office called me and said, "When you clear that bridge, will you turn around and get back on another boat, ride down through there with them?" And I said, "Yeah." So I got on the contact boat that took me right back up north of the bridge, and I got on the other company boat, and I rode down again through the bridge with them. Well, that started a trend. The insurance companies found out about it. The Coast Guard found out about it, or they were made aware of it. So they suggested that all companies with large tows have a jump pilot. I called it a jump pilot. Jump on, jump off. They called it a posting pilot. I gave it my own name, jump pilot. From that point on, the company called me and said, "Will you be available to jump these boats when they come into town?" And I said, "Yeah." They were paying me my daily rate for each boat just to go through that bridge. It was worth it to them. The Coast Guard thought it was a grand idea. The insurance company thought it was a grand idea. What they were paying me was peanuts compared to what it would have cost if they hit that bridge. Some of the pilots thought it was sort of silly. Some of them appreciated it. And, of course, you

have some of your old salty dogs that said, "I don't need nobody to hold my hand."

Here's the thing that people don't know about sandbars. They look steady. They look firm, but the current is sawing out from under them, way under them. I mean, it may be ten foot down, but it's starting to weaken that sandbar. It will actually run that current up under that sandbar. Then, all of a sudden, it will just drop off. And that's tons of sand. You're in it. It's a bad situation. This river is not a recreational river by any means. It's not a place to play. If you can live to tell about it, it's a good thing. But it scares me now. I'd have cold chills if I thought my kids were over there on that sandbar because I've seen how they collapse.

Hannibal was a big character river town in the history books. Those places are there. Whenever I go by them I think about Mark Twain. I don't want to create a controversy here, but Mark Twain could not pilot the boats that we pilot. Mark Twain in his time was a good pilot. But the tonnage that we have, the river conditions, Mark Twain couldn't do what we do. That's why I don't put a lot of stock in Mark Twain. After my career in the industry, and knowing what I know, that Mark Twain didn't know what towboating was

all about. He thought he did. I think he had only spent a year on the river.

When I started running a boat on the Mississippi River, our communication equipment was about four navigable VHF channels compared to what we have now. We have about thirty channels now. Back then, our main source of communications to the outside world was a single sideband radio system, no fax, no computers, no GPS. Now you have GPS. You have computers. When they first put a fax machine on my boat, I was tickled to death. And then of course the computer. I had a hard time dealing with change. I never was easy with change. When they came down there and threw all those computers on that boat, I just said, "Oh, this is so crazy. This stuff is just going to be in the way." Then when I got a little bit of training in it and when I started learning how to work it, it made my job easier, much easier. I loved it. Electronics are wonderful, but if you don't have that basic training, and I mean, dead-reckoning training . . .

I didn't accept change well. I was so indulged in dead-reckoning navigation. That to me was the art. It's an art. It's a skill to bring a tow up the river or down the river in those conditions. That makes a pilot.

EMILE P. DUFRENE

– b. 1948 –

My name is Emile P. Dufrene. I was born in Lafitte, Louisiana. My dad owned a shipyard in Lafitte, Louisiana, and he built and designed what was known as the Lafitte skiff. It's a shallow draft boat for fishermen, and that's what he was famous for. His name is Emile Dufrene, the same name as mine. A Lafitte skiff is a shallow draft boat for mostly fishing in the shallow waters on the inside of the Gulf of Mexico in and around Louisiana. It was made out of wood. My father was the original boat designer. That's how I originally got interested in boats was because of my dad. Before I got into the marine industry part, I worked for him up until I was around twenty. I had an interest of being out on the water from the very beginning, since I was born. We were born right on the water basically. I am of French and Indian descent as my dad was French and my mom was Houma true-blooded American Indian. On my birth certificate I have "Indian."

The Houma Indians were not really boat people; they were trappers and fishermen, so they were on the water. The Houma Indians in south Louisiana actually tried to get a tribal, but it's never been patched through Washington DC. But for several years, they've tried to have their own reservation and make it legal. But so far, they haven't been able to.

I started on the water as a career when I was around twenty. At first it was just a job and I immediately fell in love with it. When I first started it was on a twelve-hundred-horsepower boat. Basically, we were running from New Orleans east and west in both directions, and a lot of times just to salt mines around New Iberia and those areas. We were hauling salt back to New Orleans. Then, of course, the line boats would haul them up the river. I started off as a deckhand, but I didn't deck very long—maybe a couple of months. Then the captain had to get off the boat because he had a family emergency. One of the guys that we were working for, he asked me if I could take the boat with the barges through the Industrial Locks. I said, "Sure I can." Only God in heaven knows how I did it, but I went through the Industrial Locks, and I came out in the river, and I went wherever I had to go. They had told me if I could just get it in the lock, they would send somebody to help me. I said, "Sure, I can get it in the lock." Then they didn't send anybody to help me, so I had to get out of the lock and go up the river. So, in the beginning, I taught myself. That's the way I learned. We didn't have to

have a license at that time. I'm going to say that was '71, '72, something like that. I only decked for a couple of months before I started steering.

I was on that boat probably for a couple of years, and then one day, way before cell phones, I had a call from one of the bosses, and he said he wanted me to take the boat from Plaquemine, Louisiana, to Clinton, Iowa. I said, "Sure." I said, "I can do it." So immediately after I hung up with him, I thought, now, which way do I go when I leave New Orleans? Seriously, I did not know because I had been east and west, and I knew there were several other rivers that were down there. I didn't know I had to go up the Mississippi River. So I called him back, and he said, "Well, maybe we should get a chart." And I said, "I think that would be a good idea." So I went to Lehman [Lyman] Brothers and got a river chart. Then I got with a guy that I knew had been up here. In fact, he was my second oldest boy's godfather, Captain Delbert Pierce. I went to his house, and we started from New Orleans, and he showed me all the way up to Clinton, Iowa. He showed me where the bars were and where the bad areas were on the charts that I had gotten from Baker Lyman. I was making notes on my chart. I would have never made it without it. But I didn't even have a clue which way to head when I left New Orleans. I had to get a chart. I was probably around twenty-one years old then.

I was running and hopping on motorboats probably since I was six, seven years old. Just little bitty boats, but it's still a boat, and it's still currents, and it's still wind.

As far as working, I did it from hard knocks. It seems like I've been out there a hundred years, but really since the early '70s. So, forty-something years. I stay in shape when I'm on the boat by using the treadmill. I usually try to get five miles in on the treadmill every day when I'm on the boat.

I would like to see anyone that's just starting out right now to not use the electronic equipment. I would like when they come on as a trainee to turn it off. I think you learn a lot better and faster if you didn't have something that was showing you exactly. I am just totally against the electronic charts for somebody training. It's a helpful tool once you're doing it, but I learned you use the light list book. They didn't even want you to use the chart, a lot of the captains. They wanted you to strictly use light list book. So you learned the river. You learned the lights. You learned the miles that the lights were on. Now you don't have to know any of it because it's all right there on the chart right there in front of you.

As far as my training and knowledge out there a lot of times whenever I was in a bad situation, I have said, "Well, God, if you'll just get me through this place. If you'll just get me through the Vicksburg Bridge or get me through this bad place," I said, "I can do it after you get me through this spot." I'm being very serious. I've done this thousands of times, and I'm not trying to get into people's beliefs and faiths, but I tell you what, we do have a God, and he is good. He will help us, but you have got to ask for it. Don't just assume that it's going to take place, but I know I've asked thousands and thousands of times. "Just get me through here."

Being up in St. Paul when I worked up there and running up in that part of the world and we could see the northern lights and all that—we could see, of course, not as clear as if we were in Alaska, but it still was pretty far up in St. Paul, and that was just awesome. It's totally different being out on the river. A lot of the time, I don't even watch the news that much when I'm gone. So, unless it's something really tragic happening going on, sometimes it's two or three days before I even find out what's going on because I don't know. I don't pay that much attention to the news. Somebody will say, "Well, did you hear such and such?" I say, "No, no. I didn't even know that was going on."

The thing that sticks in my mind more than anything is just how the river changes so much. Every time I go back, it's so different every time. Not a lot of different, but there are some differences at every stage of water. I really appreciate the fact that I realize how the river changes so much because it's

never the same. No matter what the river stages are, you can go back and check them. It stays ten foot at Memphis. I'm not saying we didn't have ten foot at Memphis a hundred times in my lifetime, a thousand times. What I'm saying is that with St. Louis it was at minus thirty. Was New Orleans at five, six, seven? So what I'm saying is it is always different. I've seen the river at its worst on both ends—high water and low water both.

I meet boats on the river, and I often wonder how I ever made it with the equipment we had when I first started. We had a small radar that worked about 75 percent of the time and a swing meter. Now we have two radars—at least one works all of the time—and a very good swing meter and an electronic chart that shows us exactly where we are at all times. I think of all the river changes since I started—the channel has moved several times. Most changes have made navigating a lot easier.

I tell you what; thank God I've been really fortunate. I've been fortunate, but I've never drank, and I've never smoked. Everybody asked me, "Why not?" coming from New Orleans. I don't know. I don't know because I was the designated driver. I don't drink at all.

I never have.

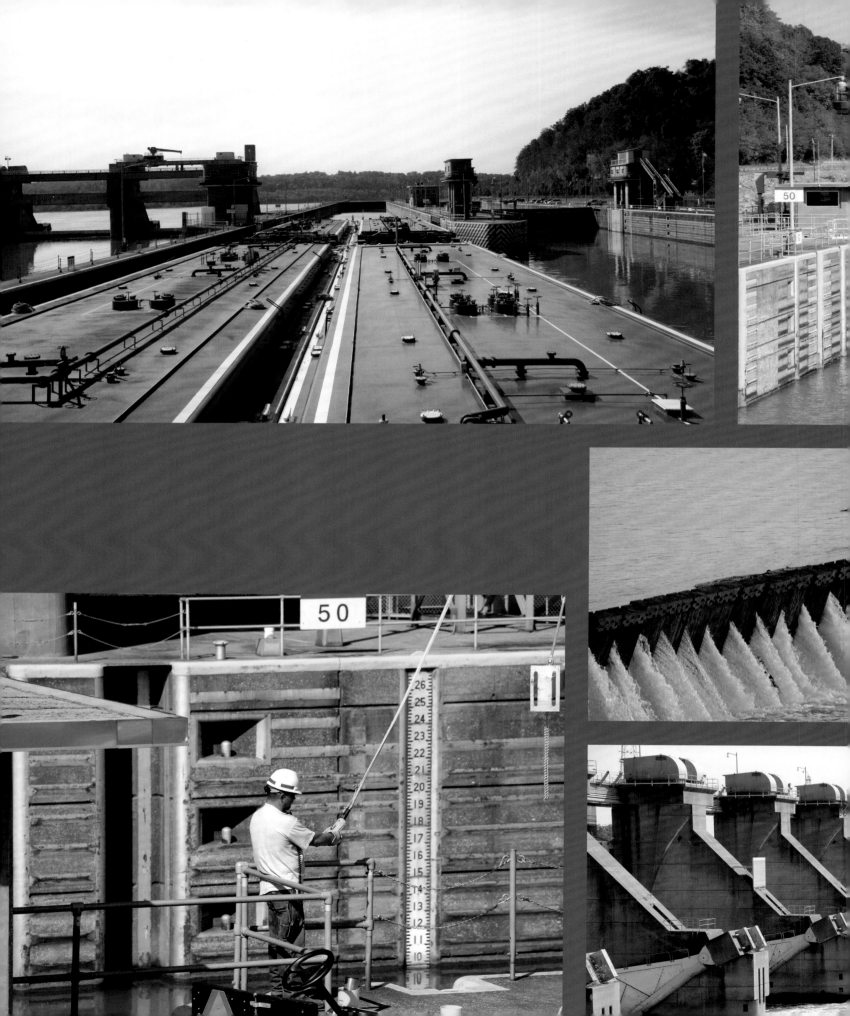

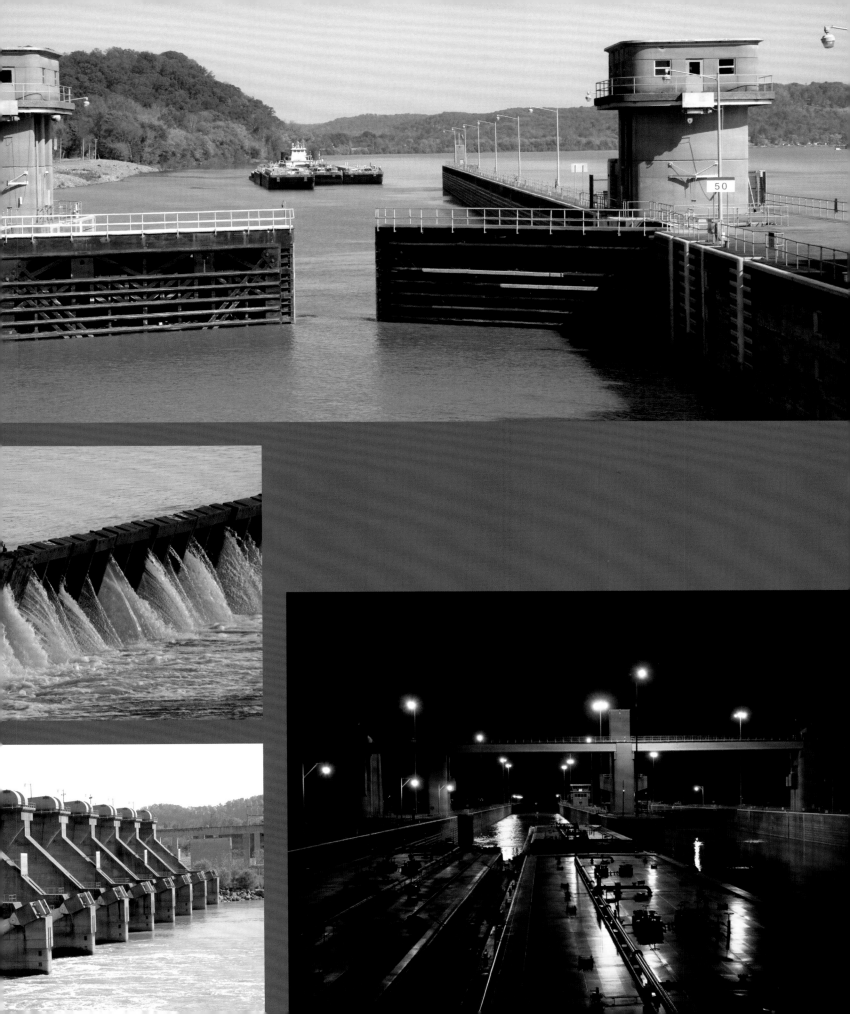

ANDY BURT

– b. 1950 –

My name is Andy Burt. I've been working on a boat ever since the first time I put foot on deck, which was in February 1967.

The way I got on the river is I went to Morgan City, Louisiana, and my stepfather worked for Petroleum Distributors. It's an oil dock, and I was seventeen. I turned eighteen that year of '68 in August. And you didn't lay around back then. You had to go to work. Mr. Roy Miller had a wooden-hull lugger boat, which is a model hull boat, and he had converted that to a little tugboat. There was no electricity whatsoever. It had no generators, no facilities on it. Model hull boats are the ones they use for seagoing also. I hired on with him in February '68, ten dollars a day. My captain was one year older than me. I was seventeen. Probably the best thing that ever happened because he was raised down at Bayou Shaffer right out of Morgan City. And he was raised on a camp boat. In other words, a houseboat. Had a sixth-grade education. I got on a boat with him, and he just turned me loose. He figured if he could do it, I could do it.

I just stumbled into this career. Farming back then I was getting three dollars a day. Farming in the Delta, ten dollars a day was a lot of money to me.

The little wooden-hull model hull boat was named the *Bradford J.* We had no facility whatsoever. He had a butane refrigerator and a butane stove on there. We had two twenty-five-gallon bottles. Up in the wheelhouse, they had a mosquito screen. Had two bunks up there. Down in the engine room, they had a five-gallon bucket with a rope on it. They had a toilet seat hanging up on the wall in there. And when you got ready to do any type business, you'd get that bucket. But don't wrap that rope or hold on to it because it will jerk you overboard if you dipped it too hard. Get you a little water and do whatever you were going to do, then you put it back overboard. We pushed a fuel barge that had potable water on it. So, in the wintertime, we just had to take a dishpan bath. And in summer time, we'd hang that water hose up off that water tank, get out there at night, and scrub up. So they talk about the good old days. I don't know what was so good about that. Dougie went and got him a job with Jesse Waller out on the *Mark David*. They had four hundred horsepower. Had a generator and air conditioner. I didn't have air conditioner at my house either, so I didn't know about air conditioner. So got on it and got an air conditioner and had a generator, and we were

hitting pretty good. But what happened was, when Dougie got the job on that push boat, he came back and said, "Look, we fixing to give Mr. Miller a two-week's notice." I said, "We?" He said, "Yeah, you are going with me." He said, "I got you eighteen dollars a day, and we're working fourteen and seven." Well, we were working straight time on Mr. Miller's boat. If you wanted time off, you had to quit. So all this time I had been steering the boat. Before that, I never had never steered a boat. Just a two-engine boat. I went from deckhand to steering. And Mr. Miller with a single screw. When you back it down, it backs down one way or the other depending on if it was a lefthand wheel or righthand wheel. So he'd have me out there in the mornings throwing that rope. Because you are going to make him look good, or he looked bad. Dougie decided he was going to go offshore on a sixty-five-foot nine-hundred-horse-power tow. So he quit, and I took the captain's job on there. He called me up. He said, "Andy, I need a wheelman." I said, "You need a wheelman?" He said, "Yeah, we got to have one." So I called my boss man, gave him a week's notice. I got on that offshore tug, and we were pulling some six to eight-thousand-pound anchors off that tug on a winch. Back then, it was full ocean service. I had never been offshore in my life. So I put it on a towline, and here we go. We left out of Houma right there by the Bayou du Large Bridge. It was a swing bridge back in the day. So we went out of there and went out the Houma Navigation Channel. And I stayed there until I went in the service, got drafted. I was drafted. I had gone through basic. I was at Fort Gordon, Georgia. He wrote me a letter and told me that we had to get a license and everything. You could grandfather clause in, but you had to take about a third of the test. So he told me, he said, "Once you start"—he said, "Come down here and take the test. You are going to flunk it because you don't think like those people. But once you start under the grandfather clause, they got to let you finish under it." So that's what I did. I flunked the test. The terminology from what the Cajuns used and what the Coast Guard

use are two different things. Timberhead, they call it a bit. A cavel, they call it a cleat. They towline, and a Coast Guard's towing by pulling astern. You had to get in the mind of the technology.

I have a sixteen-hundred-ton master's. I have a towing endorsement. I have an AB unlimited. I have a PIC, tankerman PIC. I can run anywhere from Gulf of Mexico or any of the inland waters. I have Inland Coastal Western Rivers and Great Lakes. What I'm saying, I'm really versatile. I have never been to Great Lakes, but I've used them everywhere else.

The largest tow I ever had was eighteen barges. I came out of Yazoo on old *Sibley* for Patton-Tully log barges to come off there and took them to Baton Rouge. That's the biggest tow I ever pushed. I have also pushed four of the big thirty thousand on this river too. Like I say, they call me the captain's captain because I was real versatile. But I'm going to tell you, it all stems back from Doug Adams, the confidence he gave me back then on a little single screw. That's the only talent I have. Some people never get it. I've seen some thirty-, forty-year men, and they don't have it.

When I first started, the people we had to work on the river were pretty rough fellows, pretty rough. In the '60s and the '70s. I've had one shoot through a door of a boat, the *Capricorn*. We had gotten docked, and he got drunk and shot through my door, but I had gone home that night. And Doug Driver, the engineer, hit him with a two by four. And when I came back to the boat the next morning, they had this other fellow in jail, and he was wanting me to come get him out of jail. Most of them were drunks. That's what you mostly got. But once you got them on the boat for two or three days, they got sober. They got the alcohol out of their system. That's all they worked for is the next time they could get drunk. They were some of the best hands you ever had. They were professional, and they had that nervous energy.

I will tell you about a fellow that was in the navy eight years that came on the boat with me. He was

a submarine man. We were headed from Houma, Louisiana, to Corpus Christi out in the Gulf. It was rough. I didn't see him for a day or so, so I asked the hands, I said, "What about so-and-so? What's wrong with him?" They said, "He's down there sick." So I went down there. We had automatic pilot and all at that time. So I went down there and checked on him, and I asked him how bad it was. He said, "I want my mama." He's thirty-eight years old or so. I said, "Man, you been in the navy eight years. What are you doing seasick?" He said, "We were under water. We didn't have none of this." When I got to where we were going, I had to get him off of there.

And here are some old sayings that captains use to say. When I first started on a boat, it was a wooden-hull boat. And an old captain would tell me when he started that a man was made out of steel; the boats were made out of wood. And you couldn't whistle on that boat because you'd whistle up a storm. If a seagull is flying high, you are going to have bad weather. That's how they told weather. Red sky in the morning the sailor take warning. Out in the Gulf of Mexico, out in the ocean, if you see Portuguese man-of-war all balled up together, you are going to have bad weather.

JOSEPH T. DAVISSON

– b. 1950 –

When I was still in high school, on weekends I worked at a local New Orleans pizza parlor known as Shakeys. There was also an elderly gentleman that was a musician that worked there on weekends by the name of Bert Peck. Bert would play the piano and banjo and was the live entertainment. I remember on one hot and muggy New Orleans's summer night, both Bert and I were together outside taking a break and were having a conversation. I asked Bert if he knew of any jobs that I might be qualified for. Bert thought for a minute and then told me this. "Have you ever heard of the steamboat *Delta Queen*"? I told him no, and then he gave me a brief explanation of what it was and what it did. He went on to tell me that if I was interested in applying for a job on the *Delta Queen*, I could use his name as a recommendation and to ask for the captain on the boat, Captain Ernest Wagner.

At the time, the steamer *Delta Queen* was in winter layup at the local New Orleans Avondale Shipyard. So, the following day, I made the short trip to the Avondale Shipyard, boarded the steamer *Delta Queen,* and asked for this Captain Wagner. Shortly thereafter, this giant of a man appeared before me, and in my most humble and tentative voice, I introduced myself, told him that a Mr. Bert

Peck told me to use his name as a recommendation, and was there any chance he would hire me? He looked me over from head to toe and told me I was hired and to show up first thing tomorrow! This is how I was first hired on the steamer *Delta Queen*, and, needless to say, it was my first step on my long journey for my river career that has now lasted for over forty-seven years. I went on to work on the steamer *Delta Queen* during my summer vacations from both high school and college, and when I graduated from college, I realized that over the years of working on the *DQ*, I had accumulated the required Coast Guard time to sit for a mate's license, which I did do, and I also realized that it was the river where I wanted to work and live on!

To further my river career, I attended the National River Academy in Helena, Arkansas. After graduating from there, I went on to work on towboats. At some point, I decided to return to the *Delta Queen* Steamboat Company, and at different times I worked on both the steamers *Delta Queen* and *Mississippi Queen* in such capacities as master, mate and pilot on each of these two steamboats.

I have a story about the *Brightfield*. It was December 14, 1996, at two fifteen in the afternoon, as I

and the Chinese bulk carrier the *Brightfield* passed under the Greater New Orleans Highway Bridge. Something happened that puts the fear of God in all pilots! One simple event could be summed up in just one word: *silence*! It was the silence of no noise coming from the *Brightfield*'s engine, it was the silence of the captain and mate just staring at the ship's revolution counter, and it was the silence of these two same ship's officers when I asked them if there was a problem. I jumped out of my pilot chair, picked up the VHF radio, and immediately put it on the air that I was on a ship that had just lost its power. This ship was now careening out of control and swinging to port and toward the east bank of the Mississippi River, where two passenger vessels were moored and were directly in my path. I felt that the *Brightfield* was going to not only strike the moored passenger ship in its path but in all likelihood, it was going to literally cut it in half with resulting major loss of life and property. I was also blowing the ship's whistle, which was the international danger signal, [and] screaming at the ship's captain to let go the ship's anchors. Unfortunately, the anchors were not deployed in time to stop the ship's port swing, and only at the last minute was the port anchor deployed with little if any results. Instead of continuing its swing to port to the east bank of the river with the two passenger vessels in its sights, the ship's swing came to a stop. The swing to port came to a stop, and then a swing to starboard was started and away from the east bank docks. There is no doubt in my mind that I had just witnessed a Christmas miracle. The "hand of God" had just stepped in, stopped the *Brightfield*'s port swing, and then redirected the ship's swing to starboard and away from the passenger ships. God landed this 738-foot ship in a 900-foot space between the moored passenger ship at one end and a casino passenger boat at the other end of this relative small and open space in the docks. There were no fatalities, fires, or explosions, but part of the Hilton Hotel, the River Walk shopping mall and a parking garage and the *Brightfield* were all damaged to

varying degrees. It was God that saved the day and all the innocent lives on that day in December.

During my tenure on the steamboats, one expression that unfortunately became commonplace and was used in lieu of cursing was "Well, that's steamboating." This expression was used for all manner of incidents, accidents, and all other nondescript occasions that were for the most part just not good things that happened and most often had a catastrophic ending. At the time, I was the relief captain on the steamer *Mississippi Queen*, and we were at our New Orleans landing at the Poydras Street Wharf. We were on what we referred to as "turnover day" when one trip ended, and on that very same day another trip would begin. There were two young mates on the boat that were good friends. Their work schedule evolved to the point where they would work opposite from one another; when one was on the boat, the other would be off. What made this relationship interesting was that they both started dating the same barmaid, and this situation evolved into the infamous love triangle, but neither of the two mates were aware of the fact that when one was off on vacation, the other was on the boat and sleeping with the same barmaid. This web of deceit went on for some time until they discovered just what was going on during the other's absence, and so they both decided to confront the barmaid and get to the bottom of this unfortunate situation. Then when they did confront the barmaid, her only words were, "You guessed it. But guys, that's just steamboating!" Needless to say, both of our young mates were totally flabbergasted, speechless, and both just walked away in utter amazement and bewilderment.

In the spring of '78 I was the after-watch pilot on the steamer *Delta Queen*. We were steaming up the Mississippi River below Baton Rouge. I choose to navigate the steamer *Delta Queen* out of the designated channel and go up and behind the Bayou Goula Towhead. The reason was to get out of the fast and high springtime torrential flood water and to make a little better time in the slower and

slack water behind this towhead. I noticed something that caught my eye that was taking place on the levee that I thought would also be of interest to our passengers. On the shore, I saw were what I referred to as two Louisiana dears. As I was making this announcement, I could literally feel the boat take a starboard list as passengers and crew members alike went to the starboard side of the boat to take in the sight of these two Louisiana dears in action. There on the bank in broad daylight on a beach blanket were two Louisiana dears in their "birthday suits" and were obviously in the throes of ecstasy. I went to the *DQ*'s whistle and bell in order to make our presence known. Upon seeing and hearing the steamer *Delta Queen* with a full complement of passengers and crew members taking in and enjoying their antics, the male dear leapt to his feet and made a hasty retreat to the nearest bush, leaving the female dear to fend for herself without the cover of the beach blanket that the male dear so decided to take with him. Just another day on the river and with so many sights to see and take in.

It was January 1980. I had been elected into the apprentice program with the New Orleans Baton Rouge Pilot Association, and I was on my first official training trip with an older and veteran pilot. It was a different era with different rules and different regulations and with different social mores. It was still the Wild West on the Mississippi River, and many times the rules were either made or bent as the major players saw fit. My very first training assignment was to board an anchored ship located in the Ama Anchorage in the middle of the night and then pilot it to the New Orleans General Anchorage where we would then change pilots with a Crescent River Port pilot and then make our departure from the vessel. Upon our arrival on the bridge of the ship, we made our customary introductions to the other ship's officers that were present, which included the ship's captain, the third mate, the helmsman, and to someone else that I most certainly did not expect to see there. The other person that was present on the bridge of the ship

was what I suspected to be a prostitute. After only a few minutes, my senior pilot and mentor returned to my side and uttered the words, "Hey kid do you think that you can find your way to New Orleans?" I utter the words, "Well, yes I think so." Then without saying another word to either me or the captain he went back to the lady that was there, took her by the hand, and the two made their departure from the bridge of the ship. The trip to the New Orleans General Anchorage was both short and uneventful, and when the pilot boat was on its way to our ship, only then did I see the likes of my senior pilot and mentor as he sported a smile on his face and, I am sure, a fond memory in his mind.

It was Christmas Eve back in 1978, and I was the designated relief captain on this particular trip because I was the low man on the totem pole with the other Coast Guard licensed deck officers on the steamer *Delta Queen*. The other senior captains were off for the holidays, and I was their replacement. The steamer *Delta Queen* was steaming up the Mississippi River on its routine seven-day round-trip cruise from New Orleans to Vicksburg and back. Although it was Christmas Eve, there was a prevailing atmosphere of overall depression on the boat, just possibly due to the fact that for one all the crew wished that they were off the boat and with their loved ones, friends, or families, and, secondly, the passengers were there because they simply had no one else to be with. We were above Baton Rouge and just south of Profit Island when it occurred to me that on this Christmas Eve the crew was in much need of some well-deserved entertainment and Christmas merriment. I called the mate and had him report to the pilot house on the double. I discussed this idea with both him and Captain Ware, and it was unanimously decided that we would make an unscheduled and surprise sandbar stop on Profit Island in order to provide a legendary sandbar stop and Christmas party for the crew. The deck crew gathered driftwood for a bonfire, the waiters and galley staff brought out banquet tables; food and drink was also furnished, and what would

be a sandbar party without music? The bonfire lit up the sky and Led Zeppelin blaring into the night air never sounded so good. Toasts were made, the hotel staff maids serenaded us and everyone for a brief moment forgot about their family and friends at home. Everyone realized that although they were not with their biological families they were with their steam boat friends and families. For a brief few hours, we enjoyed one another's company, sang, drank, ate, and danced by the light of a bonfire, and there were *no* passengers, there were *no* crew members, [and] there were *no* captains or mates or engineers. There was just one big family enjoying one another's company and relishing being on a sandbar in the Mississippi River with real family and real friends.

Back in the early '80s, I was still a rookie ship pilot with the NOBRA pilot association when I received what was referred to as a "rush order" from our pilot association's dispatch department. The order was to report to the Convent, Louisiana, buoy system, river mile 158 as soon as possible. I arrived on the levee and saw what lay before me. On the batcher of the river, I witnessed not only my ship in the buoys that I was dispatched to pilot, but to my amazement I saw much more. I saw members of the Coast Guard, members of the local police department, members of the Louisiana State Troopers, members of the stevedore department that were assigned to unload the ship in the buoys, members of the line-handling crew, members of the local Convent community that came out to witness this event, but what really caught my eye was that the ship in the buoy system was heeling over with a hard-starboard list. The loading platform that it was secured to was in a slow but sure process of sinking. The loading platform was an old ship, known as the *Rice Queen*. It had been converted and modified to facilitate the loading of grain to other ships that were secured to it. I boarded the launch boat [which] took me out to the ill-fated *Rice Queen* and the ship that was secured to it. I received a call on my portable VHF handheld radio from a Coast Guard official still on the batcher and curiously *not* on the ship now in obvious peril that under *no* circumstances that I should attempt to move my ship that I was now on. The captain on my ship was now near tears, and he pleaded with me to do something and even [if] it was wrong. I replied to the Coast Guard that the situation was only getting worse and that the ship's lines to the *Rice Queen* were now stretched to their limit, and it would not be long before they parted with catastrophic circumstances. I asked the Coast Guard whether or not they would take responsibility for any damage, pollution, or loss of life if we did as they ordered and did not make any attempt to move my ship. After getting no reply from the Coast Guard on the scene, I asked the line handlers to come out in their launch boat and release the ship's mooring lines from the fore and aft buoys. The captain on my ship also heard this on my radio, and then I told the captain that the only thing we could do was to cut our own ship's mooring lines regardless of what the Coast Guard and line handlers told us . . . to do. The captain gave his fore and aft mates the order to cut the lines at once. As these ship's lines were cut, the *Rice Queen* went down by the bow and with the stern high in the air but slowly sliding into its watery grave. I gave the mate in the bridge the order to put the ship's engine in a slow ahead position, and my ship slowly responded by moving ahead and away from the sinking *Rice Queen*. As the *Rice Queen* slowly slipped below the waters of the Mississippi River, the stern of the *Rice Queen* became alive with something that I never thought I would see. There on the poop deck of the *Rice Queen* were literally hundreds if not thousands of rats that had accumulated on the aft deck of the sinking ship. The rats were jumping into the river and were attempting to make a swim to the shore. Just as the rats were jumping into the river, there was also a presence of catfish waiting with open mouths to catch and consume the rats, some in midair as the rats made their escape. What A Day.

CHARLES WESLEY BROWN

– b. 1951 –

My name is Wesley Brown, and I've been on the river forty-seven years. I started out a little bitty thing running one of the little survey boats helping them piddling around. I was just a baby, just a kid, and that's how I started.

When I was three years old, my daddy hitchhiked and carried me down to 61 south. My grandpa and my great-aunt lived in a houseboat on the Big Black River, and I was raised there until I started the first grade. We moved from there to Rocky Springs into a chicken house, a chicken house that my great-aunt's sister owned, and we ran the chickens out and moved in there. It was rough. My grandpa and my great-aunt raised me. My mama and daddy really didn't until I was thirteen. At that time, my dad worked for Patton-Tully as a deckhand on the *John Morrow*. My dad working on the river had a lot to do with me working out on the river. I left school early. It was a way to go. I was a deckhand. I started in the fall of 1968. I worked for Valley Towing Company, which was owned by Ronnie LeMay, Percy LeMay's son. I was on the *City of Greenville*. Then I rode it a couple of hitches, and then I went to work for J. E. Vickers on the *Jimmy Vickers*. I made a couple of hitches with them. And then I

came home, pillaged around a little bit, and I caught the *Daniel Webster*, which was the first barge-line boat I ever rode. The captain on there, everybody called him "Hog Head" Jones. He never decked a day in his life. He got on the river with a fifty-dollar bet. He was a bartender in St. Louis. And one of the old captains was in there, and they were heehawing around, and they got to talking about the river. And the old captain said, "Anybody can work on the river." He said, "I can take that bartender and make a pilot out of him." And that's how Jimmy Jones, Hog Head Jones, got on the river. This was before my time because he was captain on the boat when I went over there.

But I realized I wanted to make a career on the river when the first paycheck came in. I did know that when I was decking that I did not want to deck. I was taking orders, and I wanted to be the one giving them. I knew early on that I wanted to be in the pilothouse. I always stood a watch on just about every boat I was on.

When I was just ten, eleven years old I drove one of E. J. Platte's little survey boats. That's how I got started really. Back in the day there weren't any bathrooms in the pilothouse. So if the wheelman, captain, or pilot had to use the bathroom,

somebody had to watch the boat. So I was the first one to volunteer. I said, "Captain, I'll do it. I can do it." But how I got my start was I worked for Mark Shurden.

We loaded out in Shell Oil at Norco, Louisiana. I was mate. I was waked up about three or four o'clock in the morning coming up below Baton Rouge. We had put the tow together, and the deckhand came down there and said, "Wesley, would you get up?" He said, "The captain wants you upstairs. So I came upstairs." The pilot that was on the boat was an alcoholic. He had kind of got his bearings all messed up and couldn't stand a watch. Dee Pegram was captain on there. He asked me if I could hold the boat and let him get a couple of hours sleep. I said, "I'll be more than glad to." So I'm thinking he's going to get on the couch back here. But he goes to bed, and we're coming up the river with three barges in tow with loaded fuel barges. This is before the amber blinking light came in effect. The blinking light didn't blink. So I'm coming up the river, and lights everywhere, and I'm just totally freaking out, and he's in bed. I was young. I was probably only eighteen. I stood a watch. When he comes upstairs, when we get above Baton Rouge, he says we need to get this gentleman off. Well, I told him, "Don't worry about it. I've already put him off at TriG Marine." I put him off and got the ambulance to come pick him up because he was in pretty bad shape. He says, "Well good." And he had slept through all that.

The river is well maintained now. Now understand this. I'm a towboat pilot. I went to work for the Corps [of Engineers] in '94. The Corps of Engineers is completely different than the river people. Understand that. I didn't care much for them because they were always in the way. They either had a dredge sitting in the crossing, or either they were sinking mats, or they were doing something. When I was being a towboat pilot, I didn't know if they were in the way, or they were not doing their job. I came around the bend with thirty or forty barges, and there's a dredge sitting there. You know,

bingo. Here we go, you know. I'm thinking, "Why are you here?" "Well, I'm here to better you. When you couldn't get thirty barges down the river, now you're getting forty barges down the river. Instead of a nine-foot draft, you're getting them down in a ten-foot draft." And it's because of the Corps of Engineers.

I can run one end of the Mississippi all the way to above St. Paul. I can name you every light.

It still amazes me that you can take a boat and thirty-five or forty barges and put them through two pieces of concrete. And then you have eleven or twelve lives in your hands and over half of them asleep.

If you could stand on a six-hour watch by yourself, I figured you were a pilot. Anybody can run a boat. I can teach you to run a boat in thirty days, but 99 percent of running a boat is knowing where you're at and what to do when you get there. And then don't change your mind when you get there. Ninety percent is knowing what you're going to do when you get there.

I've run the biggest boats out there. I've run the ten fives. I have run everything that they have out there, big tows, small tows, everything. You have to know what your boat will do. You watch the buoys and you read the buoys.

The money is super-duper good out there now. It's finally to the point where the pilots are getting really what they should. We have to go through an act of Congress to get pilot license. Then you have to go through worse than that to keep them. I mean, your health's got to be good. You can't be farsighted. You can't be nearsighted. You can't be colorblind. You can't be this, that, and the other.

The Coast Guard did it. Years ago, you didn't have to have license. You could walk into Dolly King's office, and you could walk in so-and-so's office, or you could walk in Brent or Logan's office and say, "I am a pilot," and get on a boat. Now whether you were or whether you weren't, it didn't take but six hours to know, especially if you were southbound out of Memphis, before somebody on that boat realized

you really weren't. So, in 1973 the Coast Guard realized that there was no way in the world to punish people if they messed up because they didn't have license to take away, so what were you going to take away from him? So, in 1973, they came up with the deal of the grandfather clause of your license. I was working at the boat store. Patton-Tully, Mid-River, and whoever else was around we all went to school for a week or two. When we got in there, there were some of the old timers in there. It was test day. Twenty-five multiple choice is all it was, and over half of them didn't have a license. It must have been fort-five or fifty of us in this one room. This Coast Guard fellow gets up there on this little old projector board, and he starts, "Okay. This here—I'm going to read the question, and its multiple choice." Well, the first one he read, this elderly guy raised his hand in the back, and he said, "Sir," he said, "I can't read and write." He said, "No problem. We've had people in here that can't read and write." And well over half of them couldn't anyway. So, when he started, he said, "We'll give the test to everybody orally." So he started reading the question, and then he started reading A, B, C answers, and as soon as he got to the answer somebody hollered, "That's it." Well, every one of us in there had the same score because some old timer was in there. Then they'd come up with the deal. The Coast Guard thought that the people were going to get these license, these freebies, and then later on upgrade their license. Well, they didn't. They didn't need anything else. These were unlimited tonnage license. You could run anything out there. And you got them for a song and a dance and twenty-five questions. And then all you had to do was sit beside somebody smarter than you were, and you could pass it. And that's how it all started out with the license.

I am on about my seventh or eighth issue. I have a master license. I have a sixteen-hundred-ton master license. It's just an upper-grade license. I've got a first-class pilot license. The reason I got a first-class pilot license was because I was applying for a job for the Corps of Engineers. I didn't have to have a master license. You still don't have to have a master license. I went on and sat for my master's anyway because it wasn't but two more tests anyway. So I went on and did that. I've got unlimited operator's license, the Western River's Operator License. So I've got three or four sets of license.

I can run anything but the *Mississippi* because you have got to have the unlimited master license because it's a passenger vessel. That's the Corps of Engineers. You have to have more license with the Corps of Engineers than you have to have anywhere.

The largest tow I ever pushed was forty-nine. It's like four or five football fields. Forty-nine northbound, fifteen loads involved in that. I was on the *Crimson Gem* at that time with ARTCO. The *Miss Kae D* holds the record at seventy-two. They allow you to do anything your boat will do.

Life out on the river, it's miserable sometimes because you're away from home. My wife raised my kids, and I was the guy that came home every thirty or thirty-five days and changed everything up. One time I told my boys to sooge the carport. I said, "I'm going to town. When I come back, I want y'all to sooge this carport." My wife came home, and they were both sitting there crying because they didn't know what "soogeing" meant. It means you're washing it down. My wife asked them why they were crying, and they said that Daddy told us to do something, and we don't know what he was talking about. And she said, "Well, what did he tell you?" "He wanted us to scrooge the carport," because they couldn't say "sooge." They had taken their little go-cart and slung mud all up in the carport, and I told them to sooge it down. I got back home. My wife informed me that the towboats were out there, and we were at home. She told me to leave my towboat life out there when I came home. In a sense, it's hard for me to do.

Greenville, Mississippi, years ago was the backbone of river people. They had more companies in Greenville, Mississippi, than they had anywhere. When everybody was on the boat in Greenville, the population went down a whole bunch. Dolly

King was a legend on the river. He was a good man. There were a lot of good men on the river back in those days. There was Dolly King, Jesse Brent, and J. E. Vickers and Mr. Carl Vest, Vest Towing Company out of Greenville. I run the boat the *John C. Byrd*. Chubby Byrd was his name. They were all towboaters.

I rode a boat with a guy. We were on the *Crimson Duke*. I think it's a ten five. Captain Joe Hightower, he would come upstairs. But he would come upstairs and want to play you a tune on the guitar. He'd walk over there and start banging on the guitar. The tunes he played were from back in the '20s, you know, something I'd never heard of. He'd want to play you a tune all the way down the river or something. I loved it.

It's true the river gets in your blood. It's in mine.

DAVID E. DEWEY

– b. 1951 –

My name is David Dewey. I've been on the river for forty-five years. I started as a kid. I grew up in a little town called Henry, Illinois, which is at mile 196 on the Illinois River. My dad ran a grain elevator on the river that shipped grain by barge. I grew up running up and down the riverbanks. So I got introduced to barges when I was six, seven years old. I think my first ride on a towboat I was about ten or eleven. There was a fellow that was building a little harbor boat—I think I was about fourteen—and I started helping him. I was the gopher. Go get this, get that. I would help him as he built that boat. I started out helping him out on the boat as a deckhand sort of and ended up running the boat. I started running the boat when I was probably about fifteen years old.

I went to college for two years after high school, but I worked in the summers and Christmas vacations on line boats. I knew I wanted to be a pilot when I was in high school, when I was working on these harbor boats, and I'd watch the big line boats go by. I was very enamored by that. I worked for Port City Barge Line, Greenville, Mississippi, for several years on deck and was steering in my off time.

A little about my career: I worked a couple of places at Magnolia Marine in Vicksburg. Gene Neal had gone to work there. He asked me to come to work there to help. So I worked there for several years in the late '70s. I ended up going back on line haul boats and wanting to get big horsepower experience. A line haul boat is mainly in the freight trade opposed to a unit tow operation. It's mainly oil or chemicals.

The biggest boat I was a regular pilot on was a 10,500-horsepower boat for a couple of years. The biggest tow was thirty-five loaded southbound on the Lower and probably forty-two northbound, something like that. The heaviest tow, though, was a tow we brought up thirty-six loads northbound. There's different chemicals, different commodities, steel, steel products, paper, rolls of paper, newsprint type of paper, iron ore, and different materials for the steel industry . . . , fertilizer, salt. There's a lot of that goes upriver to the Midwest for the winter and for AG use. Then grain is mainly southbound or downbound, going to the Gulf for export. It's a tremendous amount of tonnage. It takes thousands and thousands and thousands of trucks off of the highways. It's like fifteen-hundredton railcars. I think it's thirty-seven trucks, semitruck loads to fill a barge, so it's a tremendous amount of product that moves on the waterways.

If I had to compare when I first started in the river industry to what it is now, the primary [difference is] probably the technology. The river hasn't changed a whole lot. It's been improved, obviously. We can carry deeper drafts. Much less dredging is done because of the dikes and all that have been put in. But really the biggest change has been in technology. Radars have improved drastically with digital electronics. Electronic charts are a great tool that makes the job, I'm not going to say easier, but different. You have [a] higher level of certainty of your route and things like that. So electronic charting is big. The engines have improved in fuel efficiency and emissions, and some of those kind of things, but the basic river towboat hasn't changed a whole lot.

We're in a much more highly regulated environment by the government than we were thirty, forty years ago. That has made it harder and harder for the small companies to survive, so there are far fewer companies. But the basic river trade, the work hasn't changed a whole lot.

From my teenage years, I had that wanderlust, and that was really what I wanted to do. Even when I was in college and was supposed to be focusing on my academic life, I was probably more interested in what was going on the river and other things that I probably shouldn't have been concentrating on like partying or whatever. I guess I've pretty much always liked the river. I was fascinated by it and wanted to make a career out of it.

The river community is small. Paducah, Kentucky, is a town that has a lot of river people. The average person doesn't have any clue about what goes on on the other side of the flood wall. Clusters of people have gone to the river, especially from a lot of places that don't have a lot of other industry or economy. The river is a place where people can go and get good-paying jobs.

I've been in Paducah since the Seaman's Church has been here. They started here in '97 doing training, and I was here as a customer. I was always involved with Ministry on the River, with different

Christmas on the River projects, stuff like that. Our church would come down and get a bunch of youth and help pack boxes and do all that kind of stuff. So I had been somewhat involved. Last year Buddy Compton called me. He was an instructor here. He said they had a position. They were advertising for an instructor, but I really hadn't had much interest. But he called me and asked me if I'd be interested, and I said, "Well, probably not really, but I'll come and talk to you."

So I came down. In January of 2015 I came to work at Seaman's Church as an instructor. Things evolved, and I started work here. It's a great program they've got with training mariners, and it's continuing education primarily. It's not training people to be pilots, although they do have a steersman program. And so I'm enjoying that and getting to see all the people and people I've talked to over the years. So that's good.

The Seaman's Church has several chaplains on staff, and they have volunteer chaplains up and down the river that make visits to boats. If the need arises, and if somebody needs pastoral care, they will go to the boats and work with the crew and the individuals that need some guidance. So it's a good program.

Primarily, we do simulations of certain areas of the river. Then, after we run a simulation in a certain area of the river, we have what we call debrief. We talk about what went on in simulation, what went right, what went wrong, what could have been done better, all those kind of things. Then we tie all that in with situational-awareness training, rules-of-the-road training, risk assessment, risk-management training of the primary areas that we focus on. If you don't have situational awareness, bad things will happen. If you're not applying the rules of the road properly or don't know the rules of the road or interpreting correctly, then they can be your friend, or they can be your enemy, and work against you. We try to focus on how do we make the rules work in our favor.

The Seaman's Church is headquartered in New York City. They have a location in Newark, New

Jersey. They have a training facility in Houston, Texas, similar to the one in Paducah that primarily trains mariners in the Gulf Coast region. Then they also have a facility out in Oakland, California. They have a location out there that primarily ministers to mariners in that region. So it's nationwide. It started in New York harbor ministering to seamen in the 1800s when they came into port and had really nowhere to go and maybe were laid off from a ship until it sailed again, or they got another berth on a ship or to fill that gap to give them a safe place to be and a place to get some guidance. Then in World War I is when they really got into the training side of the maritime industry in training seamen for the war. So it has a rich long, long heritage of training and helping the mariner.

This facility in Paducah went into operation in 1997. It's an absolutely firstclass facility. The simulations are state of the art upgraded to the best there is. So it's pretty impressive.

The river life, sometimes it gets a bad rap. They'll tell everybody on the river the old rough-and-tumble and Mike Fink and Mark Twain stories. In reality, most of the people on the river are just common ordinary people out doing their job. Most of them really love it. It's a passion to stay with it. Either you're going to be passionate about it and like what you do, or you're going to be miserable. So most of the people are pretty dedicated and enjoy what they do, and most of them are good citizens and good all-around people that are raising families and having a career and doing the things we all do. There are men and women. There are more and more women and more and more minorities. It's become more diverse, and it's a good life. It's different than getting up and going to work from nine to five. If you like time off, and if you like to have hobbies, or if you like to hunt or fish, or you may have a side business and farm, you've got time to do a lot of other things because most people on the river now are working from six to nine months. You have got somewhere in between three and six months off. So that's not bad.

I've spent probably half my life or maybe a little more than half the time in management and the rest on the river. So, it's been a great career. It's been good to me. I have raised a family and educated my kids and all that. So, hey, it's great.

GARY GUIDRY

– b. 1951 –

My name is Gary Guidry, and I've been on the river since 1967. My dad was a captain for Chotin Transportation until he passed away. My grandpa was also a captain. He was a captain on a shrimp boat. He did tow work too. He did work in the canals. He was from Golden Meadow, Louisiana. A twenty-four-carat Cajun. He spoke nothing but French. My father spoke mixed English and French. In my younger day, I spoke French. In south Louisiana they all decide to make a living by shrimping and to feed their families.

My dad told me stories about how my grandfather would throw him into the water to teach him how to swim. He'd just throw him off the back of the boat, with a rope around him. "Swim." That is more or less what my dad did with me and my brothers. My dad used to work in the fleets. He worked for GNOTS fleet. I started going with him in summertimes like in '67. I used to spend the whole summer. Every time I got a chance, I went on a boat with him. A lot of times he'd put me in the wheelhouse. He showed me how to face the boat up and put tow together. By the time I was fifteen years old, I could handle a boat like a charm. So I started real, real young. Way before I held a pilot license, I could build tow. I got my pilot license at twenty-one. I

knew all the time that I was going to make a career out on the river. It was never no doubt. I loved it. I started with the Chotin Transportation right when I got out of high school, and I was eighteen years old.

I believe the saying that the "river gets in your blood." Oh Lord, yes.

I got a story I want to share about a mate of mine. One time, we were coming through Atchafalaya River, and it got foggy, real foggy. This is back in the early '70s. We were taking that shortcut up the Atchafalaya River. The guy's name, we called him Rodrick Johns. Back then, all we had was speakers on the head of the tow. I told him, I said, "Get on the head of the tow." I said, "I'm going to put it on the bank, and we're going to sit here for the night. If you see a tree, we are going to throw a line around it. That way I can shut the engines down, and we'll just sit here until the fog clears, and then we'll take off again." He said, "Okay." So he and the deckhand went out there. I was sliding along the shore very slowly, and he was looking. I said, "You see anything?" He said, "No, not really." He said, "I think I see a stump." I said, "Well, throw a line on it." I said, "Just anything to hold me here. We'll just watch it, you know, but I won't have to work so hard holding

it into the bank." He said, "All right." So I could see the flashlight out there. And that's all I could see. So he and the deckhand took the line. When they got up close to what they thought was a stump, it was a bear! He took that line, and he threw that line, and it hit the stump, which was a bear, and it was sleeping. It wasn't maybe six feet from this bear and barely could see it. He couldn't tell it was a bear, which it was kind of curled up. And, boy, when he hit that bear with that line, I could hear on that speaker. You ought to have heard that sound! When that bear did that, they took off running, and you got all these exposed pipelines on top of the barges. And they were falling over the pipeline. I still didn't know what was going on, but I heard that roar from that bear! They ran up all the way and tried to run back to the boat. That was the funniest thing I have ever witnessed from then on to this day, but after that happened, he was known as "Bear." Oh, did it scare them! The bear didn't come after them because he was really trying to get away too, but it scared him so much he stood up, and we could hear the bear roar over the speaker. It was funny, and them trying to run in the fog. They couldn't see anything, so they stumbled over the pipelines. It was a black bear, and he was just on the side of the river just resting in the fog.

Steve Guidry, the guy who broke me in, we were on the *Joey Chotin*. One night, I was going up the river. I had relieved Steve about one o'clock in the morning. The moon was shining bright, and on that beautiful night, you could see all the stars. We had been having trouble with one of the wheelhouse doors. And I knew this. I knew this, but for some reason I walked out of that door, and the wind started blowing a little bit. I walked out, and I opened that door just to make sure that that door would stay open. I had steered going around a turn with the tow. So I walked out of there, and I was looking at the stars and how pretty it was out there. And then, all of a sudden, I heard, "Boom." I looked over there, and the door had closed. I said, "Please." That was the only way to get in the wheelhouse the

other way; you had to go to the bottom deck and come up through the inside of the boat. They didn't have any stairs where you could go up to the wheelhouse. You had hand ladders. And I knew. I said, "This door is locked," and I pulled on it, pulled on it, and pulled on it. In the meantime, I was still going up the river. Thank God I was going up the river. And the searchlight was on. We had those old carbon lights. I could see a couple of buoys out there, and I was turning to the right. I said, "Oh, Lord, what am I going to do?" I started climbing those ladders. So I took off. Took off running. I went down one flight of stairs. And I slid in the dew. I hit the deck, and I slid all the way to the back ladder. Meanwhile, Shorty Barnett, who was the assistant chief on there, he was on watch. He had moved the drum of oil underneath the step where you come down that ladder, and I didn't know that. When I stepped down, I went into the oil up to my waist. And, man, the boat was still turning now, hooked up. The boat was still turning, man. I was in a very big hurry. Meanwhile, Shorty Barnett was in the galley and was eating a peanut butter sandwich. We had a deck crew that was up. They were in the front of the boat. This was in the back. The galley was in the back. And Shorty was back there. Well, I got out of the drum of oil, and I went around the side of the boat, and there's the door for the galley. So I had to go through the galley and go up the steps and get back to the wheelhouse, and my pants were full of oil. I was dripping, dripping oil. I didn't even stop to talk to Shorty. I came through that galley door so fast, and he was eating that peanut butter sandwich, and he threw the peanut butter sandwich up in the air because I was coming through that door, and it stuck on the ceiling. And when he saw me running like that, I didn't even say anything. I went through the engine room slipping and sliding. I slipped down a couple of times when I was trying to get back to the wheelhouse. When I got back to the wheelhouse, I was almost going out of the channel. I was behind the red buoys going out the channel.

Meanwhile, here I am full of oil and grease. My hair was standing straight up, man. Shorty thought that something really serious had happened. He wakes everybody up on the boat, including Captain Steve. Steve comes running up there in his underwear, "What's the matter? What's wrong, Gary?" I said, "What's wrong? I'm going to tell you what's wrong," after I straightened the boat out a little bit, you know. I turned the light on in the wheelhouse. They all saw me just standing there, my hair straight up full of oil, just dripping oil. They just started laughing. He said, "What happened?" I said, "I told you to fix that damn door." I said, "I got locked out." And, boy, they just started roaring. Steve said, "Well, go change your clothes. I'll hold it for you." I said, "Well, I'm sorry y'all all got woke up." Shorty Barnett said, "I got to go clean that peanut butter off the ceiling in the galley. The cook's going to be mad." I was young. I was just a youngster then. Hell, I was in my early twenties when that happened. I had just walked out there, and I was just looking at the moon. Everything looked so good, and then I got locked out.

I had a guy go under a barge hooking up a hose. We had a box to load. It was an empty. He was kind of rough looking, hippie type. We were going to hook up the barge, and we had to move a crossover hose. So we got out there, and I was out there with him. They had about three or four of us out there trying to move a crossover hose over. The mate (which was the guy this happened to), he was at the end of the hose, and the barge was tied up. Every time it was ready to go, all we had to do was move the hose, connect the dock on them, and start loading. While we were moving this hose, it was kind of kinked up and he walked too close to the edge. When we straightened the hose out to drag it, the back end of it kind of whipped around, and it hit him, and he went over and under the barge. I thought that was it for him because when he hit that water, he went below the empty. We were all standing right there, and we saw him go over, but there was nothing we could do to stop it. He was

twenty feet away from us. I was captain on the boat, and I said, "Oh, no!" Boy, we started running to the back where the boat was. I said, "Maybe he'll come out on the side of the barge." We had spike poles and the throw rings. He came out right by the boat. I was standing right on the front of the boat when he come out, me and another guy, and we handed him the spike pole, and he caught it. He was still alive. We dragged him up on the boat. He said, "Cap, you're not going to believe this. I could breathe underneath that barge. There were air pockets underneath this barge, and I took a couple of breaths." That barge was three hundred foot long. He said when he was on the bottom, he could feel the bottom of the barge, and he knew he was drifting quickly with the current. He just kind of walked himself down. So he wasn't fighting it. He said, "And there were air bubbles underneath the barge." He said, "I caught a couple of breaths." He wasn't hurt at all. One of the guys out of the office came and picked him up and brought him to the doctor, and the doctor said, "Ain't nothing wrong with him. He's okay."

The technology is real good for pilots that are coming up like the mapping system where you know where every buoy is. You put it in yourself, and you can run. When the buoys are not in the river, you could still use that. But that's the best thing they ever put on a riverboat because you can run with that thing. The radar goes out, you're still alive. When I came up, you had a searchlight and a radar that might work good, and that's the way you ran. My dad taught me how to read the water too. Back when I started, you didn't have all this technology. We used to write to each other. Can you believe that? Letters back and forth. I used to talk once a week on WaterComm.

This career takes a kind of a loner type that doesn't mind being by himself. You're by yourself for six hours, twelve hours a day, and then you're on that boat for twenty-eight days.

I like the challenge of the river. It never does the same thing to you.

One story I could tell you. I was on the boat when the dam broke at Markland. The big ice storm. It was between Louisville and Cincinnati. I was there when they had to dynamite the river to get the ice flowing. It gorged above Markland Lock to an excess. Everybody was stopped. The Corps [of Engineers] had to come in there and dynamite it to get the flow going. They closed the river because nobody could go through the gorge. The lock was closed. All the ice was piled up on the gates. It was the biggest mess you have ever seen in your life. They decided that if they dynamited it, it might get the flow going, which it did. But only one problem, the people above the lock. I was below the lock . . . They told everybody to secure their tows and their boats as much as possible because they were afraid that if they dynamited, when the flow started moving, the ice was so heavy that the boats didn't have any choice but to go down with it. It went through that dam, kill everybody on the boat. But they risked it, and they dynamited portions of it trying to keep the boats from getting into the flow. Finally, they got it broken loose to where it started free flowing. Oh, Lord, I could see the ice coming towards me. Now, it did hit us and everything, but we were at safe harbor. We got out of the way, but that was a mess up there.

I got to tell you this story. You ain't going to believe this. We were in the wheelhouse one day, and this new guy came on the boat. I forgot his name. Doesn't really matter, but I used to wear cowboy boots all the time, and I had the pair of these lizard-skin cowboy boots I used to wear to the boat. Birdie always wore his LSU jacket, the purple and the gold. A real nice jacket, you know. We were going up, and we picked up a crew. We changed crew at Vicksburg. We were going up the river. That next day, they went out on the tow, him and John. John Boswell was a mate on the boat. He went out on the tow, and that new deckhand was with him. Me and Birdie were changing watch up there, and I got to looking. I said, "Man, that guy's going to ruin that new pair of boots he got

on there." Birdie says, "That son of a gun has got a jacket just like me." I said, "Really?" I looked at Birdie. Birdie looked at me. I told John, I said, "Tell that guy come back to the boat and come up in the wheelhouse." Sure enough, he had my boots on. He was fixing to go deck in my three- or four-hundred-dollar boots, and he had Birdie's LSU jacket on. He had cleaned our rooms that morning. That was part of his job. I said, "Hey, man," I said, "where you got them boots?" He said, "I got that out your closet." I said, "What are you doing in my closet, and who told you you could wear them boots?" He says, "Well, they told me when I came out here that, you know, anything that's on the boat that you want you could have them." I said, "Who in the hell told you that?" He said, "I got that from somewhere." He said, "I didn't think y'all would mind." And Birdie said, "Where you got that jacket from?" He said, "Is that my jacket?" Birdie had his jacket with his name on it that says, "Birdie." He said, "You get that damn jacket off and go bring it back in my room, and don't ever let me see you in that room again, boy." He had gone through drawers, and he thought he could just take it. Yeah, had my boots on. I looked at Birdie. I said, "You talk about some nerve, huh?" He was going to go out there and deck like that.

Then there was the guy that was trying to kill John. We were going up the river, and we had a crew change in Paducah. Bob was on the boat with me. He was the mate. I was the captain. Birdie was on there with me. We were going to Catlessburg, Kentucky, somewhere up there. Anyway, this guy— when we changed crew, they brought this new crew member out there. John was a mate on the boat says, "You know something, Cap?" He says, "This old boy won't talk." He said, "I tell him what to do, but" he said, "when I do, he just looks at me, you know." He said, "Not a good look." I said, "Really?" He said, "Yeah." He said, "Something's not right there." So John told him to do something, and this guy would sit in the deck locker, and he would get all the fire axes off the boat. He'd go one by one, and he'd take a fire ax. He'd go in the deck locker, and

he had a file and a stone, and he would sharpen this ax until it would cut hair. And he'd be sitting in the corner. He wouldn't associate with hardly anybody. He rarely ever spoke. John said, "Man, what are you doing?" He said, "I like to sharpen axes and knifes." But John said something was funny about him. He kept looking at John all the time.

So I got off watch one day, and John says, "You need to come see this, see what this guy is doing down here, Cap." So I walked down there, and I walked in the deck locker when I got through with supper. Sure enough, he was sitting in the corner, and he was sharpening an ax. So I walked up to him, and I said, "Hey, man, what are you doing?" He said, "I'm sharping this ax." And he said, "I like to sharpen stuff." He said, "I used to do that all the time when I was younger." I said, "Really?" And like I said, you could split hairs with that ax. I said, "What are you going to do with that ax when you done? You gone cut rope or what?" He said, "Kill John." I said, "What?" I thought he was just joking. He says, "I'm going to kill John." This guy had dark, dark eyes. And, I mean, when he looked at you, when he really looked at you, this guy wasn't kidding. So that kind of scared me. And John was standing by the door. I walked in there, and John kind of followed me a little bit. I said, "You heard what that guy told me?" He said, "Yeah, he's been telling me that. Because when I asked him what he's gone do, he said, 'I'm gone kill you. I'm sharping it up to kill you.'" John said, like me, "I thought he was joking." I said, "Man, let me get to the phone." So, I called the office, Eugene. I asked Eugene, I says, "What about this guy?" Eugene said, "Yeah, we picked him up couple of weeks ago or last week." I said, "Where is he from? What's his background?" He says, "I really don't know." He says, "He come in here." He said, "We needed some hires, and I signed him on, and he signed the paperwork and everything." I said, "You mind checking that out for me?" Come to find out, he got out of Parchman prison only a few weeks before that, and somehow, he finagled his way in. This guy was bad news. We got

him off the boat at Cave-In-Rock. Never told him anything. We let him go to bed, and we called the people. They met us at Cave-In-Rock and came got him. Didn't put up a struggle or anything. He was a good worker. He would work when you get him out on the tow. But he wasn't going to take orders from nobody. It scared me. It scared me enough to make a few phone calls and to get him off the boat. It sure did.

When I was working with Chotin, I had a guy that caught a boat out of Plaquemine. He was really nuts. He said that Captain Pete was trying to murder him on the boat. We used to put him off at the locks when we were going up the river because Captain Pete said, "This guy is going to kill me, you know." He said, "He done threatened me." He'd get off the boat. We'd put him in an ambulance with two guys in the white coats, and he'd catch us at the next lock. He'd be waiting on the lock wall. I said, "How in the hell did he get away from them people?" We were going up to Chicago. The locks were only like twenty miles apart. How would he get from one lock to the next, and he was waiting at the lock wall for us? As soon as the tug hit, he'd jump on the boat and go in his room and lock the room. Well, when he came back on the boat, I called them up again. And the first time that he escaped, some kind of way, he got away. But how did he know where to go? Chicago is a big place. He would be standing on the next lock wall. He didn't have any money. But when we would put him off, he escaped and met us at the next lock. So I called them back, and they come got him again. I said, "Make sure this guy doesn't get loose." So, what they wound up doing, the company flew him back home to Plaquemine, and they put him in an insane asylum. Crazy stuff.

Steve Golding is the best guy I have ever worked for. He cares very deeply about his people. That's what I tell these guys all the time, the young guys that come out here. Won't be no mistake here at GBL. I said, "You'll find out if you ever go to the big boys where you're just a number. Because that's all it is. You're replaced. When you stop performing,

you're replaced. They don't even know your name. But one way or the other you make real good money out here." I like being in a place where I know everybody, and everybody knows me. And it's on a first-name basis, and people care about each other.

When I was a kid back in the old swamps, we used to trap nutria, and we'd sell the pelt, and then had a guy that used to come around, and he would pick up the pelts. Oh, I was just, oh Lord, ten years old, twelve years old. And we used to trap. I used to love to go trolling with my dad. We'd catch shrimp or fish, and we had a camp in Leeville, and we'd go straight to the camp. Boy, you can't get it any fresher than that. I used to eat oysters in a pirogue with a bottle of hot sauce. We'd pick the oysters out of the water, open them, put on a little hot sauce, and bring some crackers with me. Me and my mama and my daddy and all my brothers would eat it right out the shell. Oh man, you talking about good. Fried shrimp and fish. My grandpa built pirogues. A pirogue is a small boat. It's a small boat they use for fishing, trapping, anything to go in the swamp that was light draft. They used to make pirogues out of logs.

I love the river. In fact, when I retire, I don't know what I'm going to do. I'm going to play it by ear. I want to look at some football games and stuff without having to leave. I want to be off a full football season. That's my goal, and I can look at any game I want. Believe it or not, it seems like every time I ride, that's when the best games are. I seem to miss the best games when I'm on the boat. And then when they play the "gimmes," I'm at home. That's not right. I want the whole season. And I like pro football. I like the Saints, but they ain't good, but I'm big on football now.

HERMAN BLATZ "BUTCH" HARRINGTON JR.

– b. 1951 –

My given name is Herman Blatz Harrington Jr. I didn't choose that name, of course. My mother insisted. My father nicknamed me "Butch." The way I got started on the river was, first of all, I needed a job. It wasn't any sort of Mark Twain thing or anything. I was twenty-two. And I was through with music. I had gotten off the road, done. Bobby Gardener was the port captain for Alter. And my mother said, "Well, I'll call Bobby." In 1974, that's all it took. I don't even know if I took a physical or not, but that's how I got started. I made one trip. I had six hundred dollars in my pocket. I came home. I bought wedding rings, and I quit. Then three years later I went back in '77, and I stayed. What made me stay on the river the second time around was that I never did forget that first trip.

The second time I went back to Alter once again, I knew I was going to make a career out on the river. When I went up into the wheelhouse, that's all it took.

I am a musician, and there are musicians on the river. I play a guitar. There's more musicians out there than you would think. There's that one magical time where a song comes to you complete, and all you can do is sit down and just start writing.

And that is what happened to me on my song "River." I remember walking across the head of the boat of the *Shirley Bowland*, and the lyrics were just coming to me, and the melody of the song was coming to me. And so I just kept right on walking, going to the galley, and sat down and wrote the song in fifteen minutes. The lyrics, it begins with the chorus:

> The river flows long
> River run wide
> I don't know why that I keep coming back
> I hate her when I'm with her
> And I miss her when I'm gone
> Old river why can't you just leave me alone?

Then went to a verse:

> I'm a riverboat man
> And I reckon I'm proud
> A hard working man
> Lord, there ain't no doubt
> backbreaking work just to earn my pay
> And every minute I'm thinking I'll leave her someday.

That's the chorus.

It's a love/hate situation old timers say
The old man leaves the river
His memories never fade
They say he'll pray for his happiness
But the river don't let go
There ain't no rest.

And then the last verse is:

Old river sing a song
I'm way away from home
I'd like to see my wife
I've been three weeks gone
Sing a song
Make me laugh
No time for tears
Maybe I'll leave this way of life
Well, maybe next year.

I never could use the word "towboat" in a song. And river songs that I've written, towboat just didn't ever make any sense. But the songs that I have written about the river had more to do with it being a way of life than slinging rigging or talking about a towboat or talking about a captain or talking about a chief. It was always more about the lifestyle—hating being away from home and hating being away from the river. It's just a conflict.

Well, the river, it calls you. I believe it gets in your blood. It pretty much has to. I mean, if it didn't, then you wouldn't stay out there. You couldn't stay out there. It takes a special kind of person to make a life on the river.

I like being on the river. It doesn't hold as much for me as it did when I was younger. When I was younger, I was packed and ready to go three days before I caught a boat. And now, I'm throwing things in a suitcase the very last moment to get ready to go.

I am still working full time. I've got three years to where I can leave. That will give me twenty years with ARTCO. It means a difference in pension and health benefits. But I'll always have a license as long as I'm healthy enough to do that.

I am a child of the '60s, a boomer, and so there's a lot of guys my age out there, a phenomenal amount of guys. When you get to a certain age, then everybody all of a sudden wants to take an interest in when you're going to retire. "When are you going to retire?" So, last year, I started telling these guys that we talked to for years, and I said, "I got four years left." And then I began to hear four years, four years, four years. And I thought, my Lord, what if all of us go at the same time? But that's a large group of people in that generation I'd say from 1950 to 1956 or '57 as far as the baby boom generation. And if they decide to get out of the workplace, I told my wife, I said, "There's so many of us leaving, who's going to take care of us because there's not that many coming up behind us?" I don't know. It's a wonder.

I would recommend this life to young people coming up. I have said for years, literally years, that the river is the best-kept secret, the best-kept secret as far as an industry and a place to work.

There are often times that I've seen sunsets or sunrises, and I think that no one, unless you worked out here, could see this. You see cliffs, and you see holes in those cliffs. You wonder if people actually lived prehistorically back there once. But you wouldn't know unless you were on the river. You wouldn't know that.

I was on with two boys on the *Alter* boat, and they decided to make some wine. We were in our twenties. And I said, "Y'all know how to make wine?" They said, "Shoot yeah." They went down there in the galley, and they got grapefruit juice in those cans. They got yeast. They got sugar, and they got this and that. And they found some sort of big glass container and put it all together. It was one of those cold winters, and that's the reason why it was made. We were cold out there. But it got frosty and it just got ugly looking. I thought man oh man. So I call it the nine-day wine because after nine days we decided, well, because one of the boys said it's colder than you know what out there. At midnight, we were getting ready to go out and check tow, so we went and got us a tea glass full. It was

so Godawful sweet. But then, when it hit, you were warm all over, warm all over. But it was the most awful-tasting stuff I have ever tasted in my life. But I never forgot that nine-day wine. The worm comes out of the top of the bottle, and it's made out of copper, so each chief had his own design of a worm. That was their pride right there.

I wrote a song about Odie. It was *Ode to Odie*. At the very beginning of the song, I'm talking about my first year in the wheelhouse. I was working for M/G Transport, so I met the Crounse boat that Odie was working on that I had worked. And he happened to be up in the wheelhouse at the time. So I talked to him, and I remember I asked him how he was doing. He said doing pretty good but his old legs weren't getting around as good as they used to. He said, "I'm glad to hear you made a pilot after all though." There was something a little catchy about that chorus. The chorus was

> They said he once was a hell of a man
> They said he once was a hell of a man back in the
> days when they were in demand
> He loaded cross ties
> He loaded cross ties to a moon shoulder hand
> He never thought of being old
> He's a river man.

And somewhere in the song, I mentioned where Odie, he's warning me about the river. He's warning me don't let the river take your life away because forty years ago seems just like yesterday, and it does seem like forty years have gone by just like that.

Things have changed a lot. I can't say it's worse. Everybody says—well, it's not like it used to be, and the good ole days of the late '70s and '80s, but we have things so much better out there now as far as the technology that's come along that's been given us. Without these electronic charts, I don't know. I worked with a Cajun. No, I was going to say coon ass, but my wife, she says, "Honey, you can't say that." And I say, "Honey, that's what they call themselves. They're proud of that fact. They wear belt buckles that says, 'coon ass.'"

Joe told me—he's like a spider monkey. He was real small. He always had that chest out. And he described himself as just an old dumb coon ass with an eighth-grade education. But he was so meticulous, he could draw charts that were just amazing. So when this electronic thing came along, at first before you could download—now you can download. Any time they put a new dike in, or they put buoys in, you can download that from the Internet. Back then, you had to put your own buoys in and put the dikes in, and Joe was doing this. And so we lived with this river pro and all the other softwares for two or three years. And he came up, and he sat down to relieve me, and he said, "I'll tell you this." And he took a lot of pride in his memory. And that's always been known with river pilots, memory. Well, I've been trying to tell Joe. I said, "You know, when you tell a story about something that happened at a particular bend or particular light and"—then all of a sudden, we'd find ourselves blank, even Joe. And so he sat down that one day. He said, "I tell you what Butch," he said, "if that program quits, I'm backing this son of a bitch in. I'm not going any further." He said, "I don't even know how I was even able to flank a tow before I had this." He was mad about it, but I had been trying to tell him. I said this stuff is so good, it's just dumbing us down. We didn't have to have light lists. Joe used to know lights by the mile marker. He would know all of that, but it went away because there it is right there in front of you. It shows you where to go.

CHARLIE RITCHIE

– b. 1951 –

My name is Charlie Ritchie. I started working summers when I was twelve years old, but I've been riding boats since I was two weeks old. My mother was on a boat with me two weeks before I was born and two weeks after. So I've been on the river, I tell people, virtually all my life. I've been doing this forever. My father is a mariner. I'm fifth generation. And my father and all his brothers were mariners. My father's name is John Baptist Ritchie Sr. And then my grandfather was a mariner. His dad was a mariner. The first generation is George Ritchie, who was in the book by Mark Twain, *Life on the Mississippi*. [He] was the first of our family that we know of on the river. And now there's a sixth generation, my daughter, my niece, and a couple of other cousins and so forth of those two girls that also work on the river.

I was actually running mate at sixteen years old. I went all the way to Pittsburgh running mate on the boat. My brother Larry was the captain. It was a great experience for me. It's what we do. It's what we've always done. Our family has always been out there, so it wasn't anything unusual to be on a boat at sixteen running mate. I had a cook ask me the other day when I first started, and I told her twelve,

and she said that was impossible. And I said not if your daddy owns the company, so. It's hard work, and it's dangerous.

I have the longest license on the river. I have 4,911 miles that I've drawn from memory. Every major river on the Mississippi River system. I've drawn the length of the Mississippi, the Ohio, the Tennessee, the Cumberland, the Illinois, the Kanawha, the Monongahela, and from memory. So, it's fairly extensive. Plus, I have license to run the Great Lakes. I have unlimited tonnage master's license and unlimited tonnage first-class pilot which is very unusual. I got those when I was very young. I got my original license at twenty-one. My master's license I got when I was twenty-four. I have been blessed my whole life.

I did it in a fairly short period of time. My original license, I only got fifty-two miles of license in 1984. I had been on several boats. Every time I would get off a boat, I happened to be in Natchez, Mississippi, and I'd look up, and there was the *Mississippi Queen*, and my dad was working on there. He had been on that and the *Delta Queen*. And so I stayed a night in a motel. Next morning, I'd come down and said "Hi" to Dad. The captain on there said, "You need to come to work here." I'm like, too

many old people for me, and I wouldn't do it. The third time I was down there, I said, "Have those people call me." They called me, and I told them, I said, "I only got fifty-two miles of license. I've got to extend to have enough license to work for you." And they said, "Well go get them, and we'll pay for your license." I said, "I got to live." So they actually paid me $25,000 in 1984 to draw the river and get my license. Then I extended the rest of it that I needed to get over the next year and a half. Actually, running five thousand miles was what my goal was. My original goal was just get more than dad because of father/son rivalry. Dad had his at a younger age. He drew his by the time he was twenty-three. My dad was captain on a boat at sixteen. My dad's oldest brother was original half owner of *Igert,* in Indiana, out of Paducah. Dad was born in 1923. So that was 1939 he's captain on a boat. My dad was also captain on the steamer *Jason,* which was second only in power to the famous steamboat the *Sprague.* It was one of the reasons I was intrigued to go on the *Mississippi Queen* because it was a pure steamboat. It's generation power was even steam.

My dad could take anything anywhere anytime. When I decided I wanted to make a career as a pilot, my dad broke me in. My granddad and my uncles broke my dad in.

Dad had a brother named George. When I was twelve, I would get on a boat in Paducah and ride to Memphis. I steered around Craighead Point with a tow we had. We had twelve loads on an eighteen-hundred-horsepower boat, and he let me steer around there. Uncle George had this unique way of talking, and he said, "Son, you got God-given talent." And I just swelled up. That's what really made me decide this is what I wanted to do.

If you learn to handle a boat with light boat one barge in high water, low water, high wind, no wind, dead water, it's what makes you be able to control a tow because it's all relative to that.

My Uncle George was really laid back, and there were so many great stories about Uncle George. He was working for a company called Olcott Marine

out of Paducah. The adopted son of Mr. Olcott was a fellow named Hardy Roberts. Hardy was on a boat with Uncle George, and they had a long, slender unit tow. Single wide tow with four barges in it. Probably eight hundred foot long, and the boat probably had a thousand horsepower if they were lucky. They were coming out from under Belmont Point right across from Columbus, Kentucky. When the current was coming down around there like that, and it hit the head of the tow, it starts to push the tow to the right severely. Uncle George could roll a cigarette in one hand. So he's sitting there rolling a cigarette. Hardy says, "George, George, is she going to slow down? Is she going to make it? Is she going to make the turn? Going to straighten up?" Uncle George continued to roll his cigarette, licked it, struck a match on his pants, took a couple of puffs off of it, and turned around and said, "I don't know, Hardy. She's hard down." Meaning he had all the rudder he could put on it. He had done everything he could do, and basically, it's in God's hands. "There's nothing else I can do."

Of course, it did straighten up, but Uncle George was one of those people that nothing phased him. Nothing ever phased him. He was on a boat that sunk above Lock 53 one time, just the lower deck sank, and he was on the second deck, and they forgot about him. So the deckhand comes up a couple of hours later to wake him up to tell him. And he said, "George, George, get up." He said, "Get up. The boat sunk." Uncle George slowly rolls over and says, "When did it sink?" He said, "Two hours ago." He rolls back over and covers up and says, "Call me when the tug gets here, because it's not going any further if it's already sunk." He was just a laid-back guy.

There's an old saying that "once you wear out your first pair of boots, you're always going to come back to the river." I've quit and done a lot of things. I've been lucky, as some people say "blessed," but I've done all sorts of things. I've been in the office a lot in management. I've been in operations. I was in a wheel shop at a major shipyard for four years and

had no idea how to run one and got in and figured it out. So my career has been so widely diversified that when I go to apply for a job, it's sometimes difficult because I didn't stay one place for twenty-five years, but at the same time, I've gotten all these vast opportunities and experiences. The steamboats, they were great. When I went on the steamboats in '84, I was there exactly ten weeks to the day, and I was the youngest pilot there. Ten weeks after I went to work on the boat, I was captain on the *Mississippi Queen*, which at that time was the largest sternwheel steamboat in the world. Oh, that boat was wonderful. It took me a while to get used to it because I was young. You can imagine that at thirty-three years old, a lot of people, including passengers, didn't think I had the experience or knowledge to be at that point. It's funny how I got the job. My boss, Harold DeMarrero, was sitting on the *Mississippi Queen* going from St. Louis to Saint Paul running a seven-night cruise. The first night out he said, "You know, I think next year I'm going to let you be running captain on the *Delta Queen* a little bit." I said, "Okay." The next night, it was, "I'm going to let you maybe come out at the end of the year." The next night it was, "I may let you run captain on the *Mississippi Queen* a little bit." By the time I got to Saint Paul, he said, "Hell, here are the keys. You're going to be captain on the boat." I said, "When?" He said, "Today." I said, "Really?" So, we kind of did a ceremonial passing of the keys.

It was interesting working on the *Delta Queen*. There were a lot of famous people that came on there, like George Foreman, and Helen Hayes was wonderful. I loved her. She'd ride every year and always spent her birthday with us, and we have some beautiful memories. Ginger Rogers rode the boat with my dad and just a lot of really nice, famous people, like Paul Harvey, who were very gracious. We had passengers that rode over and over and over and [I] got to be good friends with a lot of them. I was there from '84 to '88 as captain the whole time basically. I went back one time. Made a trip on the *Delta Queen* just so that I could

propose to my third wife. I proposed to her at Hannibal, Missouri. They called me and wanted me to go, and I said, "I'll go if she can go," and they were like nope. I said, "Okay. Stay home." "Oh, well, then she can go," you know. So, I got on at Saint Paul and came down to St. Louis and got off. I had passengers ask me, "Why don't you move up to a cruise ship?" Well, in the first place I don't want to have to fight with sharks to swim back to shore. I like to be where I can see shore and swim to it. It's not my area of expertise. Running on a charted-course straight line is not what I do.

Piloting is a specialized art form. What we call brown water, not blue water—blue water being the ocean. Brown water being the muddy water because of the rains come down, and it gets brown, and people could see that.

On the steamboat, it was probably the best job I ever had, but I got bored with it. I get bored easily. I got to the point where it was becoming work. When it became work, and it wasn't as much fun, I decided to do something else, and I went back to towboats. Captain DeMarrero told me one time, "You know what the great thing is about riding a towboat?" I said, "What's that?" He said, "The end of your watch, the end of six hours, no one's gonna pat you on the back and say you did a good job. You know whether you had a good six-hour watch or not." I said, "There's a lot to that." So, through my lifetime, I've experienced all these people, and I was lucky.

Back to steamboats. The other great thing about that was we had lots of opportunities to show people things that were just like Mark Twain's day. I would tell them that this is the only way you could still see the river like Mark Twain did. It's very, very similar. If you rode those steamboats, and you can put yourself in that mindset because people rode packet boats, but they were also passenger boats. They carried passengers and goods. And quite a few passenger boats. That was one of the main modes of transportation for a lot of people. It was the same way he saw it. He learned it, as he says in the

book *Life on the Mississippi*, four ways: upstream, downstream, daytime, and nighttime. I had a lady, when I was doing the navigation talk one day, she asked me if Twain was among my heroes. I'd never read any Twain until I went over there. Never had thought about it because I had my family. I didn't need Twain.

Brown water is so different than blue water because it's specialized. The river will change course.

This is from Mark Twain's *Life on the Mississippi*. It's chapter 13, called "A Pilot's Needs." I'll skip down to what I consider the important part. It says,

> One cannot easily realize what a tremendous thing it is to know every trivial detail of twelve hundred miles of river and know it with absolute exactness. If you will take the longest street in New York and travel up and down it, conning its features patiently until you know every house and window and door and lamp post and big and little sign by heart, and you know them so accurately that you can instantly name the one you're abreast of when you are set down at random in that street in the middle of an inky black night, you will then have a tolerable notion of the amount of exactness of a pilot's knowledge who carries the Mississippi River in his head. And then if you will go on until you know every street crossing, character, size and position of those crossingstones, and the varying depth of mud in each of those numberless places, you'll have some idea of what a pilot must know in order to keep a Mississippi River steamer out of trouble.
>
> Next, if you will take half of the signs in that long street, and change their places one a month, and still manage to know their new positions accurately on dark nights and keep up with those repeated changes without making anything mistakes, you will understand what is required of a pilot's peerless memory by the fickle Mississippi.
>
> I think a pilot's memory is about the most wonderful thing in the world. To know the Old and New Testaments by heart and to be able to recite them glibly, forward or backward, or begin at

random anywhere in the book and recite both ways and never trip or make a mistake, is no extravagant mass of knowledge, and no marvelous facility, compared to a pilot's massed knowledge of the Mississippi and his marvelous facility in the handling of it. I make this comparison deliberately, and I believe I am not expanding the truth when I do it. Many will think my figure too strong, but pilots will not.

I do agree with this even today. It has changed in the respect that we now have electronic charting systems. We have a radar. A radar is like a TV scope. It shows you what you can see, if you can see, when you can't see. That's the best way I can describe a radar. It's not a sonar. It doesn't show you anything underneath, and it doesn't blip. And that in conjunction with the new electronic charting systems, rather than having the paper maps like we've all had for years—I've still got them. I still use them. Mine are well marked. They're colorful. There are drawings in them. They have pictures of all kind of things and what we call marks or bar book or whatever that tells you can run over this place and behind these buoys and up this sandbar with this much water at this gauge and ran it on a certain date so that you know as the river fluctuates whether there's water over there or there's not so you can safely navigate.

The charting system now has the bridges in there. It has the dikes in there. They are extremely accurate.

Most of those charting systems have a tracking feature where you could put a track line on somebody ahead of you and watch them make the Vicksburg Bridge for example. Even an inexperienced pilot can follow their track and make that bridge.

I watch everything because it's what I learned to do. I watch the buoys and how the water tails off the buoy. Some people call it the whiskers. That's what they are. When you see the tails on both sides, they're called whiskers. But I do believe that virtual buoys will be used in the future. I think twenty years from now, you won't see a hard buoy because

of the cost of them. The government's cost and the maintenance alone is huge.

The largest tow I ever pushed southbound is forty loads. Largest tow I ever pushed northbound is fifty-six barges, some loaded, some empty.

Being on the *Mississippi Queen* and a towboat are vastly different. The *Mississippi Queen* was like a single-screw light boat and very quiet—absolutely. It was so quiet it was hard for me to sleep sometimes. I used to go home and put a floor fan in the floor because I liked that woo, woo, woo, woo, that constant noise. Loaded tows southbound versus northbound, two different animals itself. I personally detest northbound tows. I hate going three miles an hour. I hate going up the river slow.

The people that I've worked with over the years have different quirks and personalities and so forth. Captain Peanut Hollinger. He's certainly a character and very colorful, a great pilot, a great engineer, a great all-around boatman, period, and could tell the best stories I've ever heard in my life. I've heard him tell stories about his daddy. His daddy was a pretty rough old guy. His name was Dub. Captain Peanut's name is W. A. Hollinger Jr., so, his dad [is] W. A. Sr., but they call him "Dub," DUB. And he was rough. He was tough. He was a heck of a fighter. One day he got into it on the radio with a guy, and the guy said, "Tell you what, if you just back in over here old man, I'll whip your butt." He said, "Park it." And they both had rock barges, deck barges, and they went over there and tied off alongside each other, and Captain Dub went over there and beat the fire out of him. They turned loose, and the guy said, "Got all I wanted." So, you know, he's like, "I don't want no more of that." Captain Dub was quite a bit older than him, but, yeah, Peanut's got some stories.

I've explained this to people on the *Mississippi Queen*: I detest the word "wheelman" because it just doesn't fit what I do. Wheelman's a term that started out in the canal. All those boats there were single screw tugs with no flanking rudders, one steering rudder, and they had a wheel. That's where the term wheelman came from, and it kind of segue

wayed up into brown water, but where we are, but nobody's got a wheel.

The funny thing about the river is, there are a lot of people you never meet in person because you only talk to them on the radio. You never see them. You never have a clue. You have a preconceived notion of what they look like, but you don't know. I remember the first time I ever saw Eddie Tapp. I had known him for a long time. Eddie's deceased now but lived here in Memphis. I was in the airport getting ready to catch a plane, and I walked by the bar, and I heard this guy's voice. I walked up to him from behind. I said, "Hello, Eddie Tapp." Before he turns around, he said, "Hey, Charlie Ritchie." We had never met in person, but because of the radio, we just know voices, and as soon as you hear them, you know who it is.

On the river, we're like any other community or any other family. There are people you like and you don't like and people you respect and people you don't respect, but we're all doing the same job. We're all trying to get up and down the river and make a living for our family. That's all we're doing. We're just doing a job. And we're trying to do it the best we can for the company.

Well, I'll tell you what. We all think we're the best, and we should. First thing I do when I walk in a room with pilots and I'm talking to them I ask, "Who in here is the best pilot? Raise your hand." I'm the first one to raise my hand. And I go, "Every one of you ought to have your hand up. Every one of you should have your hand up because you should believe that you are the best pilot in the room. You may not be, but you should believe it." I don't care if it's a guy on a two-barge boat or one of our forty-barge boats. You get a skill set, and you do it. If he's doing that to the best of his ability, getting up and down the river and making money, he's an excellent pilot. That's what his job is, is to move product the best of his ability every day, day in and day out.

I've never been out of work that I didn't want to be. I've always had nice homes. I've built several new homes, custom homes. Been through three

divorces, and they're all doing well. I've lived a wonderful life. If I died tomorrow, I don't have one regret about the life I've lived. Well, we're all born to die, and we know that. I'm not saying I want to die, but we have to face the fact that's a possibility. And it's going to happen. It's not a possibility. It's just when.

My favorite quote of Mark Twain is about a pilot. And it's called "Your True Pilot." And the quote is, "Your true pilot cares nothing for anything on earth but the river. And his pride in his occupation surpasses the pride of kings." And, to me, that sums up who we are. I ask people, "What are you doing this for?" "Aww, man, I'm trying to advance through this then make this kind of money." I said, "You know I've never piloted a boat one day in my life for money." "What?" I said, "I've never piloted a boat one day in my life for money. I've made money every day I've done it." But I said, "I pilot a boat for my pride." Why should I do a great job? Well, I go on and do the best job I can because my pride drives me to do that.

I didn't start on thirty-five barges. I started out mostly with Dad and steering. I have pictures of me steering the boat when I was three years old when I was with my dad at Valley Line. People say, "No way." I say, "Yeah, whatever."

Life always deals you a deck of cards. You take a deck of cards; you get your hand dealt. You play what you're dealt, and you deal with it. My dad was born on a shanty boat behind the Duck's Nest, which is a little bitty towhead there in Paducah on the Tennessee River. Probably about mile 2, 3 on the mouth of the river there behind Owen's Island. He grew up with his daddy. Of course, it was tough

times. Nineteen twenty-three wasn't a good time to be born, I guess. But my real grandmother died early, so he and his dad were just on their own.

Dad was at home one day. And Fontaine Johnson and Dad were really good friends. He called dad, and he said, "I need you to get on this boat and ride down with this guy." And Dad said, "Where to?" He said, "Just ride down with him to Memphis." Okay, out of Paducah. So Dad gets on at Paducah, and he takes my youngest brother with him. My youngest brother, Paul, would have been thirteen years old. He gets up there to the pilot, and he says, "I'll help you." The guys that weren't familiar with the bridges, dad said, "I'll help you down around so and so." Guy said, "No, I don't want to do it, man." He said, "I want you to do it." They were twelve barges, four wide, three long. And Dad said, "Get up here, boy. Steer. Come on back here and sit down. Let's visit." So, Dad's trying to talk to him. You learn a lot from a guy talking to him about what they do and don't know. But Paul was up there steering. He steers down through the Irvin Cobb. The I24 wasn't built yet. Steered on down over the pass down to Cairo. Steers through the IC Railroad Bridge. Dad's like, man, I'm pretty proud of this boy because at the railroad bridge Paul just turned around and said, "Well now you just hold up on those reds, and you'll be fine. Just stay up there on that pier. Steer down through there." And Paul cleared the railroad bridge, and he clears the highway bridge, and he's just thirteen years old. He turns around to my dad and said, "Hey, Dad, are we going upstream or down?" And this pilot's sitting back there going, "Oh my God." He said, "There's a thirteen-year-old boy doing what I thought I couldn't do."

night of the steamboat race, up at his home. He had these two baby grand pianos that kind of backed up next door as he called it in his parlor. He played the piano and the calliope and of course I did too. So Doc played, and I played. So there was always a lot of piano music and that going on. But then one night, Johnny Hartford of the *Julia Belle Swain* was in town. And Johnny Hartford was on the *Julia Belle*, and he came up, and he had his banjo and his fiddle. Probably one of my most fond memories as a musician was being able to accompany him. He played the fiddle and sang. I was on the piano. We did the old Steve Goodman song, but Arlo Guthrie made it famous, "The City of New Orleans," which that was just a memory that will go to my grave with that.

You wouldn't believe some of the stuff that used to go on on the *Delta Queen*. We had a guy who was the saxophone player in the band at night and ran the gift shop during the day. He was messing around with one of the passengers. And, well, he was coming up this side, him and her, and her husband was coming up the other side. And they met, and they were in what we call the Texas lounge, which is up on the Texas deck. And there was a bar up front. So he was coming up one side, and her husband coming around, and boom they meet up. Well, she had a diamond necklace on. I didn't see it because this is when I was still a night watchman. Me and my buddy, we were downstairs on a deck below. The next thing we know, we hear all this hollering and screaming stuff, dah, dah, dah, dah,

dah, dah. We run and get the captain, get the mate, whoever we need to get, and everything gets broke up. But next thing we find out is, apparently, this diamond necklace got pulled off, and there's diamonds everywhere. So the mate of course gets the crew, "Y'all come up here and try to find all these diamonds." Well, you know what's going to happen to all those diamonds. There weren't many found that night or at least admitted to. That was one of the more colorful stories on the *Delta Queen*.

I don't want to use too many clichés, but the old cliché about the river's in your blood—I don't think you can explain it to anybody. There is this want, this desire. When you're on the boat, you can't wait to get home. But when you get home, you can't wait to get back to the boat. It's like you're almost constantly torn between these two lives you're leading. But a river man—they're highly skilled professionals at what they do. Anybody from the deckhand on up it's highly skilled, and you have to be knowledgeable about what you're doing. The engineers and the captains out there—I don't think they get enough credit for the skills and the professionalism and the knowledge that they possess out there. When you think about some of the cargoes they're hauling past big cities, past large populations—not only the lives but the dollars that are involved and all those things. We know that the river is the safest, most environmentally friendly, fuel-efficient way to move cargo. In the scheme of things, we have very few accidents considering the amount of cargo that's moved on an annual basis.

DAVID CHRISTEN

– b. 1953 –

My name is David Christen. When I started, I was eighteen years old. My first job was on a tug boat working in the lakes and the bayous in Lafitte, Louisiana. I come from a line of mariners.

My grandfather had a tugboat named the *Linda*, and it was a little bitty old wooden tugboat. We had been in boats since we were kids, and he asked me if I wanted a job. So I went to work on it at seventeen. My dad taught me how to run a boat. Shrimp boats. A boat is a boat to a pilot. Once you learn how to drive a boat, it doesn't matter what boat you go to. You should be able to drive it. But I had been on the water probably always.

I'm what's known as a self-made pilot. I went to work in the fleets, and I was a deckhand. We worked twelve hours on and six off. Had a captain. And at that time, they labeled them as a mate and then a deckhand. The captain ran the boat for twelve hours. The mate ran it for six hours while he slept and decked six hours while I slept. The old boat I started on was named the *Ramrod*. It was a junky old boat, and nobody really wanted to stay on it, so I guess that's one reason I got to move up that quick. But my captain couldn't read or write. Now, he was an old Cajun. He could barely speak

English. His name was Euless Surgie. He couldn't read or write, and I did all his paperwork. Of course, me working on a shrimp boat and everything, I learned how to cook when I was probably ten, twelve years old. I was cooking. He asked me if I knew how to cook, and I said, "Yeah." When he came back, I had the old boat cleaned up. It was filthy when I got on there. I cleaned it up, and I started cooking. The first meal I cooked, a big ole pot roast. I decked, and I'd run out and tie a barge off, come back, and go write in the logs and do all the paperwork. And after about a week of that, he asked me what I wanted to be when I got big. He called me "Bunkie." He said, "Bunkie," he said, "what you want to be when you get big?" I said, "I want to be a skipper." He said, "If I tell you go to the left" with no port and starboard back then, you know, because "If I tell you go to the left, what you gonna do?" I said, "I'm going to back up on my left motor, come ahead on my right, turn the sticks to the left." "And if I tell you to go to the right, what you gonna do?" And I said, "I'm going to back up on my right motor, come ahead on the left, turn the sticks to the right." He said, "We got to spot a barge at the Bunge Dock." He said, "Watch my signals." And I said, "What?" He said, "Yep." He

said, "I'm going to go turn this barge loose." He said, "I'm gonna let you drive the boat." And that's how I started.

So, from then on, because after that first week he had never had home cooked meals on the boat and never had anybody not complain about doing his paperwork, he decked for six hours while I would run the boat. And so in a little over three months, I was his mate. I went from deckhand to mate. I would run the boat for six hours and deck for six hours. I was in the pilothouse by myself. I was never scared.

The largest tow I've pushed is forty. I'm basically a heavy-tow pilot. But I worked on the *American Queen* and the *Delta Queen*. It was like an early retirement. It's just so easy. And it's just different. The atmosphere is just relaxed. Everything is laid back. You meet a lot of nice people. But a boat is a boat, and I can drive any boat.

The *American Queen* has got Z-drives, and it's got bow thrusters. I like the *Delta Queen*—was my favorite boat. It's a true steamboat, and it did have bow thruster, and it had a little stern thruster on it because it didn't handle as good as the *Mississippi Queen*. We were called pilots. They had a master on the boat. Most of the masters couldn't drive the boat. Well, there's a few of them that could, and one of them was an organ player. He got his license because he had enough sea service on the boat to get the license. You know things were different back then. All you didn't have an apprenticeship or anything. You just got your license. If you had a license, somebody gave you a job. And them being a master, he's got the same license I have, but he just entertained the guests. He was the master, but he couldn't take that boat to Natchez. They had a couple of them that probably could. But there's a couple of them that I worked with that you wouldn't want to sleep with them driving [the] boat.

Those steamboats, they are almost like a sailboat. If you go in the engine room, you can hear the steam dump. The paddle wheel turns. But you get forward of that just midship on, you can't tell anything is running. You can't hear anything.

Jim and I were in a race together. He was on the *Mississippi Queen*. I was on the *Delta Queen*. We'd start in New Orleans, and we raced from port to port. And we all do these magic tricks; I know a shortcut and beat them by just wind. But it's fun. Then the two boats get together, and all the passengers are ribbing each other because we won today. But it's the steamboat race, and we leave from New Orleans and go to St. Louis and get there for the Fourth of July.

I would encourage anybody that this is a good career. I've got two sons that do it too. They're pilots. One works for Stone Fuel down in the harbor. And the other one, he's got it in his blood too. Right now, he's shrimping. When the shrimp's bad, he trips.

When I first started, most of the pilots were older than me, and I was captain. But I walked on the boat, and the pilot came up at midnight to relieve me—back then, we used to trade at six and twelve—and put two flashlights in my eyes. And he wanted to know, he said, "How goddamn old are you, son?" I said, "I'm twenty-seven." He said, "I got more goddamn years on the river than you are old." And I said, "Well, good. With your experience and my youth, we ought to do pretty good." So anyway, I went to bed, and about two o'clock that morning, he knocked a string of barges out of tow. I came upstairs. He said, "Take her. Take her. You're used to her. You know what she'll do." So I'm thinking all the experience and all this stuff that he's supposed to have, and he wants me to take over. So I take over and got everything back together. By the time we got it all back together was right around Washington, so I said, "Go ahead and go to bed." I said, "I got you." The next evening, he comes up to relieve me. That was about two o'clock in the morning. So the next evening at twelve o'clock when he came up to relieve me, I started telling him about some bad place. It was real low water condition. Channels weren't as stable back then. So I started telling him about problem spots. He said, "Son, there ain't nothing you can tell me that I haven't seen." He

said, "I don't need this." He said, "I got you. Just go on, and you can go to bed." About three o'clock that evening, he knocks another string of barges out. I come upstairs, and the first thing he said is, "Take her. Take her. You know what she'll do." Anyway, I took it got and everything off ground, got it all back together. And I told him, I said, "Yeah, if you do one more—" I said, "You don't want me to tell you what's going on." I said, "but if you do one more," I said, "I'm putting you off the boat." I said, "I'm calling." I said, "You're going to get off." The second one happened above Helena. And going up the Upper at Grand Tower, he runs out of the channel and knocks holes in the barges. Of course, back then we used to carry six-inch pumps. We had to get pumps on it to keep the barge up. Loads. So, I called John Lufcamp, and I said, "John," I said, "we got to get this guy off." I told him it's three accidents in five days. He said, "David, I've been knowing him a long time. He's a good pilot. He's just having a little bad luck." I said, "Well, I think it's something else going on," I said, "because he hates me to begin with. He hates me. And every time I try to tell him about problem areas, he tells me about all of his experience." And he said, "Just give him one more chance."

So we went to St. Louis, and we came out with sixteen barges on the *Harriet Ann*. That's all the channel would allow. It was on a Sunday. It was almost out of the Upper, and he came up and knocked, and I asked him if he wanted me to bring the boat out because he said he hadn't been up the Upper in a while. I said, "We already coming through 57 bridge. We only got eight more miles, seven, eight miles." I said, "You want me to just take it out of here," I said, "because you hadn't been up here in a while?" He said, "The damn day I can't get sixteen barges down the river is the damn day I'll be getting off the boat." I said, "All right." I said, "If you want it, you can have it." I said, "I'll come back

up," because we were going to pick up more barges at Cairo, and we'll go over the tow work. "No, just get it over with, so you don't have to come back." I mean, that's how much he despised me. He didn't want me to come back.

I just got to looking around, and there's a dredge working right above Eliza Point. Back then, they had little stub dikes in the bend at Eliza light. I saw what was going on, and he had the tow diagram. I just reached over there and cranked the phone in the galley. David, the guy that that used to work here, his mom's name was Doris. I said, "Ms. Doris." "Yes." Said, "Get away from the stove. Find you a place to sit down. Tell the guys to get ready." Because I knew it was too late. We were gonna hit. The port stern barge hit the tip of the dike. Knocked a couple of holes in it. It almost sunk. The boat hit the dike and broke all the face wires, all the port-side face wires. And the first thing he did was holler, "Take her. Take her. You know what she'll do. You know how she handles. Take her." So, I took it, and I did get it settled in. Right there in front of him, I called John Lufcamp, and I told him what happened. I said, "You will need a pilot at Cairo," I said, "because if he doesn't get off, I'm getting off." But anyway, he got fired that day. But he hated me so much because I was young and because I was a Cajun. But that was three times northbound, one time southbound.

A real river man is somebody that cares, because I try to be as fair to my crew from the youngest deckhand up to the mate, the engine room and all that, and we all have to be confident. We don't have to be cocky. You have some guys that are real confident and cocky, and they don't treat people the way they should. A real riverboat man cares about his crew. I care about the next boat's crew, too. So, to me, a real riverboat man cares. He cares about his people.

JAMES W. "JIMBO" DAVIS JR.

– b. 1953 –

My name is James W. Davis Jr. I was born in 1953, in Greenville, Mississippi, at Kings Daughters Hospital after seventy-two hours of hellacious labor as Mother said. I grew up in a river town. In 1956 I was three years old. My grandpa took me down to Warfield Point, which used to be the old ferry crossing prior to the Greenville Bridge being completed. I was sitting in his lap, and I pointed down the river, and I asked him, I said, "What is that?" He told me that it was the *Delta Queen*, the finest majestic lady on the river. I told him, I said, "Paw paw, I'm gonna drive that boat one day." he said, "Jimmy, you can do anything you want to." In 2001, a picture was taken of me, and I printed it out. I went to Greenlawn Cemetery in Greenville, Mississippi, and put it on his headstone, and told him I did it.

When I turned sixteen, Elmer Vickers give me a chance to go to work at the shipyard since I had dropped out of school. So I got a little taste of towboats there.

I went to work on the riverboats just as soon as I turned eighteen in 1971 for sixteen dollars a day. My mother took me to get in my first crew van at Weathers Transportation, and she was crying. She said, "I hate that you're doing this because every day you spend on a boat is a lost day in your life." I said, "Well, pull over right here." I walked into a convenience store, and I got a notebook and a couple of ink pens, and I came back. She said, "What are you going to do with that?" I said, "I'm going to keep a daily log, so I'll remember where I'm at on certain days, and there will never be a lost day of my life." I kept a handwritten log from August the 20th of 1971 until July the 20th of 2008, and then I just quit doing it because I got tired of it. I'm going to have that donated to a river museum, and I figure it's probably worth about two bucks. Everything about me was put in those books, so it would not be a lost day in my life.

I started out as a deckhand. The day I caught the boat is the day I realized I was going to make a career on the river. I went out there to make a career. The first day I walked on the boat, I went out there to get in the wheelhouse. When I walked into Weathers Transportation, I asked them, I said, "Who makes the best money on the boat?" The boy told me, he said, "The captain does." I said, "Well, I'd like to start there. If I have to, I'll work my way down." He said, "We don't need anybody." So I said, "Well, you can't write my number and my name

157

down?" He said, "Don't need you." I said, "Okay. All right. Thank you very much." So I started toward the door, and then all of a sudden, I hear this big fat guy down the hallway. He said, "Hey, come here, boy." So, I walked down there. He never got out of his chair. He said, "I'm going to put you on a boat." I said, "Well, he just said he doesn't need anybody." And he said, "Yeah, we need you." I said, "Well, that's kind of what I was thinking, you know." I said, "Well, why are you hiring me?" He said, "Because you're the first person in all the years that I've been involved in riverboats has ever walked in that door there and said you're here for work. Everybody else is looking for a job." He said, "Now do me good." So he hollers up there, and he says, "Chip, put him on the *Patricia Ann* and tell Jack to feed him two steaks on Saturday and make sure he keeps bananas on the boat. We're going to put some weight on him." I think I weighed about 110 pounds. But that was a good start, sixteen dollars day. When my mother found out what I was going to be making, she squalled. When my wife found out what I was making, she just threatened to leave me. I went and caught the boat. My first trip was sixty days.

It took me 615 days to get in the pilothouse. I had a goal. When you have a goal, you don't go slack. I never actually did the math. From August the 20th of 1971 and then I went in the pilothouse March 23rd of 1973. So think about it. How much time did I take off? None. No, I had a goal. I'd get a week here, three days there, and go catch something else. Basically, I stayed on the boat all the time, and now I still like it. I love it. I believe that the river gets in your blood.

Jack McClendon, W. O. Crow, Bear Kellen, Junior Johnson, those guys broke me in but anybody that would let me sit between the sticks. I steered for everybody I could, and I took all their good things together and then some of my bad, and that's what I made was a pilot. But one of the best feelings I ever had in my life was some years later because they had a sheet going around with all the mates' names on it. I went to Flowers because they

had a steersman program. Nobody wanted to make pilots. But I got my license while I was there. They had a sheet of paper running around with all the mates' names on it, and each captain had to fill out his feelings about his mate. The mate's got to see these remarks by these captains. Mine was, "Least likely to succeed," "Wouldn't train him if I had a gun held on me," "Hasn't got enough sense to pour piss out of a boot," "Is he retarded?" "Don't even go there." I mean, you know, that's the things they were saying about me. Then I was the first one out of all those mates on that sheet that got a license. I was the first one that got in the wheelhouse. Some years later, the government decides that they're going to make everybody get radar, and all of these captains are in class, and I'm teaching them radars. I said, "Yeah, I remember what you wrote, boy." Yeah, it's a small world, this industry.

What makes a river man? It's not really the money, okay? Of course, everybody wants more money. It's a way of life that you're not punching a clock. You're not having to jump in your car and get a speeding ticket to get to work every morning. It's not getting off in the afternoon and going in and listening to these kids with snot running down their nose and some fat old lady telling you, "Supper is not ready," you know? It's the smell of the air. When I walk out on the bank of Lake Ferguson, and there's a dead gar over there, that's home to me. That's the river. Old Bachelor Bend right there. The smell, the feeling of watching the sun come up, the sun going down, the slinking of ratchets, the sparks you make, the checking the lines going in and out of the locks, the squealing and the hollering back, "Hey, you better back her up. You better back her up." You know, well, "Hey, I'm doing everything I can." I mean, it grows into you. It's a woven fabric that becomes a man's life, a livelihood and something that he will take to the grave with him. It's not anything that anybody that's never been out there will ever understand.

When I was running pilot on the *Mississippi Queen*, I had a group of passengers. They said, "If

you had one word to describe a riverboat pilot, what word would it be? Would you have any idea what the word would be?" I said "Coyote. The Coyote is the most adaptable animal in the world." The pilot has to be adaptable.

I was on the *Mississippi Queen* from 2001 till August of 2006. There's no comparison of being on the *Mississippi Queen* to a towboat. You're surrounded with people, and they want to hear your stories, and I loved it. I've never been on a towboat and go to St. Louis and have the high school band out there playing the "Star-Spangled Banner" when I'd show up and balloons and confetti going everywhere. I made sure to be involved in the steamboat races every year. We'd start in New Orleans, and we'd have stop-off points all the way up the river. They would have tents set up, say, in Vicksburg and Greenville and all the way up. It was called the Great Steamboat Race. It was originally between Robert E. Lee, Captain John Cannon, and P. T. Leathers on the *Natchez* that actually ran that race. That was a famous race.

We usually would have ten people working on the barge lines. We had 189 crew members on the *Mississippi Queen*. Four hundred twenty-six at full capacity. She's a pretty good size vessel.

There was a remarkable man that I enjoyed talking to, and I got to ride a boat with him after I became an adult. His name was Wayne Wilcox. My mother worked at Greenville Mill; she would drop me off at this girl's house name Judy Mims. Judy was friends with one of the Wilcox girls. So every day after mom would drop me off, we would walk from Broadway and Central down to Chicago Mill and walk across these planks to get on a rickety old boat. We would go down there and have lunch with the Wilcoxes. During the summer, all of them would line up. There's a big log table centered on it, except it was just made out of two by sixes, very rough, and had benches on both sides. The kids would pile in on the benches. I got to pile in there with them. I want to say there were nine or ten of them. I would get to sit there and watch Captain

Wilcox when he walked in. If one of them said something, he didn't get up and go down there and get that kid. He just slapped the first one he came to, and everybody went off the bench. I've been on the floor a few times. I loved it. Mrs. Wilcox, bless her heart, she worked herself like a slave. She just worked and worked and scrubbed and put clothes out on the clotheslines on that old shanty boat. But they chained the kids to the boat and to the barge. How else you'd babysit heathens like that? I was with them. I needed to be chained down because I was, as Mrs. Wilcox said, "hell on wheels" anyway. I was like having a pet raccoon turned loose, but chained around the ankle or sometimes around the wrist. The kids just lined up, and everybody just got chained to the barge for quiet time. Some people would call that child abuse. We called that babysitting back then. But, that way, nobody could fall off or get in any trouble.

Well, I was on the boat with Wayne Wilcox, and I finally got to ride the boat with him. Wayne Wilcox was a chew man. He chewed tobacco in his sleep. I'd go up there in the wheelhouse and relieve him and, "Damn, Hoot, what you been doing?" There it would be; he'd miss the cans. He had had three or four cans in the wheelhouse, and he still couldn't hit them. I'd have to get me a mop. That was a bad characteristic to have, but I was a smoker. So which was the nastiest? He put up with my smoking, and I put up with his spitting. But, to this day, you'll never find one as good as Wayne Wilcox. Hootenanny. He got that name by just being a hell raiser when he was a kid. His daddy started calling him that. A true river rat. When I got chained when I was a kid and I was just visiting—you know, when in Rome you do what the Romans do. Or if you're at the Wilcoxes, you do what the Wilcoxes do.

One time I was running captain on the *Rose Marie Walden* for Jim Walden. I was trip pilot over there for him, but I stood the front watch, and I got a call. In fact, their marine operator said that they had reports that we were diving off the top of the pilothouse at Lock 15. We were waiting lock turn

for 14. And I said, "That's a lie. We are not." They said, "Okay. We just want to check." We were actually diving off of the handrail on the flying bridge, okay. We were not on top of a pilothouse. I was 24 and we had milk money on the boat back then. We would send a boat out and they wouldn't bring milk back. (They'd bring beer). I'd get up and go in there and I'd sprinkle a little sugar on some Rice Krispies. We didn't have milk, so I'd just pour some beer on the Rice Krispies. People in those days, I mean it was wild out there up until the 31st of December, 1989.

David Stokes called me at home and told me to come to his office he needed me to sit down and have a talk with him. I said, "Huh uh." He said, "Yeah. Come." So, I went. I sat down there, and I was looking at him. He said, "Jim, I want the truth." I said, "I've never lied to you. I'm not going to start now." He said, "Is there marijuana on the boat?" I said, "Yeah." "Is there beer on the boat?" I said, "Yeah." "Is there whiskey on the boat?" I said, "Yeah." "What about women?" I said, "Yeah." "And how many?" I said, "Four." "Where did y'all get them at?" I said, "Picked them up at St. Paul. They rode to St. Louis and back up to St. Paul." He said, "Do you know what that's doing to the grocery bill?" I said, "They don't eat much." They stayed drunk and stoned most of the time, so they didn't eat much. He didn't find any humor in it. He said, "I ought to fire the whole bunch." I said, "For what?" He said, "For doing that." I said, "That ain't no reason to fire them." I said, "You're going to fire them. You already know what they do." I said, "And then you're going to hire a whole new bunch. They are going to come in here and do it, and you ain't gone know it." I said, "What you need to do is go up there and give the captain his boat back." He said, "What do you mean?" I said, "Captain messed up and did some things with them, so they had him over a barrel. He's behind the eight ball just as far as he can get. He can't get control of his crew." He said, "Do you think that'll help?" I said, "I know it will. Give the captain his boat back and let them know,

"Hey, everything from this day forward is forgiven. Everything after this will get you terminated." I said, "because it's a good crew. It's a hard-working crew. They keep the boat clean. They keep the boat painted." I said, "Of course they're not doing much of that painting right now since snow is about neck deep to Wilt Chamberlain up there," I said, "but where are you gone find somebody to go up there and take their place with all that going on right now?" He said, "Well, yeah, you're right." He said, "I'm going to go up there and get the captain's boat back. "I said, "All right. Well, I'm out of here." I turned to him and asked him, I said, "Who was it that told?" He said, "Well, that don't matter." He said, "But they didn't have nothing on you because I asked him, well, what about Jim Davis? Was he smoking marijuana?" "I didn't see him." "Was he drinking whiskey or beer?" "No, didn't see him." "What about with the women?" "No, never saw him do that either." Dave said, "Well, why wasn't you not in the middle of that?" I said, "Dave, I was. I'm just more discreet than the captain is." I'd go up there in the guest lounge and watch TV and have me a beer and smoke me a doobie and then go to bed. But, I mean, that was the way of life back then. That was in '83, and it was like that out there then.

My father was a pilot. My grandfather, he was a surveyor for the Corps [of Engineers] after he got out of the navy. My intentions were straight up. I went to Ella Darling in Greenville, Mississippi. My first-grade class had fifteen boys, and thirteen of us became riverboat pilots. I still got some lawyer buddies there in Greenville, diehards, that I've worked with over the years doing the professional witness stuff. My deal with professional witness stuff, I might add that I never did go with plaintiffs. I always worked on the side of the companies. Whenever those other guys are out there that sell themselves as whores doing this, they hear my name involved in a case, I want them to fear because I'm going to come in there and slaughter them because I'm smarter than they are. I've won every case.

I have a school, and it's Davis Marine Training, Inc. for master, mates, pilots, and engineers. It's in Bartlett, Tennessee. When 9/11 hit . . . I had gone out of the office, and I went back to the steamboats. I probably would have never left the office and gone back to towboats, but I left the office to go to steamboats. I got a call from the *Delta Queen* Steamboat Company asking me to come down and talk to them. I told them I didn't need a job. They said, "Well, come on down anyway. Well, let us take you out to eat. Let's talk, you know." So I went down, and they had ninety-three days on the schedule for that year. Asked me how many of them I wanted, and I looked at them, and none of them crossed over each other. I said, "Well, I'll take them all." So, when I got back to Memphis, my wife said, "Well, you told them what they could do with their boats?" I said, "Yeah. I told them I could catch the boat in March." So I left out of there and left her and Andy, and I went and caught the steamboat there at Memphis. I liked it so much, whenever they went out of business, I really wanted to cry.

Right now, to date, I would say that myself and Charles Ritchie are probably the two highest licensed people out there on the waterways.

My demeanor with the vessel, I just don't believe in overworking a boat. I treat it like an old woman. You got to coddle them, you know. You got to let them do what they want to do but still get done what you need done.

We have a picnic at Lake Village every year, and we've been doing this since 1999. It's not labor related. It's just pilots, engineers, their wives, grandkids, and every once in a while an old straggler that don't even know us that shows up, and we'll feed them and talk and have a good time with them. I've been watching over the years as the older ones pass. It came to my mind and heart that we should never forget them. I started this Facebook page called "They Crossed the Bar." I collect the names and put them in there with their position, what they served on board the vessels. I'm looking for somebody now to take over when I pass so that my name will also go there with my dad's. That goes back to my mom saying, "a lost day in your life." Some of those cooks out there we've had over the years are just like old mamas to us. They need to be remembered. You ought to see me when I have to add a name. It's just something I feel that needs to be done. We're hoping one day to turn it into a physical address, and we don't even know what type of monument. There are, on the list, 1308 today. Every time we lose one, that's a piece of our history. It's a book in itself. Every individual out there is a book in itself.

When I die, I'm going to be cremated and I'm going to go back home to the river. I'm going to be dropped at the foot of Mud Island, so I can make Memphis bridges one more time.

If they want to know the river, they've got to know the past of the river.

Hopefully, in the future, when this book is out, there will be a young man that's troubled, can't find his way, and he will read this book and find the spot that he needs to go to. Because there are so many of us out there that were lost, but we had something to go to. And maybe he'll think the same thing I did: If I have only one life to live, let me live it as a riverboat pilot. That's all I got to say.

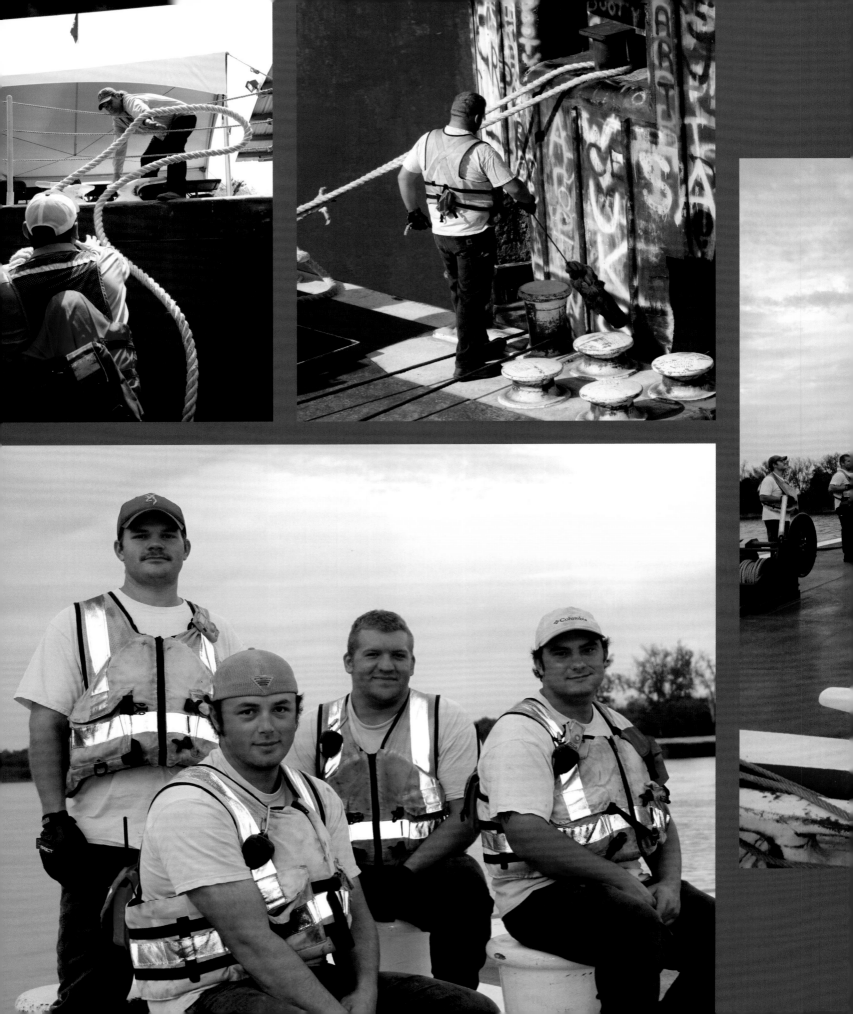

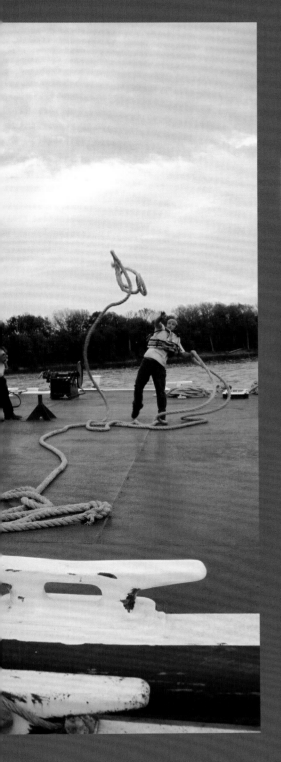
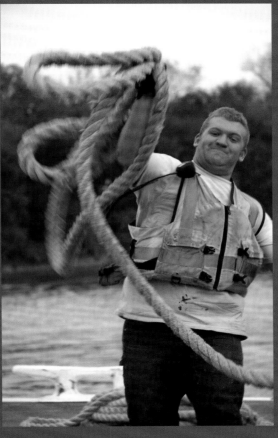
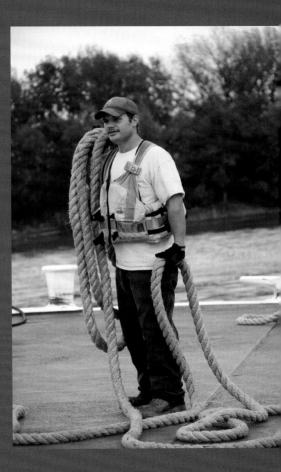

KEITH E. MENZ

– b. 1953 –

My name is Keith Menz. I started on the river in 1974, after I got out of the army. When I was in school, my brother and I used to mow the yard of a captain that used to work out on the river. When I got out of the army, he got me a job on the river. I worked for Inland Oil and Transportation, which no longer exists, but that's where I started. I worked there for about two years, and then I quit. In about six months I hired out to Canal Barge. I have been there going on 38 years.

The longest time I've ever been out on the river is seventy-two days.

I have met all kinds of people out there. There are people out there that I've talked to on the radios, and if they'd walk up to me as long as they didn't speak, I wouldn't know them. But as soon as they speak, I would know who it was. There are people that I've talked to over the years, and we know each other only by our voices, and that's it. But I've never met them in person. They're just like the friends that I have at home.

When something happens out there, it's just like the grapevine. It ain't long before everybody knows about it.

What I would describe . . . being out on the river is to me . . . a place to go to work where a person who has little or no education can go out there and make something of their life and can make a decent living and hold down a good job. These people don't usually fit in a normal society, and that's how I figure it, because I'm one of those people. There's no way I could work in a factory punching a time clock. Working on the river gives me the time to do the things I like to do. On my time off, it's my time. Some people say okay, well, you're gone twenty-eight days. Well, no, I'm home twenty-eight days. It's like the glass is half full or half empty, just however you look at it. When I'm home, I'm off; and when I'm at work, I'm at work. I try to keep them both separate.

The biggest tow for me was about thirty-five barges, and I was going downriver. You go on watch, and you stay on watch standing up, and you're on pins and needles. You just have to pay attention. The thing is, it changes every hour; every minute, every day, something is changing. You can run the bridges or a stretch of river a hundred different times and every time it will be different.

The technology when I started out, there was a single sideband radio and the marine operator. Then the next step was a fax machine. But now,

everybody has got cell phones, and technology has changed tremendously in my lifetime out there.

I was steering for the captain, and I learned the river. I learned where the lights were. When I walked up in the wheelhouse, I knew where I was. I knew what light was what. I knew what the next bend was or how far we're going to run that watch. I knew where were and where we were going to be. We had to learn the river. We didn't have the electronic charts and stuff to figure out where you're going to meet. You had to do that in your head.

My first trip, I rode forty-eight days. On my thirtieth day, the day I was supposed to get off, I was in Cairo, Illinois, and they didn't wake me up because if they woke me up, then I'd get off. So I had to ride to Pittsburgh and back and to Carrolton before I got off.

The captain that steered me was Bud Sandage. He's the one that took me underneath his wing and steered me and taught me. He's the one that broke me in.

The thing about him, the boat I was steering was the little eighteen-hundred-horsepower *Marian Hagestad*. We had an engineer on there named Chambers and then Bud Sandage. We had a little bluegrass band on there. Anytime we'd get delayed or have dock delay or get tied off at dock, we'd play music. We'd always have our instruments right there in the wheelhouse, and we would sit there in the dark and play sometimes with the search light on the bank and sitting there playing music. I played the guitar, my captain played the mandolin, and the other guy played a banjo. We played bluegrass and gospel. A lot of the dock people, they would come down and listen to us.

I used to take my guitar with me every time I came out on the river, but I don't anymore. People are not into this stuff. Now they're more into their cell phones. I used to take it out and just sit in my room and play. But if you don't have anybody to play with, it's no fun anymore. I've had a couple of them to bring a guitar on a boat, and we'd sit down and play, but there's not many of them doing it anymore. They're more into listening than playing. It used to be a common thing, but nowadays it's not.

A lot of times, those of us who work out on the river, we're kind of in the background. People don't really know about us. It's kind of like we're in our own little world out there. People don't realize that if they ever lose the barge industry, what they would be losing, because everything would come to a standstill. The price of the commodities that we move would go skyrocket. We move a lot of stuff that can't be moved on the interstate.

WILLIAM R. "RANDY" SCARBOROUGH

– b. 1953 –

My name is Randy Scarborough, and I've been on the river since September 1972. When I started, I was just a green deckhand. I was on deck about four and a half, five years. But the old captain I was working for, he had me steering a boat when I was a tankerman. He took me under his wing, and I worked my way up to the pilothouse.

After my first or second trip, I realized that I was going to make a career out on the river. I just knew that it was for me. It's something that gets in your blood. They say if you ever wear out your first pair of boots, you're on for life, but I don't think that's true because I've seen a lot of them come and go over the years.

Once, a long time ago and when I was steersman on the boat, we were coming up the Ohio River and were up there across from Maysville, Kentucky. There was a bar called Daniel Boone's Tavern that was on the Ohio side. The captain and the pilot and the mate, they all got off and went to the bar. The captain asked me, he said, "You think you can drive the boat?" I said, "Yes, sir, I can drive the boat." We had four barges and were headed up the river. He said, "Well, just follow the empty beer cans." So they left the boat, and they went to the bar. Eventually, they came back and got in the skiff. Well, we were still going up the river. I drove for a couple of hours like that.

Finally, they came up alongside the boat.

The captain had already taught me enough to know how to meet other vessels. That sort of thing won't happen nowadays, but back then it was in the mid '70s, and those kinds of things did happen.

I've researched my family history and my family owned the *Mayflower*. My ancestor was Colonel Edmund Scarborough from England, and he owned the *Mayflower*. I've got documentation that he owned seven ships, and for the hundreds of people that they brought over from England, he got so many acres of land. This is what my daddy told me. He said at one time, Colonel Scarborough owned just about the whole state of Virginia. There were ten ships named the *Scarborough* from the 1600s up until I think the last one was in '57, and it was a navy destroyer that they just decommissioned after World War II. It was in the Battle of D-Day. So my family history of mariners goes way back.

It's a good life out on the river. People have to sacrifice being away from home and family for a month at a time, but it's a good living. I've enjoyed it. Looking back, I don't think I could have chosen a better profession than what I did. I'm glad my dad pointed me in this direction.

REX WILLIAMS

– b. 1953 –

My name is Rex Williams, and I'm originally from Bayou Sorrel, Louisiana, just below Plaquemine below Baton Rouge. I was born on a houseboat, and I've been on the river all my life. I was born in the canal in old Bayou Plaquemine. I started out at sixteen commercial fishing. The first towboat that I ever worked with was the *George W. Banta*. I've been on the river forty-six years. When I first started on the river, I was a deckhand. When I started at sixteen, I knew then that I was going to make a career on the river because that was my dream when I was a kid coming up. We used to go coon hunting, and you'd see these boats at nighttime in the Intracoastal, and I knew it was what I wanted.

When I came up, it was very different than what it is now. We didn't have any kind of electronics we have now. All we had was a radar. The old swing meters we used to have were nothing like the old time. We didn't have any kind of Rose Point. No nothing. We used to have two charts going up the river. We looked at the bank, with binoculars, looking at the lights and making sure because all your lights back then had your mile board signs on them where it makes sure you were at the right place you thought you were and you'd run by the radar to go

with it. The electronic charts today, they make everything easy.

There are so many stories out on the river that I don't even know where to start. It's a good life on the river. You just have to pay attention, especially if you get in the wheelhouse. You have to think ahead all the time about what you have to do. You think ahead when you're driving in a vehicle. If you don't think ahead, anything can happen. The river is the same way. The river is just a road. We just run it on water.

Most of my time is out here on the boat. My kids are all grown. I see these guys on the boat way more than I do my family at home. These guys become your family. When something happens to them or their family, then it really takes a toll on you and your life. They become your kids, especially if you're the captain on the boat, and you are responsible for them. You look out after them, and you have to make sure that they are safe at all times. It's just so hard to say the way it goes. But they do become your family more so than your family at home.

I've been crawfishing, fishing, and hunting all my life. We were brought up commercial fishing when we were kids. We used to go coon hunting at nighttime and stay coon hunting until two or

three o'clock in the morning and then come in, go to bed, get back up at seven o'clock and go to school and then come back in in the evening time and skin coons. We'd sell them. You had to leave the feet and heads on them, or they would think they were dogs. That's some work, especially when you had to come in and skin them and then go to school in a couple of hours. Same thing crawfishing. Get up in the morning and go crawfishing. We used to leave our house at three o'clock in the morning and go crawfishing and wouldn't come in until, sometimes, five, six o'clock that evening. Commercial fishing is a hard living. We would run six hundred, seven hundred traps a day. You catch a few crawfish, but you actually don't never get paid for your time. You figure you are putting in twelve, fourteen hours in a day and never get paid for your time. Work on a towboat, by comparison, is much easier. And the money!

If you are going to work on the water, it's a good living. It's a good life. You are gone away from home a lot, so understand that. I mean, you have to work somewhere. Once it gets in your blood though, you are not going to get it out.

My wife encouraged me to buy our houseboat. That way I can have something to do when I retire. I started out on a houseboat and most probably will end up on a houseboat.

WILLIAM "BILLY" ALLEN

– b. 1954 –

My name is Billy Allen. My brother Richard Allen is the one that got me started in this business.

Being on the river, it's a unique kind of life. It's got its moments, don't get me wrong. Every day is an adventure, and it's a very dangerous business. Safety has got to be your number one concern for your crew, your equipment. But you don't have the rat race of getting up in the mornings and fighting traffic going to work and going home at night. You're not dealing with the general public like you do if you work on land. Everybody out here is committed to each other. Everybody keeps each other safe. I love it. I've been doing it for thirty-eight years. I watched my kids grow up on VHS camera because I'm gone usually nine months out of a year on average, but I wouldn't trade it for anything in the world.

My wife, Janet, got used to this kind of life, but it's not an easy life. I remember telling Janet one time—one of my daughters had a bad report card. When I got home off the boat—I had been gone thirty days, and she wanted me to spank her because of the bad report card. I told Janet ain't no way I'm going to do it. I said I'm not going to come home—be gone for thirty days at a time and come home and right out of the bat whoop one of my kids and have them hate me the fifteen days I'm home. So me and Janet argued about that awhile. But needless to say, Donna never did get a whooping. I just couldn't do it. It's a unique kind of life. It's a hard life to get used to. It's hard for your wife. It's hard for your kids, but it is a good life. Nowadays, if you want to supply them with everything that they need and all that, this is the kind of work to do it.

Back in the '70s you didn't have the DOT. You didn't have environmental systems. You didn't have politics that you have to deal with on a dayin, day-out basis, especially with the kind of cargo that we haul—any kind of chemicals, gas, whatever, diesel. Basically, all you had was a logbook, two radios, sounders, a radar and you were good to go. You kept that up and running and you didn't have to mess with nobody.

When OPA 90 kicked in after the *Exxon Valdez* spill, it started changing this industry dramatically on both sides: on the towboat operator side and also shore office side on rules and regulations. We had to start implementing all that in, and, of course, everybody in the world had been fighting it—something new that you had to deal with, more

169

paperwork and to a new guy now that's starting out on the river or getting into the wheelhouse [who] doesn't have a clue to what it was like back in the '70s when I started. Back in the '70s when I started, I used to sit on the stairs of the boat when I was an engineer, and I'd have me a sandwich or something just looking at the stars going down the river, and it was romantic, you know. It was great. It's not like that nowadays as far as that because you've got to keep your mind on it all the time with river conditions and so much traffic. You've got three times the traffic on the river now than you used to have back when I started. It's just a whole lot more to it.

We used to pull tricks out here. You get a green deckhand, and like you were heading up on the lock or something like that, he gets halfway out there to the head of the tow, and you ask him on the radio has he got a lock key, so he can unlock the lock. Needless to say, the deckhand didn't know which one he was talking about, and he'd say no. So he'll walk all the way back to the boat before he finally figures out there ain't a lock key that opens the lock. It's a lock gate.

I had a pilot, Jay McDaniel, one time. Me and him was riding together on the old *Nathan Golding*. It's called the *City of Jonesville* now. We had a new deckhand on there, and I was sitting up in the wheelhouse with Jay. It was getting close to dark, and they were checking the lights out on the head of the tow. Well, Jay asked that new deckhand to check those lights. So the deckhand walked onto the red one, and he told Jay it was good. And so he walked over to the amber one in the center of the tow, and he said, "It's on. No, it ain't. Yeah, it is. No, it ain't. Yeah, it is." He got plum mad. He thought Jay was up in the wheelhouse cutting the switch on and off, and that amber light is supposed to blink. We were laughing so hard in the wheelhouse, we couldn't say anything. Finally, the guy out there with him told him, said, "That light is supposed to blink."

To become a captain, well, nowadays it's a whole lot more to it than what it was. You've got a pretty

good process that the Coast Guard has implemented for these new guys. It takes them at least two years just to get turned a loose in the wheelhouse. Back then, when I got turned a loose in the wheelhouse, it was less than twelve months. But what made me want to do it was that when I come out here and started working out here, and I loved it, still do, that I decided that if I'm going to miss my family, I want to go all the way as far as I could go. And that was the captain spot. Can't get any higher unless you get on top of the wheelhouse.

The guys you work with out here, they're just like family. I mean, you are with them more than you are your family. These guys out here, they work good together. The ones I got on here, they do anything for each other. It's a good working relationship. They look after you. They take care of you, and you take care of them.

I've seen places that I never would see if I worked on land.

A little river history. At Starved Rock Lock, there's actually two big cliffs right across the river from the lock. The reason the lock got the name Starved Rock Lock was because back during the Indian days, the army, they hemmed hundreds [of] Indians up on this cliff just as far as they could go, and they surrounded them. They couldn't leave. So what one that didn't commit suicide and jump off, which was real high, and it would have killed them when they hit the water, they kept them there all winter, kept them hemmed up all winter. They starved them. Little kids and everything, they starved them out. They couldn't get anything to eat. If they tried to break through where they were surrounded, they'd kill them. So they basically stayed up on top of that rock until they all died. And that's how it got the name Starved Rock Lock. It's up on the Illinois River.

You know every bend has a story.

I went past Angola Prison one night when they electrocuted somebody. All their lights went out when they actually did the electrocution right when I was going by. The water was high up. I

could actually see all of the street lights, the outside lights, and all of the building lights. And they did it at 12:01, at midnight. We were going by there, and every light over there went dim, real dim. Didn't go all the way out. And stayed like that for just a little bit, and then they lit right back up, and that's when they executed him.

WILLIAM "BILL" RANKINE

– b. 1954 –

My name is William Rankine. And I go by Bill. I went to sea after high school when I was seventeen years old back in 1971. I'm originally from Glasgow in Scotland.

In Scotland, very many young men went to sea, yes. We're an island, so we're very much a seafaring nation. When I first went into the service, I was set on becoming a captain early on. That was the whole intent at that time. It took ten years, which was as fast as I could do it. In fact, my mother had a friend who worked for the shipping company. She told my mother later on that I was actually the youngest that that company had ever had reach that goal in all their hundred-year history.

I signed up, and the contract I had with the shipping company was an evergreen contract. Every year, it automatically renewed unless one of us decided not to do so. When you signed on the ship, we signed what they called "The Articles." And the Articles you signed on were for two years, but they didn't keep you on there for two years. They could if they wanted to, but they typically were running six-month trips. So I would do six months at sea, and then, as a cadet, I was getting seven days accumulated leave for every month on board. So you would do six months, and then you would have six weeks at home for leave and then join the next ship after that. Being on the ship for six solid months, I thoroughly enjoyed it. I loved it. You were getting to see places that many people will never get to see. When we were in port, we were allowed off if we had enough time. As a cadet, it was important that you get as much time ashore as you could, which we did. We had uniforms. We had a full wool uniform for winter months, black suit essentially. And we had white tropical uniforms for the summer for all the tropical climates. We were required to wear the uniform all times except when we were on the shore.

My captain's license is any tonnage, any ocean, which means I'm capable and qualified to sail any ship on any ocean out there. So it could be a tanker. It could be a passenger ship. It could be anything.

For someone from Scotland, it was a very popular career choice to become a seaman. A lot of the folks from the Highlands or the Islands, that was their way to get off the island or the Highlands was a job at sea. A few did what I did and went the officer route. But it was a way of expanding horizons getting off an island, which is what we are at the end of the day in the UK. And it was a good career.

I wish I'd kept a logbook. I have circumnavigated the globe it has to have been more than twenty times I would think because I was on one ship that we essentially did that every six weeks because we loaded oil in the Persian Gulf. We took that oil all the way around to Valparaiso in Chile. That was what we called an OBO. It was [an] oil, bulk, ore ship. It could carry oil. It could carry dry bulk cargo. And it was a conversion process that we had to do. We had to clean the tanks and then convert her to a dry boat cargo ship. And then we would load iron ore in South America and take it to Japan across the Pacific and then finish in Japan and go back to the Persian Gulf and pick up the oil. So we actually circumnavigated the globe every few weeks. So it has to be more than twenty times I've done that.

In 1981 I was twenty-seven years old. I became a captain, so I was a very young man by any standard to be a captain. The funny thing about it was, while I got the rank and the license as captain and I sailed with a captain's license, I actually sailed the second in command. And that's where I ended up when I came ashore. I have the captain's license, the qualification, but sadly I came ashore before I got to captain's rank.

I actually was trying to get my sea legs, and you had to learn how you moved as the ship moved. I hadn't quite learned it yet, and I fell on my back. I was in the wheelhouse with the captain, and as the ship rolled, I was sliding with the ship. And he, of course, was busy trying to keep the ship safe, so he wasn't too worried other than just trying to get out of my way as I slid across this deck. I finally got up on my feet, and he explained to me. He said, "You got to move with the ship. So as the ship goes this way, you make sure your body goes the opposite way. If your body goes the same way as the ship, your body will go. You'll fall. You've got to balance yourself." So that's where that seaman's walk comes in. Sea legs, yep. And when you come ashore after a period of time, you actually have a little wobble to you as you walk because you get used to that movement.

The difference between us and the captains—mainly the captains because you're talking to their pilots, of course, as a foreign ship coming into New Orleans and were required by law to hire a pilot. All the states have rules that say you must hire a local pilot. So you're very much depending on his local knowledge. And the pilots on the Mississippi are probably some of the best in the world because that's a very, very tricky river to navigate. The rule is that the pilot is an advisor to the captain. The captain is always finally responsible, but the pilot advises him on the local conditions. They'll help you come up the river and into the port, into the berth. I came into New Orleans a couple of times. It's a tricky river. I very much admired the pilots on the inland waterways that navigate that river.

I remember one time coming down, and I was actually steering the ship at the time. I was the cadet, and the captain had me steering the ship. We were coming down the Mississippi, and there was a bend coming up. And it was a bend to port. The pilot had me put the wheel to starboard, which struck me as so odd, and I asked him, "Are you sure?" as a cadet. And I said, "Are you sure you want me to do that?" And he said, "Trust me, son. It will work." And, low and behold, I had that wheel, and he just took her around that bend so neat it was fascinating. I'll always remember that. And that was a lot where my admiration for the pilots came from. He knew exactly how to get that thing to just come on around that bend.

Now, I'm stateside, and I'm dealing with brown water. I think we're all very, very much of the same breed. There has to be a certain mentality that says you can go away for an extended period of time and do what we do and what your captains do and what your crew do. There's a tremendous amount of respect. I certainly have it, and I think they have it too.

My wife, Linda, and I moved from the northeast to the Gulf Coast in 2005. That was when I first started to work with the inland barge industry. It has been such an eye-opener to me because there's

a tremendous amount of competition, but at the same time when there's a situation arises that needs teamwork, they all chip in and help each other. The correlation I see there is similar to if we were sailing in the middle of the Pacific and a distress call came out, we would drop everything and answer that call. That's the unwritten law of the sea. And it's very similar to what I see in the inland barge industry because when things go wrong, and boats are needed, there's just this tremendous response. And I think that runs throughout the industry.

It gets in your blood, I think. It's something that you're either going to do and enjoy, or you're just not going to do at all. Some people did it for a couple of years before they realized that. The rest of us just loved it.

But one of the watches I did as chief mate was that four to eight. And every morning, again

depending on the weather, but very often I got to see the sunrise, and I got to see the sunset. And it was absolutely beautiful at times, just absolutely gorgeous and the stars at night. There's no light.

I loved it. I really did. And I didn't want to come ashore. I only came ashore at the end of the day because the industry was changing so much, and even now there is no British Merchant Fleet anymore. It's a great life. If someone was to come to me today and say, "Would you recommend this for my son?" I would say as long as it's something like the US where the Jones Act protects that industry, yes, certainly because it's a good life. It was hard. It was hard work, but it was rewarding, really rewarding, and you get to meet different cultures and different people. And without it, I wouldn't have met my wife.

RUDY WARD

– b. 1954 –

My name is Rudy Ward, and I've been on the river forty-two years. The way I got on the river is I was looking at ten years in the penitentiary for sales of cocaine and sales of marijuana, but I didn't get convicted, and so I left home. My daddy told me if I was going to live that kind of a life that I couldn't stay at home. And I told him, "Well, I'll never change." So, I just left.

So I bummed around for about six months. I was raised in Greenville, and I knew everybody. I just hit the road hitchhiking, and I finally hitchhiked back into Greenville. I was just a kid. I wound up back home, and a guy asked me, he said, "Do you want to catch a boat?" I said, "Well, I guess so." I had no idea. I caught one of Dr. Winn's boats. I didn't do too good. I'll just be honest with you. I caught the boat with a pound of marijuana, so I didn't last too long. I made it about a month. Of course, back in those days, all boats had marijuana. All boats drank. It was river life and river towns.

Back in the old days, there were not a lot of rules, and there was not a lot of structure. In the early days, it was just about making these companies money. In the early days, it was about rolling and hustling. They said that a towboat man was the only man that could be a thousand miles away from his

boss and give him 150 percent. So that was a pretty unique group of men.

When I made my first trip, I didn't know that I was going to make a career on the river. I just knew that I was trying to stay out of jail. I was nineteen. I didn't deck but about a year and then went straight in the pilothouse.

Actually, I didn't last long that first trip. What happened was they found some seeds in my room. The old mate and the deckhand, they challenged me. So, I pulled a knife on them and told them probably be best for me to just get off. They thought that would be best, so I bailed off in St. Louis and rode the bus to Greenville.

From my first trip until I got back on the river, it was almost instant. I just got off one and said, "Man, I messed up." because I liked it. When you've been hitchhiking and living not too good you get to thinking. I never will forget, I was on the side of the road about ten o'clock at night, and I was just wrapped up in an old beach blanket. It was all I had, and it was cold. I said, "Man, if I could just get home." I knew what was waiting at the house, a good whooping, but I was willing to take that whipping just to get home.

I finally hitchhiked on into Greenville. Got home and then—but to get on a boat, where you had food,

good food, a clean place to sleep, good facilities, and got paid on top of it—now that sounds funny today, but for me I couldn't believe that I was going to get to work, and it didn't seem that hard to me, and get paid on top of it. I thought, hey, this is the life for me. This is good.

I wound up catching another boat out of Vicksburg. I started getting my faculties together and getting off the dope and getting off the drinking, and because you had enough time being on the boat to break away from that kind of lifestyle to be able to kind of start seeing things. I was just fascinated. I always had a huge amount of respect for the pilot. I looked out there, and I said, man, to be able to take something that heavy and that big and to be able to just lay it into the dock just like a feather and just couldn't even break a thread with it. I was fascinated by that, and I said, "I want to do that."

"I want to be a pilot." I said. I wound up with Barge Transport out of Houston, Texas, on a little old 350 horsepower boat. It had just steel floors, steel walls, and no flushing commode. A little five-gallon hot water heater is all we had and no cooks. I got on the boat. and the captain was the only man on there with a set of license. I told him, I said, "Look, man, I want to be a pilot." He said, "Can you run a boat?" I said, "Well, yeah, I can run a boat." In truth all I ever did was clean the pilothouse, but I said, "Yeah, I can run the thing." He said, "Well, let's see." So I grabbed ahold of the sticks. I started doing loops out in the river. He said, "I thought you could run a boat?" I said, "Man, I been running big boats. I'm not use to running these little old boats like this."

Anyway, he stayed up two or three hours one afternoon, and I steered going down the canal. It didn't take too long. I kind of got to where I could hold it steady and meet a couple of boats. Well, he was dead tired, and he was a drunk anyway. He was an alcoholic, and he was drinking whiskey. So, he wasn't even wanting to work. He found out that I could run the straightaway, and I could run back in the canal. You might be able to run ten or fifteen miles without having to make a turn and maybe make one little ole turn and run another ten or fifteen miles. I could do that, and then he could sleep in the straightaways. Anyway, I made it.

Finally, the boss came down one day at the dock. I told him, "Man, I need my license." He said, "You will quit me." I said, "Man, no." I said, "I'm not going to ever quit." And he said, "All right." So they wrote me a big letter that was not true at all at the time and just said I'd been to all these places So, I got a big full set of licenses.

I went to school with Captain Bill Hutto at Western Rivers Training Centers back in those days in Greenville when it first started. I was the very first one to pass in the Memphis district, so I had to really and truly learn navigation. I had to know how to navigate. So, long story short, I passed, got my license, and worked in the industry.

Well, now, I've got some pretty colorful stories. You're talking to a pretty colorful character. I'm an old-fashioned Pentecostal preacher too. I've done everything from real true drama rescues, guys in the river drowning, to funny things. It just kind of depends.

One time there was this captain. He had this old gal he brought on the boat all the time, and they were wild. We had holes in the boat where they'd shoot it out with pistols and fuss and fight. Well, she kind of ruled. Whatever she said, Captain Jack kind of had to do. One time out on the tow, the boys saw this huge wild cat. He was just an old tom cat, but he was huge. He was big as a coon and had a head like a grapefruit. You could look at him and see he'd been living on blackbirds and rainwater for who knows how long.

So Polly says, "Jack, I want that cat." He said, "Not getting that cat." She said, "I want that cat." So, he tells the deckhand, "Y'all go out there and catch that cat." Two big guys they go out on the tow and they are not out there very long. That cat has done whooped them off the tow. And they come back. They said, "Man, you cannot get that cat." Jack says, "I want that cat."

So they go down there, and they get welding gloves, and they put on a leather welding suit, and they go back out there. They get that cat, and they grab him. This cat probably weighed twenty pounds. And that cat was mean. Old yellow eyes, and I mean that cat was bad. They come up in the pilothouse holding this cat. Polly and Captain Jack and I were up there. They said, "What you want us to do with this cat?" Captain said, "Throw the thing down." They threw that wild cat down in the pilothouse. It was unbelievable. So I leave. I said, "Man, I'm getting out of here." I left because I was going to have to go to work at midnight. We were on the Upper river with fifteen barges and fifteen empties, and the wind blowing, and little ole narrow bridges.

So, I came back up there at midnight. I said, "I got you." He said, "We are coming up on Burlington Bridge." I said, "Where is that cat, Captain Jack?" He said, "Right over there in that window." So, I flipped the pilothouse light on. That cat was about two feet away. He was just staring at me. I said, "Man, I don't like the way that cat's looking at me," I said, "up here in this pilothouse like that." I said, "Y'all touch him?" "Can't touch him," Captain said. I said, "Well, what am I supposed to do?" He said, "Just ride and leave that old thing alone." I said, "Well, have y'all fed him?" He said, "He won't eat." I said, "You tried some sardines?" He said, "Hmmm, didn't think about that."

So Captain Jack called down and said, "Bring me some sardines." So the cat eats a can of sardines. Well, Captain Jack goes down. Well, see, I had not thought about it. That cat has been living on blackbirds or the good Lord knows what, and he eats a can of rich, greasy, oily sardines. I'm sitting up there, and I hear that cat's stomach. I said "Lord have mercy." And "Huhoh." And then I heard something moving. I flipped the light back on, and that cat was staring at me. And "Oh Lord." I'm coming up on the Burlington Bridge and the wind is blowing and I'm trying to pilot. I mean, it's narrow up in there on the river. I thought "Lord have mercy." I can't leave the light on, and I was getting ready to have to make this bridge. So I cut the light out, and then I smelled it. Horrible. This cat had started using the bathroom everywhere, all over the pilothouse. Its stomach's upset, and it's bad, real bad. So I'm trapped, and this is just the beginning of the watch. I flip that light back on, and Lord have mercy.

I called Rudolph Gentry downstairs and I said, "Get up here, Rudolph, and get this cat." So he comes up there. When he gets up there, he went to try to make a move on the cat, and the cat went wild, and the cat starts running. The pilothouse is real small. The cat is running in circles, and loops, and he has cat mess all everywhere, all on the windows and across the console, and all around the floor, and he just won't stop. He is in a dead run like something you see on TV. And so I said, "Get him, Rudolph! Get him!"

Finally, the cat ran up under the sounding machine and the radar. Rudolph had a pair of gloves on, and Rudolph was able to choke him. I shouted, "Kill him, man! Kill him!" So he was trying to kill him, and he could have killed him, which he should have. Lord knows what kind of disease that cat had. But Rudolf messed up. He pulled that cat out from behind. That cat was trapped down in there between the sounding machine and the radar. He pulled that cat out. Bad move. When he pulled that cat out, that cat went wild again. And he whooped Rudolph Gentry. I'm talking about whooped him good. Rudolph wound up turning that cat loose, and he's making loops again. Man, it just won't end. And out of all this time I'm going up the river trying to get through Burlington Highway Bridge with that cat—bad. Bad.

There was a window right above the stairwell coming up to the pilothouse. At the bottom of the stairwell was a door. So the old cat wound up in this window. We couldn't shoo him out. It wouldn't go out of the pilothouse door for whatever reason. I told Rudolph, I said, "Get down here and open that door, Rudolph. We got him!" And so, Rudolph goes down there, and he's standing at the bottom of the

stairwell where the door is and it's just a little cubby hole. I start closing in on the cat. The cat jumps. And when that cat jumps, he landed on Rudolph Gentry. Landed on him, on top of him, with them claws, and it was bad. Rudolph squealed like a little girl. I'm telling you that cat was working on Rudolph Gentry. And he's at the bottom of the stairwell, and there is nowhere to go. He fought that cat until he fought him outside on the back deck of the boat. Now whatever happened, happened, but we got rid of the cat. It was just unreal. I don't know what Rudolph's mental state is today. He probably has a phobia about cats now.

Out on the river, it looks easy at times, and sometimes it is easy, but you're not being paid for that. You're being paid for that five minutes coming down on Vicksburg Bridge, five minutes going through any of these narrow harbors, and so on and so forth. You're not getting paid to just run up the river. You're getting paid for those times when that's what it takes.

I've been in the pilothouse forty years. As soon as I got my pilot license, I wasn't on the river very long that I got saved and started living a Christian life. I had put all that partying behind me. All of my career, basically, I've been a Christian. So it can be done. It's not easy, but it can be done.

George Reed was kind of like my towboat daddy. He loved my wife, Eileen, and he liked me. George was pretty crusty. He was pretty tough, but we knew him from church. Captain George, he could not read. But Captain George Reed could not write his name and could not read his name and boxcar letters. Somehow or another—I don't remember the whole story on how George found the Lord, but he did find the Lord some kind of way in. He told the Lord, he said, "Lord, I want to read that Bible." He couldn't read anything else. But when that old man died, he could read the Bible, King James version. He didn't have trouble understanding. Captain George, he was just real crusty, but he made a lot of money, and he was committed to the industry.

These people who take canoes and rafts and things like that on the river it is just dangerous.

Dangerous. They need to figure out somewhere else to go to have fun because this is just too dangerous out on the river. We can't help them, you know.

Captain George Reed, he always said, "Rudy," said, "I love the Lower Mississippi River running down below Natchez, an old, wide, lazy river, on a full moonlight night." I guess that would probably kind of be myself. That's the stretch of river that I like the most too. Down there it's not as intense.

I've run everywhere there's water. I've run them all.

I've been on all the rivers.

All towboat pilots live their life in extremes. You always live with life's ups and downs. So there is high water, and there is the low water, and it was the fact that you saw things that maybe people will never see again. We saw old stuff down below Memphis when the water was low that was just out on sandbars, old shipwrecks and, I mean, Lord only knows what.

I have a story about a cook. I walked down in the galley, and there's a big ole fat cook. I mean big ole fat cook, and she had on black leotards. Horrible. It was like something that came out of a horror movie. She had a T-shirt on. She was dirty and nasty, no bra, and these black leotards. Her fingernails just were terrible and dirty too. I walked in. I thought, "Whoa . . ." She said, "Would you like a biscuit?" And she turned. And when she did, there was a perfect white handprint of where she had been scratching. It was like she just put her hand up there and painted white paint on it. It was horrible. I mean, terrible. Scratching! I said, "No, baby." I said, "I'm not much into biscuits." I said, "I'm kind of a toast man, really." I said, "I mostly eat cereal." I said, "No, no, I don't want any biscuits. No, no." And so, you kind of have to watch. It was pretty bad. "No biscuits this morning, but thank you anyway."

This is probably one of the best stories. We were on the Upper river, and the deckhand brings me an envelope from off the lock wall. He said, "I think you need to look at this." So I looked at it, and it was from a clinic addressed to our boat, a doctor's clinic.

So I opened it up. When I opened it up, there's this letter in there, and I'll leave the cook's name out. But it says—I'll just call her Jane. It said, "If you have had any sexual contact with Jane," said, "you need to immediately go to your nearest doctor. She is HIV positive." I thought what's happening? I've had this woman cooking for me for years. She was an awesome cook. I hadn't lost a deckhand. I haven't lost any personnel. It's almost unheard of on a boat to go five or six years and not lose a deckhand. Come to find out, she's having sex with everybody on the boat but me. I thought I was doing such a great job, and I wasn't doing anything. They were bees in the honey. I had thought, "Man, I'm doing pretty good." The office was telling me, said, "Man y'all—we don't have any trouble out of y'all. Said "Y'all got it going on." I said, "Well, I don't know." Eileen, my wife even had Jane a plaque made up, "Most Awesome Cook on the River." Man, she was burning the beans. I mean, we were eating big. Come to find out, it's just all the sex you wanted, whenever you wanted. She was serving candy and cookies, just all you wanted, and I couldn't believe it when I found out. She wasn't very young, but she wasn't very old either. She was probably forty-five at the time. I had not a clue. I mean, I'm captain on the boat and not even a clue. I've seen that a lot on the boat where they're having sex and people getting mad, and they fall in love and want to kill each other, and, you know, on and on. She is taking care of everybody, and everybody is happy. Everybody. Everybody.

So, then I get this letter, and I said, "HIV positive!" Well, that was really in the very early days of that disease, and it was really scary because nobody knew anything about it. I'm thinking, "Man, we are all getting ready to die. We've been exposed to AIDS." I said good Lord. And so I told the deckhand, I said, "Jane, is HIV positive. She's got AIDS, son." And the blood ran out of his head. He turned white as a sheep. And he said, "Captain, Rudy, I've had sex with her." I said, "What?" I said, "You've had sex?" He said, "I've had sex." I said, "Good Lord." I said, "You are getting ready to die, man." I said, "You

got AIDS." I said, "Man, get away from me!" I said, "Back up!" I said, "Get back! Get back!" I said, "Take this letter downstairs."

So he goes downstairs, and the crew they look like a bunch of cats headed to the litter box. They all come back up there, the pilot included, and all of them has this look. And now they're confessing. And they said, "Captain, Rudy, we've all had sex with Jane." I said, "Get back!" I said, "Y'all get back!" "You mean to tell me y'all have all had sex?" I said, "Man, y'all are infested!" "This place is infested with AIDS!" I said, "Get away from me!" I said, "Back up!" I said, "Do not touch me." So I called Brenda at the office. I said, "Brenda." "Can't believe it!" I said, "They all got AIDS! They are all having sex." I said, "The boat's"—she said, "Slow down." I said, "I can't slow down!" I said, "They going to infect me." I said, "What if I have infected my wife with AIDS?" I said, "This is unbelievable!" I said, "The whole boat is infested with AIDS!" She said, "You got to calm down." I said, "I can't calm down!" I said, "They've all had sex with Jane! Yeah, all of them! I said, "I can't believe it!" "They've all had sex, and she's got AIDS!" Brenda said, "Well, how do you know she's got AIDS?" I said, "I'm looking at a letter right here in front of me from a doctor that says for all these guys to report immediately to this doctor's office. She is HIV positive." She said, "Fax me the letter." That was when we first got fax machines. So I faxed her that letter.

In the meantime, I told them I said, "I know you've had more sex than with Jane." "Y'all are passing this around just like a ball." "It's unbelievable!"

It took almost a week to get to the bottom of it. Now, they are all confessing, talking, and living with this. They are sick. And I won't get near them. You know, I told them, I said, "Y'all get back." Come to find out, Jane had gotten off our boat and was on another boat. She was having sex with the chief engineer on that boat, and his wife found out about it. His wife was at the clinic. She stole the letterhead. The only thing kept her out of jail was that she didn't forge the doctor's name. And she

sent out all these letters. It took a while to get to the bottom of it. So now all of these guys have all confessed. They're getting divorces. They're getting new girlfriends. They're going with no girlfriends. It's horrible. So Brenda finally called me. She said, "Rudy," she said, "I got the answer." So she told me the answer, the truth. I said, "That's kind of disappointing." "I really thought that I was doing a great job. I'm doing all I can do really trying everything I can do, and it had nothing to do with me at all." You might have just put one on every boat. We'd get a lot more done and a lot less trouble because ain't nobody quitting, and they all working. They are just full of vitality. You can't make that kind of story up.

River life, it's mostly isolation. You've got to be able to deal with being alone. People are working, so they're not sitting up in the pilothouse telling all these stories. See, your crew is busy, and you're busy.

I preach a lot of funerals for river guys. But I've tried to help these guys through the years. I truly believe this though that if you don't truly want to be a pilot, you will never be a real pilot. If you don't truly want to be a Christian—if I just set you down and push you into a corner and get you to say a prayer, that is not going to constitute salvation. But if it didn't truly come from the interior of your spirit that you truly want to change your life and be a different person, then it won't work. I've tried to be a Christian and live the life. I never sat around in the circles and told dirty jokes. I've never tried to have sex with the cook. But I've always tried to be there for the men on the river.

So I've just tried to use opportunity through the years to try to be there so that the guys could see that there's another way you could live your life. You do not have to live having sex with the cook, drinking, drugs, and wild living. There is a way. You can never start wrong and finish right in navigation because that's the reason we have set and drift. Then you have to figure that out, so you can recalculate, so you can maintain your course and speed. Otherwise, if you start one degree wrong here, you can never get to where you're trying to go to. You'll spend your whole life running off course. So if you start wrong, you cannot finish right. Somewhere you have to change and readjust your course to get back on track so that you can follow the true course. You must compensate for the set and the drift of life because we're always being pushed, and you're always being set and drug off course. It's much better to stay with Jesus and ask for forgiveness and stay on course as to deviate. We call that variation and deviation. In your life, it's real easy to deviate and be pushed off course. On the boats I've tried to always say "Let your light shine." Most river men, you're not going to bulldog them into anything, not many of them.

WILLIAM B. "BILL" WINDERS JR.

– b. 1954 –

My name is Bill Winders, and I've been on the river since April the 1st of 1972. The way I got on the river is my dad was an engineer on the boat. To me it was just a job. I was out here to work. I was eighteen years old and had a pocket full of money and running wild and free. In 1980, I got my license and had made it up to the pilothouse pretty quick.

The captain taught me how to deck and lay wires and splice lines and splice wires. He taught me to go to bed when he sent me to bed. Because if you went in there and sat down in the lounge and watched TV and he walked through, he'd say, "Boy, I didn't work you hard enough. If you can't lay down and go to sleep, then go get your clothes on." When he turned you loose again, you went to sleep. You weren't worried about any TV. Back then when you got called up on a boat, you didn't go sit down and watch a TV or sit around twiddling your thumbs. When you had spare time, you were on the stern with tow somewhere with a line in your hand throwing a line and learning how to throw a line and catch the timber head and buttons because back then when the captain said, "Get me a line," he didn't mean wait till I got five foot from it where you can do that. When you got within thirty feet,

he wanted a line. It takes technique, strength, and a lot of practice.

My longest trip was seventy-three days, and it was just so I could be off for Christmas. After that hitch, I told my wife I didn't care if I never got Christmas off again. That wasn't happening any more. Seventy-three days is a long time.

The most I've ever pushed is forty. That was pretty heavy. I was going downriver. All grain. It takes many, many acres of grain to fill one of these barges up. Right here on these barges in front of me that's sixty thousand tons right there, and this is thirty barges. I'm headed to New Orleans. When I get there, I'll leave these and bring loads and empties north. It will be salt, fertilizer, steel, and stuff like that. Weight is weight. It's no difference what you're pushing. Barges are barges.

We eat pretty good on the boat because I'm not going to have somebody on here that can't cook. I mean, when those boys put in six hours out there, handling all that rigging and attacking all that stuff and doing what they have to do out there, they want a meal. Breakfast, lunch, and dinner. There's lunchmeat and anything you want in the refrigerator any time you want it. Part of your pay is all of this good food.

We were at a seminar once that was to help us in leadership. On one of the deals you had to describe yourself. The guy asked me how I would describe myself and my relationship with most people in my crew, and I said "tenacious." He looked at me, and he said, "Do you know what tenacious means?" I said, "I know exactly what tenacious means." And he said, "Are you sure?" I said, "Oh, yeah." He said, "Why do you describe yourself as tenacious?" I said, "You screw with my crew, and you'll find out." He said, "Oh." So I take care of my boys, and they know it.

Being out on the river, there is a lot of being away from home, and it's not for everybody. To be honest about it, I worked harder in a hay field than I ever have on a boat. On a boat, when the work's there, it's work. And when the work's not there, you're basically doing cleanup and maintenance on the boat and maintenance on the tows and stuff like that. It's not bowed up pulling your guts out twenty-four seven. When you're in a hay field, it's bowed up twelve hours a day, no matter how hot or how cold it gets. Throwing a 110pound bale of alfalfa or sailing high on a cotton trailer is not fun. But, like I said, being out on this river, it's not for everybody. Usually, we say if a person makes it six months, they'll be here. But a whole bunch of them don't hardly make it even for one trip.

Once, we were overhauling at Ashland, Kentucky, and this was a long time ago. I didn't care for going to town. I don't drink. I never have. I didn't care anything about all that mess. But, basically, everybody else went to town, and I stayed on the boat. They came straggling back in about one thirty, two o'clock in the morning. And I was in the wheelhouse. We had some old furniture that came out with that boat in 1960. I was sanding and refinishing it. We were at the repair terminal, and there was a guard at the guard shack. We had a Motorola, and he calls me on the Motorola. He said, "Are you expecting anybody?" I said, "No, why?" He said, "There's a carload of women up here from Tennessee." I said, "Keep them there as long as you can. Do not let them through that gate until I come back up and call you." I ran downstairs kicking doors open and screaming, "Get up and get in the shower! Your wives are here!" You are talking about a bunch of drunks sobering up pretty quick. Yeah, they sobered up pretty quick. It was their wives. They were just coming down to surprise their husbands. They were allowed on the boat back then.

In 1978, we were at the foot of Campaign Bend above Markland Lock on the Ohio River. There was real bad ice up here in '77 and '78 both. The Ohio River froze from Cairo all the way to Pittsburgh, eighteen to twenty inches thick. Because of the gorge above Markland, we couldn't get through the lock. There were three boats there, the *City of Pittsburgh*, the *Northern*, and the *Brimstone*. The *Northern* was a five thousand horsepower. The *Brimstone* was an old thirty-two hundred and the *Pittsburgh* was a thirty-two hundred. We tied off right underneath the point there at Campaign Bend. The *Northern* and the *Brimstone* were below us. That gorge broke loose and moved about a hundred foot one day, and it snapped our tow in two like it was a rotten shoestring. We were already tied to the bank with everything we could get tied to the bank. Four-part lock lines and three-part inch and eighth wire. We wired the tow back together. The *Northern* come over here and helped us get the tow wired back together, and we triple rigged everything. We tripled up all of the rigging, and instead of one set, we put three sets. I took every piece of line I had on the boat. If I could catch twenty parts on something, I caught twenty parts. When I got through, I only had one piece of lock line left that was about a hundred foot long. There wasn't a place to put it.

When we went down, we made up underneath the tow. Instead of being on the upstream end, we went down and got on the downstream end while pushing. About two days later, that gorge broke loose and started moving down the river at six miles an hour. The *Northern* and the *Brimstone* lost their tows. They just peeled them off the bank like they were just sitting out there. The ice moved

down the river and started piling up in front of the dam. It's called gorging. It can't go through the dam, so it was just stacking up and getting thicker and thicker and thicker. It's just backed up, backed up, and backed up. Then it warmed up and rained, and then the water started rising. When the water rose, it broke the ice loose, and it started moving down. It was several miles from Markland Lock all the way up into Cincinnati. We were underneath the point. The river came down and made the turn, and we were underneath that point. We had a mixed tow of tank barges. After putting all those tripled up wires and everything on there, there was only one wire left on that tow that was holding. All the lines that we put out saved us. That's the only reason why we didn't lose our tows. When we first got there, the temperature was down in the teens and twenties. It happens on the Upper a lot when it falls up there in winter after the winter freeze.

In the winter of '77 we were northbound at Pittsburgh point, and I was a mate on there. The third mate and our deckhand were out on the barge. We were going to Exxon. They were putting the reducers on the barges getting ready to hook the hose and stuff up and the reducer for the steam line. All of a sudden, they went to waving their flashlights. We were faced up on a 120-foot box, so you know they were right there. They went to hollering and pointing with a flashlight and waving for us to stop. So I stepped out on the side of the pilothouse, and Jerry said, "Look, Bill, look right there." I said, "Put your light right over there Captain." He swung the searchlight over there, and there was a girl in the water. There was fourteen inches of ice on the Allegheny River that night. That girl was holding onto the ice. She was alive. We immediately called the Coast Guard, and the Coast Guard called Search and Rescue. Search and Rescue had been there for an hour and a half trying to find that

girl. She had been in that water that long. That third mate wanted to go in and get her. I went to school with him, and I said, "No, you ain't going in there. You're not going to freak out." So I had a boy on there from Alabama that had been in Vietnam and had been in some pretty rough stuff over there. I knew that he could handle this situation.

He said, "Let me." So we put two lifejackets on him. I threw the life ring close to her head, and all she could do was just barely take it in her hand, and we could just barely hear her saying, "Help. Help." When we broke the boat out, we were trying to get in there to her with the boat, but all we were doing was shoving that ice. I said, "Huh-Uh, stop! Stop!" And so we put two lifejackets on John, tied a rope to him, and he went in and got her and brought her to the side of the boat. I was on the right side of her, and my dad was on the left side. We both reached down, and she was a pretty hefty gal. She was probably 5'5, probably go 175, 180 pounds. Daddy got her under one arm, and I got her under the other, and we eased her up. The instant that she touched that steel, she froze to it just like that. I literally took my knife and had to cut her hair and we just ripped her shirt off her back to get her loose and get her up on the boat. We took her back there and turned her over to the cooks, and they put her in the shower and ran cold water on her till we got to the bank. We found out that she escaped from the nuthouse. Search and Rescue had been there an hour and a half looking for her. It just wasn't her time to go. There's no fooling around on this river. You take your mind off what you're doing and get careless, and you're going to get hurt or killed.

I've had some pretty hairy experiences on that river with pleasure craft. It's plumb stupidity. Stupidity. You just can't believe people are that ignorant. They get full of that ignorant oil, and they really ain't got no sense.

JOHN HENRY WALKER

– b. 1955 –

My name is John Henry Walker. I started on the river right after the flood in '73. The first few years I worked out here, I was always going to do something else. My first trip, I jumped boat in Saint Paul, Minnesota. I had three dollars in my pocket. That's the truth. Anyhow, I made it home, and I stayed home a couple of months. I was actually seventeen years old. Turned eighteen on the boat. The first mate and the pilot, they were quitting, so I thought, Well, I will too. I had forty-seven days on the boat. So they left, and I left. I stayed off a couple of months until I ran out of money. Then I called the same company back, and they put me straight back on the boat, just a different boat, and they gave me a two-dollar raise a day. But I worked off and on. Then I came out here regular in 1975, and I been out here ever since.

I got my first issued license in 1988. It was actually like 1990 or late '89 before I ever got to use it and make any money. It took me probably ten years before I decided I was going to stay. I was always going to do something else. But back where I came from—I live in Walnut Ridge, Arkansas. Back then, around where I was from, there just wasn't any work. There were a bunch of us out here. I had

brothers-in-law and brothers on a boat. We had engineers and then pilots and deckhands. There were enough of us that if we were all together, we could crew a boat.

I would say I have an advantage on a lot of the guys that are coming up now because they do rely too heavily on the technology. Don't get me wrong, I think they're great. The electronic charts are the best thing since sliced bread out here. It's good, but you cannot depend on it. I've been told all my life out here you can't believe your eyes. The radar is going to tell you the true story. It's going to show you where you are. You get out there in the river and look out across your barges, and the distance is real deceiving. You can see something down there. We can come around Kings Point, and you can see the boat store down here, but it's still seven miles from it.

The alligators are impressive to me down in the canal. You see a lot of alligators. Mostly, when I've seen alligators is if you've been waiting for a lock or something and you can actually throw them a biscuit or something, and they'll get it. Get them right up next to the boat. They are some vicious-looking things. I mean, that's where the dinosaur came from or the dinosaur went.

Near misses. There would be people that tell you they don't have them, and then there's people that tell you the truth. They do. If you're driving a boat, you're going to have some near misses. Here's a good story on losing your engines. I was running mate for Valley Line, and it was the *Valley Transporter*. We were going down the river with thirty loads and just lost everything but. We were loaded with coal and grain, and basically what happened was we got water in the fuel line, so it shut the whole operation down. The pilot's name was Menville Trosclair. There's nothing any darker than one of these boats when you lose everything. The moral of the story was Menville, he didn't have a radio that would go to a battery. You were lucky if you had a walkie talkie on the boat. Well, Menville has got the walkie talkie, and we're floating down the river. Menville's downstairs looking over the rail at the chief engineer. There's nobody around us. I mean, who is he going to call on the walkie talkie? The captain—I forget what his name was, but he was pretty spastic. He was scared. The old man would be standing there and yell, "What are you doing down there? What are you doing down there?" And Menville just looked at him as calm as you can be and said, "Well, I can't do anything up there till he does something down here. I thought I'd just come down and watch him." That's the way it went. Would you believe that they got enough going that we actually didn't bust up tow? We topped around one time. I didn't really know the river then; I didn't know where we were. But we went around in a couple of circles, but we never broke up tow.

One time there was a crazy kind of guy on the boat. Human Resource wouldn't let me put him off. I have never been on a boat to the fact to where I actually thought about locking my door when I went to bed. This guy I really thought was going to go postal. He was that bipolar and probably something else. But you add that and just being a fullf-ledge nut on top of it. He was dangerous. Finally, they got rid of him because he didn't pass a drug test when it came time to catch a boat one time, and they did a random test. I'm glad of that. The thing about it is, he was a big guy, and I had to look up at him. They were painting the boat one day around the wheelhouse, and he starts back there. He paints the whole side. He gets up here at the front and realizes that he doesn't have any more paint in his tray. He walks back across the wet paint to get his paint bucket. I said, "Awe, man, we're never going to get this boat painted like that."

Overall, the river's been good to me. I make a good living out here. You miss a lot at home. But you still have to make the living. I'm old school. I feel if you have a family, you owe them the best living you can make them. This turned out to be the best for me. I chopped cotton before I came out on the river.

CECIL D. DUNCAN

– b. 1956 –

My name is Cecil D. Duncan. My father wanted to find for my brother and me a way of making a living. My father was a pilot on the river back in the forties. He decided to move my brother and me into the maritime industry. My brother was a graduate of Mass Maritime outside of Boston. He became a ship's captain.

When my time came around, I had no desire to do anything like that. I had no desire to do anything period. I wanted to play tennis and do other things. I didn't see that as a career. My dad had contacts with Ingram Barge Company unbeknownst to me.

I am a product of the National River Academy at Helena, Arkansas. I finished high school about four months after my seventeenth birthday. This is how much my father wanted me to get out. I went to the River Academy and then stepped on a boat around June, July of '73 on the motor vessel *O. H. Ingram*. And that is how I got started. I had seen up to that time one towboat, and that was in Clarksville, and I had no idea my father had worked on the river. He had never brought that up. So it was all kind of new.

I found the people, the characters, a lot different than I had been used to being around. They were good people. They were honest people. They were rough. At nineteen, I had my first license, a second-class operator's license. Then, at twenty-one, I became a pilot for Ingram. From that standpoint, I progressed into running captain for them for three or four years and then decided that I'd like to see other things.

I made a decision to leave Ingram and go to college. I was twenty-nine at the time. I left and went to the University of Louisville. And then, through college, I tripped for Ingram quite bit. I went year-round, so I graduated in three years. When I got out, I had no desire to be in the barge business. I took a job with Depuy Orthopedics. I learned for about three, four years the orthopedic business, total joint replacement, and I sat in on about two hundred total joints in the OR. I wore the boots, caps, gowns, and the whole sitting there watching them opening people up and working with the doctors and learned a lot of valuable lessons. But the most valuable was when you're asked a question, you give an answer. You don't do a do a towboat answer. Towboat answers would have gotten you out the door. A towboat answer would be, "Oh, I don't know, doctor. Let me look at it. Hey, looking good there. Little more wiggle in that ligament there, but, you know, they'll be all right. How big is that lady anyhow?" When they're lying there, you

know, they're big, and they're small, and you can come up with some good remarks when they're filleting each side of a person open, and you're seeing this much fat in them. It was certainly not towboats, but you gave them an answer. You were at, "Yes, doctor, I know. No, doctor, I don't know. And if I don't know, I'm on the phone now." There is no BS.

Fortunately, I stayed in touch with a friend of mine, Jim Farley, who we all know who's president of Kirby Inland Marine. Jim, at the time, was vice president over at ACBL. We had lunch, and I'd go and say hi to him. I was seeing that the end of the road for me was coming. One day, Jim called and asked me if I would be interested in a position or an interview with some people about South America. I met with Dale Wilkins, Oscar Kirth, from Greenville, Mississippi. We met, and I guess I had everything they were looking for: a college degree and the piloting side of it. So, the next thing I know, I make a trip to Venezuela. Venezuela, it was not the cup of tea for me, but, you know, I wasn't sure. Then I got a call from Lou Meece who was overseeing this operation. Venezuela had been such a profitable venture for them. They had decided and already started a company down in Rosario, Argentina. Lou called and, "Aww, we want you to go to Argentina." I'm thinking, Where the hell is Argentina first of all? So I get the map, and I start looking, flipping pages. There was Argentina.

And so off to Argentina I go. I spent a year and a half overseeing both operations in the building up of what would become the El Le Hidrovia. Hidrovia being the waterways. I lived in Rosario but primarily worked in Bolivia overseeing the operations loading of soybeans, some iron ore up there, and soybean oil. The pilots who came down for ACBL truly are the unsung heroes of what became the genesis of the growth of South America. They showed the pilots how to run twenty-four hours a day, 7 days a week, 365 days a year. They slept sometimes. I got on one boat, and a captain was in a hammock in the back at the dock. They put in a lot of time, and we would run yaws with Hummingbird sounders

to buoy the bends and take huge water jugs that I found finally and painted them neon green and orange and would throw them out with hooks.

In '97, at Christmas, I was in Puerto Suarez, Bolivia, loading at five to six feet in Bolivia then trend and floating them out and topping them off at Brazil because Puerto Suarez, Columbia are side by side with a canal. The iron ore in Brazil, it has a higher mineral count, which means you have to have less nickel to create the steel. So that's why they move about 320 million tons a year of iron ore out of Brazil to China.

But, after that, I came back. After a year-and-half, I wasn't offered a job with ACBL. I came back, and I moved back to Woodville, Kentucky, for about a year, and I was under a noncompete. There's a guy named Dave Dewey, and he's operating these boats. So I made a call, and Dave just so happened to be coming into Louisville to see the ACBL people one day, and we met. Shortly thereafter, I made a trip over on the *Pam Dewey* just to see if I could still run boats. I ran boats in South America just a little bit. You just start questioning whether you still have it, and if you still want to. I took a job with them and was running pilot and then captain on the *City of St. Louis* for a day.

What we did not know was the commodities boom was starting in '07, '08, '09, has run up until this past year. Then, all of a sudden, the iron ore business took off in China. The growth in China was based on steel. Ships, everything, labor being what they were, cheap labor. And we got call from a company from Greece that had just bought controlling interest in an Argentine company. They were in an expansion boat, and another hundred-barge order came in.

And that ended. That has run its course because literally we ran out of light draft boats. When the barges sunk, the Prefeitura, which is the Coast Guard, down there started looking at barges.

Then, in 2013, we didn't come up with the plan, but in South America, they started widening the boats by adding sponsons. Sponsons are

attachments to the sides of a vessel, a canoe, a kayak, for buoyancy and things.

But, after 2014, there's been some other qualifying events that occurred in my life. We sold the office at WKN. It was the end of moving equipment to South America. So I decided to go back out and, I guess, do some trip work and see if I still wanted to do that. I've been tripping on and off for the past eight months, nine months, just taking a little nap and seeing what comes up.

Mainly, I've been running the Ohio just because I really didn't want to do anything else. I don't think I'm here to prove anything anymore.

Coming from a seven-thousand-person town in Kentucky, I couldn't imagine the things I've done. Basically, it stems from leaving and wanting to further my education because I would not have gotten a chance to do orthopedic sales unless I had a college degree. I met every criteria that Lou and Oscar and them wanted to go to South America. So everything has been based on furthering one's education.

I've run into people whose children are in college and/or they're thinking about making changes.

I'm big on trying to sell them on the fact that this industry is dying for people. Frankly, companies who have been able to accomplish or excel at training and transit are the companies like Golding, Blessey, Kirby to some degree. The smaller boats still are family-run operations who are building boats right and left. There are these big companies they can't crew.

You have to stay on top. That's what makes the industry interesting. If you don't participate, how can you enjoy it? There have been a lot of people who've said, "I don't like this industry." Well, it's because you don't get out and see it. You have to be able to participate to understand it.

I've always seen it, and I taught this in South America, and I got a lot of this from working in the medical business. When you start down the path, you give an answer. You move on, and you make it work because towboating is point A to point B, back to point A. That's it. How you do it is what makes it easy or makes it hard. That can be a straight line, a wavy line, or look like a drunk. It's how you decide how you do that that makes it work.

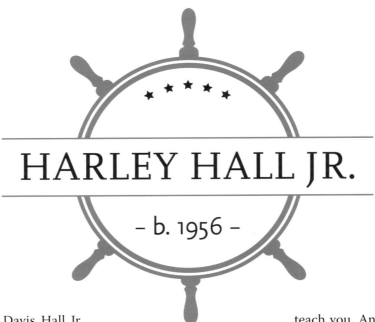

HARLEY HALL JR.

– b. 1956 –

My name is Harley Davis Hall Jr. The way I first got started on the river is I grew up with it. All my family worked on the river. My father and my uncles and my aunts were cooks. Just the whole family, we all worked on the river.

I started out when I was about sixteen or seventeen. My father wanted me to stay in school, but I would skip school and come down to Molloy Marine Service and clean barges. I would sneak off, and I'd go down there and clean barges. I always wanted to make a living. I went on the boat December 10th of '72.

When I began, I had a little understanding of it. During the summertime, sometimes, my dad would take me out on the river. I was lucky, and he got to take me on a few trips with him on the boat when I was a little kid. Then when I got on the boat the first time on a line boat, I've always been lucky. That was another time that things in fell in place for me because when I got to the boat, and they opened the door, and I looked down that passageway, all I saw was old men. Which having grown up and worked around farms and stuff, I'd always gravitated to the old men. You stick with old men; they know things. If you'll work hard, they'll

teach you. And that's what I did. I got on there, and I was lucky. Here is just this wealth of knowledge right down this passageway just waiting for me to soak it up. So I really lucked out on that.

I knew I was going to make a career on the river long before I ever got on. All it did was validate. I always wanted to do what my dad had done and my uncles did. I always wanted to be a pilot. That's all I ever wanted. They would ask me in school, "What do you think you're going to do for a living?" I'd say, "I'm going to work on a boat." And that's exactly what I'm going to do is work on a boat. It turned out it's just one of those dream things that was exactly more than I thought it would be. I mean, I really enjoyed it.

In that hallway, those guys all had one thing in common they passed along to me, and it was just knowledge and work. That was the big thing, "You work, boy. You work."

Bill Templeton was the port captain then at Igert. I think I got my license in '75. So I go in, and I talk to Bill, who by the way is a great guy. But Bill leaned back in that chair like I'm leaning back. But for whatever reason, I asked him about getting in the pilothouse, and for whatever reason Bill had formed

it in his mind that I wasn't pilot material. He says, "Harley, you can't make pilot." I said, "Well"—and of course I was just a kid. I think I was nineteen. I went home. On my way, I stopped by my dad's house, and I told him what Bill said. He said, "You can be anything you want to be. You want to do it, you can do it." So I came back, and I think I made one more trip at Crounse decking. The pilot I was working with was a captain, Jamie Bowland, another great guy. Again, Bill Templeton was a great guy. He just had his opinion. I had mine. Jamie said, "Just call around and find you a trip." I said, "Well, I haven't done anything." He said, "You can do it." He said, "Call Arrow Transportation." So, when I got off the boat, I called Arrow Transportation and asked them, "Well, do you need trip pilots?" And you know they did. I thought this would be a snap. So I took off, and I found out later that they thought they were talking to my dad. They didn't know they were talking to me. I just said Harley, and it came in handy, and you know I didn't correct it.

So I went to Decatur, Alabama, and got on the *Alamo*. I got on, and it was after lunch. The captain on there was already in bed. I got on. The pilot got off. We were going up the river. I'm sitting there, and I notice that I'm shaking like a leaf. Now, I have run this stretch probably dozens of times steering for people, but I was by myself, and I was shaking like a leaf. I said, "Lord, Lord, I know what to do." About four-thirty or five, the captain came up there and sat down on the couch back there. He introduced himself as Jim Robinson. He was with Federal Barge Line, and he was over there tripping. He sat there on the couch and asked my name and where I worked. I said, "Well, I worked for Crounse." And he said nothing. He said, "You kind of young, ain't you, boy?" I'm sitting there, and I'm looking straight ahead, and I'm thinking, "This jig's up. This has ran." I said, "No, not too young." He said, "Well, how old are you?" "I'm nineteen." He said, "How old are you?" I said, "I'm nineteen." He said, "How long have you been in the wheelhouse?" I'm sitting there, and that was a moment I thought, What do

I do now? Do I lie or what? And I said, "About four hours now."

He sat there, and there was silence. I'm looking out that front window, and he said, "The office know this?" I turned around, and I said, "No. And I sure wish you wouldn't tell them." I turned back around, and there was silence a long time. He started laughing and hit his knees and said, "Aww hell, boy, we'll make it just fine." And we did. We did. I rode with him for the two or three weeks he was on there.

I think it was about a year and a half later, and I can't remember that woman's name that was in there dispatching, but she called me, and, well, she didn't even know. They had had a mate get his leg broken at Cairo and had to take him off the boat. And they were already short. She called because somebody had told her that I was Harley's son. She called me to see about me getting on and doing that, and I said, "Well, I can, Jo," that was her name, "but are you going to pay me pilot's pay?" She said, "Well, Lord no. We can't do that." I said, "Well, you been paying me pilot's pay." "What?" She said, "That's not your daddy?" I said, "No, that's been me." She said, "We thought that was your daddy. Well, how long you been in the pilothouse?" I said, "Since y'all hired me."

Oh, I've had lots of characters in my career. Rod Church is one. Rod taught a guy. I watched this go on through the trip. I said I'm not believing this is happening. But he taught a guy to read. Had a guy on the boat that couldn't read, and he taught a guy to read using *Playboy* magazines and *Field & Stream*. It took him a couple of hitches, but he taught this man to read through those magazines. I was thinking, There's no way you're going to teach a grown man to read and especially because it's structured how you learn to read and learn the alphabet.

One of the great lessons, my dad taught me, and I'm still learning it. My dad was the quickest man to forgive I ever saw. He would forgive always. The second it's over, he'd start making an excuse for somebody. If somebody did something to him or wronged him in some way, the second it was done,

he will be saying "He doesn't know any better. He didn't mean that. He don't know any better." He never held a grudge. I never heard him say anything bad about somebody. If it was something that was really bad he said, "Well, he just don't know," you know. "He's going to learn." He hardly had a temper at all. And I'm still learning that.

I've told every guy that I've brought up that I've held, "You're captain now. Now what comes with that is you no longer get to do what you want. You no longer get to do what you like. That's over with. You have to do what's right. You have to think about things. It may not be what you like. You may have one man here that needs to be reprimanded here, and you like him, and you have to reprimand him over another guy you really wouldn't want coming to dinner, but you got to do what's right, and you got to set an example. If you don't, the men will never respect you. If you don't hold yourself at the same standard on the same level as them on the rules, on our policies and everything and on how you conduct yourself, they're not going to respect you. If they don't respect you, they will not work for you. They will not work for you." That's the biggest part of it. You have to earn that respect.

Now that I am port captain, I miss driving the boat and being out there. Every day. You miss handling a boat. You miss—I call it playing with a boat. Any of the guys I ever brought up, I taught them: Study your river. Study your craft. Watch what the water is doing over at the dike on this stage of water

and study the river. Keep your bar book up. Always study what is done. And if you do you'll have an easy job.

But what I would tell somebody, "If you're not going to further your education with specific training in mind, whether it be a doctor, a lawyer, and not even those things. Are you going to be a plumber or carpenter or whatever? If you're not willing to put the time in and do that, and that's not something that you have a love for, try working on the river. Try it because you're going to go out here, and it's going to be different. It's not a bad thing. If my children were still little, I would still be out on the boat because I got to spend more time with them than I would with this job I'm in now.

These guys can go out here, and they can see things that they never dreamed they would see. I've recently in the last year got on this Facebook, and there are friends on there. A lot of them are boat pilots. A lot of them will post a sunset or sunrise, the things that you'll see on the river. You get out there, and you get the camaraderie of these guys, and you can make something out of yourself if you want to. It is a team. I say try it. While you are trying to figure out what it is that you do love, give it a shot. You'll get more out of it than working at McDonald's or somewhere while you're trying to figure it out. Give us a shot, and you may find that what you didn't even know anything about is exactly what you've been looking for.

If I had it to do over again, this is what I'd do.

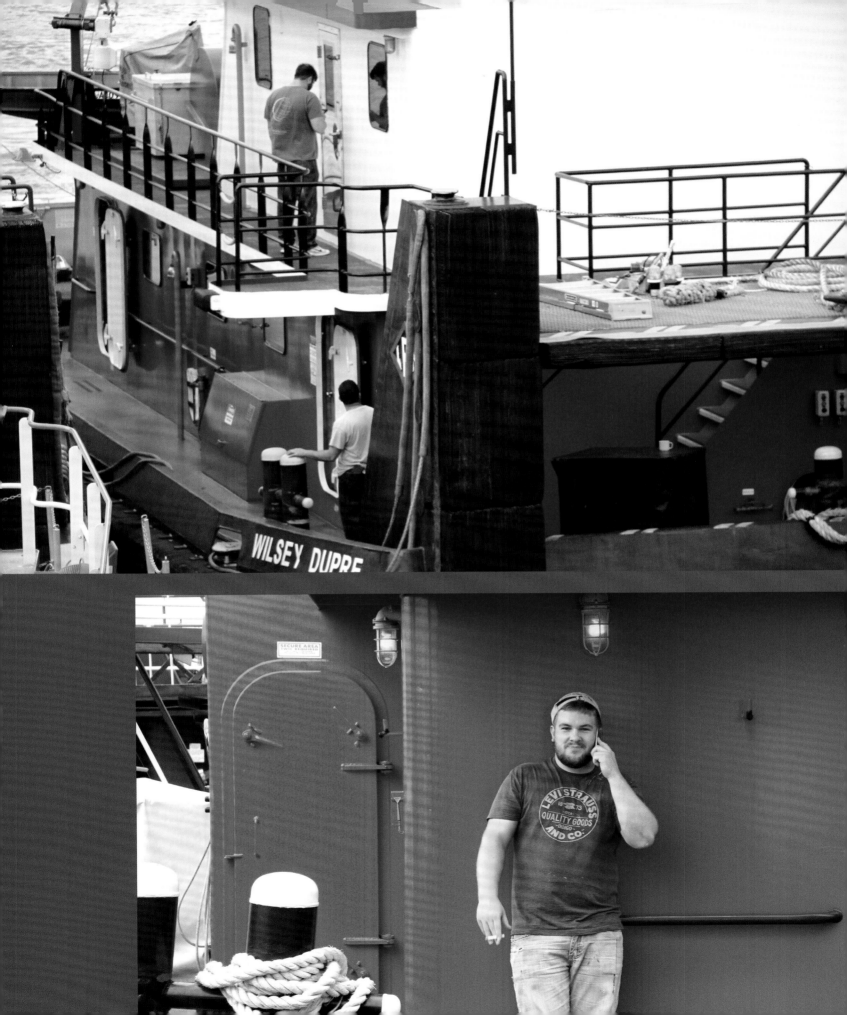

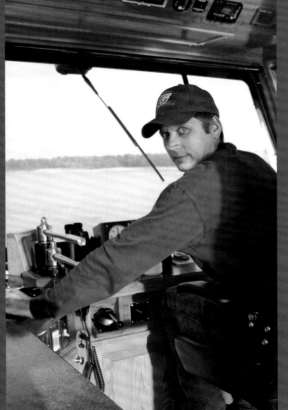
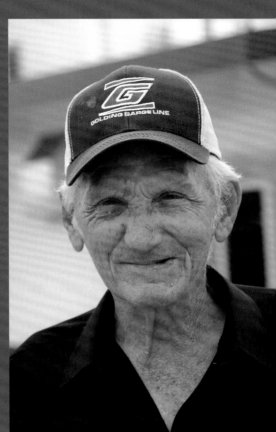

MARKHAM DEWAYNE "BOZO" MANDOLINI

– b. 1956 –

My name is Markham Dewayne Mandolini. If you don't want to say all that, say "Bozo." I have been on the river since 1980. Nobody steered me towards working on the river. I got out of jail. I started out as a deckhand. So it was just a job. You don't want to go back to jail. I was twenty-eight. I worked on the river ten years before I got my pilot's license. But I just had a job, and it didn't matter what it was. I did it well. If you had to be a janitor, you'd be a janitor. If you had to be a cook, you'd be a cook. On a riverboat, you might have to help somebody work on an engine. You might have to clean a toilet. I was getting paid and earning my money, and I didn't have any goals. They asked me "When are you going to get your tankerman's license?" I had never thought about it. That was after I had been with Ole Man River five years. I didn't ever think about advancing. I was working. Get off the boat, party hardy, marry this wife, marry that wife. The other wives, they left. I just have a bunch of ex-wives. I have four. And all because of towboats. Because, well, they have to deal with the kids by themselves. And when they were young, I probably didn't see five Christmases, but I had a job. And then by the time you get home they are grown, and they don't have a clue.

I'm doing a life sentence now thirty days at a time. And I have a wife that loves me and bunch of kids I want to get rid of.

You know, I'm a wild child. Always have been. I don't dress the part. You know, they say "Captain Bozo," and I don't like being called captain. I'm Bozo, but you better do your damn job.

I never had faith in myself. And somehow or another, that water, it's dangerous. You know, you want to be home. You have to be aware of all the things around you. I just found my way by getting on a boat. I didn't have to deal with life out here because I didn't know how to deal with life.

I've seen a lot of stuff. Crazy stories.

There was a guy that was working for a boat company that worked for the Corps [of Engineers], and back in the day everybody knew if you were tied up, unless you were really, really straight, everybody went off and drank or did somebody, everybody. And this dude and all, they went all out to a lady's bar, and there was one stripper that did an act with a boa constrictor. And then they came back. And when the corps did their crew change, it was everybody gets on, and they have this lady, and they snuck her on the boat, and everybody sitting here on this doggone barge getting ready to go to

work. You're supposed to have your lifejacket on. You're supposed to be ready to go to work. And this big bosom girl come out, and all they could see was bosoms. And then, all of a sudden, they saw what they thought she had a feather boa. And they kept looking at it, and that thing got to moving. They didn't ever let them cut him loose because they knew everybody on this boat and on this barge was going to bail. And then they realized that, and everybody hit the water. She was just doing her job and shaking around.

And, see, for that kind of stuff, people would get fired. They think, when I'm off the boat, I'm supposed to have a good time. But the minute I step foot on that boat, that good time is gone. You can't play pranks out there on the water. You know, Old Man River, that's what they call that, Mother Nature. That old girl out there will kill you. You can't teach them enough to be safe.

I remember Captain Leon Johnson. He was real nervous, couldn't be still. He started me out in the wheelhouse. He'd sit behind me—little bench, and he'd have a fly swatter in his hand. And when you're driving a boat or steering a boat, some people think that was a steering wheel like the old days. Well, we got what they call sticks, and you move it this way and that way, and that makes you go where you want to go. But if you subconsciously have your hand on that stick, you will move it when you aren't thinking about it. Just move your arm, and it will make that rudder move a little bit. And when you did it, he'd hit your hand with that fly swatter. And I tried so hard. Finally, I got tired of it. I said, "Leon, you hit me with that fly swatter one more time, they ain't going to have no captain, and he ain't going to have no steersman." And he put that fly swatter up, but I drive a boat to this day with my hands.

You have to understand my background a little bit. I was supposed to be spending the night with a friend, and the friend was supposed to be spending the night with me. About three days later, they ain't seen me or Danny, and so they called the cops. And, finally, my sister said he went to that hippy thing,

you know. And I hitchhiked from Baton Rouge, Louisiana, to Woodstock, New York, and party, party, party. Well, when I got home, my stuff was sitting out on the front porch. And my father told me, well, my old man told me, "You worried your mother that much, you just keep right on worrying her." I was thirteen.

I was a grown man at thirteen. My old man was a Hells Angels biker, so that just tells you I was raised a little rough. Love and peace, baby. I still wear my hair long. I don't know if it's because I am a hippie. I'm a hippie from Mississippi. Bozo fits me because I'm a clown. I love to play.

And I'm a clown. I can be happy but you don't want Chuckey to come out.

I got a Bible in my briefcase, my saddle bags. If I'm anywhere, I got a Bible. Might not read it enough.

But nobody led me down here to the river. Nobody. I just had a job, and that's the job I had to do, my home. My daughter is Bozette. I named her Ally Bozette on her birth certificate because I couldn't name her Bozo Jr. So I named her Bozette.

The river gets in your blood. If you wear out a pair of shoes, you're done. If you ever make one trip, it's either for you, or it ain't. None of us was born knowing how to do this, none of us.

I ain't got no hate in me for nobody unless they mess with my family. I don't look at color, or I don't look at hair. A man cannot work on the river or any job that takes you away from home without having a strong woman. It took me four wives to figure out that wasn't right. But there's always a good woman behind every man.

There is a difference in when I first started out on the river and how things are now. It's totally different now. You have to have rules and regulations. You have to dress safely. You don't catch a boat in flip flops and sandals. I wear long pants and boots when I catch the boat. Now I can wear sandals and shorts in my wheelhouse. But if I walk out there on that barge with the deckhands, I'm dressed properly.

I got my GED. I did my last "time" in Florida. I had a state-paid vacation, baby.

The river, it's been good to me. And then you have somebody on there has got to learn how to teach them, and usually it's the captain. You got to try and be one of them. You got to try and understand. But one thing I do know, I pick and joke a lot, but you can't walk on that water. There's only one person that can walk on that water.

JOY MARY MANTHEY

– b. 1957 –

My name is Joy Manthey, and I've been on the river for forty-nine years. I was born in 1957, and I started working on the boats when I was ten years old. I ended up walking up on the dock at Canal Street. They had this big boat there, and they had these two young girls that were playing on something. I didn't know what it was then, but it ended up being the old stage of the steamer *President*. One of them said, "We'll get you on the boat if you clean the popcorn machine." So I was like, "Well, okay." so I went on the two-and-a-half-hour harbor sightseeing cruise that afternoon, and I cleaned the popcorn machine and I was just ten years old.

On the steamer *President*, Captain R. M. Streckfus was the captain. It was part of the Streckfus steamer family which was one of the biggest excursion boat families on the waterways on the Mississippi River and the Ohio River. He was the captain on there. He let me steer the boat. I had to stand on the milk crate to see over the wheel, and I steered the boat. I loved it. I mean, I was only ten years old.

In fifth grade, we took a test, "What do you want to do when you grow up?" and I put "other," and I put "river pilot." My teacher made me erase it and told me I could either be a teacher or a nurse. So

that's really what made me start striving to be a captain because my fifth-grade teacher told me I couldn't do it.

When I graduated from high school, the prophecy was that I was going to be a nun chasing juveniles down the Mississippi River because I wanted to be a juvenile probation officer. Then I was going to be a captain at night on the night crew is what my prophecy was. But I knew in fifth grade I wanted to be a pilot, and I wanted to be a heavy-tow pilot, like doing twenty-five or thirty-six barges because I used to watch them. I'd hear them come down the river on the radio, and they'd come around Upper 6-mile point, Upper 9-mile point. I wanted to see them flank Algiers Point, so I would stay afterwards and wait for them to come.

When I was a senior in high school, I got off of school every day at twelve o'clock, and I'd go down. I was the purser on the *Admiral* and did all the money. Then the sticks on the *Admiral* were higher than the sticks on the *President*. The *President* in 1974, '75 was brought up to St. Louis, and it was converted from steam to diesel, and the *Admiral* had been converted two years prior to that from steam to diesel. They put in the Z-drives. We had Z-drives back in the '70s on the boats that I was captain on.

And so anyway, when the *President* went up to St. Louis, the *Admiral* came down. And we had an old-time pilot. His name was Captain T. Joe Decareaux. Great, great man. Just a gentleman. He worked on the old *Standard Oil* and the *Exxon*. He actually worked on the *Sprague*, and he was from Paulina, Louisiana, and he was our pilot on the afternoon cruises, and he had bursitis, and so it was hard for him to steer the high stick on the *Admiral*. I used to be his cub pilot every afternoon for the two-thirty and five o'clock trip. And then, right after then is when I got my hundred-ton license that summer. I turned eighteen that year, and then I got my hundred-ton license and started running the four-hundred-passenger boats. I graduated from high school in 1975. My first license I got was a master of a passenger-carrying vessel of not more than a hundred gross ton.

It took me years to get a job on a towboat because nobody would hire me . . . I started LSU as a freshman in the fall of '75 and joined a sorority and did the whole collegiate thing for four years. At the same time I went to school, I was working on the boats as a captain on the four-hundred-passenger boat. I was master on the *Commodore* with a four-hundred-passenger excursion boat that ran the New Orleans harbor. We did private parties and dinner cruises and sightseeing trips.

From '81 to '99, I was part owner of the *Samuel Clemens*, a 276-passenger boat in the Baton Rouge harbor. Every time I saw an ad anywhere for a towboat job or for a pilot job, I'd go apply. They would just laugh me out of the office, and they'd tell me I needed a license. In the middle of this, I got my first-class pilot's license, and I got a master's unlimited inland license any gross ton. So I got two substantial licenses then.

In 1984, I started trying to get a job towboating. I answered every ad in the newspaper for a pilot's job, and I just never got anywhere. I just got left.

I went to one place in New Orleans in Harahan. They had an ad every single day in the paper for a pilot's job. Finally, I walked in there, and I told them I was applying for a pilot's job, and they said, "Well, you know you have to have a license?" I'm like, "Oh, yes, sir, I know that." He said, "Well, we're not hiring any cooks." I said, "No, I'm looking for a pilot's job." He said, "Well, you can't have a pilot's job. You have to have a license." I said, "Well, I do have a license." So I showed him my license, and he was pretty astounded because it was so much of a license. Then he said, "Well, no, you know, we're not going to be able to hire you." So then the boss comes in, and he walks me to the back office to talk to me. On his wall, he had picture of almost every boat that I had already been a captain on. I showed him on his wall, I said, "You see that boat? I've been a captain of that boat. You see that boat? I've been a captain on that boat." There were five boats on his wall that I had been a captain on, so they still didn't hire me.

In 1991, I was captain and mate on the first casino boat in the United States, and that was the steamer *President*, the boat I grew up on. It was turned into a casino boat, and they offered me a job to go up to Iowa. I went up and was captain on the steamer—the *President Riverboat Casino*. So I did that from '91 to '94. And so in 1996, they were hurting for pilots so bad that the guy who hired for Scott Chotin called up and said, "Joy, you know, now is your chance. We're looking for pilots. You know, if you want to do this, I think I can get you in the door now." And I'm like, "Yeah, I definitely want to do it." So I went from making $100,000 as senior captain for the *Belle of Baton Rouge Casino* to take a $30,000-a-year job towboating for Scott Chotin. A $70,000 cut in pay. I got on a towboat and have never regretted a minute of it and have loved it and still love it. When I started working for Scott Chotin, that's when I started working regular as a towboat pilot, and I have been a towboat pilot ever since.

In between my day cruise and my night cruise, I would go sometimes make a holy hour up at the Catholic church. I was kind of doing the deep meditation one afternoon in church, and I heard all this commotion, and I looked up, and I thought I

was seeing the back of the Blessed Mother with all these roses coming out the side of her arm. It was actually Mother Teresa of Calcutta who was in the church. To make a long story short, Mother Teresa was there. And that started my relationship with the Missionary Charity Sisters. I ended up becoming one of Mother's bodyguards. I traveled with her around the United States and Mexico. When she came to Lafayette or Baton Rouge, I'd pick her up at the airport, and I'd bring her from city to city, and then I traveled with her in New York. She didn't call me her bodyguard, but, I mean, I traveled with her, and I kind of took care of her. But she wouldn't call me her bodyguard, but she didn't know what I was at first because I always had my captain's uniform on, my epaulettes and my white shirt and my black pants because I was always coming from the boat when she was in Baton Rouge, or I'd be coming from the boat going to pick her up.

That was a precious time in my life. Every young girl wants to be a nun if they had nuns in school. But Mother Teresa was just like you and me. She was a regular old Joe I think. She was just a very nice, kind person that didn't take no for an answer no matter what.

I was sitting on the pilothouse on the casino boat in Baton Rouge, and they had a little ad in the paper for a "come and see" for the Sisters of St. Joseph, and so I picked up the phone. The phone was sitting right there, and that was 1996 maybe. I was in my thirties. I was a late vocation. I felt a little comfortable with the Sisters of St. Joseph and felt like that's what I was called to do. So I entered the Sisters of St. Joseph and stayed with them for about fifteen years. I lived with them, but I never let my license go, so I was always a pilot. In 1998 I was a novice. A novice is like a nun in training. It's a very strict time. You can't like go out anywhere. It's not a cloister, but it's a strict time of formation when you're really affirming yourself to become a nun. I only made like a month and a half of doing two years being on the boats when I was a nun in training, I call it, in formation.

I had read about Seamen's Church Institute and how they were going to have this simulator in Paducah. I just wasn't a believer of that. I was like, How in the hell can they simulate the wind and the current and the upstream eddies, and just how could they do that? Reverend Jean Smith, who was the executive director of Seamen's Church at that time, she was actually going to be in Paducah that day. I met her, and she knew that I was a nun and everything. She wanted to meet me. After I got the boat docked, her and Karen Russell came down to the boat. She was asking me when I made vows what did I plan on doing. I said "Well, I plan on going to all these towing companies and asking them how much they can pay me, and I was going to become a chaplain to the guys who worked on the boats." So she said, "Well, why do you want to do that?" I said, "Well, before I started my novitiate, I was still working on the towboats when I was entering the convent." There's a year where you do your regular job and you kind of start the process to become a nun. During that year I was towboating. I had already gone to work for Scott Chotin. When I was going to the fleets, all these guys would come over, and they'd be sneaking around my boat wanting to know whether I was a guy with a squeaky voice or whether I was a good-looking chick—and I'm not a good-looking chic. I mean, I'm overweight. I'm obese. I mean I'm not just this cute little thing. So this one man came over on the boat. I was in Houston tied up at the building at Kirby. This guy was sneaking around the outside of the boat. I went out the other side of the boat, and I said, "Cap, you need something?" He said, "No, no. I was just coming to check and tell you." So this is his first day back on the boats, and I could see he was tearing up, and he was really still hurting. I just started talking to him about it and just visiting with him and everything. I clearly remember the light going off in my head; these guys don't have anybody on the brown-water boats. This was before I even knew anything about Seamen's Church. I said the ships have chaplains. I used to see them in New Orleans.

So, anyway, I realized the need for that. Jean Smith, the executive director of Seamen's Church, she asked me what I planned on doing. I told her, I said, "Well, I plan on going to all the companies and asking them how much money can they put into it, and I'll be a pastoral care and counselor chaplain to the guys on the boat." I could see that this didn't sit well with her. I didn't know they had chaplains and stuff. She told me to call her when I made my vows [and] she might have something for me.

About three or four months later, I called her up, and she said she had a job for me. Told me to go get a car, go get an office, go get a computer, and start working for Seamen's Church. So that's how I got started with Seamen's Church and really started the Ministry on the Rivers program. I did all the boat visiting in the south. So, most guys, if you mention Sister Joy, most guys will know me who worked on the boats back in 2001, 2002, all the way up to 2007. All I do is I visit the boats every day. I visit fifteen, sixteen boats a day, sometimes visiting with the guys because I still think it's a very important ministry.

[B]oat visiting as the chaplain, I would say, kind of started changing in 2002. I can see God's hand in everything with this because I was a nun. I was working for Scott Chotin, and then Kirby bought us out. Then shortly the nuns gotten off the boat because I started really becoming interested.

Steve Valerius was the biggest one to support women being on the boats. Kirby was always very good to me when I was with Seamen's Church. I went with Kirby because Steve Valerius was saying, "Okay, we want you to mentor the young women who are coming on board." We have more women working for Kirby than all the other brown-water companies put together because of Steve Valerius and because of him trying to bring women on board and setting the tone.

I was at Seamen's Church from 2000 to 2007. Then I decided to leave the convent after Katrina. I just discerned that I had a temporary vocation. I just discerned that my vocation was a temporary vocation, and so I came out of the convent in 2007 and went back to work for Kirby full time. I'm happiest when I'm sitting between the sticks of a towboat.

Somebody gave me a shirt the other day. I said if I wanted to be cremated and thrown into the river, this is the shirt that they'd put me into my coffin in. It says, "The river is calling, and I must go." I was like, That's the perfect shirt for me.

I really can't say I've accomplished what I wanted to because I wanted to be a heavy-tow pilot, and I never got to be a heavy-tow pilot. I pushed thirty-six barges just up the river. I've never flanked a thirty-six-barge tow, which I still would think I would love to do. I really wanted to be a ship pilot, but they shut me down on that too. But I've opened the doors for other women because I did take them to court and forced them to open the doors, but they weren't going to take me in. So I wouldn't say that I've done everything.

I really felt like I was chosen to open the doors for women in the towboat world because Steve allowed me to come back to Kirby full time. But because I was a nun, the wives weren't threatened. It's so stupid for the wives to be threatened to begin with because, my God, they're on the bank with thousands of men, and you're talking about one woman on the boat. It's just men on the boat; everybody hears it or knows about it or something. But the wives were okay with me working on the boat because I was Sister Joy. Because I was a nun, I guess they thought I was a refrigerator that I didn't have any interest in sex or whatever. I don't know what the hell they thought. But I think God used me for that. He used me also as the chaplain.

Some people tease me and call me "Sister Mary Captain," but a lot still call me sister because that's how they know me or met me. I still am a chaplain. I'm a corporate chaplain for Kirby. So I do pastoral care and counseling.

Working on the river is the best job they have in the world. I'm the happiest when I'm sitting between the sticks on the boat going down the canal or the river. It's a great life. I absolutely love it. But for a

young woman, if you want to have family and children one day, it's a little bit more difficult because, honestly, who's going to leave a baby? That would be a very, very hard thing to do. It's hard enough on the guys, so I can't imagine what it would be like on the women.

So yeah, for women and men, they can do it. There's no doubt about it, and it's a great, great job. I think it's the best job in the world.

I've been very blessed. No doubt about it. I'm one of ten children, and I would say I've probably done better than my nine brothers and sisters, and I was just very, very fortunate because God's been watching out for me. I try to do what I'm supposed to do and try to help others and be right. I don't always succeed, but I try. I try to walk the part.

RODNEY W. COCKRELL SR.

– b. 1958 –

My name is Rodney Cockrell. I started when I was fifteen, with my dad, working summers. My dad's name is Robert Cockrell, and he was a towboat captain. He started working on the river in the 1940s.

There were many stories that he told me about. Sometimes they slept on the decks at night because it was too hot to sleep inside the little boat. They didn't have air conditioning back then, and they didn't shower much unless they fell into the river. Maybe that was a Saturday thing, that you fell in the river. He was telling me about the little search lights back then; it wasn't anything to run up in willow trees and knock the windows out of the boats and knock all the light off because they couldn't see and probably no radars. It was very crude. Those men were real river men. They navigated by the seat of their pants. I'm not so sure that everybody that sits between these sticks today could run under those same circumstances.

I don't know how they brought some of the big tows down. It was just a set of sticks and a light that was inferior to what we have and a lot of times no radars. So they knew the river. It started with Mark Twain and those fellows. It was a lifestyle. I've known guys that kept their clothes on the boat, but they took a full suitcase of clothes home to visit. They lived on a boat and visited home. It takes an odd bird to survive out here.

By the time I was eighteen, I could drive from St. Louis to Cairo on the river with two or three small barges. I knew the river well enough. My dad, he broke me in. He always told me, "I don't want to apologize for my son being on boats," and therefore I had to work twice as hard as everybody else. I had a brother, also, that was just a year behind me, and man we worked. My brother was so clumsy that I don't think my dad slept much on his off watch because he was always worried. He'd say my brother would trip on a painted line on the boat, and he was afraid he was going to go overboard. He ended up losing a leg. It got smashed between two barges. He was almost nineteen. So that ended his career.

My dad was from Louisiana. He said life was just so poor back when he first started on the river. The river was a way out. He found his way to the river, and he always had a paycheck, and he always had money in his pocket. He said no matter how bad things got, there was always a job on the river. He said it may not be exactly what you want, but you can feed your family on the river if you're willing to work.

Some people are just not made to be in an office. They're not. I've seen in my lifetime that the river has been the salvation for a lot of people that, for lack of better words, they can't function in public. They get in trouble when they're at home. The river gives them a haven.

Being a captain, there's still a little freedom out here that you don't get on the bank. I've seen some magnificent sunrises and sunsets, which I always tell my wife about. I almost feel guilty for some of the stuff I've seen, and she doesn't. You know, she doesn't get to share it. It takes a special person to make it out here.

Some years ago, I was on the Missouri River, which is a very fast river. We had three barges doing sixteen miles an hour idling. We were just idling. I got on the boat in Kansas City, and I remember I got sick to my stomach because I was watching the logs go by. They were going by so fast, I thought, There's got to be a motor on them. A log cannot float that fast. The two guys that me and the other pilot relieved, they ran off of the boat: "See ya. We got to go." They jumped in a crew van, and we're like, "Oh Lord, Lord."

I live on the *Kaskaskia*. I've been up a lot of rivers that your normal pilots probably wouldn't because I worked marine construction. I've been on the Raccoon River. I've been on the Colorado on the Arizona border, the Green River, the Missouri, just about everything above Cairo at some point. I've been on the Monongahela once. The Illinois, the Ohio, the Obion.

An old joke amongst a lot of the old timers was that on the Missouri River, the Illinois River, and the Upper Mississippi, there are some bridges that would have had to really be planned. They couldn't have built one in a worse spot. Everybody on the river knows I'm talking about the railroad and . . . some of the lock and dams and the old joke, "There's another drunken railroad engineer's doings." The

younger pilots that are coming up, they have all these charts and computers, so many tools to help them and you're not running by the seat of your pants so much anymore. That bridge in Vicksburg, I don't know who designed it, but surely there was a spot somewhere closer or in a better spot, but it's been tagged a few times.

A lot of captains, I hate to say this, but they are very egotistical. I know there are some somewhere that think that the deckhands are farm animals or whatever. They can work them any way they want to, but they're people. But that person, one day, one of those guys down there is going to be relieving you up here, and he may take your place when you go to the bank. You have got to respect everyone on the boat. Your crew needs to know that you respect what they've got going on. Otherwise, in this small a space, you can't get along.

The river, it is a way of life for me. I'm gone for twenty-eight days. When I come home—it's a homecoming every time I come home. It's a good way to make a living for me. It may not be for everyone. You have to be comfortable with yourself out here. I've seen all kinds of people out on this river. There's some good ones, some really good ones that you would trust with your life. Then there are some that you don't turn your back on.

It seems like my life on the river just started yesterday. I was telling some guys, "Fellows, in the river of life, I am past the half way mark, and I can't see the bank where I came from. I can't make out the shore too good over there, and I don't know how close I'm to the end of this journey. But from here on out, I'm looking that way. I'm not looking where I came from." I still feel like I'm eighteen, but my body tells me otherwise. It has been a very fast— I'm not saying a short career, but it's been very fast, and some things I would have done different. But it's a good living out here.

MARK HAURY

– b. 1958 –

My name is Mark Haury. I've been on the river since 1976. I was in the navy for three years and did a couple of other jobs. I lied to a company called Switch Boats in Baton Rouge and told them I was eighteen and got hired on working fleets for $28.50 a day tightening ratchets. They had an ad in the classifieds, and I needed to make some money. I didn't want to live at home anymore.

It was probably a year or two before it even really started hitting me that I was going to make a career out on the river. At eighteen, I went to the navy. So probably when I came back. I got a good friend of mine, Doug Benoit, who works at Capitol Fleet. Doug one time told me I was such an asshole when I was younger, and I kind of I asked him why. He said, "I can remember you telling me"—and this is when we were both deckhands. Doug was my deck-hand. He said, "You told me that you were going to get to the wheelhouse. You were going to be a pilot and that you were going to step on anybody that got in your way." I said, "Doug, I don't remember, but could have been." Hopefully, I didn't step on any-body, but I got there, so . . . I went into the navy '77 and then got back out in '80. I was three years

reserve on a sub tender and hated that. I was told I would never amount to anything. I would never become anything. In '82, when I got my license, I took a picture of me waving to the old chief. I'd sent him a picture of me in command of my boat. So when I got out of the navy, I came back to the river.

A river man is independent. Twain had said that there's no more independent, free person on the face of the earth than a river pilot. It's not quite as true nowadays as it used to be, but I still think that it's one of the most independent jobs there is. Blessey Marine that I work for can tell me where to go.

Back when I first started out on the river, it was fun. I used to make more money selling pot when I was a deckhand than I actually made being paid as a deckhand. That is not the way it is now. Hadn't been that way. Everybody's got retirement plans. My retirement plan is to retire and sit on my porch in Kentucky and smoke pot the rest of my life because I loved it. I think I do a much better job sober, completely sober, than I ever did when I was high running boats. I did run boats high for a while. I think company owners have the absolute right to know that their people are sober doing their job on

this kind of equipment. Now, I don't see any drugs on the boat. The drug testing will get them. I think that's completely within the realms of the rights of the owners to know that people are not under the influence operating their equipment. I don't think it's their right to tell me what I can do when I'm sitting on that hill in Kentucky.

With all of the computer technology you've got a higher grade of person out there. You can't have people that were just wonderful boat operators but couldn't read or write like they did back in the '70s and '80s and could run the hell out of a boat. Could do anything but couldn't write down what they had done. They had to get their deckhand up there to fill out the logs for them. Those days are gone, and that's good.

According to LaVern Riley, the guy that taught me to run boats, he said, "There's two kinds of pilots. There's taught pilots, and there's natural pilots." Computer navigation is not a fad. This is the future. You know, we're changing. We're adapting to the future. What operations does a lot is get these steersmen with other pilots to teach them how to run boats.

Computer navigation charts are the very best aid of navigation that has ever happened. Ever. Buoys are good. Day marks are good. Spotlights are good. The very best thing about computer navigation, if you understand how to use it, is not so much that it's going to teach you how to run the boat because it won't. You've got to understand how the throttles and how the rudders and all that work. The best thing about the investment and the satellite compasses and the program itself is that my stress level is about as close to zero as it can get doing this job. The stress level for doing this has been way lowered by using electronic chart systems. It's a good thing. Hopefully, it will keep me alive for a few more years.

I work for six hours, and I'm off for six hours. If it's a good trip, I will work my six hours and have nothing bad happen, and I'll enjoy myself because it's great. It's an office job with a wonderful view

basically. It's very regimented. I'm able to get into an exercise routine because everything is regimented, which I have trouble doing when I'm at home because I don't have any guidelines or any rules really to go by.

I have a wife that I have heard is a wonderful person. I don't really know her that well. I'd like to. I'm still pretty healthy, and I want to spend time with her. It's true I want to spend time with her.

I told my son about working in this industry, "Make your decision because even though you're gone so much, you at least have money to do things with your family when you're home. While these boats have afforded me, if not always a good life it's always been an interesting life. I will be able to retire at sixty. Then there's also the fact that while lots of people have lots of different opinions about me concerning lots of things, most of them think I'm a pretty good pilot.

I will always remember that first rule of piloting that LaVern taught me, which is never forget where you come from. Never. Because anything can happen where that guy that you're talking down to, that deckhand you're disrespecting and cussing becomes your boss in ten years. What goes around comes around again.

I have pushed a boat into the bank and me, and a deckhand had it out to see who was going to get back on the boat. Now, I was a lot younger and probably in better shape then. But you can't get away with that kind of stuff anymore. Of course, you also can't fire a guy off the boat anymore. You can't hire a guy to get on your boat anymore. You can't have friends come out and visit you on the boat.

I can never see me doing any job other than this one. Never. I know the customer is always right in some of these other jobs. My personality just doesn't jive with that. And I don't think I could work in a job where I have to deal with the public. As long as the public is acting right, I can do that. But most of the time, you don't have the public act right. I'm not one to take a big ration of shit from anybody, and it

would get me in trouble quickly. I don't have to take anything when I'm out on the boats. I know exactly what my position is. I get kind of frustrated just being home because I don't know what my position is exactly. But this has been a wonderful career. I have no complaints about my life. This has been a huge part of it. There's so few people that do this. There's not that many people that do what I do.

CHARLES K. "KENNY" MURPHY JR.

– b. 1958 –

My name is Charles "Kenny" Murphy Jr., known as Kenny. I am originally from McCrory, Arkansas, and was raised in south Louisiana in a little town called Sunshine. My dad has always been on the river. My mom was a cook until I came along. I started on the river in 1974 at sixteen years old. I quit school. The old man said, "Well, if you're not going to go to school, you're going to go to work. You are not going to lay around and mooch off of me."

I used to ride the summers with my dad on the boats. I guess I always wanted to be like my dad. Since I can remember anything, I've been on a boat. They told me I took my first steps on a boat. That was back in the day when your families could ride with you. After I was born, Mom was riding the boat with Dad, and I was on the boat with them. So when I was an infant, I was on a towboat. So all I know is this river life.

It's definitely in my blood. I officially started when I was 16. I remember before that I was kind of like cabin boy, fourteen and fifteen. I use to come out and ride summers with my dad, and then, officially, when I was sixteen, he had to sign a waiver.

I have been on the majority of the rivers. The Tennessee is my favorite. The Upper Tennessee is the part between Guntersville and Chattanooga and is what they go through the foothills of the Appalachian Mountains what they call Raccoon Valley. Just imagine a crystal clear water, and you'd have to look up and out just to see the tops of the mountains. When it's fall, just the color is just breathtaking. It's just awesome. When you get above Chickamauga or Chattanooga, it's big lake reservoirs and rock. It's beautiful water, and it's just beautiful up there.

I don't know if you remember the gas company or oil company Sinclair. The dinosaur. Well, they used to have dinosaurs on their barges, and I didn't know that. And there was another time we would stop. We were going to tie off alongside this tow. And we were out there, and it was foggy, and you know how fog rolls in and boils up. I went up there, and I'm young. I'm sixteen, and I'm looking up. But it opens up, and all you can see is dinosaur heads. It was another moment I had to stop and say, "Wait a minute. What's going on here?" It scared me to death. I fell in the water.

And then I got in the pilothouse and had good fortune. I don't know if it was good fortune or what, but I was really fortunate to have my dad steering me. If you look at my ears, that's how come one

is laid in, and my head's lumpy because he always bopped me up on the side of the head. He could let me just about get in trouble or show me how to get out of trouble that I got in, but he taught me a lot.

I remember when I was on deck, we used to trade coffee and stuff to fishermen for fresh fish, and people on the side the bank, the lock men that knew these gardeners, we would trade stuff, we would buy stuff. That's at the time that boats had petty cash, and we would buy produce and vegetables from them. We used to do a lot of that back in the day. There's a few people still do it, but there are a lot of the companies that frown on it because it's not FDA approved. If you get sick or something. But then again, you don't know what you are getting in the package.

Then I went to steersman, so I got in the wheelhouse, and I got to be turned a loose. They suggested. So I got a fleet job in Baton Rouge for Tiger Fleet. It's like taking a country boy out of the town of about two thousand people and putting him in the big city. You know when a dog gets out of the pen or off the chain, you know, you holler at him, and he'd just run faster. I can sympathize with that dog. I know the dog's feeling. It's ultimate bliss. It's like freedom. It's like, Wow, I can't believe this!

Cooks were more like family members. Back in my day, I was so young, they were more like a mama figure. I had this one instance, matter of fact, where the first day I got on the boat, I threw my duffel bag up on the side of the boat. The galley door from the engine room opened up, and a deckhand ran out. The cook was behind him with a knife. And I thought, Well, this is going to be interesting. And it was, I guess, about four or five days. It wasn't long. In the galley you had the dining area on one side and then the cooking kitchen on another side and had a wall between. Well, I had walked back to the wall, and there was a door right here. I don't know, I was eating my ice cream, and he's in there arguing.

And he comes back, and he's stomping really bad through. And he comes back my way. He says, "You ain't got a hair on your butt if you don't come back and tell me that to my face." So that means he must have been in the pantry. He had been in there. So he turns around and walks back in there and starts out. Next thing I know, I hear something, and he falls out and lays out, and he's got blood all down through his face. And she stands out the door, has a big cast-iron skillet pointing at him. She says, "Next time you talk to me that way, I'm going to knock you out." And I'm sitting there eating my ice cream. I say, "Well, looks like you did a pretty good job," because he was out. I became her pet. I got on her good side real quick. He didn't talk back to her again. He got fired.

I lost my dad May 24th, 2000. He's better off, though, because he had non-Hodgkin's lymphoma cancer. I miss him because I can't call him up and ask him things. But now when I do something stupid, I can't hide it because I still feel my ear getting real hot over here because I know that's when I'm slapped from the other. I still hear him in the back of my head saying, "Now what were you thinking when you did this? or "Are you sure about this one?" So . . .

My dad inspired a lot of people. He never met a stranger. His name was Charles Kenneth Murphy Sr., but everybody knows him as Captain Ken or Ken Murphy. His famous words were he didn't come into this world begging and stealing. He came in this world wheeling and dealing.

Working on the river, it's a love-hate relationship. There are days when you're down with things going on. But the river has been good to me, and I love the river. When I first got married, I tried to be the true husband and get a land job. It was the most miserable eight months of my life. She finally she threw the duffel bag at me. She said, "Go find you a boat and make us all happy." So here I am back on the river.

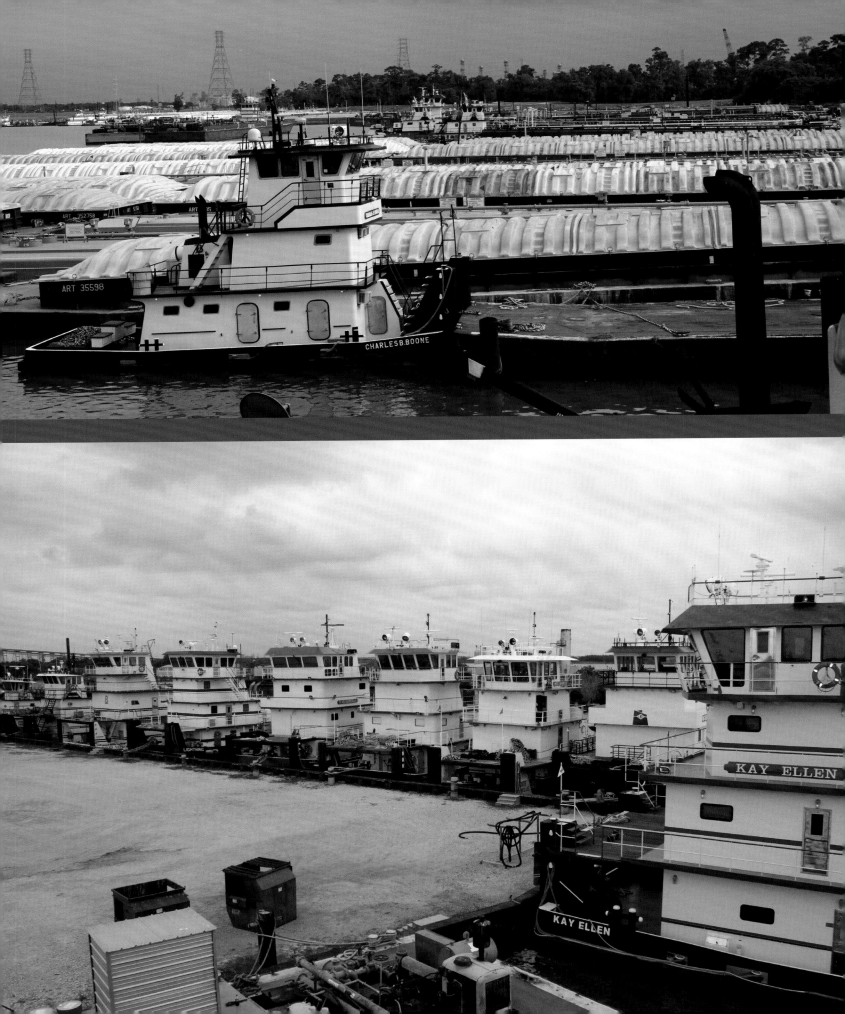

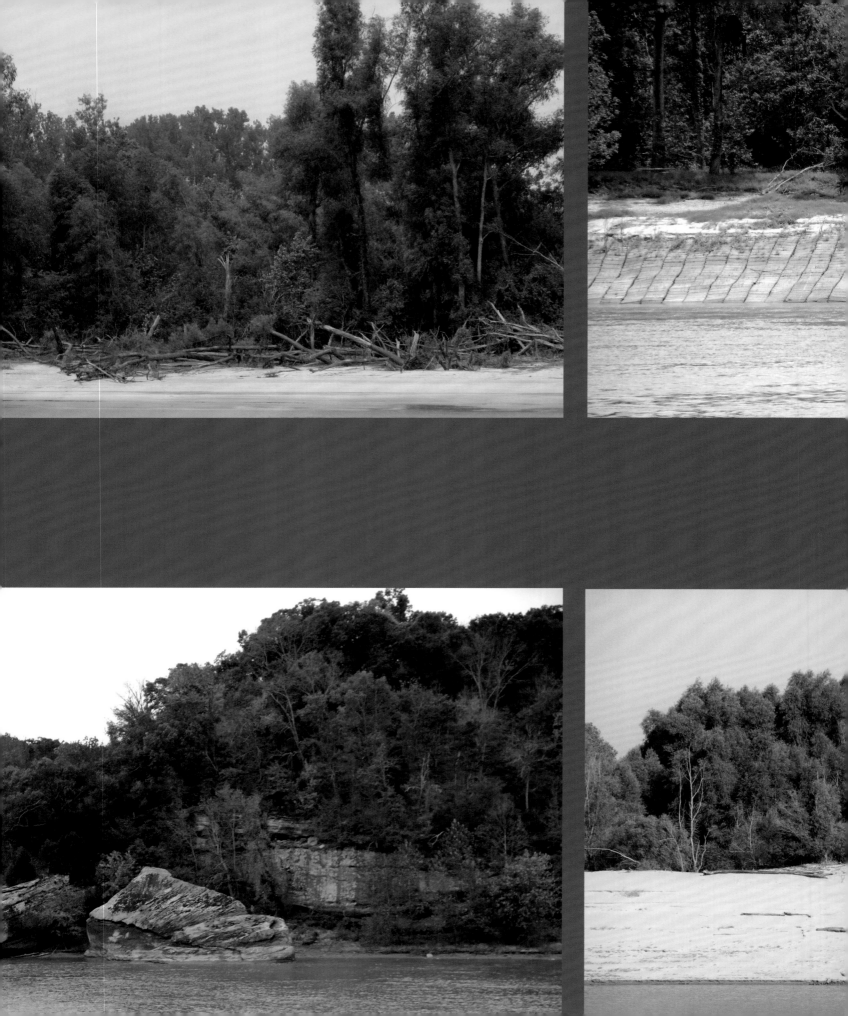

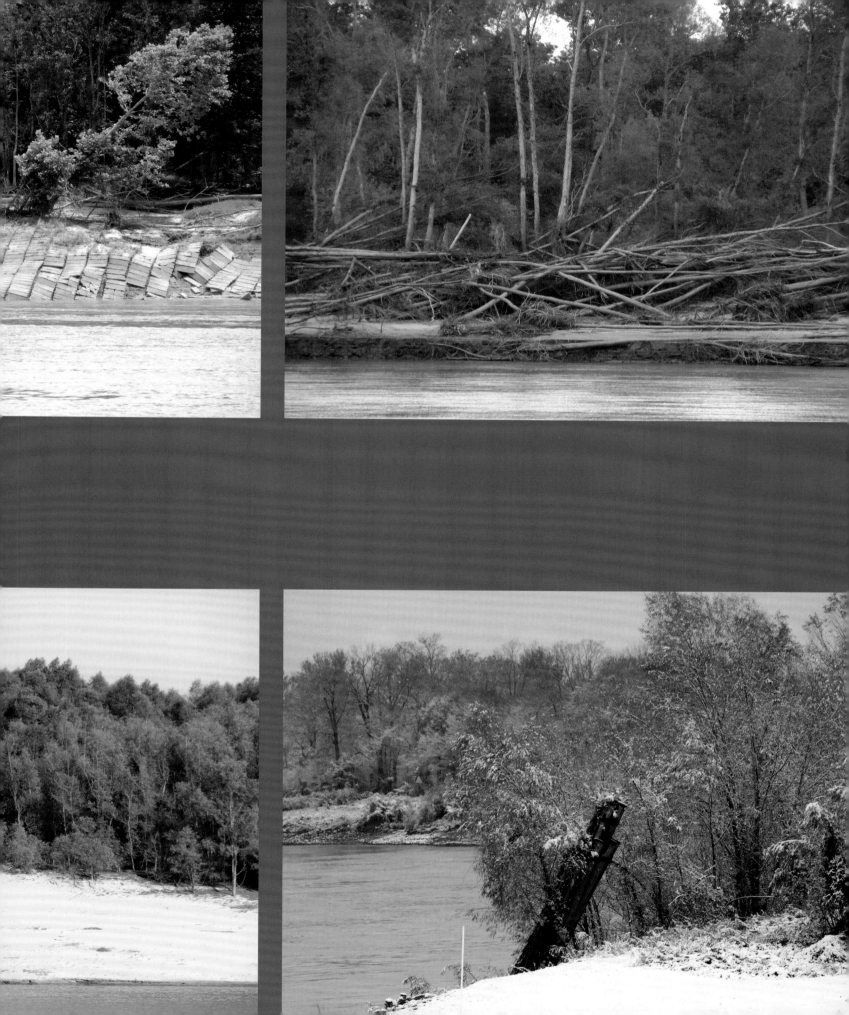

TERRI L. SMILEY

– b. 1958 –

My name is Terri Smiley, and I've been on the river thirty-two years. I was working construction as a laborer for seven years, running a ninety-five-pound jackhammer and raising two kids on my own. It was just a seasonal job, and unemployment wasn't paying the bills. I had a pretty rough life. With those two kids and trying to pay insurance, I said to myself, "I need something that's year round in order to make a living for my children." So I decided to go out on the river as a towboat cook. I was twenty-five years old, and in doing so I broke all the rules. I knew about work on the river and jobs on the river because I've been around towboaters all my life.

There used to be an old bar right down the road from Paducah, and it was a towboat bar. That's where I would run into a lot of towboaters, and they talked about how they didn't hire cooks as young as me. (That was in 1984.) They had to be old, fat, and ugly, one foot on the banana peel and the other one in a bucket. Well, I'm very persistent and hard headed. They didn't want to hire me. The guy at the towboat company told me, he said, "I can't hire you." I said, "Why not?" He said, "Because you're not old, you're not fat, and you're not ugly." I said, "That's discriminating." He said, "Go home.

Pack your bags for seven days." He let me go out there on the river for thirty-six days. He was trying to discourage me because he didn't want to hire me. So after I worked those thirty-six days I came home for just one night, and the very next morning, I was right back at the office. He said, "What are you doing back here?" I said, "I want a physical. I want a job." So that's how I got started.

I was definitely able to hold my own out on the towboat. They didn't think I could at first, but it didn't take them long to find out otherwise. At first, they tried to intimidate me. I had worked with men my whole life. I had grown up on a farm, and there were seven kids in the family, so—horses, cows, hogs, chickens. I was used to hard work. Then, working construction, I was the first woman to work out of a labor hall in Paducah, and they didn't want to hire me either because I was a woman. Well, I wouldn't quit until I got my foot in the door there. It wasn't new for me to have to earn a man's respect because I was the only woman working construction. That wasn't easy either. When I started out at twenty-five years old on the river, of course, they looked at me in a different way, but they also tried me in several different departments.

After my first trip on the boat, I realized that I was going to make a career on the river. I spent my first sixteen years in the galley, and I was a cook. I got burnt out looking at four walls cooking three squares a day and baking. I just got burnt out. I got to a point where I didn't want to go back out on the boat anymore because I hated my job. I loved to cook, but I didn't want to do it as a living anymore.

My captain at the time was Captain Gerald Boggs. Gosh, he was out there for fifty-two years. He started when he was just fourteen years old. When I was a cook, I periodically went up and steered the boat. I was going up in the evenings after I closed the galley down and was steering for Captain Gerry because it was something different, and it was spiking my interest. He kept trying to talk to me into going to the wheelhouse, and I didn't think AEP [American Electric Power] would let me do it because I'm a woman. He said that's discriminating.

So one night he comes down for supper. We were pushing fifteen loads of coal. He said, "We're going to be at Newburgh Lock at seven o'clock tonight." He said, "I want you up there." I said, "All right, Captain." That was the first lock I ever made. I knew right then and there that this is it; this is what I want. I fell in love with it immediately. September the 7th of 2000, I hit the deck. I never went back to the galley. It was really exciting for me. Exciting!

When I became a deckhand, I had sights on the wheelhouse. I went to the wheelhouse in '05, so it took me five years. I was a deckhand for a year, and then I moved up to second mate. They kept me on the big boats because there was a guest room, and so I would not have to share a room with the deckhand.

In March of this year, I went to the WOW conference, Women on Water. It was a huge academy. Those women, they amazed me, and it's very hard to impress me. They had so many credentials and licenses that they had really worked for. Some of them had been out on the blue water and worked on the big ships. I met an older lady. She had her own ship, and she was a little bitty tiny thing. Boy, she had a hand grip like a grizzly. Anyway, things they're changing now. It's still about three-quarters of a man's world, but the women now are making their way out there. We have women mates. We have women engineers. There are women pilots, women captains, and we are coming out. There are a lot of us out there that are making a good reputation for the women. The men are starting to respect us. They really are.

I'm known as Sunshine. I got that name from being a class clown in high school, but out on the river, I'm called Captain Sunshine. People I've known for thirty-five years don't know my real name.

There was one time there was this second mate. On top of the wheelhouse, everybody knew I laid out in the summertime, and on top of that wheelhouse was my private beach. Everybody knew that. Nobody went up there except me. Well, this second mate he gets on the boat. I'd been on there about a week. He gets on there. The next day, after lunch in the afternoon, is usually when I would go up there. I would wear my swimsuit. It was my private beach because nobody came up there. I went up there to lay out, and there he was. He was on top of the wheelhouse. He said, "Come on up here, Sunshine." He said, "There's plenty of room." I said, "No, I don't think so." So I went back down. The next day, he was up there again. Well, he used Coppertone suntan oil. He would leave his suntan oil up there with his lounge chair. So that afternoon on the second day when he came down at three o'clock to take a shower and get ready to go to work—he came on watch at five-thirty because he worked front watch—I went up on top of that wheelhouse and got his bottle of Coppertone. I brought it back down to the galley, and I put white Karo syrup in it and shook it up. I took it back up there on top of the wheelhouse. The next day, there he goes back up there on top of that wheelhouse. He wasn't up there but fifteen minutes. He came back down, and he said, "Sunshine," he said, "if you got any ideas of laying out today," he said, "I'd think twice about it." He said, "Them bees are awful bad out there." He found out what I had done, and he stayed off my

beach after that. He was just going up there to be in my space. That amongst a few other things, but it wasn't happening.

Life on the river has been good to me. It really has. I've enjoyed it. I've had thirty-two years out there. A lot of the captains and pilots will stay out there until they're almost seventy years old and then six months later say goodnight Nick. They're gone. I didn't want that. I'm doing good. I have everything paid for. I wanted to retire early so that I can enjoy my grandchildren, enjoy my life.

I would absolutely recommend this career for women, if they can get out there and do the work as a deckhand because that's the hardest challenge right there. Some of us can do it, and some of us can't. Carrying a set of rigging out from the boat to the next coupling, I had a little problem with that. I didn't have a problem carrying the rigging. It was carrying the rolled up wires because I'm only five foot tall. It was getting hung up on the timber heads and the cavels. I'd swap my wire out for the other guy's ratchet. He'd carry two wires out, and I'd carry two ratchets. I have little short legs, and it jerked me back, and there I went right back on my tush because it would get hung up on the cavel and timber head. I said, "Hey, here's a ratchet. You take my wire." So it worked out.

You have to have nerves of steel if you're in that wheelhouse, especially with high water. When that river is smoking, you've got to. I've stood up several times and kicked that chair back. Sure have. It can look so pretty one minute, and in two seconds flat, it can go. You've got to be able to make a choice, make a decision at the snap of a finger because it happens quick out there.

I've had to make my way in a man's world. I had to show them that I can do my job and make my own decisions. Sometimes on the radio [is] a guy who doesn't know me, and he will say, "Thank you, sir," or "Thank you, young man." "You're welcome," I'll say. I'm so used to it because I have that rough voice, and they all think I'm a man. I just got used to it, so I just let it go.

The way river life used to be, we were river rats. That's what we were, dirty, nasty river rats. That's what we were considered. Everybody wanted to come around us when we came in off the boat because we had a pocket full of money. Years ago, before they stepped in and said zero tolerance, it wasn't anything to walk to the galley and get you a beer out of the refrigerator or grab one out of the cooler. And if that captain ran out of whiskey, oh boy.

We didn't have engines on our skiffs either. We had to manually row ashore because we didn't have engines. This is back in the '80s, and before the '80s. The captain would stop that tow in the middle of the river, and he would put that skiff in the water, and a crew member would row ashore and load up with booze and come on back to the boat. But don't forget that captain's whiskey. You'll be on his shit list for the rest of the trip.

Back then, sometimes guys would settle their differences with their hands instead of their heads. If they got into a fight, and then they go whine in the wheelhouse, that captain would say, "Don't bring your crap up here in the wheelhouse. Take it out there on tow and duke it out. Settle it yourself, but don't bring your whiny ass up here in this wheelhouse. I don't want to hear it." I've seen fist fights out from a dog house on tow several times years ago. It's a whole different generation now. It's all professional now.

JOHN S. BOSWELL

– b. 1959 –

My name is John Boswell. The reason I got started on the river is because there wasn't a lot of work going on in Vicksburg, and somebody said, "You know, they hire guys out on the boat, and it's a good place to go work and not have to spend money while you're out there." I was getting ready to go through a divorce. I needed money. I needed to be out of town. I started out as a deckhand. I worked on the deck for about sixteen years. At the time, the industry wasn't making a lot of pilots. So, the opportunity wasn't there for a few years. When I did go to the wheelhouse, the industry wasn't as short on wheelmen.

Captain Gary Guidry and Captain Red Harvey taught me how to maneuver a boat. Davey Johnson is who turned me loose. There was no technology back then. The difference from then and now is we used to run across that Mississippi sound, and it didn't take much to get lost out there without the technology we have today. I can remember one of our wheelmen following some lights of a shrimp boat and didn't read lights. But it was a moving object, and before long we were pointed south and headed out from behind the islands in the Mississippi sound. The flashing light he was seeing was actually a fishing boat, and we were following them out to sea. With today's technology, you can just straight line. It tells you where you're going and which direction you're going.

I remember a lot of characters that were captains at Ole Man River way back when. Captain L. C. Williams and Captain Bill Miller had a very lasting impression on me and were some of the people that taught me how to run a boat.

Some of my first wheelhouse training and when I did run mate for L. C., I would fill out his paper logbooks and do a lot of the grocery orders and him telling me what to write and what he wanted. It actually took me a very long time to realize just how much he didn't know how to read or write. It is impossible to get by without reading these days. He was probably one of the last real old-school wheelmen I worked with.

Captain Red Harvey, I think Red started out on riverboats at like fourteen or fifteen years old. I have no idea what year that was because it was always hard to get Red to tell you the truth about how old he was. He probably taught me more about patience and tolerance living in close quarters with everybody. It was a life lesson. He knew I had a temper. He had a temper, and living in such close

quarters on a boat, you had to have some patience and some tolerance. He taught me to tame my temper by not opening my mouth. Red agreed that was one of the hardest things to do. Sometimes you just have to be quiet and go on.

River life isn't for everybody. It's been really good to me. I wouldn't trade it for anything in the world. You have to be a certain type of person to work out here. It has to be an adventure, and you have to have a lot of drive. It's not just a job. It's a way of life. It really is. When you can accept that, it will be good to you. When I'm not on the boat, I miss it. I look forward to getting back on.

CHRISTOPHER R. EDWARDS

– b. 1959 –

I began working for my father, Thomas Edwards. He began his business as a barge repair service in the Quad Cities in Southeast Iowa in 1972. I was officially on the payroll when he opened a shipyard in Keokuk, and I worked in the shop doing odd jobs thru high school. I received my first license in Memphis in 1983.

My early experience was on a tramp boat up and down the Illinois from Lemont to St. Louis harbor, also on a coal run from Quincy to Muscatine. I eventually hired as a fleet pilot in Morris and also worked in the Channahon/Joliet area. I spent most of my early career either on the Illinois or Mississippi.

My father, it's been suggested, but not proven, that he may have injected some Mississippi mud into each of his four children at birth. He has a tugboat on his tombstone. His grandson wants to follow in his footsteps. He had the river in his blood.

I have been blessed with a long career that has provided a comfortable living to raise my own family. In that time, I have worked with many different types of individuals. But the ones that were the best had a deep appreciation of what the river is really about, a vital cog in the world's transportation wheel. They understood that sacrifice was just a part of the game. When that "aha" moment finally bopped me over the head, it was like the heavens opening and the sun shined on my face. Eventually, that sun turned to rain, dusty wind, hail, sleet, snow, ice, frozen feet and fingers.

I recommend that any young man or woman that can find appreciation in their uncomfortable labor, that doesn't fit into society's typical mold, who wants to be a part of something bigger than the 35-foot by 195-foot piece of floating steel they're standing on, should turn loose of their comfort zone and take it for a cruise. They'll never regret being able to say to anyone listening, "I worked on the river once." The history of the divide between commerce and pleasure must be as old as waterways and navigation itself. It is undeniable that every pilot is sure to have had dozens [of] near misses, or worse, the direct hits, collisions, injuries, and, regrettably, also fatalities.

The purpose of this story is to inform those that are not aware of the challenge of the towing industry to co-exist with the pleasure-boat community. The river industry is vital to the well-being of our nation. One barge, takes f rail cars or 155 trucks to fill it with cargo, add those numbers by 15, the size

of a typical upper-river barge tow. An enormous amount of burden is taken off our crowded highways and helps reduce pollution, not to mention the thousands of jobs that the industry provides our nations' economy.

The question continues to be asked, how best to share our rivers for all to use and enjoy? I am not one to begrudge anyone the pleasure of a boating experience. As the calendar turns to spring, the recreational craft emerge from hibernation and begin to appear like flies to a summer picnic. Marinas begin to come to life; soon boats zip up, down, back, forth, and around and around, day or night. Often, they race barge traffic to get to a space of river first, as if to claim rights to be able to sit in the way, despite the fact that a barge could crush them in an instant. Pleasure boats often operate with their music too loud; they go too fast or alternatively just sit stubbornly, blissful and clueless of the wind or current that nearby tows or tugs are contending with as they go about the business of attending to work orders, while trying to avoid accidents and Coast Guard investigations. The wake from passing speed boats can get barges bobbing up and down so heavily that deck crew; working to hook wires, can get injured due to the unexpected motion. Fishermen, in search of their lucky, secret out-of-the-way spot, will weave in between or behind fleets, standing on their flat deck boats, without life jackets, out

of sight of everyone, including the tug operator, subjecting themselves to sudden, unwelcome contact with a shifting fleet. Casting their reels in the perfect location may produce the catch of the day, but can hardly be defined as having proper lookout in their prevailing circumstances.

In spite of all these examples, I do not contend that all people operating a recreational motor vessel are reckless and irresponsible. It appears to me that many, if not most, do have a healthy regard for their activities on our waterways. I respect their right to relax and have fun, and I hope that they'll value my need to protect my license and livelihood.

As with everything on our crowded planet, we have to learn to co-exist with each other. Of course, communication is the key to understanding; these points are intended to enlighten those that may not comprehend the concerns of the towing industry.

This is not a river story of individual accomplishment, but it is very much a story of universal acknowledgment. As I have already indicated, every mariner understands how just one incident can result in a wave of repercussions. To borrow from the phrase that freedom isn't free; a carefree day on a pleasure boat is anything but carefree. I propose that "Proper Awareness" becomes a standard catch phrase for boating safety for everyone and a happy ending for all of our river stories!

JOHN GRAMMER

– b. 1959 –

My name is John Grammer. I went up to Friars Point, Mississippi, to visit my dad. I asked him if there were any jobs around there in Clarksdale because I'd like to move back up to the Delta. He said, "Why don't you go down to the gas station and ask old Jack down there get you on a riverboat." I said, "Well, is he going to be at the gas station?" He said, "He'll be down there at noon playing checkers." So I went down there at noon, and he was in there playing checkers. He had been working on the river since men were made of steel, and the boats were made of wood. I told him, "I'd like a job." He told me to go to Memphis and talk to Ted Waxler, at Waxler Towing Company, and I did. They put me on the boat next day, and I've been out here ever since.

I started out as deckhand, and I worked my way through tankerman, mate. I got real cold outside on the deck, and so I tried to get in the engine room. They put me on as the oiler. So I was an oiler, then relief chief, up to chief. We had a bunch of pilots that seemed like they were tearing my boat up all time. I thought, "If they can do it, I can do it." I walked in the office and said, "Can I get a letter of service? I want to go try my pilot's license." Damon Waxler, one of the owners of Waxler Towing Company,

he said, "Well, we will start up a steersman program. Let me take care of that." And that's when it happened. Here in the pilot house, you are constantly thinking and working and watching out for the others and their safety and waiting for the phone to ring. There's a lot of responsibility being up here.

You run across interesting people out on the river all the time. When I first started, it was kind of a place to get away and to take a break from life. It's like that when you are out here.

When I was a tankerman, they had an old timer named Simon Phillip McNeal. He had worked on the boats when they were steamboats, and he had shoveled coal. He was about seventy years old when I first started. He had been on boats that were made of wood, and he was made of steel too because he was still out there in the 1960s.

Some people like to get away. This is their freedom working out on the river—to be able to get away from home, get away from the hustle and bustle or get away from the wife.

When I first got my license, it was before we had all of this technology on the boats except for a radar, a radio, and a swing meter. I learned how to steer the boat without all of that technology we

have now. Several years ago, I had a steersman, and I taught him to steer without all of the technology we have today. It was a good idea just to turn the electronic chart off because it has your prediction where you're going to be, and it shows your slide. Turn all that off and learn how to watch trees and the current and see your set and drift and your swing by looking out the window. Between the computer and the computer charts, I still look out the window. But I look at those screens more than anything now. In about the 1970s, I had an old chart. The captain let me have it, and it had all kind of notes from pilots through the years.

I've got a story to tell. I was working on the river, and I was single, but I had a young daughter. I was sitting at the bar drinking beer with this old boy. We were friends. His daddy worked on riverboats.

This was twenty-three years ago. We were drinking buddies. I asked him, I said, "Well, listen, did you ever hold it against your dad for being gone all the time on the river? Did it ever affect you in any way that if he had had a land job your life would have been better?" He said, "No, it didn't affect me one bit. We knew he had to work and had to make a living to be able to get us the things we needed. "If he'd said anything whatsoever, I would have probably quit right then because of that new baby I had. That was the turning point right there. If he had said anything whatsoever negative, I would have quit and gone and worked at Taco Bell.

Pilots are steady and dedicated. Those are the two words that pop into my mind to describe a pilot. They are a breed of their own for sure.

DANIEL LEE "DANNY" REDD

– b. 1960 –

My name is Daniel Lee Redd. I had crossed the river all my life and just decided I'd try it. I always said when I got off after riding thirty days I wasn't coming back, but you see where I'm at right now. So I made it thirty days that first time. Every time I came back, I had the same goal: I wasn't going back again. "This is the absolute last time." But, probably my third year, when I got my pilot's license and I started running tugs in the Memphis harbor, that's when I decided I'd make a career out of it. I worked with some real good guys back in the day, Captain Danny Evans, which they named a mile marker after him at Island 40 headlight. I steered under him and Robert West and John Williams. I took their advice and took a job in the harbor. They said that's where you get your best boat handling experience is to run a smaller boat. You can always come back to the bigger boats. So that's what I did. Back in the '80s it took 1,088 eight-hour days, which was equivalent to like three years. So I did it the fastest route. As soon as I was eligible and had my three signatures from pilots that I'd worked with, I went and tested. You're still required to this day to get signatures. It's a character reference to say that, "Yes, he has steered a boat." You can't just go up there and say, "I

want to do it." Somebody is going to have to vouch for you, put their name down saying that you can do it.

If it's got water in it, I'd run it. It's the river, so. My longest stretch on the river was ninety-five days because I didn't have a relief. If you don't have a relief, you don't leave. Because if you leave, that means you quit.

You have to learn hands-on, on the river. People can coach you and tell you what to look out for, but if you're not gathering all this information and understanding current and wind and weather, if you never grasp that, you're going to be in bad shape.

Out there, you're always going to have freaks of nature and these little squalls that come up. You might not be able to see anything for just maybe ten minutes, but that's enough that if your radar knocks out and you visually can't see anything, it gets you concerned for sure. I've been on vessels where tornadoes went right across the boat.

Every river man will tell you about the scenery, especially in the summertime.

I've worked for the Corps of Engineers twenty-four years now. I have a master's license. There are different licenses. You have master of towing, and then you have master of steam or any gross ton

(which I have that). But I'm considered a pilot. And that's the roll I just kind of want to be nowadays, just pilot. I don't care about being a captain anymore because I still feel young, and I just don't like being the whole crew's daddy all the time.

I've been a captain.

Working for the Corps of Engineers, it's completely different from towboating. What they do with the corps, they try to what they call a fifty-six-hour workweek schedule. So you work seven days on and three days off. On towboats, you'll have two captains, two pilots, and they all relieve, so you have a bunch of people working for you, like four watch groups. You have the captain and his crew on his watch and then the pilot and his watch. And then they have relief, so you have four. Well, the Corps of Engineers has got it broken down to three. They have A, B, and C. So A and B will be on the boat. C will be off. When C comes back, A will go home, and it just does a cycle rotation . . . So that's the difference in the work schedule, versus the thirty and thirty like in the towing industry. It's completely different. For the corps, you'll work a weekend, and then you'll be off one. I think it's about every third weekend you'll be home. One out of three. That's what it is.

I chose to do that because I talked to them before I even took the job, and I liked that. Plus they have every benefit you can think of as far as retirement and insurance and everything else. It's been a real good job. They don't have a mandatory retirement. You just reissue your license and just keep on working. The corps requires you have to have these higher license. For the M/V *Mississippi,* you have to have the any gross ton master inland to cover everything. So you could run the *Delta Queen* or the *Mississippi Queen,* which they're no longer around. You have the *American Queen,* but you have to have a license like that for passenger-carrying vessels.

There are several different things the corps does. You have your dredging operation, and then you have your revetment operation. Now, that's what I'm in now. I've been on both sides. But we put the articulated concrete mat down on the riverbanks. We go in. We have three stages. One goes in and clears the location that we're going to lay the mat. Then, the next phase, they come in, and they grade the bank to get it nice and smooth. Then, we come in with the mat-sinking operation. We put the concrete matting. That stops the erosion. A lot of people don't understand it. But if we didn't do it, the river would continue to do like it did back in the 1800s. When it gets high water, it ought to come up over in Louisiana way over the other side of Luling instead of right here. So the levee system and the concrete mat all work hand in hand. If you didn't have them, it would still meander like it used to. It's a neverending battle because it is the mighty Mississippi. Because the river is controlled with locks and dams, revetment, rip rap, all of that, the river is faster. That's one other thing that they're doing. That's what all the dikes and revetted banks are.

Everything we have is government owned. Our cargo is articulated concrete mat or stone rock or whatever that we do. We put rock in the river too. You just never know what you're going to do with the corps. It's basically the same job, but every bend you go on is different. We can't do our job . . . unless the banks are exposed.

When you're not out doing your river work, you're doing your maintenance on your equipment here in the harbor. If you live in town, it's easy. It's like having a regular forty-hour-week job. You go home every night. But I chose to come down here. I live on the boat. I stay on the boat all week, and then I go back home on Fridays. It is completely different than a towboater.

Like on the *Mississippi* or the *Hurley,* if they're somewhere in a location where they have access to go to town, you can't hold these people back that work on there. They just have to be back when they start their watch. And you can't come on there drunk. The only time you have to be accountable for your crew twenty-four seven is when the wheels are turning and when that boat is underway, in

motion. Most of the people live locally around here, so they just go home. There's only a handful of us that stay on board that live out of town.

Our hours are 7 to three-thirty, Monday through Friday, and when we're in maintenance mode. Then when we start doing revetment season, we'll work just like a towboat: six hours on, six hours off. So you stand regular watches. They have security. Every hour they have little time clocks they have to punch over that whole area, everything that they have down there. There are fire alarms, smoke, heat, and bilge alarms.

If we were underway, there would be somebody in the wheelhouse twenty-four seven, but in the fleet, no. They're not cooking on the boat, so you pay for your own meals. So it's good to get off in the evening and go get something to eat and come back. We get a lot more benefits than private industry out here, but our pay scale at one time, we were the highest paid. Now we're not anymore because we had our percentages decrease, and then we had a wage freeze for three years. Then the last two years we got a 1 percent raise. We're not keeping up with the industry, but there's nothing we can do about it. That's way above our pay grade.

It's a good living out on the river, and you're going to see a lot of things. Every day is different out there. It's a new morning every morning. I don't care how many times you run, there's going to be something a little different that next time. But it's a challenge if you're a pilot or a captain. It's a challenge to run a boat and to navigate this river in all types of weather and all types of river stages. You have to pay attention. That's the key to it. It's a very tough life. I didn't go to college. I went to the School of Hard Knocks right out here cleaning toilets and being a regular deckhand.

Working for the corps on the M/V *Mississippi* I got to see all walks of life. We do carry passengers on there, and we have had people for day trips on there. People see all this new technology. The Rose Point's the hot one now, the electronic charting. It's got you pinpointed within a foot of where you are at all times. People say, "Aww this makes it easy." I say, "Yeah, it's a video game in a sense, but you can't hit restart when it gets bad." These bridges don't move, and these banks don't move, and you probably won't be doing this much longer if you keep running into stuff. You won't hold a license very long because it's a challenge. That's one thing. I guess that keeps all the pilots out here. Some of them, I call them lifers. They don't want to go home. They like doing this too much. I like doing it when I want to do it.

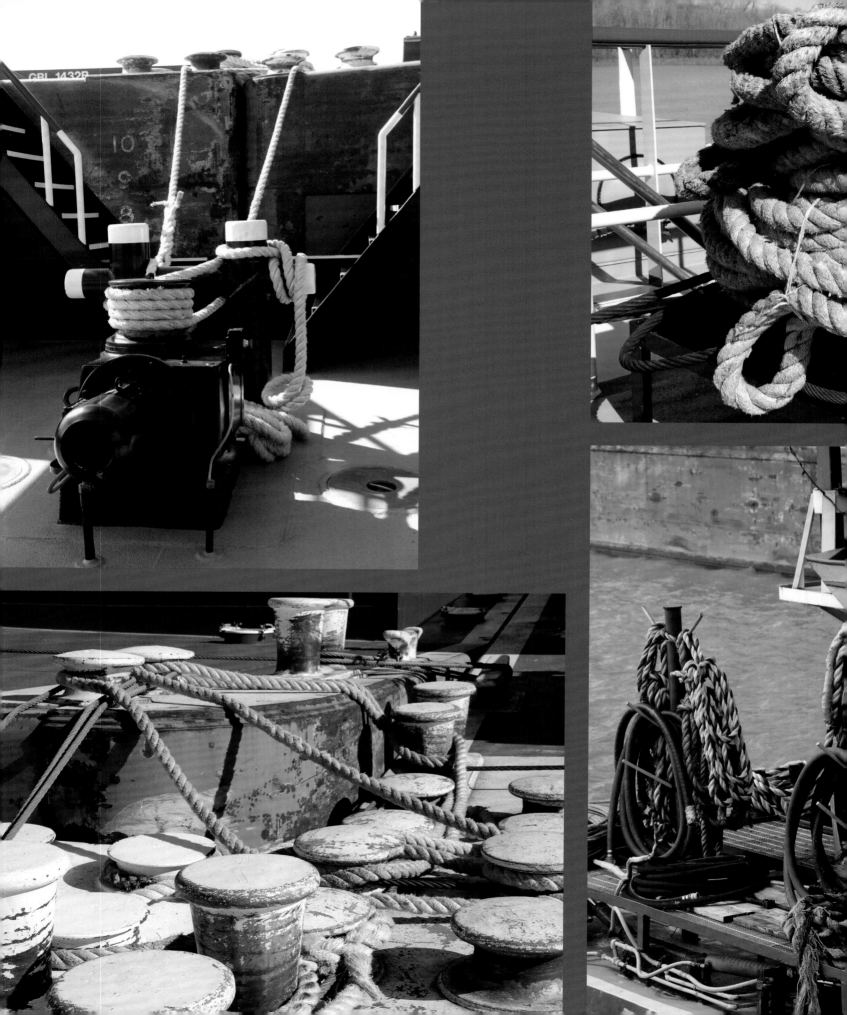

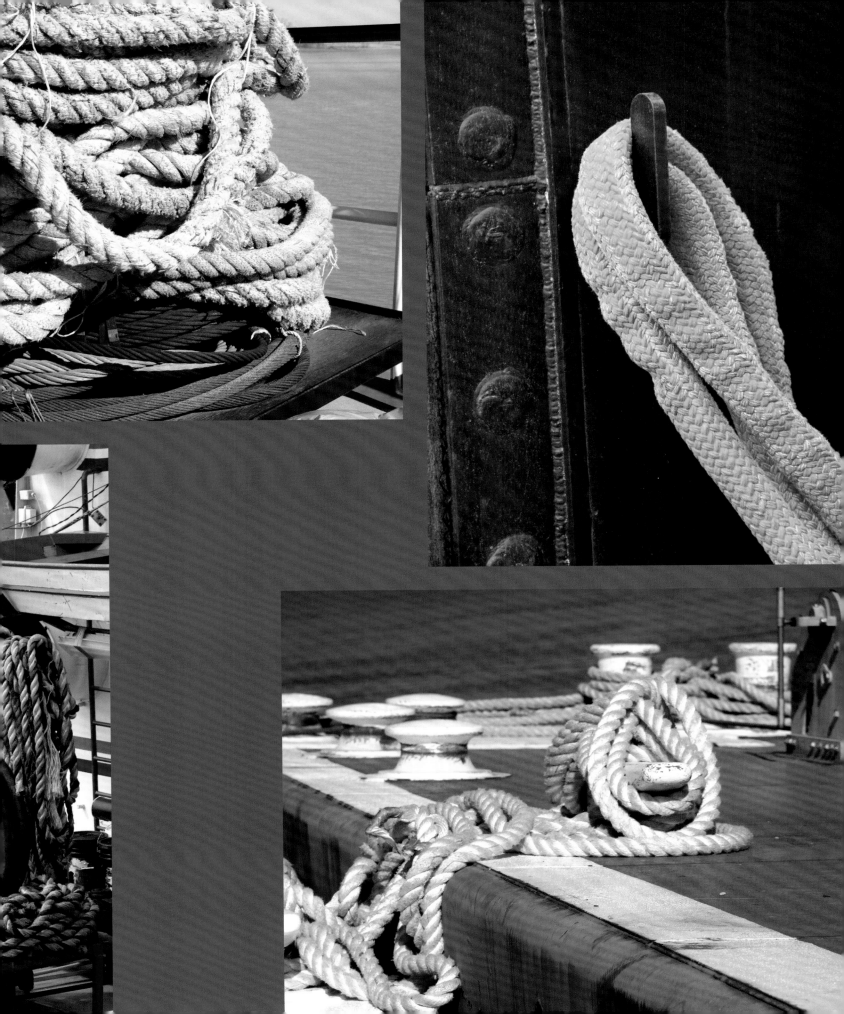

JOSEPH E. GAUDIN JR.

– b. 1961 –

My name is Joseph Gaudin. I knew I was going to make a life on the river probably about six months to a year after I first started. Within my first year, I knew this was where I was going to be. I just kind of fit. It felt good. I liked the work. I liked the camaraderie with the people I was working with. I think it was a fact of knowing you were making good money, and you had two to three weeks off to do whatever you wanted. I think that was the most intriguing part of it.

The most interesting thing for me out on the river was the first time I actually saw snow and ice. Being from south Louisiana, actually you don't ever see snow and ice. When it starts to freeze down here, people can't even drive on the highway. Well, you got this kid nineteen years old in the middle of St. Louis, literally during blizzard conditions. They had shut the harbor down. It was the first time I had seen ice to that degree with my own eyes. I had seen it on TV but never standing on a boat and seeing sheets of ice so thick that they were blue. They had a blue tint to them where you could pitch a tent on these things and banging on the boat and the barges and shoving across these lakes and the water splashing on the bow of the barge. Everything is covered in a layer of ice. It's two or three inches thick.

My friend that got me the job had told me to buy some warm clothes, we were going to be going up north. The warm clothes that you buy down here are nothing compared to what you need in Green Bay, Wisconsin. We get up there, and we had a chance to get off the boat. We went straight to a Walmart and went to the sporting goods section trying to buy warm boots and so on. I actually bought my first pair of snow boots, and I live in south Louisiana. I bought these boots to work in because you're standing in snow knee deep. Literally, have got to shovel couplings.

During my first year as a deckhand, I go from fighting the mosquitos and the snakes at Bayou Sorrel Lock to literally having to take a snow shovel and shovel a coupling out. You learn a little bit of everything on a boat. You learn a little bit of electrical, little bit of plumbing. You learn how to weld. You learn how to work ropes and lines and everything else. This is what you know. This is where I'm at. This is where I belong.

I've met hundreds of interesting characters out on the river. I think the most interesting person that I've met was my very first captain that I worked for. He was from De Funiak Springs, Florida. This

man, he didn't even know me. I came on his boat as a green deckhand. He had been on the water at that particular time probably thirty-five or forty years. He was a captain. He came from before you had to have a license to run a boat. He broke me in. His name is Gene Willingham. He taught me a lot about the river. He basically took me under his wing. I didn't know anything. I'm out there trying to build tow with one guy. They had put me on a call watch. Man sends me back to the boat to get a ratchet. I didn't know. I went to the engine room, and I got him a ratchet. I got a three-eighths-drive and a five-eighths-drive ratchet and some sockets. I come walking out there, and they all start laughing. Gene is on the radio. He's like, "You know, hey, the kid doesn't know nothing. You have got to explain it to him. Steel Trap, come back to the boat." He called me "Steel Trap." I don't know how I got this name, but he called me Steel Trap. "Come back to the boat. I'll show you what they're looking for." The guy literally come out of the wheelhouse. The captain came out and started explaining things to me one step at a time. On the off time, he'd spend an hour, him and the mate, spend an hour throwing lines, showing me how to splice lines, everything else. The guy took me under his wing.

Back in that day, we didn't have all this electronic stuff, so they had charts sprawled all over the wheelhouse. We still have them today on the boats, this big navigational chart. If they had writing all over [them], I'd look at them.

All we had was a compass and a radar. The spotlight that you had back in 1978, '79, '80, when I started out here, that boat still had one old carbon light. The other one was what we call a flashlight by today's standards. It was a regular halogen light, but you didn't have your big fancy Xenon lights like you have today to pop out there and pick up that buoy a mile and a half, two miles out. Basically, when you got to where you could see the light flashing, your spotlight would pick up the day board. These guys pretty much ran on that radar with a chart and a compass. That's how they ran across those sounds, that open water. He knew he had to run so far at 268 degrees. When he got to beacon 5 he was going to make a lefthand turn and run 183-degrees or whatever his course was going to be, and that was going to bring him up towards Gulfport. That's how they ran it. So it's very scientific.

It's an honorable job, and you can see it in people's faces when you tell them what you do. Their faces light up because they see the boats. They see the barges. They see the ships, but they don't really think about the profession and what goes into it. All of these guys are all living on these boats and are being away from their families.

RONALD "JONESY" JONES

– b. 1961 –

My name is Captain Ronald Jones, a.k.a. "Jonesy." I've been out on the river since August of 1981. My dad was a towboat captain; that's how I got on the river. It's kind of like a family trade. I was twenty years old when I first started. I pulled three years in the army, and I was twenty years old. When I came out of the army, I went straight on the boats. I spent thirteen years as a tankerman because, at the time, I didn't really want to move up to the wheelhouse. I thought it was just a little too much stress, and I enjoyed working the deck. At the time, I was young and strong and enjoyed the physical labor.

My dad started me out, and I started out steering boats with him. I worked on his boats for about a year, and he taught me pretty much all the basics. My dad had some hand-drawn charts, and he enjoyed plotting. Even when he was at home, after he got on up in years, he would sit around in his room. He had plotting equipment and old charts, and he would sit there and play with plotting courses all over the world, and he really enjoyed it.

I guess the most memorable thing in my career was the first year I was a pilot, and it was the year that Halley's Comet passed by. I was out working on the river. We were running from Baton Rouge to Louisville. I was on the back watch, midnight to six in the morning. Every night, going up the river, I'd watch that comet going across the sky. I thought about this being a once-in-a-lifetime thing. And there are people that will be born and die that will never see this comet. I'll never forget that. You see a lot of things out on the river that most people don't see.

One time I was going up the Ohio River, and there was a tow behind me, and he calls me on the radio. He said, "There is a pleasure boat fixing to overtake you." He said, "Take a look at it." So the pleasure boat comes alongside. I get my binoculars and look, and it was four elderly people like in their seventies. And one man was driving. Two elderly women and another elderly man was sitting on the stern, and everyone was just butt naked. I said, "My goodness, seventy-year-old nudists." I blew the horn at them!

The Mississippi River is very strong and has very strong currents, and at certain stages, it has suction holes, big eddies that will pull you down, pull you down to the bottom of the river in fifty or sixty, seventy feet of water and hold you down long enough to drown you before you could get back to the surface. Another thing is, the swift current and the big tows that tramp up the river. I saw a pleasure

boat one time at Victoria Bend run underneath a forty-barge northbound tow, right there in Victoria Bend. The guy left out of Memphis headed to New Orleans. The towboat captain tried numerous times to contact him on the radio and never could get in contact with him. He had stopped his tow and was already backing down, and the current just brought the guy right up under those barges. I saw it because I was behind the next tow behind him. We searched for the guy. His boat surfaced, but we never could find him. It was a couple of days before they found him on further down the river. They never did figure out just what happened, if he had some kind of engine failure or just didn't know.

The people in the canoes and kayaks that are smart will get over close to the bank and stay close to the bank. But there's a lot of them that just don't know any better, and they'll be out in the middle of the river, and you have to slow down or try to steer around them. You know, just do what you can to keep from running over them sometimes.

In my career, I've known some old captains that I'll never forget. I have one old captain, and he was originally from the Cayman Islands, and his dad was a seaman. His dad sailed on steampowered sailing ships. He sailed all over the world on them. This captain that started out on ships, he jumped ship in Mobile, Alabama and ended up becoming a US citizen and getting on towboats. He was a real interesting old fellow. When he grew up on whatever island it was down there in the Caymans, it was before there were many tourists. He was real superstitious. He was raised around where they used voodoo and stuff like that. One time, we were

tying up above Old River Locks, and I was out on the head of his tow going to catch a line in the tree. I was talking to him on the radio, talking him into the tree lines, so he could grab a tree, and I decided to mess with him a little bit. I told him, I said, "Captain Vick, I heard something out in these woods." It was ten o'clock at night. His name was Captain Vick Boden. He said, "Oh, it's probably an armadillo or something." I said, "No, this is sounding real large." I said, "Sound like it's big as an elephant out there." He had a real heavy accent. He said, "Well, what do you think it is, man?" I said, "I don't know." I said, "I believe, you know, couple of months ago they claim they spotted Big Foot out here." He said, "Man, forget that line. I'll just hold it—I'll hold the tow out in the middle of the river. Just forget about the line." He taught me a lot about tow boating. He had quite a bit of knowledge about ships. He taught me a lot about splicing lines and tying different knots and splicing wires and a lot of knots that we don't use on towboats that they used on ships.

I try to teach the young guys coming up like he taught me. I try to pass on as much knowledge as I can to younger guys and keep it going.

Being out on that river, it's a love/hate kind of thing. I love being out here. It's a challenging career, but it's hard on a family man. But I wouldn't do anything else. My wife asked me to quit one time when we first got married to try working on land. That lasted about three months, and both of us wanted me to go back on the towboat. I think that I actually spend more time with my family than a man that works eight to five days a week. We plan trips, and we have time to do things.

DALE E. COX

– b. 1962 –

My name is Dale Cox. My dad was forty-six years a wheelman, captain, and I started riding towboats with him when I was nine years old. I knew early on that that's where I was going to end up once I was old enough to apply for a job and work on the river. It was family tradition.

I started as a deckhand and at the very bottom twenty-five dollars a day. I got ten extra dollars a day when I started taking care of the engine room. I thought I had all the money in the world. I was like, "Goodness gracious! What am I going to do with these checks!"

I stayed on deck for eight or nine years before I went to the wheelhouse. I just wasn't ready to be confined to the wheelhouse. I couldn't stand being cooped up like that. I had to be out where I could run over the barges and be outside. I have two brothers, and both of them are wheelmen. Both of them are captains. All three sons. My dad did everything in the world to keep us off the towboats. He said, "I do not want you boys on towboats. Y'all go to college, use your brain." All three of us made wheelman.

I see recreational boaters all the time. I've had to hit the bank to keep from running over them. I've

done everything. I've blown the danger whistles, the three I'm backing. They have no clue what I'm blowing that horn for. When I blow the danger whistle, they go to waving. I'm saying, "Hey, buddy, ain't no time to wave. It's time to get out the way." I wish that the pleasure crafts would really, really respect the boats because us guys driving, we can only do so much. But to a point it becomes out of our hands, and we can't stop them. We don't have brakes on them. Thank the good Lord, so far I'm doing good, and I want to keep it that way. But I went out through the trees. I've hit sandbars. But I'll do it again if it saves a human life.

You cannot learn our profession out of a book. You can't go to college and learn it. It has to be handed down generation to generation to generation. You cannot go sit in a classroom and say, "I'm going to be a tow boater. Give me all the paperwork I need to get my captain's license." "We don't have it." That's what he's going to tell you. You have to get out there and learn it. It's handson experience, and it's just passed on from the old guys.

Over the years, there's one thing I'll never forget. I couldn't tell you where all the good spots on the river are. But you can bet one thing, I can tell you

where the bad ones are. I can tell you every bad spot on the river pretty much. The very worst spot on the river, and I don't dread coming to it, but 90 percent of the wheelmen hate that Vicksburg Bridge. Ninety percent of them are scared to death of that bridge. I know that for a fact. But I love it. I like that bridge. But that bridge and the upper Baton Rouge Bridge, that's two that have a bad reputation big time. And they earned it. I mean, they have earned their reputation. Trust me.

When I was working with Chotin, Incorporated, we were up in Wood River, Illinois, and we were loading a thirty-thousand-barrel barge out of freight trucks, eighteen wheelers. I had to keep count, and the other tankerman that relieved me had to keep count of every freight truck once he finished and say, "All right we're finished. We can mark it down as one." It took seventy-three or seventy-four freight trucks. And that was not even a deck load. That was not even a full capacity load. It was like an eight six something draft, which you could say was three-quarters. It took seventy-four trucks just for one barge, and we had four barges. You figure if you're coming down with a six-pack of thirty thousand barges, that's six times seventy-three freight trucks that would be on the road hindering everybody trying to go on vacation. That's a lot of freight trucks that's just for one tow and you know the tows that come down that river every day. That's a lot of cargo.

The towing industry. It has stood the test of time of hauling goods. It has since the keel boats.

The most knowledgeable thing that I can pass on to somebody about the river is "Take your time." The longest haul I've ever done at one time is ninety days. It was not good, I'll tell you, but I was paying for a divorce. I had credit cards I didn't even know I owned. They let me know I owned them, though, trust me. "You are paying for them," they said. Oh my God.

If you were a good hand, the company worked you as long as you wanted to work. That's what the good thing is about the river out there. It's there

to be made if you want to make it. Opportunity is there on the river out of this world.

Back when guys like my dad and Captain L. C. and a lot of the old captains that have gone before us—they knew the river by knowledge. They had to pass all this on to us guys. I was one of the first ones when they came out with the Rose Point compass and the electronic charts. I was one of the first ones screaming from the rooftops, saying, "That's just what we need, something else up in the wheelhouse that's blinding us. We can't see at night like it is. Now y'all making us use this thing." But I love it now. It's so helpful. It's so handy. It just takes all the guesswork out of it. We don't have to figure up the running ETA meeting places. We're not guessing or using the lights at the sailing line. We can look right on that chart and tell you right where you're going to meet somebody, where you're going to overtake and what time you're going to be there and where you're headed to. Back then we used to have to figure it up. "I'll be up at Wood River at X amount of time." You just type in that machine now and click on it, and it'll come up there, Wood River, Illinois, mile 196, Upper Mississippi River. You click on it, and it'll tell you right over there you're going to be up there in seventeen hours. The new guys coming on now are lucky. They are some lucky men, buddy.

When I got cut loose as a pilot for the first time, I was making $135, day and I got put on a boat with Captain Frank Gibson. He could not read or write. But, Captain Frank Gibson, that guy could drive a boat. Good gracious. He could put a tow through the eye of a needle, I reckon. He may not can read or write, but I tell you what he could do; when he stepped between those sticks, he was strictly business, buddy. He knew how to do his business. The river never stays the same. It always changes, and that's what I love about it more than anything.

Back in the day, the cook ended up being kind of like the mama on the boat. We were all young, and they would be like a mother figure, and we'd do anything in the world for them. I love a woman cook on the boat. It kind of keeps everybody in

check, and the language in check. You don't have so much cursing going on out there with just a female around out there, so when they go home, they're not talking like a bunch of sailors. It's terrible. I know I get potty mouth like crazy when I come off the river, and I have to get checked up, you know, "Hey, watch your mouth."

What it takes to be a good wheelman is tons of patience.

I don't ever see myself ever really retiring. That's the good thing about our profession. Nobody steps in there and tells us, "You're going home." As long as the Coast Guard says that I can pass the physical, I can renew my license. We have wheelmen out there that are eighty-something years old.

STEVEN HEARN

– b. 1962 –

My name is Steven Hearn. A few years ago, I retired from the US Coast Guard. I actually started off on the East Coast commanding Coast Guard cutters in the Chesapeake Bay. I spent several years on the East Coast, almost twenty years or so, and eventually worked my way into the inland river system.

As far as the Coast Guard [is concerned], the inland river system is kind of like a hidden gem or jewel. A lot of people don't know a lot about it. It seems like it's hard to get an assignment on the inland rivers.

The stuff that we do on the inland river is really nothing like what you do on the coast. It's a totally different environment. The towboats out there really rely on the Coast Guard buoy tenders to mark the waters for them, so they can safely navigate the channels, not run aground, make approaches to bridges, stuff like that. They play a real important part. Dealing with the captains on the towboats, you talk to them on the radio, and they're always a big help, and they'll pass information along to you, and it makes it so you can do your job a little bit better.

I had four river commands. The Coast Guard is similar to the navy. What the Coast Guard does is they pick a person to be in charge of a Coast Guard cutter. It's a high-responsibility position. You're in charge of the crew. You're in charge of the vessel. You have to meet certain standards. You basically compete for those positions. It's something that they don't take lightly. They try to put the very best person in command of the boats because there is a lot of responsibility. The biggest one is the safety of the crew. It's always our top concern.

During my time in the Coast Guard, I had accumulated the most sea time of anybody in the Coast Guard. At twenty years, I was designated what they call a "master mariner," and I had twenty years on that sea. Even on the rivers, they consider that "at sea." You're assigned to a ship. You get credit for that. At one point, I was designated as the Coast Guard Silver Ancient Mariner. That's the person that has the most sea time. There's two of them. There's a silver, and that's for an enlisted person. And then there's a gold. Probably one of the most unique things about that was my father was in the Coast Guard, and he was an officer, and he held the title as a gold ancient mariner. Then I held the title as a silver ancient mariner. That's never been done before, father and son. It will probably never be done again.

My father was well known to the Coast Guard. His name was John Robert Hearn Jr. When I was a kid growing up, he had more commands in the Coast Guard than I think anybody else ever had on ships. Growing up and when I was out of school for the summer I would go with him to work and hang out on the ship. I think the crews kind of liked it. I was probably ten years old, but they would put me to work cleaning and shining the brass and that type of stuff. There were times when he would get underway, and he would get permission for me to ride with him, and I would go for a few days at time. That probably started my love for the Coast Guard, and it's probably the reason I joined. In my career, the Coast Guard time I got was twenty-four years on ships. But the time with my dad is another eighteen years.

I think that the brown water is more challenging than blue water—the navigation of the ship. A lot of places you go, there are a lot of dangers, rocks under the water, and that's the kind of the stuff that we're out there marking. We're trying to get as close as we can get to those items, but it's the towboats—they don't want to be anywhere near them. We kind of put ourselves in danger to try to help protect the towboats.

The Coast Guard is different than the towing industry. We don't get assigned to crews like a towboat might have. Typically, what we would do is we'd have the thirteen or sixteen people. When we're in port, you typically worked an eight-to-four job loading the ship and getting it ready for the next trip, doing the maintenance. Then after the workday you went home. Then you'd come back in the next morning Monday through Friday. We always had somebody on the ship that spent the night overnight as a security watch standard. They'd make rounds, make sure the boat doesn't sink, and just protect the vessel. The weekends, the guys would be off. Then we would call a buoy run. So everybody comes in. You get underway, and you're on the boat. Your runs would take different amounts of time. It could be seven days. It could be ten days. Then we would come back to port and tie up. If you tied up on a weekend, the guys were off for a couple of days, and they would come back in on Monday, and then we'd start the in-port thing all over again.

The river is very dangerous. People need to be careful, and the pleasure boats need to stay out of the way of the towboats. They don't realize that it takes forever for a towboat to stop. You see pleasure boaters cutting in front of towboats and jet skis, and it really creates a very dangerous environment.

It's a very unique industry. If you look up towards the pilothouse, that's your opportunity. It might take you a few years, but you can work your way to the pilothouse. It's a trade that you have to learn. It's not like you can go to a school, and they're going to teach you to be a captain. It's something you have to have experience. It's not an easy task. It's a very challenging job. It pays very well, but you're under a lot of pressure a lot of the time, especially when you have high water. It just makes it so much harder. The good people will work their way from the deck up to the pilothouse and eventually become a pilot or become the captain, and it's just a position where you have to learn it, and you have to experience it.

There's a lot of change in technology out there now days, computer and just all kinds of things that are up in the pilothouse. Back in the old days, the guys just had a big wheel in front of them or a set of sticks and they drove the boat. It's an art. It's a challenge but it's a pleasure to be able to drive a boat, too. You have to have leadership skills as well. You can't just drive the boat. You're in charge of your whole crew. You're in charge of the budget for the boat. You're in charge of the maintenance. You're in charge of the people. You have your hands full. It's a very challenging position, and the Coast Guard is very similar. They're really kind of set up the same, but our schedules might be a little bit different. But it is pretty similar. If you get the honor of being a captain or a pilot, it's a joy.

PATRICK SOILEAU

– b. 1962 –

My name is Patrick Soileau. I've been thirty years on the waterways. In 1980, after graduation, most of my friends were in the business already, and they introduced me to this kind of work. It is just a culture where I come from in south Louisiana where you either worked in the oil field or on the boats. So I chose the boats from day one.

I think from the beginning I wanted to be a captain. I had some friends of my father that were captains. So I had an idea that I most likely would live up in a wheelhouse of some type. We didn't have a training program back then. It was just a self-motivation thing. That's how we used to do it back then.

Down in south Louisiana, it is just a way of life. You did something with the waterways. That's about the biggest thing in the Cajun culture where we are from. We are surrounded by water, and water is our main industry in south Louisiana.

I worked with some real true people from the Deep South where their second language was English. They talked a lot of French. To this day, they talk like that on the radios. They have to catch themselves not talking the English that we should be talking on the radios. So, down here in the South, they still have the Deep South culture of the Cajun French. The Acadian. That's Cajun French. They speak French to one another on the radio down there in south Louisiana now on the navigational channel. They still hold conversations, and it is a culture that's dying every day. It's a culture that's passing by us. It's being forgotten. But the older generation still speak it. I speak a little bit of French. I can listen to a conversation more than I can speak it.

There is a lot of wildlife down there in south Louisiana. We have black bears in the Morgan City area. The black bears cross around the Morgan City area around the mile 102 area; [it's] a bear crossing, and they get across the Intracoastal Waterway from the Atchafalaya around that area. We would literally see them crossing in the early morning hours. The black bears cross, and, of course, there are a lot of alligators. It's quite often that we see wildlife while we are sitting at the refineries or docks. We catch our share of catfish and clean and also eat the catfish that we catch. It's real good pastime to break the stress level on these boats sometimes to fish a little bit.

South Louisiana just seems so much more colorful than the rest of the waterways.

Back in the '80s we had good Cajun cooks on the boats. That's how we learned how to cook.

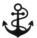

They pass some good recipes and good gumbo recipes down to us; that's for sure. The key to a good gumbo is a good roux. So it's all about the roux. We also have crawfish etouffees, and we have fried catfish. That's your basic good Cajun dishes out here. Andouille sausage dishes and jambalaya too. The jambalaya is a very good dish. All kinds of cultures come through Louisiana for their food. People love Cajun foods. They really, really like it. It's good. I guess because it's all fresh.

There is not a job like it. Once it gets in your blood, you stay. I've actually left the industry for a couple of months. But I missed it so much that I came back. I just missed the quiet time and the time that I had for myself, and I missed the people. That's how I knew it was for me. You get accustomed to it to where it's your time for solitude. It's time to do a lot of thinking while I'm up here. I could probably solve the world's problems up here. Of course I didn't, but I like the quiet time.

There's a story back in Frog Bayou, which is back north of Bayou Sorrel Lock. This is a true story. Years ago, a man actually got lost back there on a tug boat. He couldn't find himself. Every intersection looked the same. That place, it's all manmade, so none of that stuff is on the charts. The oil field companies made a lot of those bayous back there to put their drilling rigs and platforms. They literally had to get a seaplane to escort that man out of that bayou to get him out to the main Port Allen route. They used to put jugs at the intersections because when you come through the intersection, it was a four-way turn. It looks like a T, like a fourway stop sign. You had jugs in the tree. That's how they identified which way they were going. They were talking to him on the radio at the time, and they kept trying to explain to him how to get out. Eventually, a seaplane went in, and he followed the seaplane, and they escorted him out of there. I could not believe that, though.

Down there in those bayous, it's narrow. You are driving a boat, and a tree branch just slaps you. You know, it just slaps you on the wheelhouse on your front window. You will be passing right through the woods, and almost all of the branches are overhanging. It'll tear your antennas off. A tree will get hung up on you.

It's a different culture down here. It's definitely different down in south Louisiana. Some people don't ever leave the area. That's okay because it's the common culture down there. You know, it's all right.

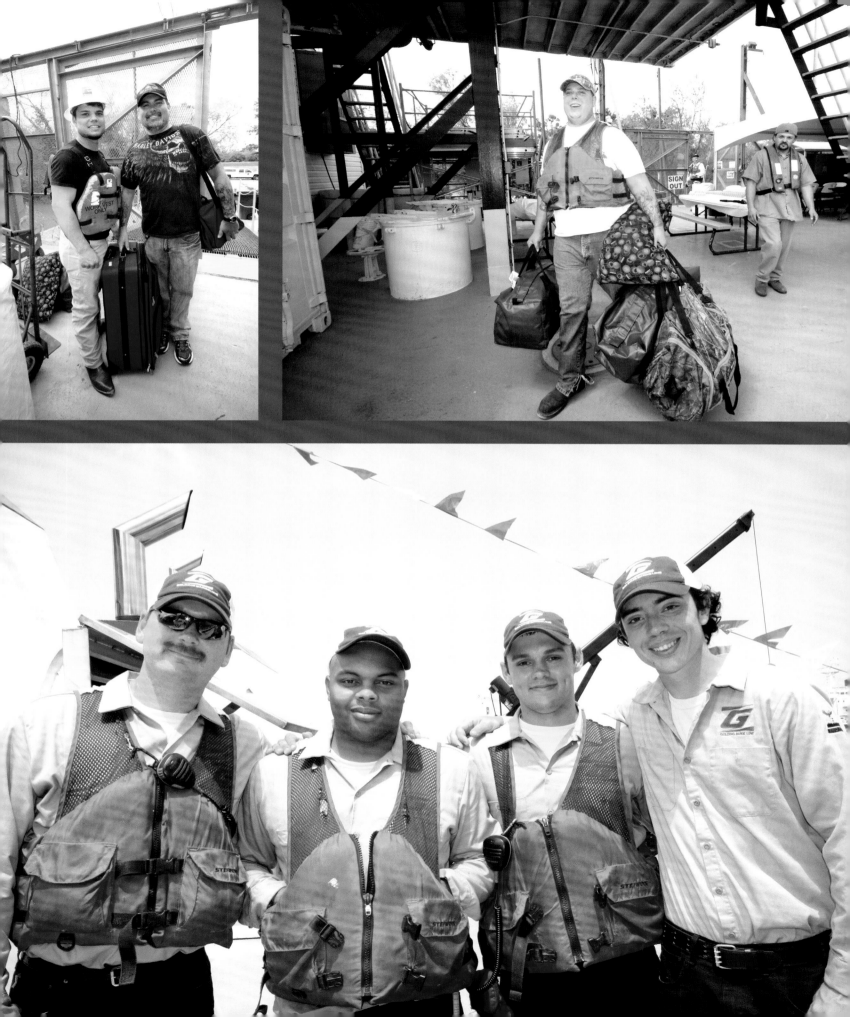

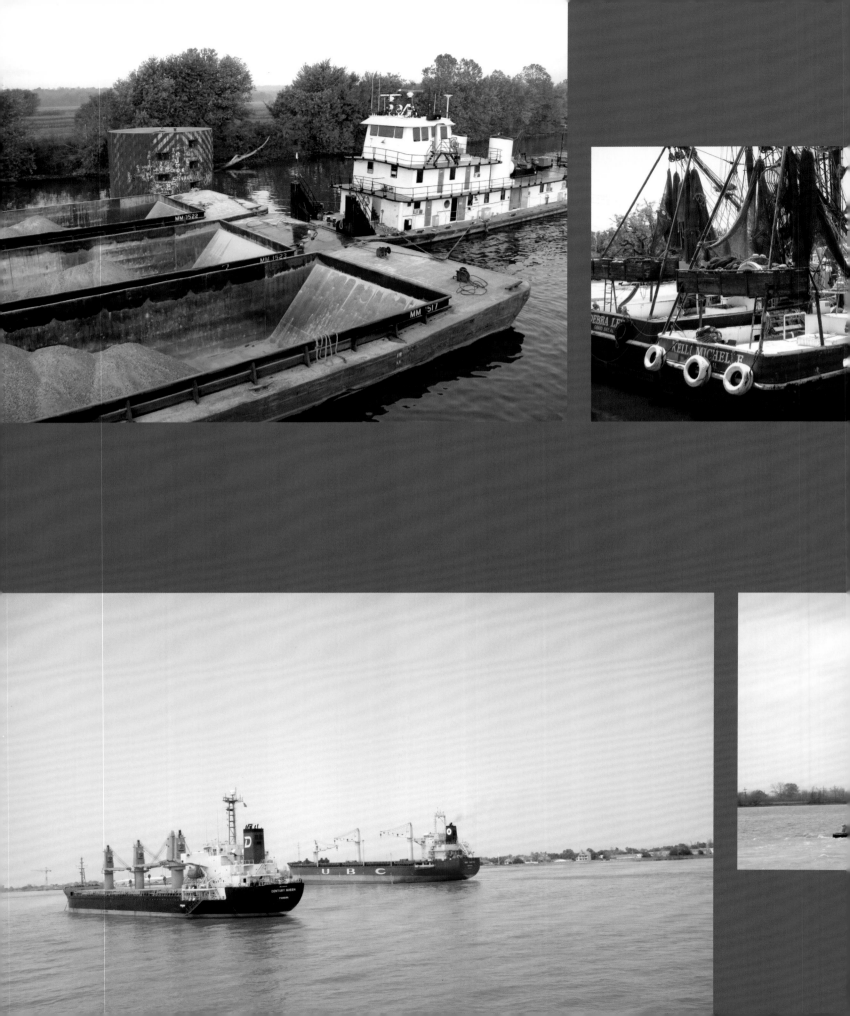

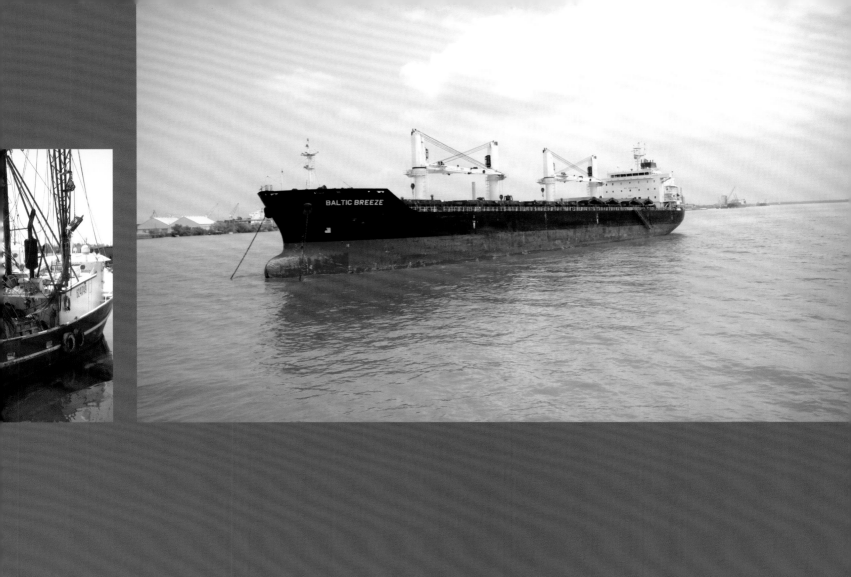
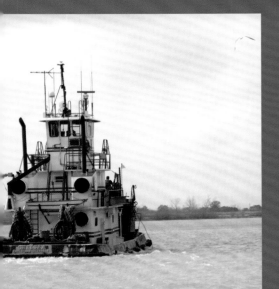
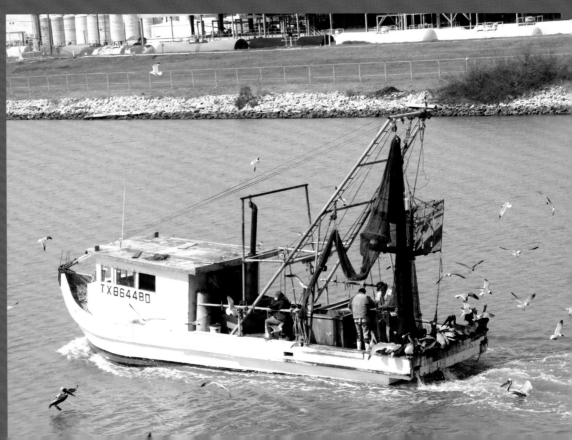

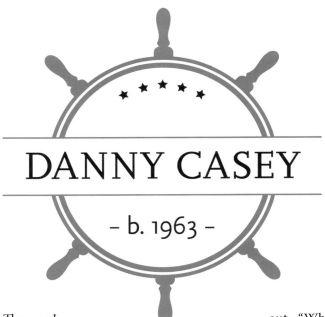

DANNY CASEY

– b. 1963 –

My name is Danny Casey. The way I got started on the river was my cousin was a captain for a small company out of St. Marks, Florida. When I graduated high school, he came to the house. We noticed he always had nice vehicles and nice things. He asked me if I was interested in a job. So I said, "Yeah, I'll go to work." But I was only seventeen, so I couldn't hire on right out of high school. I had to wait till October. So, when I turned eighteen in September, I caught my first boat October 1981, and I rode boats ever since then.

I've done some crazy stuff with the first company that my cousin was the captain of the boat, which back then you could get away with a lot of things. We were running into a little river, the St. Marks River in Florida, which is where our home office was. So we were real comfortable there. I caught an alligator off the barge one day that was about seven foot, and I taped his mouth shut, and I put him in the rudder room. I was going to deal with him when I got off watch. Sure enough, it wasn't long after the president of the company came walking down on our boat, because we were at our home dock. I was like, "Oh, my God. I hope he doesn't go into the rudder room." He was walking around looking at the boat, and all of a sudden, he comes out, "Who put this gator in the boat? Get it out of here!" The captain came. He said, "I know who did it. We'll get rid of it." So I had to let it go. The way I caught it, I just took a piece of cable and made a loop in the end of it. He would come right up by the barge, so you could feed him. I just slid the loop down, put it around his neck, cinched it up. I pulled him up on the barge and just grabbed him. He was wrestling, but you get them on that steel, and they're wet, they can't get any traction. They'll just flop around. It wasn't hard to do.

There's so much technology in the wheelhouse now compared to thirty years ago. It's a lot easier now. Nowadays, with all these young guys, if the computer goes down, or they don't have a chart to look at, I don't know if they can run a boat or not. That's why I try, while I'm training Evan, my son. There's actually times going up the river that I'll just reach over and turn the monitor off. I'll make him run for an hour or two without that helping him and just with the radar and the other equipment, hoping to prepare him one day, and I hope it works because, you never know, a computer could quit just like that.

A couple of years ago, that tornado that came through Tallulah and went to Yazoo City and killed

all those people, I ran through that with the boat. I couldn't see anything. It was scary. I couldn't stop it hit me so fast. I was moving. Before I knew it, it was on me. The handrails that are three foot in front of the wheelhouse, I couldn't see them. We had trees and pieces of trees and big dirt clods, everything, hit the boat all over it. It didn't move the boat that much, but the windows were shaking so bad I thought they were going to blow out. Once it hit me I knew it was a tornado. I stayed in the wheelhouse but told everybody else to go down just in case a window blew out. It broke two of my antennas, tore my loudspeaker off the front of the boat. It was pretty bad. It didn't last long though. I think I'm lucky. I think I just caught the edge of it. From the time I went in it until when I came out, it probably wasn't but about a minute and a half, two minutes.

When it first happened, it was just windy and just got really dark fast for some reason. Right before it came over me and my radar, it painted a perfect circle in my radar. And that's why I said, "That's a tornado." But it was too late to do anything about it.

Another time, we were northbound below Greenville, and the fog shut us out. We had stopped. I was the mate. Every morning, I'd walk my tow and check the couplings when I got out to the first coupling. I saw something in the water. I thought it was a person because it was splashing like it was trying to get on the barge. I set my coffee down and ran up there to see what it was. It was a big ole black bear. He had swam across the river in the fog and swam into the side of our tow and couldn't get up on it. When it saw me, it just turned and swam back out into the fog. And I guess it went back across the river. It looked like somebody struggling. I guess it was tired. I don't know. Looked like somebody trying to swim and get up on the barge.

PERRY HILLARD JONES

– b. 1963 –

My name is Perry Hillard Jones. I was born and raised in Honduras.

I moved to Mississippi in 1997. I started in Honduras. My dad owned shrimp boats. After moving to the states, I worked offshore on the boats, and I got sick of being away from home for such long periods of time because we went all the way across to Africa and Russia and all over the world when I worked offshore. I just got sick of being gone for eighty days at a time. I said, "No, that's enough of that." I moved inland in 1998, and that is when I started working in the inland river system in the canals, and I'm enjoying it. A lot of people say that me coming from an offshore background and that I had been used to working offshore wide open ocean, I wasn't going to like it, but I love it.

One thing that I've always heard the old people say is that whistling on a boat is bad. I always tell those guys on the boat, "Hey, no whistling on the boat." Old timers say that it whistles up a storm. A lot of time I proved it with several guys and just left them alone. I let them whistle. All of a sudden, it just so happens, the weather will get bad that afternoon. I look at them and say, "See, I told you so." And it stops them from whistling. I'm 49 years old and don't know how to whistle. I'm not going to start.

English is my first language. I learned Spanish at probably around five, six years old. We had to learn Spanish because all our education was in Spanish. We lived on some islands south of the north coast of Honduras, and working on a boat is what we knew we were going to be doing.

Now, we have more modern equipment. The equipment on the boats [is] super. It makes it almost foolproof to be able to drive a boat now with the equipment we have, the radars, the charts, and technology. When I started, we used paper charts. Now, they're trying to get rid of the paper chart and just use a computer.

Once we got caught in a snowstorm. That was really surprising to me because I grew up in a tropical country. Out of the middle of nowhere, the snow just started blowing and coming down. It started to snow, and I was out on the back deck. I ran upstairs to the captain. I said, "What the hell is going on?" We had a guy from New York who was the captain of the boat. He was used to it. I said, "What is that stuff?" I knew what it was, but just I had never seen it. We rode about four hours in it, and we had three inches of snow on our back deck. So we decided

to make snowmen. It was the cutest thing because when we got it built, we stuck a broom in it. His sides for his arm, we put spare gloves on him. Then we put a bucket with a straw brush in it. We put a hard hat on him and life jacket. We called him our little deckhand. That was kind of neat.

I always tell the deckhands or the crew that are working with me, "Think about your family at home. Whatever you're doing, if you're toting a line on your shoulder, or if you're toting a ratchet, we can always pay for it. Try not to fall in the water. The river can be very dangerous. Always try and be aware of your surroundings. Look around you and watch where you're stepping." Just be careful of what you're doing. Nothing is so important that we can't stop and start over again.

The industry has really changed a whole lot with getting your license with the Coast Guard. You have to be so careful nowadays when you're doing this for a living because, in the blink of an eye, the Coast Guard can take your license. If you do something, if you get a DUI at home, they can take your license from you if they feel like it. They take it away usually for about six months to a year. That's time that you won't have anywhere to work. You lose your income. So you have to be so careful of what you do. I'm glad I don't drink. Never did. So that makes it a lot easier.

Way back in '94 or '95, I was on an articulated tug and barge. We pushed the barge that we met across the ocean. We met all the way across the Atlantic. We went up to Turkey. We got to go through the Dardanelles and Istanbul and what they call the Bosporus into the Black Sea. Then we get to the country of Georgia. It was a long trip, eighty something days on the boat. That was different, just going across the Atlantic. We stopped in Greece. I've been across the ocean a lot. It's nice because it's wide open out there. The area we were, we didn't even see ships that much. Now, when you're getting close to land, close to Africa or Europe, wherever you're going, then you start seeing the big ships again. But when we're going across, we go in a straight line across, which is the longest route. There are ships and they have shipping routes where they go. We just went straight across.

MARK "RED" JONES

– b. 1964 –

My name is Captain Red Jones. I've been out on the river thirty-plus years. I guess I got my first taste of it when I was about twelve or thirteen years old. My dad was working with Dixie Carriers at the time. He slipped me on the boat for about two weeks. I stayed with him, and I guess I was hooked from then on. I actually decked for him those two weeks on the boat. He didn't cut me much slack. My dad would let me come up there and steer his boat a little on his watch. That's what really hooked me. He didn't leave the wheelhouse. He put me behind the sticks and tell me "See that little blue light out there? Follow it," talking about the Jack staff light. Back then it wasn't anything for the family to ride the boat for a little while. I officially started riding the boats in '81. I took my GED when I was seventeen to get out of school a year early and went to work with Alamo Barge Line.

I went through several guys that broke me in. The one that really broke me into the wheelhouse was Ted Strickland. That's where I got most of my steering time was with him. He was definitely an old timer. He was one of those that ran off four or five deckhands a trip. He felt like if he didn't do that, he wasn't doing his job. He said to me, "I can't run you off, so I might as well start training you."

I have talked to a lot of people when I'm off that don't have any idea what we do out here. They really think we just come out here and kind of go on like a cruise on a steamboat or something. They don't understand the work that goes with it. So I have to explain to them and how you start from the bottom and work your way up. You explain to them that you start out basically as a deckhand, and you're washing and cleaning 99 percent of the time and trying to get some sleep and rest. You spend a lot of years working your way up to the pilot-house. But it's not as romantic as it seems standing on the bank looking at the boat go by. There's a lot involved to keep that boat going. It's kind of hard to explain to someone that hasn't been out here to try it, but when all is said and done you look back, it was well worth it.

I would say my favorite stretch of river is from Catlettsburg on up to Pittsburgh on the Ohio. I thought that that has always been the prettiest part of the river. It can be definitely cold. I like coming into it in the fall of the year, with the trees and all turning. It's just beautiful up there. But last winter I was wishing I was somewhere else when we were

up there. I have to say that that was the toughest winter I have ever spent on the river. It was hard that time because one day we had wind chills of thirty to forty below zero. We had the heat going in the wheelhouse on that M/V *John Reid Golding* and plus three or four more heaters sticking in the window trying to keep them from icing over. It was all we could do just to keep the wheelhouse warm. It was a couple of days when that northerner first come in. The real temperature was around four or five degrees, and then we had twenty- and thirty-miles-an-hour wind blowing on top of that. It was just bitter cold. My cabin stayed warm because we were underway, so the main engine was running and keeping it warm. When the initial front came through, it started freezing the surface of the water. Then, after the winds quit blowing, the temperature stayed for a week or two below freezing. It stayed around the twenties. The river just started freezing over quick after that. It was very unusual for that Ohio to get like that. We had all those little space heaters pointed at the front. Really, you couldn't do anything. Whatever side the wind was hitting the windows, it was basically a losing battle because it would freeze up. We kept the front three or four windows where you could see out, and we kept the ice off of them enough so that we could see. But the rest of them you pretty much just had to let freeze.

The best thing I can say about working out on the river is that for a poor boy from Mississippi to come out here and make the kind of living you can make, it is something I never would have dreamed of when I was in school. There are not many opportunities in Mississippi to make the kind of living that you can make on the river. Being on the river is just a totally different world really. I see it in people's eyes when they ask you on the bank, and they find out that you're a captain on a riverboat. You can just see it in their eyes. They light up, and then the questions start. They just have all kinds of questions about it.

The Corps of Engineers does a great job harnessing that big river like they do. I know it makes a lot less stress on us and makes our job a little easier.

TIMOTHY D. "TIM" MILLER

– b. 1964 –

My name is Tim Miller. I started in 1987 as a green deckhand and worked my way up to captain. My dad, Bill Miller, inspired me to make a career on the river. I'm a third-generation river man. My granddad, Charles Miller, actually used to raft logs on the Choctawhatchee River, and they would raft them over to Pensacola and the Milton area to cut and saw up logs for timber. My dad would have been ten or twelve, thirteen when they were doing that. Dad worked doing that and my uncle Bobby too. They all worked pulling logs out of the swamp. They'd cut them and drag them to the river and then raft them.

I started in 1987 and worked up pretty quickly to tankerman and mate and steersman. I've been a pilot for twenty-three years. I got my first pilot license in 1990, and I'm on my sixth issue. You have to renew your license every five years. You have to take a physical, and you have to have documented time that you've operated the vessel for the area that you're renewing your license for, a western, an inland, near coastal, great lakes. You have to have the sea time to maintain the license.

What my dad taught me the most is just always respect the boat. Don't put your boat in a position to get you in trouble. I see a lot of guys that do things with a boat that they probably shouldn't. I've always tried to teach the guys that I train to protect the boat. As long as you can protect the boat and keep your boat in good condition, it will get you out of trouble. If you have to tear something up, tear that barge up. Don't tear your boat up.

I learned the old-school way on how to be a pilot. What we have today is a tremendous improvement from the past with all of the technology and I'd hate to know that we had to run every run without the equipment that we have today because it is a tremendous aid for what we do. When I first started and learned to read the chart and know where I am on the chart. I believe I can take a publicized paper chart and go anywhere in the country that I need to go. The electronic charts and the equipment we have now are a great tool, but they are electronic. They are mechanical, and they will tear up at some point. You have to know what you are doing to be able to get yourself out of trouble.

Every person you meet on the river is interesting, but I guess the most interesting person that I remember is Leon Johnson. I say that just because he was such a colorful character. Once, we were going up the Ouachita at mile 5 on the Black.

There's a camp house there, and a man and a lady were sitting under a swing rocking. I guess the guy thought we were going too fast by his skiff boat. He came running down there with a shotgun and shot at us. I had just stepped up there to make coffee, and I told Leon. I said, "Captain Leon," I said, "That fellow has got a shotgun and is fixing to shoot at us." Leon said, "Here. Take it." and he ran out the back door on the old *Austin Golding*, and the guy shot up over the boat just warning us. Leon jerked his shirt up and went to cussing him and said, "I've been shot at. I've been to Vietnam. I've got seven or eight holes in me, and you don't scare me." And he hollered at me, "Start backing up! Back up!" I said, "Leon, we can't back up. That guy is still shooting." He shouted, "Back up!" So I started backing. I did what I was told and backed back down there pretty close to him, and Leon ran back out again hollering and shaking his fist at him. He came back in and hooked it up and tried to sink the guy's boat. We got on up away from him, and Leon called the sheriff's department and told him that he had been shot at. That was the fourth or fifth time that they had had a report on that guy shooting, so they went ahead and supposedly came down there to arrest him for shooting at us.

If you go into the Mississippi River and come out alive, or if you fall in the river off of a tow, if you make it out alive, you better thank your maker because he has something else planned for you in your life. What makes it so treacherous if you fall in the river is the currents and the undertows and the dikes. It's just that the turbulence is what will pull you down. And also there is the danger of the sandbars—they shift. I guess the most dangerous thing is, especially like with a pleasure boat, they'll just cut right across in front of you because their boat is a lot faster than you. They're running a lot faster, and that's all fine and good. But that one time if it runs out of gas or the engine stops, we can't stop.

It's interesting that the mariner lifestyle stays in a family. So it runs in my family. It's deep. I consider myself a third-generation river man because my granddad rafted logs. It's not the same as we do, but he worked on water.

MARTY RINEHEART

– b. 1964 –

My name is Marty Rineheart. I started out when I was fifteen years old, mainly in the oil fields in the swamps of Louisiana. I got in this industry following my daddy, Louis Rineheart. He was a riverboat captain also. It was just kind of a family thing.

I was broke in, in the oil field on a twoperson boat. We were only two crew members. When the captain got tired, the deckhand had to learn how to run the boat. It wasn't really required to have a license back then in the oil field. So you learned to steer a boat quick because you only had two people. When the captain got tired, the deckhand took over. That's where I mainly got my wheel time. You learned on your own. I was in one of those swamps with nothing to run over but trees. I couldn't do much damage. I was fifteen years old. When the oil field started slowing down, that's when I went and got a license because I knew I was going to be with the bigger boats.

When I was about nineteen or twenty, that's when I actually started running the rivers between Baton Rouge and New Orleans and Baton Rouge to Houston, Baton Rouge to Mobile.

The boats have gotten a lot better. More comfortable boats. A lot better living conditions. When I first started out in the oil field, we ran off of 12-volt systems. The only time you have 110 was when you were at the dock or at the oil rig where you could plug in, run the AC, and stuff up. Other than that, you didn't have AC and of course no cell phones. No communication. None. When I started out when I was fifteen, they had pay phones at the dock sometimes you could go to, and they had marine operators you could use. But you didn't use them. They cost a lot, and everybody could hear your conversations at that time. That was in the early '70s. Sometimes while you were at the lock, you could use the telephone. About the only time you had a phone was when you got to a fleet, and you were able to go to the bank. You could use a pay phone. But other than that, you didn't have communication with home unless they mailed you a letter to the office and you would get it at crew change.

Nowadays, cell phones are good, but they're also bad. It's a major distraction out here, but it's nice to know what's going on with the family. A cell phone is actually a luxury, but it's abused and just like computers. We have the internet now. Back then, we didn't even know what a computer was.

Back when I learned how to steer, we had a wooden wheel to steer with on the boats. It had

regular rudder, but it had wooden wheel sitting up here that you could steer the wheel. It wasn't a hydraulic system because we didn't have 110-volt. We didn't have electricity. All we had was a 12-volt, system. There wasn't any electricity to run a steering system like we have today. It was cable driven. They had a chain that went down and hooked up pipe, and it would run out the back. And then another set of chains going down the stern. It had a cable on a rudder on two pulleys. You turn it one way and it would wind and let out and it would just do the opposite. That's what moved the rudder.

When I started working on boats, I was on the deck, and I looked up at the man in the wheelhouse, and I said, "That's my job. It's too cold out here, and it's too wet." I knew early on that I wanted to be in the wheelhouse. I knew when I walked on the boat that's where I needed to be because I had ridden the boats with Daddy. That's some of my enjoyable moments, too, that I remember making a few trips with him. I had the pleasure of riding a boat with him as a deckhand. He was a captain. When he finally got off the boats, he was running the ten five out there, 10,500. It's a big boat and big line tow. My granddaddy was a commercial fisherman. He was on the water too. We hunted from boats. We took boats to go to land. We had pirogues that we used to crawfish out of. I have been chasing boats since I can remember.

My daddy used to tell me how they used to get off in the different towns and end up in the bars and barroom fights and end up in jail. He told me how they used to towline barges through the old Plaquemine Locks. They had to tow them from the stern. They wouldn't push them. It was called tow lining.

Tow lining is when you pull barges from the stern instead of pushing them from the head of the boat.

A regular day for me now is I get up probably at about ten minutes after five in the morning. I get up, get ready, get dressed, and come on watch about twenty minutes to six. I don't eat breakfast. Sometimes I'll eat about eight o'clock in the morning, but I don't eat when I first get up. I don't drink coffee either. I fix me a Coke. But I'll get up and come on watch and check the boat out and check everything out and make sure everything is going good and stand on watch until about noon. Then I'll get off and walk around the boat and be involved with the other crew that had just come on watch for about an hour or so. Then I'll go get me a shower and lay down.

Sometimes I'm up about three o'clock. Sometimes I'm up at five o'clock again. And then that evening watch, I just come on watch and drive again for another five and a half hours, six hours. At midnight, I'll go to bed, and I'll sleep all night. I don't get tired when I'm on watch. I used to. When I rode pilot's watch, I'd get tired, the back watch, midnight to about three o'clock in the morning.

Just knowing where you're at is the main thing of running a boat.

River traffic nowadays compared to river traffic when I first started, it's a whole lot more. It's probably double or triple since I started. And the tows have gotten bigger. Because in the canal at one time 600 foot was a long tow. You push 1180 foot back there now. Most of the barges back then were 25- and 30-foot wide. Now they're 54-foot wide. The industry has grown a whole lot.

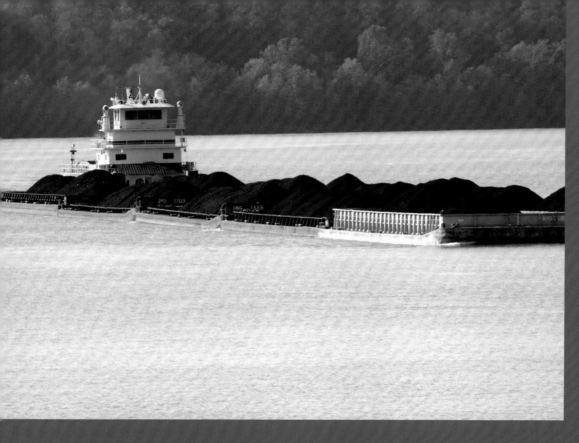
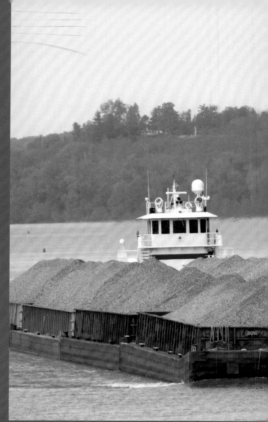
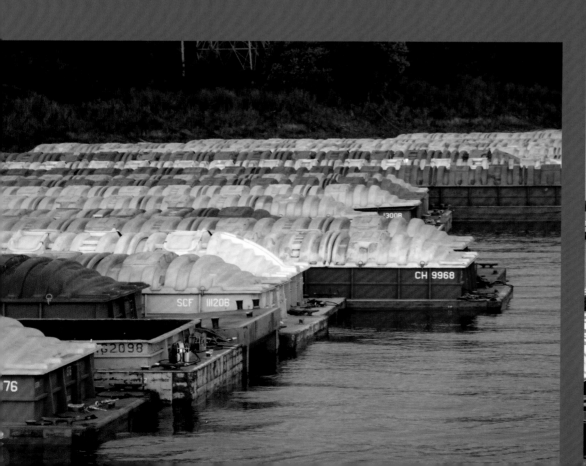

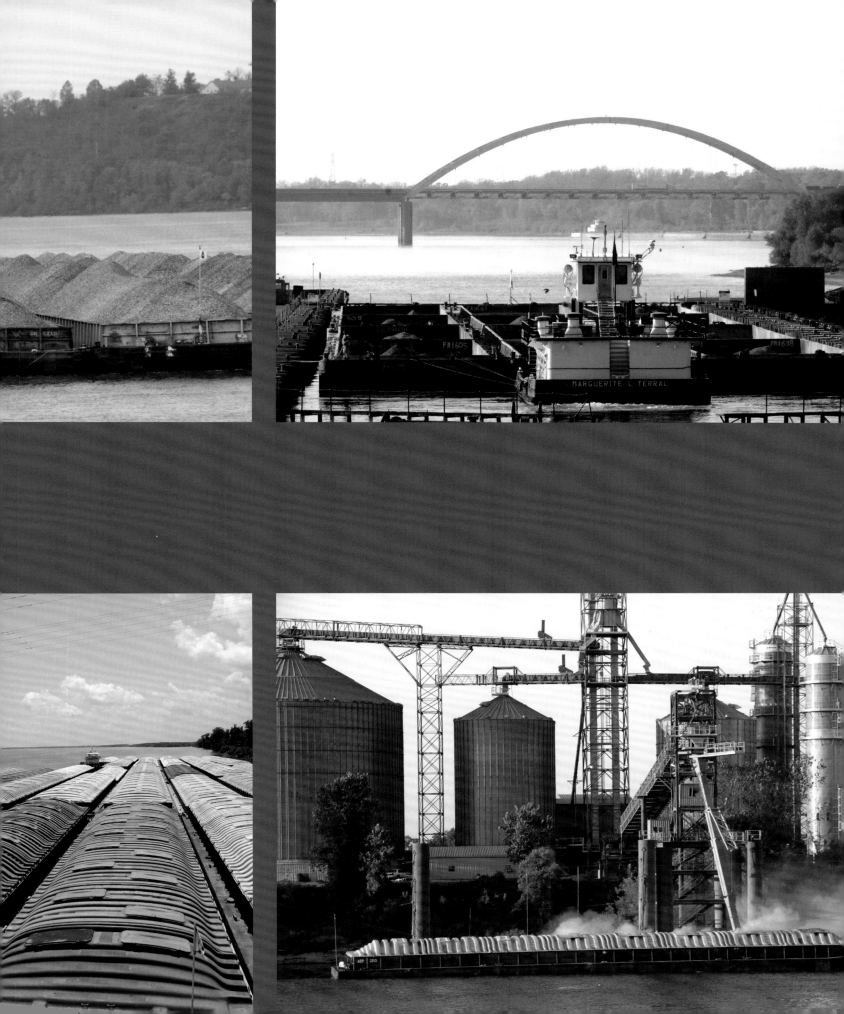

ROBERT WAYNE "BOB" MATCHUNY

– b. 1965 –

My name is Robert Wayne Matchuny.

I go by "Bob" usually or "Captain Bob."

I've been on the rivers since I was a child. We lived on a boat about six to nine months out of a year since I was born. When I was eight, my dad bought the hull of a boat. My dad was just a river rat pretty much is what you would call him. We bought the hull of that boat, and we had to cut about twenty-five feet out of the middle of it, so the local facility could actually handle it. We lived on land on the boat, for three years, and then we finally got it in the water.

My mom's name is Nora. So all of our boats were called *Nora's Ark*. This one really fit the picture big time because it was a massive undertaking. It's a big boat, over two thousand square feet. It was one hundred feet by twenty-six feet. It was sitting five feet up off of the ground. It was towering. Just from the roof to the water would be twenty-something feet.

Everybody knew we lived on that boat in the shipyard. The boat was sitting up on wooden cross timbers. A school bus would pick us up for school and drop us back off right there, and they'd look way up there and see this boat that we lived in.

As a child, I was driving all kind of boats. I was helping deliver boats in my very early teens. Some rich guy would want to take his boat from wherever to the Gulf or something or way up the Tennessee River or somewhere. People would say, "I'm telling you, that's your man." Talking about me, but I wasn't even a man, you know.

The first real job I took was in my late teens for McBride Towing. That's in New Albany, Indiana, 5M Transportation. I just helped out and decked and unofficially spotted barges. I was about seventeen, probably. One year, I took a job at the *Star of Louisville*, which was a dinner boat at the Louisville City Front. That was my first official job.

I got my hundred-ton master's license on the *Star of Louisville* in 1989. I mostly ran engineer on that boat, and I did a lot of boat handling with it. I started working on casino boats back in the mid '90s. One could carry 5,030 people. It was 450-foot long by 100-foot. We cruised, but it didn't cruise very far, and we had to stay a couple of feet off the riverbank. It was in southern Indiana near Louisville, Kentucky, *Caesar's*. Now it's *Horseshoe*. Kentucky was adamant that if we got in their waters, which they own 90 percent of, they were going to confiscate the boat. There were helicopters and cars and boats hovering all around. The horse-racing industry were horrified that it was going to have a huge impact on it, but it didn't.

Right now, I am working on the *American Queen*, and I think it is 450 feet. It is 100 tall with the stacks up—99 feet. There are 356 guests on board, and there's another 154 crew. In any kind of water, it can be problematic. It's a real paddle wheel. The paddle wheel provides about 60 percent of propulsion. We have Z-drives, which provide the other 40 percent. The Z-drives make it a lot more maneuverable. You can operate each one of them independently. There's no reverse. You just turn the unit around. This is a steamer, a steamboat. It's called the steamer *American Queen*. Here on the *American Queen* I work twenty-eight on and twenty-eight off, twelve-hour days, 10:00 a.m. to 10:00 p.m.

I can't picture any other way of living. I live on the water. I work on the water. I play on the water. I vacation on the water. It's literally in my blood. I don't know any other way of describing it. I can't get away from it. I'll always be on some kind of water, preferably rivers. After I die, I want my ashes in the river. I don't care where they'll throw them. I hope wherever I ask them to I guess.

DAVID "D. W." WETHERINGTON

– b. 1966 –

My name is David Wetherington. I started on the river when I was twenty-one. I had been married for a couple of years and had a child. My wife told me that she wouldn't be married to a person who was gone all the time and said she wouldn't be there when I got back. So I rode thirty-six days my first trip and having to deal with that. Then, when she started receiving my checks, it was more money than I had ever made, and she decided not to go anywhere.

The first day that I stepped foot on the boat and I walked upstairs and I saw the pilot up here with his feet propped up and I found out how much money they made, I said to myself, If I'm going to stay out here, that's what I'm going to do. I decked for six years before I got in the pilothouse. I got my license in 1993.

My son Corey worked for us for a while. That was really great riding with my son out here. If you're twenty-one, twenty-two years old, don't stay out here just for the money. Don't do that because if you don't like it, it's going to really make your life miserable. It really is because you're going to be away from home and away from everything. That's why my son basically quit or wanted to quit because he just got tired of being away from home, and he just had a baby and he wanted to be home with his baby, and I understood that. I was kind of looking forward to maybe him becoming a tankerman and then maybe his dad getting to train him to be a pilot, but it just wasn't for him.

Let me tell you a little story about what an engineer did to me one time. I worked for a company called Tolen Marine out of Paducah, Kentucky. They had found a blowup doll on the boat we were on. I hadn't been in the wheelhouse but just a couple of trips. The engineer had a pair of coveralls. It was wintertime, and it snowed one night, and he had found this doll. He dressed it up in those coveralls and put a cap on it. Well, he comes up stairs that afternoon. It's around noon. I'm on watch. He comes upstairs and tells me, "David, I've got to go up to the top of the wheelhouse and change a bulb." He said, "I'll be back in a minute." I said, "Okay." Well, earlier that morning while I was in bed asleep, he had taken that doll and put it up on top of the wheelhouse. Well, he went back up there that afternoon, and he took it, and he threw it down in front of me. I mean that was evil as hell actually. I just about crapped in my pants. You know what I'm saying? I mean, I thought that he had fallen off

the top of the wheelhouse. I about freaked out. I looked down and saw that doll in those coveralls, and I didn't talk to that man for a week. His name is Brad Barton. I actually love the guy to death, but I wanted to kill him. That may have been one of the worst pranks ever I've seen out here, and he did it to me.

What I love so much about this life is I can't even count how many numerous new people and different people I've met in my twenty-five years out here. I've made numerous friends. I'm sure I've made a few enemies. I try my best to get along with everybody. But you meet so many different people out here, [from] the noneducated to the just flat out stupid. Probably the most favorite part of this job more than just the job itself is getting to meet new people. I meet somebody new every other trip, and I've always enjoyed that.

Life on the river back when I first started was different than it is now because of technology. When I first started out here, we had to get off on lock walls to make phone calls. There weren't any cell phones. There weren't any computers, no Internet. We got our traffic off of what they call a single sideband radio. You would write your barge numbers down, get your barge orders and stuff off of that thing, and there might be five thousand people talking on that thing at the same time. Those things would reach out all the way out to Japan. It was rough when I started. Also, the technology as far as now, the new charting systems—we didn't even have speedometers on the boats when I first started. We didn't

have daytime radars. The very first boat I rode captain and pilot, they had two big ole radars, and they had this hood they had to put over it to be able to see if it got foggy, or if in the daytime they needed to see it, and they could look in it and see. It wasn't like the bright daylight radars like we have now. But it did help me become a better pilot learning that way not having the electronic charts like we do now with the GPS and all that. It made me a better pilot even though I'd probably cry if I lost all this now. But I could do it. It just would be getting back to basics is what it would be.

When I first started working on the river, I was young, just twenty-one years old. It was my birthday. I had never been in a bar before I came to work out here because I had only just turned twenty-one. When I got off the boat, of course, the first thing I wanted to do was go to the bar and everything. People don't realize that when you are out here you're almost like a caged animal. I mean, that's kind of a bad metaphor I guess. But you're limited to where you can go and where you can move. I have found that I like a lot of alone time sometimes. I like to go to my room and be by myself or read when I'm on the boat.

When I first started, an old captain told me one time that no matter how bad things can be out here, and no matter how rough your trip might be for twenty-eight days, when you go home, everything's going to be all right. Everything is fine. It's like it never happened. So that's kind of the way I look at it. That's what I do.

EARL M. CONNER JR.

– b. 1967 –

My name is Earl Conner, and I started as a deckhand when I was thirteen, part time with my daddy and my cousin, and I've been at it ever since. We were down there on the coast in the canal working in between there and the Gulf. The boat was a model bow tug. A tugboat. My father, he was a deckhand. My cousin Norman Roy got me started. He was a captain. I was in school until my daddy got hurt when I was fifteen, and I started full time then. Right then and there, I realized that I was going to make it a career.

Been places everywhere. I broke my teeth. That's a figure of speech. One of those coonie sayings.

When I was still with Crane Brothers we blew up wells and stuff on the Atchafalaya. It was fun in one way, but it was dangerous in another way because it could have cracked the hull of the boat and sank the boat. So we had to stay a distance from there. The fishing was good when we would dynamite wells.

We would get catfish and gar fish. Everything that was around would come up because they were using C4 dynamite to blow the casings of wellheads up. We always got plenty of fish and didn't have to worry about buying any. They were blowing them up because they were abandoning the wells, so nobody would run into them.

Captain Norman Roy, the one that broke me in, he's a one-armed fellow, but he could run a boat. He had one arm, and his other arm was amputated, but he had a hook on it. We called him "Captain Hook" all the time. But he could run a boat. The sticks, he'd use his hips to do the sticks and his hands with the throttles. He lost his hands shrimping. Before he started running tugboats, he had owned his own shrimp boat and fell while they were picking up the nets, and the winch cut his arm off. My poor daddy was working with him then. They had both moved up to doing the tugboats. I come in right in amongst it with them. I was with them the whole time they were there, and when Captain Roy (I was sixteen years old), him and my daddy, they said, "Well it's yours." I said, "What you mean it's mine?" Norman Roy said, "Well, I'm retired." He says, "You been docking and doing all kind of other stuff with me watching you and then going to tie up the barges yourself while you were running the boat." So, he says, "You're welcome to do my job now." He went ahead and left it to me. We were out in the middle of the Grand Lake, and he had launched a skiff boat, and the boat went in, and he said, "Your deckhand is out on his way." I was scared at first

because it was mine to do all by myself then. So I was still learning, but I learned a lot more after I had it to myself. I had to learn if I was going to make my profession. I've been doing it ever since. They knew what they were doing. They wouldn't have let me do it if they didn't think I could do it. Then when I got back in from that job, they put me on a bigger offshore tug to go in the Gulf full of platforms and stuff, and I was just sixteen.

It's fun out on the river. I like it. It's home away from home. I got two families, one at home, and I got a family out here.

CHRIS WAKELAND

– b. 1968 –

My name is Chris Wakeland. I started getting sent home from my job because they didn't have any work to do. My father had been a tankerman years and years ago. He said, "You might try Hollywood Marine to get a tankerman's job. If you can do that, you can probably make a decent living." So I called them up, and they hired me. That was in 1990.

Once, we were coming into Houston, and I was coming to relieve the captain. It was about midnight. We were in the Galveston Bay heading into town. As I was coming up the back of the stairs, you can see out the back of the window, and I saw a guy shining a light at us. I come up there, and I said—captain's name was Harold. I said, "Harold, you know there's somebody behind us." He said, "Yeah, there's always somebody behind us." I said, "No, he's right behind us, and he's in a little boat." Oh, okay. So, we get the deckhand, and we went to the back of the boat. The captain slowed the boat down. It was cold. It was wintertime. I say, "You having a problem?" He said, "We don't know how to get back to town." He had his son with him, and they were freezing. So we stopped and let them get on the boat, and we probably should not have done

that by company policy, but they were freezing, and he was lost.

It's kind of sad because my old captain that I worked with at AP, he used to call them MasterCard mariners. Just because you can buy a boat doesn't mean you ought to. Basically, this guy was one of those, and that's fine, but, I mean, he's got his kid with him, you know. He put his life at risk and his child's life at risk. People who are out on the water assume towboats can stop a heavy loaded tow going through an area in time. The best way I can explain trying to stop one of these is like a train on ice. It doesn't stop quickly. When you do stop, you don't know where it's going to go because it's going to take off and a million factors come into play once you change everything. The scariest thing is when we come into contact with recreational craft in the summertime because you don't know how much liquor is involved and whatever. People don't know the danger, and they make the assumption that we can do anything. And that's probably the most scared I have ever been is when having to maneuver around people that do something. They come into contact with me, and there's nothing I can do to keep them from hurting themselves.

Once I rode with a captain who had a cat. I think he found him at a lock one night in New Orleans, and he put him on the boat, and he fed him shrimp every day, and then the cat blew up to be this big ole gigantic ball of fur. He would come and sit on your lap. It was like a Doberman was sitting on you. It was huge, and his name was Tater. When the captain went home, the cat stayed on the boat because he lived on the boat. He never went outside or out on the barges. He just stayed on the boat. That cat Tater ate better than us sometimes I think.

I recommend this kind of career for anybody willing to accept it for what it is and make the most of it. If you don't want to do it, I don't want you out here. If you're just here punching a clock, then we don't need you out here.

KATHERINE A. CHAPLIN

– b. 1969 –

My name is Katherine Chaplin. I got on the river because of my little brother, Otis Chaplin. He worked on the river. I started from the bottom and worked my way up. I started out as a deckhand on the *Marian Hagestad*. I got hired on November the 15th of '95 and started on the boat December the 7th of '95 in Wood River, Illinois. It was the coldest trip in my life. Captain Randy Scarborough, who was the captain at the time, turned out to be my mentor. He called me up to the wheelhouse, and I thought I was in trouble. We were coming through Louisville, and all he wanted to do was show me the Christmas lights there in Louisville.

When I went up to clean the wheelhouse for the first time by myself as a deckhand, and it was probably about four trips later, and we were heading down on Sunshine right there above Victoria, he asked me to hold the sticks while he ran to the bathroom, and I was like, "Okay." It was high water. I didn't know what the heck I was doing. I knew port and starboard from being in high school. So when he came back up, we were headed to the bank, needless to say. I froze. I guess you could say about that time is when I realized I wanted to be in the wheelhouse.

It was hard for me as a woman because every time I went to a boat or someone came over there that never rode with me I had to prove myself all over again. So it was a lot harder than what most of the guys have to do. But Captain Scarborough broke me in and kind of took me under his wing, and he mentored me from about six to eight months after being with the company.

The advice that I have for other women that want to make a career out on the river is you have to have a strong will and a strong mind. Don't let someone tell you that you can't do something. I'll prove anybody wrong. And eventually I did. I made history with Canal five times. I was the first female tankerman, the first female mate, the first female steersman, the first female pilot, and the first female captain. If there are other women that want to do it, it takes a lot out of you. Even to this day I still feel like I have to prove myself. I'll help anybody that's willing to help themselves.

My first trip out, I caught the boat with my brother. I didn't know it until we got back home, but my dad had pulled my brother off to the side and said, "You better take care of your sister, and y'all better behave out there. Don't you be starting

nothing with her." because me and him, we were tight. Me and my family are probably like everybody else's family. We'll fight amongst each other, but you don't let nobody else come in between it. My brother was not a captain; he just wanted to be a tankerman. He is really proud of me. That was the one thing I was scared of was if he found out I was steering and everything, I was afraid he was going to be mad and jealous and all that. He was like, "Naw, Sis, I'm happy for you. Go for it."

To me, it's a total different atmosphere for sure out here. My best friend, she says the reason that we work out here is because we can't handle the real life, you know, the real stuff that happens on land. I said, "Are you kidding?" I said, "Are you kidding me?" There is more drama on those boats than a pack of high school cheerleaders. Everybody knows everybody's business. You are living with the same people for twenty-eight days.

Even to this day like talking on the radio people say, "All right, yes, sir," "Yes, sir," "No, sir," whatever, you know. Some of them that know that I'm a female, they'll call me "Kat" because that's what everybody calls me out here is Kat. And so it's either that, or they'll say "Yes, sir" and I don't say anything. But every now and again, I might wake up in a bad mood, wake up on the wrong side of the bed, or deckhand might have said something wrong to me or something, and then I'll just let that person

know real quick, "I am not a guy," you know? A couple of trips ago, we were up there at LBC Sunshine, and I put some beans on that night in the crock pot. I just happened to wake up like four o'clock in the morning. I went downstairs to the galley, and I'm adding water to the beans. So this new guy was on board, and I knew he thought I was the cook. So he's like, "Where's the coffee?" I said, "Hell, I don't know. I ain't even got a cup yet." I make some coffee and everything, and next thing I know, he's going to say, "So you the cook?" I said, "No, I'm the captain." It was one of those moments where, you know, Okay, let me get a shovel and pick my face up now. He was just shocked. He goes, "Seriously?" I said, "Seriously, you know, I'm the captain." He was like, "Oh, I'm sorry." I said, "It's no biggie." I said, "I get it all the time." My pilot said he had been waiting for it to happen. I went upstairs, and I told him. He's like, "Dang it. I missed it."

The guys, they couldn't believe that I could pick up the ratchets and the wires and all of that just as good as them.

Captain Bo, he goes, "You know, in all hindsight, women are better at this job than men." I said, "Why do you say that?" He said, "Because women are better coordinated, can handle stress better, and this that and the other, you know." I said, "Oh, I know." I said, "You know women make better welders too."

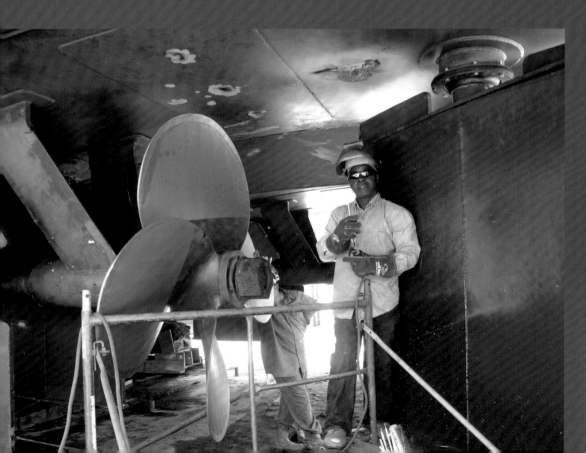

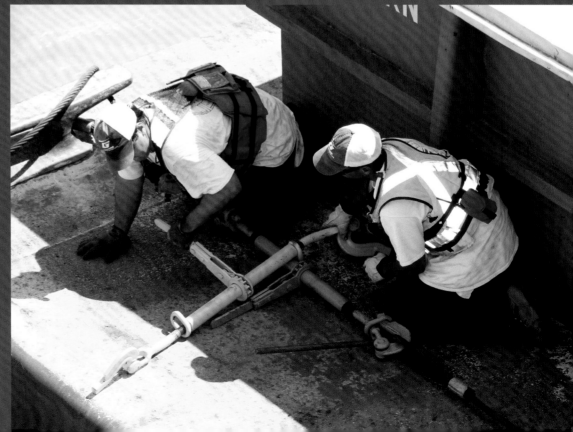

PERRY MAUPIN

– b. 1969 –

My name is Perry Maupin. L. C. Williams was my main captain that broke me in working on deck to become a tankerman. When I first caught a boat, I just loved it. I worked on deck for ten years and then got my pilot's license. It took me about twelve years to become a captain.

When I first started, it was a lot different than it is now. There weren't as many rules and regulations. There was a lot more goofing around. We worked hard, but we had fun too. Back when I first started, we would go swimming off the boat. The boat would be tied up somewhere, and we'd go swimming or just hang out playing cards and having a good time. We would dive off the boat or the barge or both because we'd be tied up. The boat wouldn't be running. But you can't do that now. No. You would be in big trouble. The Coast Guard and safety have rules, so somebody won't drown or anything.

I would recommend working out on the river for a career because you can make a good living and provide for your family. You can move up real fast. I don't know anywhere else where you can move up as fast as you can out on the river like we do.

Captain L. C. wore the blue-jean coverall bibs, and he just was a big ole guy. He was real big, and

that's all I ever saw him wearing.

He was a tough guy too. If you didn't do right, he'd set you straight. But he taught me a lot about if a person got in trouble, you don't get onto them in front of everybody. Take them to the side. I feel like I was fortunate to be able to be broke in by him because there were a lot of people who didn't get along with him because he was hard. For some reason, he liked me, because whatever he wanted, he knew I'd do it. He just took me under his wing and showed me how to do everything. I think he started in the 1950s.

I have drawn some maps where I've traced where I've worked on a river, and I put a lot of information on the chart. I didn't want to lose that information, so I traced the river all out and wrote everything down. I still have it. I'd use my new charting system and all that, but I would use my chart to know where all the sandbars are.

I have a book I've kept for a long time where I keep all my information on docks and places I've been. A lot of pilots do that. I keep it on my boat. I'll add to it. I'll look in it a lot to find out what a fleet channel is. There are all kinds of information I have. I have a book along because we used to have to keep up with our information because we didn't

have computers back then when I first started, and we couldn't get all this information. Nowadays we can find that information out through computers.

I use all the technology we have in the wheelhouse now. I use everything, but I don't rely on it as much as the newer guys because that's what they've been taught with, and they're used to it.

One joke that we do is we have the mail boat that comes out and checks the mail that is on the buoy out there. So we go past it and have them looking at it and looking for the mail, or we'd go into a lock we tell them that we need the key to the lock, and we have them go back to the boat and to go find the keys, so we can get in the lock. So they go back, and they're asking the cook and they're asking everybody where the key is to the lock. Everybody knows what's going on but that person. And they're just, "Oh, I don't know where that key is." "Go ask so and so," you know. We have them walking all over the place looking for it. So it's terrible to be a green deckhand. It can be bad. Sometimes they are told to go get five gallons of wheel wash. The wheel wash is what comes out behind the boat. And so he's walking around asking people, "Hey, I'm looking for and trying to find five gallons of wheel wash." He can't find it. We all just laugh about it. Then it's nice whenever somebody greener than you gets on, and they start picking on him. We laugh a lot on my boat. But when it's time to work, we work.

I've been on boats a lot where the river gets real low, and we've run aground. I remember one time we were sitting in the galley eating, and we ran aground, and the refrigerators and everything shot across the galley and landed on the other side. All the canned goods and everything came out the cabinets. I didn't get hit by anything.

If you had a good cook, it was all right. If they cooked really good, it was great. But then there were people who said they could cook, and they couldn't even fry an egg. I didn't like that. So it had its pros and cons.

Going up to Chicago is probably the most interesting place I ever went to on the river because of just all the bridges and how narrow it is. It is difficult to go through all the bridges. It's pretty tough. There are a lot of bridges, and then it's just a big ditch. It's a big concrete ditch you go through up there. It just amazes me going through there and when you're meeting other boats and you're dragging on the side of concrete just to keep from hitting each other.

Going through a lock. A lock can be good, and it can be bad, but it's just getting from one pull to another pull. Sometimes, when you go into it, it's just a big, big concrete chamber you go into. Our tow is almost as wide as the chamber. So you only have a foot on each side, and it can be tough getting up in there. You have to take your time. It can be hard getting in the locks. We have our men out on the head of the tow, and they're telling us how wide we are. They're our eyes out there because you can't see. It's too far. You can't see. You can't judge anything, so they tell you. They tell you over the radio.

I've seen all kinds of wildlife in the river. I've seen lots of deer. I've seen everything. But it's just amazing to see a deer swim across the Mississippi River. The river is a mile wide, and they'll swim all the way across the river and then jump up on the other side and just run off like it was nothing. I've seen wild hogs swim across the river. We go out in the middle of nowhere. We go to places out in the river that nobody ever sees, nobody. Unless you are traveling it by boat, there's no way you can see it. We see eagles. I never saw a bald eagle until I started working on boats. Go up north and to be out there working and see a big eagle come flying over you with a fish hanging out from under it. I mean, it's wild. You stop what you're doing and watch it. That's amazing. The river hasn't changed much. It's the one place where through time that has been like that forever and hasn't changed.

We see a lot of guys in kayaks and canoes. We'll see them on the Lower Mississippi, which is the most traveled commercialized river, and I don't think it's safe. I think if I wanted to kayak or something, I'd find another place besides the Mississippi

River to do that. There is just so much danger. A lot of times, you don't see canoers or kayakers until they're right next to you because they look like a buoy or something. You have to look for them. People and their ski boats and bass boats you have to watch out for them too. They don't know that we can't stop. I mean, we can stop, but it takes a long time to do it. If somebody starts at the beginning of the river and goes all the way down to New Orleans on something like that, they think they know the river. But they don't really know the river, they're just lucky.

Our boats are really comfortable. They're really nice. They're nicer than most anybody's home. I had a friend of mine, he came and visited one of our boats. I brought him down to check it out, and he got on there. We were looking around, and he told me, he said, "Perry, I used to feel sorry for you when you caught the boat." He said, "I don't feel sorry for you anymore." He's like, "This is a really nice place. You know, this boat is really, really nice." People have no idea how nice, you know. That makes a big difference in being comfortable. It makes it easier being gone.

TODD HUNDLEY

– b. 1970 –

My name is Todd Hundley. I started out as an engineer. Then I got my pilot license and became a captain. I've been on just about every river that you can ride. When I turned eighteen, I took a job pushing rock barges.

Captain Red Brunswick from Hickman, Kentucky, was the first captain I rode with. He used to ride the *Sprague* and another boat. He was an oiler—you know, oil and steam engines. He's the one that made me want to stay. I remember the first time I went to New Orleans. We were working on the *Red*, and we were on a boat pushing twenty barges. We got a contract to take 15 grain loads down there. Captain Red couldn't read or write, and so we're going down through New Orleans, and I'm looking. He's like, "Where we at, Todd?" I said, "I think we're at Philadelphia Point." We came around Philadelphia Point for an hour because I had no idea where we were. But I remember just reading the charts for him and talked on the radio for him. He could navigate the river because he knew just from learning the river where he was. I dang sure didn't know where we were. I was an engineer. I was like, "I think we're at Philadelphia Point." Half an hour later, he said, "Where we at?" I said, "Well, I think we're still at Philadelphia Point, you know,

according to this chart." He only knew two speeds and that was wide open and stop. That was it.

We had this deckhand that was running the capstan line. We called him Baby Huey. He was a big old sucker. He was a whole different story because on his time off he would go to state parks in Arkansas, and he would hike nude. Well, that's what he told us. He had some marijuana growing. That's what he would do. He would just hike—for a whole two weeks off just hike around, smoke his dope, and then come back to work. He was really, really strange, but he was a good deckhand.

Another time, I was in the engine room on a boat called the *Martha May*. We left with Captain L. C. Williams. We went to Greenville and discharged two barges of gasoline. We had turned the boat. We were heading back south, and we were hauling ass. We're doing eighteen miles an hour. I went to bed at eleven o'clock, and we had just left Greenville. At 4:30 a.m., we were getting run over down here at LeTourneau. What happened was the steering had gone hard down. We ran right underneath the tow of the M/V *Dan McMillan*, which was pushing forty-eight barges, and we hit him. It was a single-skin gasoline barge. It knocked a huge hole. I'm

not kidding. You could drive a truck into the side of the barge. Why it didn't catch on fire, I don't know. And the boat kept coming around. The guy on the big boat, he saw it happen, so he started backing up. But he was backing so hard, they smoked all his clutches, which is on the transmission of the boat. When the boat came around, we hit those empty rakes, and the boat dipped under.

Well, I woke up when we first hit. So I stepped on the starboard stern portion of the boat. I had one foot in the boat and one foot out of the boat. I'm looking like "What the hell did we hit?" because it hit us on the side. All of the sudden, the boat then came around. The whole deck went under water, so I closed my door in the bunk room. I went and got my life jacket on. I tried to. The life jacket was wrapped up with the straps, and I couldn't get it—I was all nervous. I couldn't get it unwrapped, so I just pulled it over my head. Like to ripped my damn ears off. I walked around with the life jacket sticking out in front of me. I went through my bathroom, and I had a door that went straight to the engine room. I opened that door, and there was a solid column of water coming in the engine room door. It blew the doors off the engine room going out the other side. So I went back in my bunk room. The boat was leaning so much then that I just sat on my desk because it was leaning so bad. The only thing I could think of the whole time was, "As long as the lights are going I know we're still o.k. We weren't at the bottom of the river yet."

I couldn't open the door. The water pressure had the door shut. I couldn't get out. The water was halfway—I don't know how high the water got on the side of the boat. I think the whole second deck. The bottom deck was under water. Before this happened, I always lay in bed thinking, well, If this happens, I would just swim out this window. Or if this happens, I would do this. And there I was—I could not budge that door.

Well, about this time, the water pressure blew my air conditioner out, and the water started coming in through the window, and all of a sudden,

the boat popped up. And, man, I come out of that sucker. It popped up, and I got out, but the boat was still leaning really bad. There was still water on the deck, but it got to where I could open the door.

What had happened, the guy's wheel wash—he was seven or eight long. Finally, he started making some stern way, and his wheel wash flushed us out. The only thing that saved us from going under was a tow knee on a barge that caught the second deck. We were leaning the whole time—the same angle as a rake and finally popped us out. The first thing I did was I went around to the stern. The steering was working, and I saw we were okay. It was pretty cold, too. I had been the only person trapped inside. It was pretty bad. I was scared. It almost ended my career. I almost quit that day. We had a tankerman on there named Yazoo Flash. His name was Jay Watford. He was there. It was so bad. The boat was leaning over so much. He had just taken L. C. a bologna sandwich—L. C. loved bologna sandwiches; and it better be some bologna, too; couldn't be no thin stuff. He had just taken him a bologna sandwich, and both the refrigerators fell on him. It happened because Captain L. C. went hard down on the steering. He just turned right in front of that guy. We hit starboard to starboard just like that right there at LeTourneau. Nobody got hurt or killed. The first thing after we got popped up, I saw that the engine room was slap full. I'm talking up to the sniffer valve about four foot above the deck plate. I had my engine room door shut. So first thing I did was I went down there and got the bilge pump going. I was pumping the water out of the engine room. Well, I filled all the fuel tanks up on that side of the boat, so I started losing the engines. It wiped everything off the stern. We had oil drums and everything that had gone off of the boat, off of the bow. We went over and found our barges, and they were over in the trees. We get up there and L. C. is like, "Catch me a capstan line." Mate says, "We ain't got no damn capstan lines. It's gone." "Well, catch my face wires." "We done broke both our face, you know." We couldn't even catch our own barges.

That's the worst thing I have ever been through. That was in maybe 1998. That was the last day, last time that L. C. ever rode a boat.

We had barges everywhere. Man, there's barges all around us. I mean, I thought we had hit a damn fleet. I couldn't tell what we had hit. Then it dawned on me that we hit a northbound tow. That was about the worst accident I have ever been through. There's actually nothing that you can do. I could not get out of my room. I was trapped in there. I thought, man, this is it. I guess once it fills up with water maybe you can get out. You can't swim in the river. I try to tell that story to a lot of people because I worked on boats where you ring the general alarm, and it's like, "Aww, that's the drill. Let's get up." But if I hear a general alarm, any kind of alarm, I get up because I almost died. Now, on the boats we do an alarm drill every time somebody new comes on. I always do my drills at dinner time. That way we always know it's a drill. We are required by the Coast Guard to do a fire drill once a month. We do two or three extras.

JODY LaGRANGE

– b. 1970 –

My name is Jody LaGrange, and I'm from Arnaudville, Louisiana. I started offshore on supply boats in blue water. Then I went to dredge boats. Then I was sent on dredges as an engineer. Back then, I saw one of these towboats pass by going down the river. We were in the ship channel in Houston. I looked at it. I said, "I wonder how that would be to work on that?" So [I] decided to put in an application. I got a job on a towboat, and I've been there since then.

All my family, my uncles, my dad, and everybody worked on dredges or were towboaters. I came from a mariner family. Dad started working on dredges, and he was working on a little push boat that was for T. L. James. My Uncle Henry LaGrange was a captain for the same company, but he was on boats instead of the dredges. My *paran*, which is my dad's brother (a *paran* is my godfather—it's French), he was a captain. So I became interested in the industry. I said, "Well, I want to try it out. It's got to be good. All my uncles are out there." So that's where I wound up. This life is rough. You're away from your family a lot and miss a lot of stuff, but it's a good living, and it's a good career.

I met one guy named Charles Turner. He's the one that actually did a lot of training to cut me

loose in the river. He's a barrel of laughs. He broke me in on the river, he and Mike Lacomb, and Mike Foster also. They're the ones that were on me to go up to the wheelhouse to try it out. We had to get up there and start telling him every mile marker that was coming up. That's how we learned it like the old-school days like they did before all this new technology. Now, new technology is nice, but when it does go out, at least you know where you are, and you know what to do because you're going to have failures on the equipment and anything else you can still run. He broke us in the old way.

I think that people in south Louisiana are better mariners because they grow up on the water. A lot of them were shrimpers when they were younger. Now, I'm not taking anything away from these guys up north. I worked with guys from New York. I was running from Boston to Portland, Maine. I was working in New York, Boston to Portland, Maine and Atlantic Ocean.

Sometimes on the boat I'll speak French. It depends on who I'm talking to. It takes me a while to think about what I need to say in French. But if they're talking on the radio, I can understand what they're telling me. These guys will look at me and

say, "What did he just say?" I said he's speaking French. I can understand it more than I speak it because it's a practice.

This is a good story. We were coming down on Peoria bridge, and it was at night. Captain Andy Lake and I were on there. I was sitting in the wheelhouse with my other engineer then. We were talking. He's showing me stuff about the river and things like that, and we hear the Coast Guard come on the radio and say, "Hey, y'all need to watch this boat that's sitting against the bridge right here." The captain picks up the radio and says, "Yes, sir, we see them." We could see the lights of the boat. So he calls back and says, "Hey, Captain, y'all need to watch this boat that's tied up by the bridge right here, anchored out by the bridge." We're like, "Yeah, Captain, we do see him. He's on our starboard side." He's like, "No, Captain, you don't understand. You need to really put your spotlights on that boat and

see this." So we said, "Oh, okay." We put the spotlights on, and they had about four strippers on a pole that were dancing on there. They had a banner up. It said, "Come and meet your local strip club right here by the Peoria bridge." We were like, well, you know, we can't get off the boat or anything, and we don't want to get in trouble. Hey, it was something you don't see every day.

Around a couple of days before it's time for me to go home—before I go back on the boat; I say home . . . because I'm more visiting at the house than I do on the boat . . . [I say to my wife,] "Well, babe, I'm about to go home." "You are home." Well, yeah, home for two weeks, but my home is on the boat really. You know when holidays would come you would just be down. Everybody's kids are at the house opening presents and you're sitting on the boat. But you can't have it off every year. That's just the way it's got to be.

TIM BENNETT

– b. 1971 –

My name is Tim Bennett. I started in a land job to be a welder's helper with a seagoing company. I worked there for five years on land. I would fly and meet the barges at different locations along the coast, and I'd fly overseas and watch them discharge down in third world countries like Honduras, Guatemala, Panama, Nicaragua, Aruba, Puerto Rico, and Chile.

I had no intention to ever work on the boats. I have a cousin that ran a shore tanking company, and he called me. He said, "I need you to come do some work." I said, "Well, I don't have a tankerman ticket." He said, "Well, can you get one?" I said, "Yeah, I can get one." I went to a place where I used to order fuel, and I called them, and I got a job. They knew who I was from a long time. They said, "You're interested in going in the wheelhouse?" I said, "No, I'm not interested at all." One year from that day, I was in the wheelhouse. I made a few days. When I

got back to the cell phone, I called my wife. I said, "I think I'm going to be a captain." She said, "I thought you didn't want to do that." The guy on the other side of the phone was the relief captain. I said, "If these two idiots I'm on a boat with can do it, I can do it." The guy looked around and said, "I can hear you tell her."

What it takes to be a good captain is good leadership and a good calm head, to have will and determination to do a good job for yourself and whomever you are working for. You are in charge of the boat, you are in charge of the babysitting and helping with their family problems and helping your crew, whatever it takes, especially when you get to know them and are with them for a long time. A good captain tries to stay out of their business, on the one hand. On the other hand, a good captain will try to drop hints to help them out. Yes, it's pretty much captain, engineer, momma, and cook.

RICHARD T. BONDURANT

– b. 1971 –

My name is Richard Bondurant. I'm from Paducah, Kentucky. I was twenty-two when I first started out on the river. I was actually trying to get in the navy and they turned me down because of my knee. When I got back to the recruiter's office, I was kind of mad. I walked across the street to North Star Navigation, which is no longer in business, but the next day I went out and caught the boat. My first trip was thirty days. I enjoyed it especially when I came home and saw my checking account. It was the most money I had ever made up until that time, so I was pretty happy. I get all kinds of interesting people out on this river, different kinds. Some you can't stand to be around; others you love to death. I think my job is better than somebody with an office job because I only work eight months out of the year. I get two weeks off at a time. My biggest downside is being away from my wife and children. I've worked up over the years, and I'm fine. I'm at a place where I'm happy.

I knew a lot of old timers, and a lot of them have passed away. Several of them broke me in, and they were great captains, some of the finest I've ever seen, and God rest their soul, they've moved on. Two of them that really stick out in my mind are Captain Jim Bethel and Jimmy Parnell. They were heavy-tow pilots.

They could run anything anywhere anytime, and that's what I wanted to be. I wanted to have that skill. They showed me all that stuff, high water, low water, and what to do. Then a lot of it I had to learn on my own because you can only teach a person so much. Of course, back then, it was a lot different from today. All we had was a chart and a radar, and that's it. If you had a sounder, a depth finder, you thought that was luxury. Now we have electronic navigation. I like it, but I use it as an aid. I don't rely on it.

We stay in pretty good communication with each other out here on the river. If somebody spots a canoer or kayaker, we give everybody the heads up and keep a track on them. They think that we can just stop on a dime. I had all kinds of bass fishermen out there, and they would not move. I had to call out the water patrol to come out there and move them. My deckhands were out there on the head of the tow trying to get them to move, and they said some nasty remarks to us.

As far as recommending this career to a young guy, I'd I try to push them for college if it was somebody I know. It all depends on who they are, and

what I think of them. It's not a weak man's game. You have to have some body strength. You have to sweat and freeze and be willing to get down and dirty.

A lot of people don't realize how much tonnage and product and what kind of product we move and that we are much more efficient than trucks. They don't have a concept of it. They don't understand it.

I take a great amount of pride in my job and where I work.

Since 9–11 things on the river have changed a lot. More stuff is required of us like security drills and the TWIC card. You have to be on your toes. But the likelihood of a terrorist getting on a tow boat is slim to none.

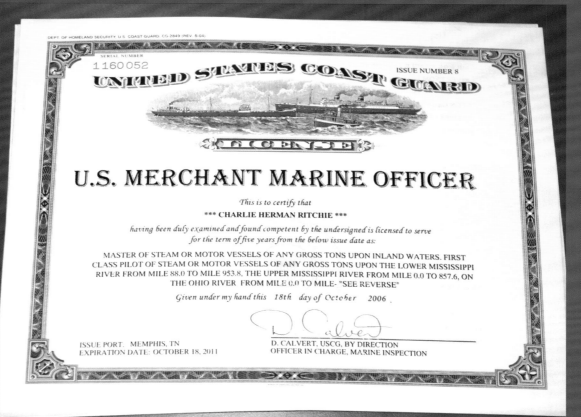

SERIAL NUMBER
1160052

ISSUE NUMBER 8

UNITED STATES COAST GUARD

LICENSE

U.S. MERCHANT MARINE OFFICER

This is to certify that

*** CHARLIE HERMAN RITCHIE ***

having been duly examined and found competent by the undersigned is licensed to serve
for the term of five years from the below issue date as:

MASTER OF STEAM OR MOTOR VESSELS OF ANY GROSS TONS UPON INLAND WATERS. FIRST
CLASS PILOT OF STEAM OR MOTOR VESSELS OF ANY GROSS TONS UPON THE LOWER MISSISSIPPI
RIVER FROM MILE 88.0 TO MILE 953.8, THE UPPER MISSISSIPPI RIVER FROM MILE 0.0 TO 857.6, ON
THE OHIO RIVER FROM MILE 0.0 TO MILE- "SEE REVERSE"

Given under my hand this 18th day of October 2006 .

D. Calvert

ISSUE PORT. MEMPHIS, TN
EXPIRATION DATE: OCTOBER 18, 2011

D. CALVERT, USCG, BY DIRECTION
OFFICER IN CHARGE, MARINE INSPECTION

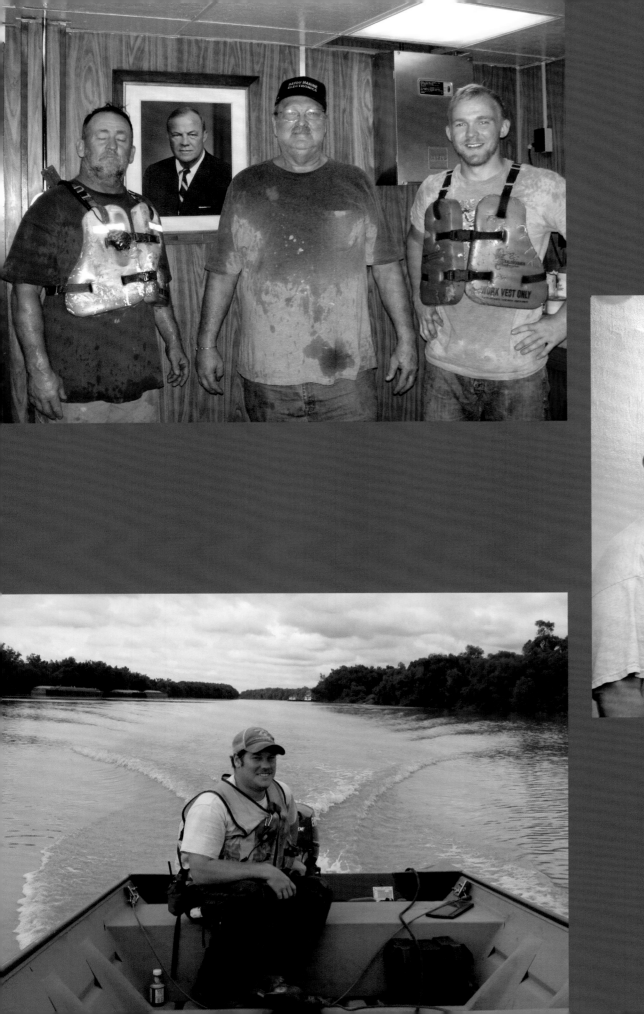

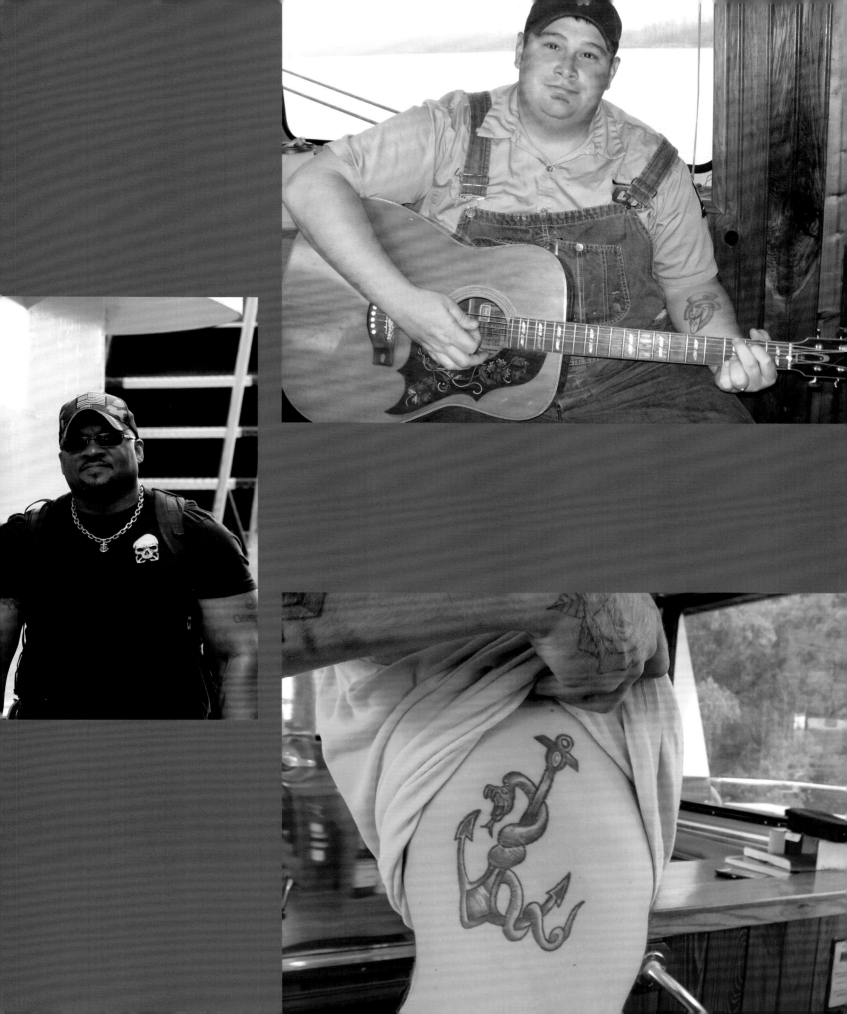

BOYCE "PETE" STUCKEY

– b. 1972 –

My name is Pete Stuckey. I grew up in Arkansas. My next-door neighbor when I was growing up was a riverboat captain. It just kind of went from there, I guess. Probably the first day I stepped on the boat was when I decided to make a career out here. It's pretty much home for me. I was looking for a home I guess. I was young and fairly uneducated. I left school when I was sixteen years old, so it was either the river life or farming. Farming just wasn't working out. I was nineteen when I came out. I did leave the river for a few months, and when I got married. I thought I would try the home life, but I found it was best and to keep from starving to death to work out here.

The Corps of Engineers is a vital part of this industry, in my opinion. They keep the water flowing, you might say, they keep the barges where the barges can float. When I got my license though, they didn't have a steersman program like they do now. Now you have to have so many hours, get so many days in to get your license. Then you have to do the steersman process. You get a steersman, apprentice mate and then a mate and then a license then a master's license. When I got my license, we didn't have that. You got a license. If somebody wanted to train you, then you got trained. If somebody didn't

want to train you, then you figured it out on your own, or you tore up a lot of stuff trying. Nowadays it's a lot different and lot better than what it was.

Back in '98 we had a radar and a swing indicator, and that was it. When we got our first GPS on the boat, we bought it ourselves. It was a handheld Magellan GPS. All it showed was the speed you were going.

When I started out here, all we had was a radar. I worked everything from a twelve-hundred-horsepower boat to a fifty-six-hundred-horsepower boat, and when I started out here, we had a radar that was fit for a yacht. It wasn't even meant to be on a boat, I don't think. I never seen one that small since I left there, and we had a swing indicator. Now, with all the charting systems and the camera systems and the GPSs that are just on the mark that they tell you everything that you need to know, it's unreal. I don't know that we can go back to the old way of doing things. Just trying to keep up with the technology is pretty challenging. Even the traffic system. I remember back when I first started riding the boat, we'd just gotten rid of the sideband radios and went to cell phones. When I first started riding the boat, we did all the traffic at eight o'clock

in the morning on a cell phone calling the office to beat the boat. Nowadays you have a fax, and you can fax the logs in if you get a signal. It automatically updates itself every three hours and tells them where you are.

Even the charting system, it can go back and backtrack where we've been and show me exactly where I went and where I went wrong or what went wrong. So technology is a great thing. It tells on you sometimes but it's a great thing. If you do right, I guess it isn't a problem.

The charting system, back when I first started riding, the boat didn't have all this. To meet a boat, just say back in Victoria Bend, you had to determine who was coming by radio. You didn't have anything to show you that there was a boat coming. You didn't have anything but a paper chart. You got good at math real quick. Nowadays you can watch the track line and the other boat coming at you. That's what they call a CPA—it's a center point of arrival. It tells exactly within feet of where those two vessels will meet.

Technology is a great thing for the industry. It has made it a lot easier on training wheelman. It's made it a lot easier on learning as a wheelman. You can set up your ETAs on your computer, and it will tell you down to an exact minute at what time you are going to arrive at a certain point. It makes it a lot easier for us as wheelmen on figuring ETAs and dock times and crew changes, most importantly. Technology surprised most of us. I guess you would say it's more than beyond what it used to be.

For a person that works twelve hours a day at a land job seven days a week, that would be horrifying to me. I don't think I could ever do that. But to live three minutes from your office and work twelve hours a day, it's really not that bad. It's not that tiresome. You work six hours on, six hours off. You basically sleep three minutes from where you work or less. You sleep three minutes from where you eat or less. It takes an acquired taste I've noticed over the years of all the people that's come and gone. It's not for everyone. It's great for me. I've enjoyed my career out here. I enjoy being gone. I enjoy seeing different places. You can't wake up and see the sun set over the river at home every day.

You know what they say. The river gets in your blood. It must be in mine because I can't find anything else to do. I don't plan on quitting any time soon. My wife doesn't plan on me quitting any time soon. Working on the river, it's different. It takes an acquired taste, but it pays the bills, I always say. It's put one kid through college and supported me for twenty years. So I'm happy with it.

GUSTAVE ANTHONY "BUTCH" MARIE III

– b. 1973 –

My name is Gustave Anthony Marie III. How I got on the river is, I needed a job, to tell you the truth. I grew up in Chauvin, Louisiana. It means "hot wine" in French. It is south of Houma. I grew up on the water, oyster fishing, shrimping, charter fishing. All of that. I've been on the water all of my life.

Life on the river is something you grow to love, but it's something that's hard on your family. I can still remember when my boys were little bitty, and I was leaving to go to work with my bags, and they'd be holding onto my legs and I'd be dragging them, and they are like, "Daddy, don't go," and that was tough. I missed their first steps. I wasn't there.

Once, I got caught in a tornado between the St. Louis bridges with eight empties. I was northbound coming up below Eads Bridge. It got pitch black, and my wind gauge pegged out, and I couldn't see anything. I was like, "Oh my God." But we did have the computer chart on there, so I was looking in the computer chart to see where I was in reference to the river. I tried to steer as close to the middle as I could, but it was trying to throw me under that casino in the bend. It lasted maybe thirty seconds, but it seemed like days. When I came out of it, I was almost sideways in the river pointed towards the arch. I had to start over, hook it up, and then spin back around. I went under the bridges, and it was one of those moments. It was in a congested area where if you touch anything you're probably in trouble. It took me and cocked me sideways, but it was so strong that the river wasn't pushing me down. It was pushing me towards that casino. I was watching for the second when I could see the head of that tow or even any of the tow because I couldn't see any of the tow. As soon as I saw where I was, and it was over, I hooked up, and I lined up on that bridge.

We have had some times. I remember a lot of days and nights busting ice on that Illinois River, north and southbound six packs, (six barge tows). The coldest temperature I've experienced was like forty below—that's the wind chill, but it was probably like thirteen, fourteen below regular temperature. It was cold. That's when you're in the wheelhouse and you have six heaters around you. You have the central heater going, fully decked out in winter clothes, snow boots on, with a blanket on driving the boat. It gets so cold up there.

I'd have to say the most interesting character out on the river for me was my first captain. His name was Ricky Foulgut. He is the one that broke

me in. Oh, he was mean. He just talked to us like dirt. Nobody could ever do anything good enough for him. I saw him put one guy off on the bank in the middle of nowhere. He said, "You're fired. Get your bags. Get off." He put the tow on the bank, and put that guy off, and then took off, in the middle of nowhere. We didn't have cell phones then. We didn't have computers on the boat. The guy smarted off to him, I guess. You couldn't talk back to him at all. He was real mean, but I learned a lot about piloting. He did teach me some good things. He was a good towboater and could run the boat good, but he taught me how not to treat people. I think about that every time. Every time somebody gets me mad on a boat, I'm like, "Nope, I ain't doing a Ricky Foulgut on them," you know. "Ain't doing it."

MITCHELL SCOTT COULTER

– b. 1974 –

My name is Mitchell Coulter. I started with Ole Man River in November of '93. I rode seventy-three days my first hitch because I needed the money. I thought then that I was making a pocket full of money.

I have been out on the river since I was five years old with my dad and my grandpa. They used to commercial fish. Captain Ted told me that I was a natural at it because I already understood how the currents of the river worked. I was running the outboard when I was only eight years old for them in the current.

Some of those eddies you have to watch if you're out there in a skiff. We had one, one time. We were running across the river. It was low water there at Cottonwood Chute in '88. I think I was fourteen years old and we were coming across the river in our flat bottom boat there and hit a whirlpool. My dad was driving. We hit a whirlpool, and it actually turned our boat in a 360. My dad had to drive around the circle and finally drive out of the whirlpool it was so big. It was turning the whole boat. Those eddies, they can be really huge, especially when the water gets low, and when all that current funnels down into a narrow channel. They'll start working real hard.

These boats now, everything is electronic. If you lose a generator, you pretty much have lost everything.

I got my license in 1998. I didn't even have a cell phone then. We didn't even have a digital chart system. All we had was the normal navigation equipment, a radar, and a swing meter. We had a little ole AIS GPS thing. But it wasn't until probably 2000, 2001 before we got the CAPN Voyager digital chart system. I learned where I ran by paper charts. I have got a set of hand-drawn maps myself. I got them from Johnny Walker, and I have them downloaded on my computer, my laptop. They have some good information, which I've transferred over to my uptodate charts, paper charts, and river charts, but they're so old. Those charts are pretty much out of date. I just have them as memorabilia.

I see some of the old timers on those big tows that run up and down the river all the time. They still run those backwater chutes over all those dikes and everything. They run places that I'm not taking a red-flag tow. They take those grain barges, and the next thing you know, you can't even see them. They're over there behind the trees and behind an island. And then, next thing you know, they pop out way up the river. They just have passed down information and experience, about a high river. They're taking shortcuts. I've seen them run places that I just never would have thought to run.

JOHN HALL

– b. 1974 –

My name is John Hall. I am from a little town in Arkansas. About six to eight months after I started on the river, I knew I was going to make a career out here. I started off as a mechanic on the river. I was chasing boats. I would just go wherever they broke down. It wasn't long after that I decided I wanted a career in the wheelhouse, so I went to river school in Memphis, Tennessee.

I've been on the Lower Mississippi and the Upper Mississippi, where I trained and got cut loose. I've run from mile 173 on the Lower to Pine Bend, which is mile 823. It's just a short distance below St. Paul, Minnesota. Sometimes we turned up the Illinois and went to as high as Seneca, which is Mile 253. That's where I got most of my experience. I've got my experience on the Ohio River, Illinois, Cumberland, Arkansas, Verdigris. I don't really have a favorite. When they're all raging, none of them are any fun. But sometimes when they're high they're easier.

I've seen sunsets on the Ohio that were worth taking pictures of or painting. And coming through St. Louis during those sunsets or sunrises, they're great. I think the Arkansas River is something to see. Everybody ought to see it, especially where it goes up through the Crowley's Ridge area. It's just a huge land—it's the hill part of Arkansas. The water is clear up there.

I would say it's a way of life out on the river. You're going to spend more time on the river in a job like what we do than you are at home. Sometimes the days are long; sometimes they're short. Sometimes trips go by easy; sometimes they're very long. The old saying is, if you stay long enough to wear out a pair of boots, you're there forever. It's something that you and your family have to really adjust to. I was married ten years before I decided to come to the river. We celebrated our tenth anniversary while I was in Mobile, Alabama, and she was in Arkansas. Me being on the river was a harsh adjustment for my wife and me. But we've made it work.

You don't have to have a high education sometimes to come out. Just some hard work and some good studying will get you a wage that most college students can't match. It's a different type education. It's a different way of life. You're joining a culture of people that's got generations in this, generations and generations and generations. The wages, they'll make you stay out here.

JASON PAUL JONES

– b. 1974 –

My name is Jason Jones. I've been in the towing industry since 1999. I said to myself, "Well, if I'm going to do it, I might as well go all out, go to the top." I will do this for the rest of my life. The river is always going to be there.

The hardest thing about working on the river is just being gone from your family, the birthdays, the holidays. My time home, if we go somewhere, we go on vacation. But the rest of the time, I'm with my wife and kids, and we're together.

It's another world out on the river. It gives back more than it takes. It provides for so many families.

Most people in America don't they don't know we exist.

On that boat, I have to assume the father figure. I've heard some stories. I've been to a lot of family emergencies. But some grandmothers have died seven times because the deckhands want to get off. It's hard to describe the feelings that you have for home and for the boat because both of them are home. I love my crew, and I love my home. You just have to learn how to delegate both at the same time. I don't see how a lot of people do it, to just go to a job they hate. I've never regretted one moment working on the river.

NON-SMOKING
AREA

BRETT H. SHANNON

– b. 1975 –

My name is Brett H. Shannon, and I'm from San Antonio, Texas. When I first got started, I did not know that I was going to make a career on the river. I thought it was just going to be a summer job for a nineteen-year-old kid and make a little money and be able to save a little money and maybe have a neat experience. I got my tankerman's license in '95. In 2000, I decided that I think this is what I want to do, be on the river. At that point, I was still decking. Probably not until 2007 did I realize I wanted to make it up to the wheelhouse. Once you do that, then this is going to be your career. When you start making that kind of money your options are much more limited because nobody really wants to back off their money.

It's very regimented, what we do. What I've always done is worked red-flag barges. I explained to people that if it wasn't for my industry, when you went to fill up your gas tank, gas wouldn't come out. People that live up north and have heating oil systems in their home, this is how heating oil is moved. Any kind of a petroleum derivative is moved by the water, and farming stuff and grain. If it wasn't for me and my coworkers, gasoline wouldn't get delivered.

I have one story in particular that I want to tell. In March 2013 we were in Wood River, Illinois, at the Valero Refinery loading two barges. It was a windy day, and the river was pretty high. I went out to check on my tankerman from the boat to the barges, which are part of my duties. There's lot of drift on the river, which there generally is when the river comes up because trees, all kinds of stuff, drift, it's coming down. It's being washed down the river, so you don't pay much attention to it. It was heavy that day. So I went out. We had our conversation, and we were walking from the barges back to the boat. I was getting on the boat and my tankerman looked, and we both saw it at the same time something out of place. It was blue. And we saw movement. And then we're really focused because something was going on. The current was bringing this object to us. It wasn't long before we realized it was a little boy. So we just went into action. I called to him and he answered me. We already had our lifejackets on. We grabbed the lifeline, and the current brought him real close to the boat, and I yelled at him. I said, "Buddy, I'm going to throw you this line. And when I throw it to you, you grab it." And he did. His little hand came up and grabbed it. The water

temperature was probably forty-eight degrees, so he was hypothermic. He was a pretty big kid even though he was ten years old. We both grabbed him and picked him up on the boat and called the refinery. They had their own internal paramedics, and they came down to the boat. Then the local fire and rescue was notified, and the river was shut down and a search began for two other people that were on the boat he had been on. Come to find out, his stepdad and either his stepdad's best friend or a family friend, the boat capsized while they were fishing, and neither one of them had their lifejackets on. They both drowned, and the little boy's lifejacket saved his life. There are a million reasons why we should have never even seen him. It was really, really special because that boy's mom lost her husband that day, but she came down to the boat, and we were able to see her get her child back, basically retrieved from the jaws of death because his lifejacket wasn't going to last much longer. His body temperature was taken about twenty minutes after we got him out of the water, and his core temperature was eighty-nine degrees. We immediately got him out of his wet clothes and wrapped him in blankets, and we rubbed him down and tried to get him warm. He was in bad shape. It was a very emotional experience, but it was a special deal because the little boy lived.

When it happened and when we first saw him, our adrenaline just kicked in, and then our training kicked in. I just thought, I'm going to have one chance with the lifeline. My backup plan was I'm going to jump in the river and grab him and then hopefully my tankerman will be able to get me the second lifeline. That little boy wasn't going to pass us by, I'll put it that way, because I knew if he made it to the end of our tow that he couldn't swim. He

could barely grab that line. He had floated about two and a half miles downriver already. He couldn't hardly even talk when we got him out of the river. It had to be outside intervention because you can't just chalk it up to luck.

That is not a recreational river. Lots of people that go into it don't come out of it. People don't realize the danger of the river. They have absolutely no idea. When we see recreational craft out on the river, it heightens your sense of awareness and makes you pretty damn nervous sometimes. People die out there on the river. Towboaters are on the river twenty-four hours a day, 7 days a week, 365 days a year. The river is a dangerous place. You have to have a respect for it.

When I first came out on the river, I didn't mind being away from home really because I was nineteen. It was kind of an adventure. I was a kid in a world of men. So all of a sudden, I was a man just by association.

I tell people at home, "Imagine going into your living room and your bedroom with a bathroom and closing the door and not leaving for twenty-eight days with people from the most diverse background you can think of, be it culturally, economically, it's just diversity." So, first of all, you have to have fortitude to get through that time of being away from home. Then you have to be able to manage and deal with five, six, seven, eight different personalities in a very confined area. So it can be challenging. When you get the same crew on board every time, they become like a family. They are your family because you're with them just as much as you are with your family at home and in some guy's cases even more so. I love my career, and I love what I do. Your goal in a career is to enjoy what you do for a living. To me, that's the definition of success.

JEREMY BRISTER

– b. 1977 –

My name is Jeremy Brister. I'm from Vicksburg, Mississippi. In my career, I've seen a few things. I got promoted to relief captain. It was during a crew change in the morning. I got on the boat and had been on the boat for twenty minutes. I was in the bunk room unpacking my stuff. All of a sudden, the general alarm goes off, and I ran up to the wheelhouse and stood at the console. We had probably ten barges in tow and another company boat. I look up, and there's a ship, and it is broadside. It hit the tow. It broke the face wire, and the captain was just sitting there watching what was going on. I told him to back down real hard, so he could break the other face wire because I didn't want to be attached to this stuff.

We were about mile 180 on the Lower Mississippi River. What happened was, we started around the point, and a ship went up in the bend, and there is a strong eddy in the bend. The eddy caught him. The bow of his ship hit the oncoming current, and he just made a big U-turn. As we're coming around the point, we were running right there in the middle of it. We went from five miles an hour to a dead stop sideways, and the barges were rolling. They were loaded barges of coal. One deckhand got knocked in the barge in the coal. When the barge slipped upside down, he didn't want to drown, and he tried to break his own neck, but he didn't have the strength to do it. Luckily for him, he couldn't break his own neck. The barge kept rolling, and he popped back up. He came up on top of the barge, and he blew out a bunch of coal, and he lived. One guy made it to the boat. He jumped on the boat. One guy dove and landed on the side of the boat. The other guy was running behind him, and he jumped, but he didn't make it. The barge was rolling, and he kind of got thrown off the barge into the water.

By this time, barges are going everywhere, sinking, flipping, and I'm just watching everything. The boat ran right underneath the point in the eddy. Nobody died. The ship was a large container ship that runs to Baton Rouge. It really wasn't anyone's fault. It was a freak accident. Just a bad area. Ever since then, I keep my life jacket in the wheelhouse. No matter what, I know where my life jacket is.

I knew that I wanted to be in the pilot house. I definitely didn't want to be a deckhand forever. Every time it rained, as I was sitting there soaking wet, I was like, "Man, I got to go to school. I got to get out of this." I had been there about two years

when I got my license. It takes certain people for this kind of life. Not everybody can stay out here and stay away from home. As a matter of fact, after about my first month on the river, I quit. I was like, "This ain't for me." I came back to Vicksburg and tried roofing for a week, but I don't like heights. I said, "This ain't going to work either." So I went back to the river and stayed. Over the years, I just kind of got used to it.

M. SAGE COLE

– b. 1977 –

My name is Sage Cole, and you spell it just like the spice. I got on the river by accident really. My dad was a towboat pilot. I went to this little bitty towboat company in Mobile. I went in, and I said, "Hey, I'd like to get on a boat." The port captain is this real salty, just a crotchety old man that turned out to be one of the best people I've ever met in my life. But he said, "Son, you know that this is not just a job. I mean, you can't just go home after you do this." I was committed to this career from day one.

It wasn't long before I realized I wanted to be in the pilot house. My dad wasn't happy with my career change at all. He wrote me a letter and left it at the Coffeeville Lock. I still have it. That's how we used to communicate back and forth before we had cell phones. He left me a letter at Coffeeville Lock. Basically, it said "I think you made a mistake. This is not the kind of career that you want, and I think you're going to regret the decision you made." Of course, I didn't leave him a response letter because it made me mad. Then shortly after I had been on the boat for six or eight months, there was another letter left at Coffeeville Lock for me. It was a total retraction of the first letter. He said, "You know what, I was wrong because you've taken up to this,

and you've started to progress, and you seem to enjoy it. So, I apologize for sending you that letter."

I started in May 2000. I tested for my wheelhouse license in April 2002. It took me two years to get into the wheelhouse as a cut-loose pilot from a green deckhand. That was back then. You can't do that now. Billy Fields is the captain that broke me in. Back then, I think he was probably fifty-eight years old in 2000. He was one of the most patient men I have ever known and became more of a father figure to me than my dad was at the time. I was always super thankful that he saw something in me to take me under his wing and say, "Hey, here's my boat. Let's run this thing together."

I don't think we got a GPS on the boat till 2006. At the same time, we got a swing meter on the boat. So we were sitting in high cotton when that happened for lack of a better word. We didn't know what to do. They put a depth sounder on the boat. So that was a big to-do as well. Billy Fields taught me how to look for sandbars and how to look at characteristics on the river to tell where the deep water was and where it wasn't. He'd just give me characteristics of the bank that give pretty solid indicators that there's good water there, and you

can run. He also let you mess up every chance he got if it wouldn't damage anything. I'd look at him and say, "Man, why did you let me do that?" He was a firm believer that you had to fail to learn. He can show you the right way to do it, and you can do it the right way.

When I first started, we had no electronic charts, no depth finders, no swing meters. GPS was nothing. We didn't have any of that. In a hundred years mariners they'll be like, "Man, what is a swing meter? You looked through binoculars, and you used a compass? What are you talking about?" It makes you more appreciative of what you have now compared to not having it when I first started working on the river. It teaches you a whole different way to navigate as opposed to before. You can look over at a computer screen and know exactly where you are, how fast you're going, where that dude that's coming down that river you're going to meet him, how fast he's going. We didn't have that before. We had to do math. Believe me before this Rose Point, lying about your position on a towboat was rampant because nobody wanted to stop. You can't lie as much as you could. The technology takes a lot of

the human error out of it. It's two different worlds. I'm thankful for the new way. I'm not going to lie to you. I like being able to know where that guy is and where he's going and where I'm going to meet him. But I can handle it all day if the electronic should go out because I've done it. That's a skill I try to teach the guys that come up in the wheelhouse. We make them run without that electronic chart. We make them work those ETAs. Turn that computer off and use this chart and tell me where you're going to meet this boat. It makes our guys stronger. You turn the computer back on, and their face goes right back into the computer. But at least they have that stuck in the back of their head somewhere. It's a skill and a discipline that really needs to be taught to the people in the wheelhouse that come up from the deck up.

I love the river though. I wouldn't do anything else ever. I couldn't imagine not being on a boat. It's a job like no other. It becomes who you are. I don't think I'll ever retire fully. Boat captains retire and then they come back and just get a taste of it for a week or two and then go back home for a couple of months. I've never seen a boat captain retire.

J. R. MILLER

– b. 1977 –

My name is J. R. Miller. I am originally from Oak Dale, Louisiana. It took me about ten years working on boats to make captain. It's what you always aspire to be, once you get on the boat looking at the captain. When you start out, you don't even know if you're going to make it past one trip, but eventually you start thinking about it and then one day it becomes reality. It's what you want to be. You want to be "The Man."

I worked for one particular captain. His name was Roland LeBlanc. I started under him as a deckhand. All the way from deckhand to pilot, he's the only person I ever worked under, only person I ever threw a line for. He set an example of how to be everything. He was hard, but he was kind. He just was such a big influence. Everybody that ever stayed with him, they used to say he couldn't keep a deckhand. But every deckhand that's ever been with him is already a captain now, every one of us. So, we're like a little club. He inspired me to become a captain. I wanted to be where he was. I wanted to sit in his chair. I wanted to be the boss.

We see things that other people don't see. We appreciate things that other people don't. They take it for granted. This is our way of life. To me, the river and the water in general in this country is the greatest resource we have.

One story that comes to mind is once I picked a dead guy up out of the water somewhere around Greenville. I actually went to school to be a mortician. I remember the general alarm going off one morning on the boat. They were looking for a mate off a line boat somewhere above Greenville. I remember it being as cold as hell. But the captain said, "Wake Junior up. He ain't scared of no dead person." They said, "Well, you don't know if he's going to be dead or alive." He woke me up. He told them, "He ain't scared of him." And I remember going and getting that guy and holding onto him. I couldn't get him in the skiff. He still had his radio on and his life jacket; everything was on him. He had fallen off a boat. I didn't see anything that would have made me think something happened to him. He just apparently fell off. He looked like he was just resting. I remember holding onto him until we got him on the back of another boat, kind of taking care of him. I was making sure that nothing happened until the Coast Guard got there.

The road from being a deckhand to a captain, it's kind of like being the last kid in the line at school or being the least guy on the ball team or the last one

to bat or even like I said being the last one picked in the game. Then once you make it to being captain, it's like you are the star player then. All eyes and everyone is on you. All the decisions that you make, they're all on you. I recall my dad saying to someone one time when they asked him what I did. He said, "Well," he said, "you know, my son could have been a lawyer. He could have been a doctor. He could have been the garbage man. He could have changed your cable." He said all those are good jobs, but, he said, "My son does something that none of you guys can do," you know. So that's pretty cool.

When you get on the boat, you like to keep your same crew. You definitely want the same people with you. They are your family when you're on the river. I spend more time with my crew than I do with my own family. We celebrate Christmas together. Holidays we cook. We do everything that a regular family does. I tell guys this, "We are like family. Even though it's business and there's a line with rules and regulations and just in our job duties, you are like family."

ERIC STERN

– b. 1977 –

My name is Eric Stern. I started on the water in July of 2005 as a green deckhand. I had never even seen a towboat before, not even the ones going down the river. I had no boat experience prior to this. I actually thought it was really cool because of the size of the boat, and, of course, the first placed I walked into was the engine room. I love diesel engines. I love anything that has an engine in it. I wanted to see what made this big boat move.

Joe, the wheelman that trained me, had this saying that any time we were going around a hard bend, he always called it a compound bilateral power slide. Kind of like drifting. And it was anytime he used that we knew that we were sliding faster than we were coming ahead. I've caught myself using the same saying on the radio, especially if I'm southbound on the river, and I'm sliding pretty good because the river is up. I'll say, "Yeah, I'm coming down, compound bilateral power slide because I'm sliding seven and a half miles an hour sideways and only coming ahead three."

But me and Joe had many occasions whereas Joe called it putting the Josephus on it. Coming through West Port Arthur Bridge, forty-five-mile-an-hour wind getting caught in the gust and putting the Josephus on it. You put a point on it until you can't set it any more. Put it on the dash, and you hold it until you're sweating. Then you give it a few more minutes and then steer off of it. Having empties in wind like that is like flying a kite that you almost have no control over. You're basically pushing small sky scrapers laying down. And they're big sails. Our barges are 297 foot long. If you were to take our barges standing on end, they would not fit under any bridge in America. And it usually is as tall as the uprights, the main supports for the bridges. So you're moving around with skyscrapers. When you have three barges in the canal with 114foot boat, you're not far from pushing almost a quarter mile long. And that's a lot of weight and a lot of length.

What it takes to be a good river man is the ability to listen because there's always going to be someone that knows something more about an area or a trick. If you're not sure ask because there's so much experience on the river out there. And there's so many people willing to help. When people teach you things, listen to them. Pay attention because a lot of these older guys are getting ready to retire. That's a lot of river knowledge that's going to go with them. You still got some old crabby towboaters out there.

But the ones that do want to pass it along, I think it's important that we listen to them and try to keep some love of information, so we can pass it down and kind of keep some of that stuff alive. The industry's changing, but it still takes good listening and common sense to run a towboat. Because the canal doesn't hardly change. The water levels change. You get new docks, new little cuts here and there. But for the most part, the ICW stays the same, but the river changes constantly.

I'm glad I made this career choice. It's an adventure. I get to see something different every day. I get to work with amazing people. I get to meet some very crazy people. It has allowed me the ability to provide for my family in a way I wouldn't have been able to because I'm a high school dropout. I did go to tech school, and I do have some college education. I have my GED, but I would have never been able to give my son and my wife the things that they can have, the luxuries they can have, without this industry. That makes me feel proud as a husband and a father.

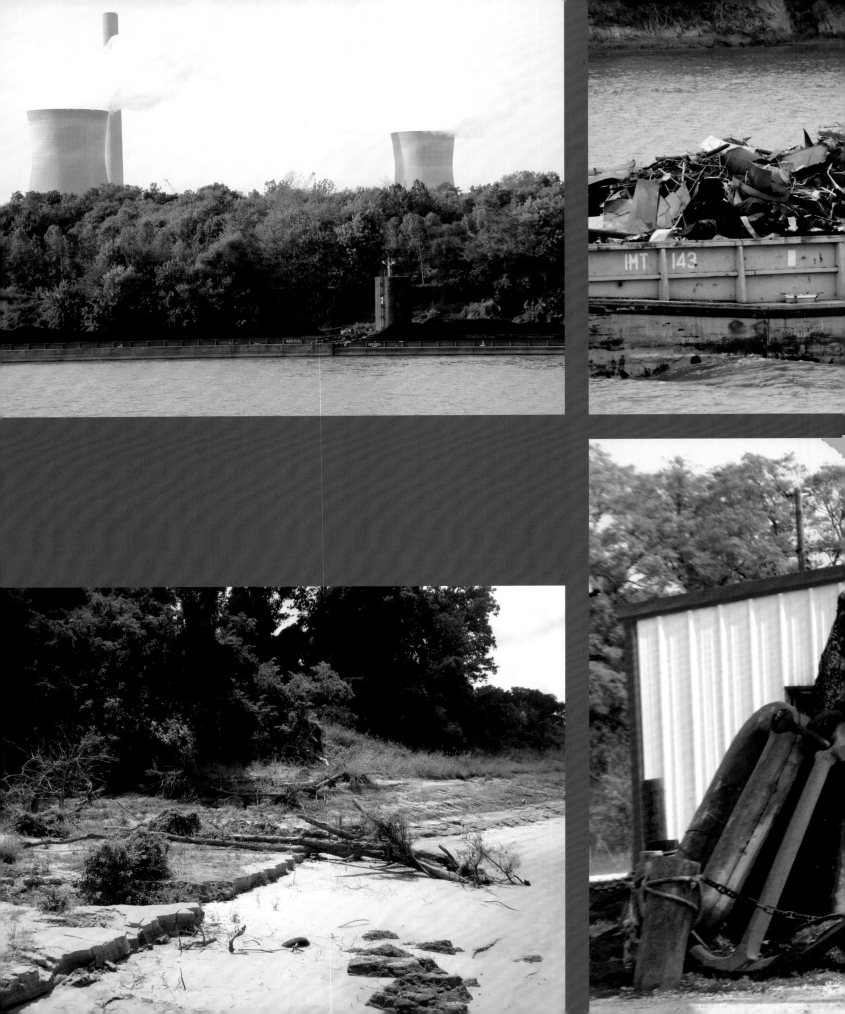

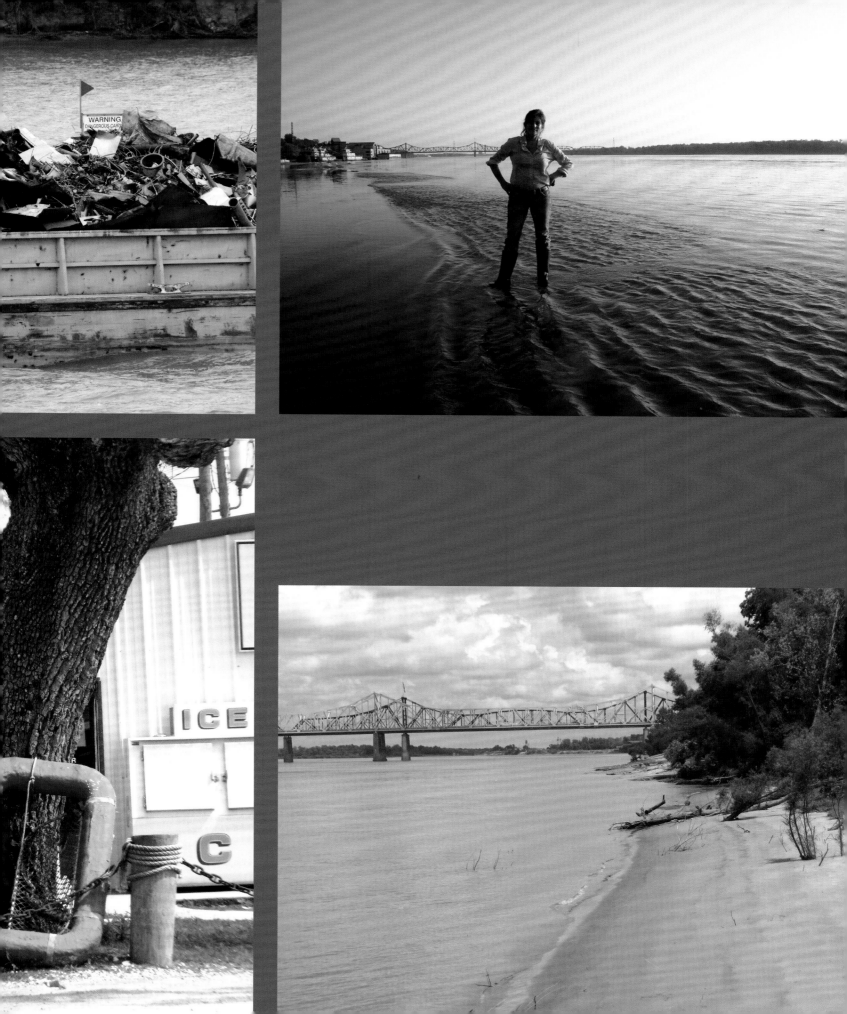

JEFFREY ORR

– b. 1979 –

My name is Jeffrey Orr. I've been working on the river since '97. I've pretty much been on just about every river I think you can go on. I spent forty-five days on the boat with one guy. He and I were the only two on deck and a captain in the wheelhouse. I was a deckhand at the time, and it was my fourth trip out. We were shuffling rock barges back and forth building the dikes at Lake Providence. We were putting our last barge in tow for a northbound boat to take empty barges. We had one ratchet left to snatch up to tighten the wire up to have the tow done, then we were going to break for lunch. When we snatched that ratchet, the keeper come off the pelican hook. I hit the deck, and the other deckhand fell overboard. Before we could get him, he went under four barges and had drowned. We had twenty-five barges floating around in the river trying to get to him. I had been on the boat forty-five straight days, and I was just eighteen years old. The only person I could think of to call and talk to was my grandmother. I grew up around her and all. She is a real religious lady. And so, I said, "Well, I'll call her to see what her advice is," because in my head after it happened, all I could think of was, I'm glad it wasn't me. I felt like I was a bad person for that.

So, I called her and was talking to her. She said "No, you are not a bad person. Any normal human being would think that." It was just such a bad ordeal.

I went home for two weeks after that happened, and then I came back to the boat and worked thirty more days, and then I quit. It wasn't the same on the boat. Every step you took you were worried. So I decided to quit and found out the hard way that towboaters, when you start and get in it, you can't work at home any more. There's no way to adjust back to working on land. I tried. I had made up my mind that that wasn't going to be me on a towboat and get killed, but you can't make it on land after you've been on a boat. It's just a completely different way of life, and nothing on land is anything like it.

I knew an old man, he said, "You wear out a pair of boots, you'll be out there." So, in my mind, I've never wore a pair of boots out. I'll buy a new pair before they get worn out. I met him on a boat my last trip, and he said, "See, I told you if you'd wear a pair of boots out you'd be out there." I said, "I never wore a pair out. I just buy a new pair." He said, "Counts the same. No difference." So, I mean, I thought I had it in my head that I'm just going to ride boats for now, and then I'll find something else to do.

I guess about my third year on boats I decided to stay out here. After about two years, I was way up north on the Ohio. There was probably three feet of snow on the barge. I'm sitting out there as a tanker-man on it looking up in the wheelhouse, and the captain is sitting up there with a short-sleeved shirt on eating a sandwich, and I'm out on this barge shaking in the snow. And I said, "Well, that's where I need to be. I need to get out of this weather." So that's when I probably made up my mind.

BRAD JUNEAU

– b. 1980 –

My name is Brad Juneau. Both of my grandfathers were in the navy. And when they came out of the navy, one of them was a stevedore down in the New Orleans harbor. The other one went to work at a big shipyard. From there, my father and my uncle both started working down there in Pilot Town on crew boats running pilots out to the sea buoy for ships. My dad was a towboat captain. He's still on the river till this day, and I watched what he did. I just wanted to be like him. My first time out on the river was when I was in a car seat. My first time working was right out of high school, 1998.

My earliest memory of the water is when we used to go pick my dad up from work. I might have been four or five. When I was twelve, I was going out with my dad. The kind of boat I was working on was about a thirty-two-foot crew boat running pilots out to the ships.

We see dolphins. Sometimes, in certain times in the year, the phosphorous is in the water. It's like you're going across a sea of glow sticks. And you look at your wheel wash, and it's glowing green. Sometimes when the moon comes, it's red. It looks like a fireball coming out of the Gulf. There are all kind of pretty sights. But we see sea gulls, porpoises, crabs, pogies, which are little bitty minnows that they catch. You see pods and pods of them. It's a fish. They're pogy boats that go around in circles with giant nets, and that's how I know they're called pogies. When we're out there, there are a lot of other mariners out there but on different kinds of vessels. We see shrimp boats, a lot of trawlers, a lot of recreational fisherman, the pogy boats, lot of ships when we pass the Gulfport Ship Channel.

I try to make it like Christmas every time I'm home, so it's nice to know I can get them everything they want because of this job. My son is five. My little girl is seven. They know what Daddy does. And now with the FaceTime and texting—well, FaceTime is awesome. You know, I get to see them every morning. Back in the day when I first started, there were no cell phones. If you got to the dock, you hoped that they had a pay phone, and you hoped that nobody else was on that pay phone because nine times out of ten they were going to be there the whole time. When you got to a lock, you would climb up the wall like a raccoon and go look for the pay phone. It's definitely gotten better. Modern technology is awesome. When cell phones first came out, if you weren't

next to the city, you couldn't talk to anybody. Now it's anywhere any time.

When I first started out, we were just getting the plotter computer screens. When we typed in logs, it was a Qualcomm box, and it had a little bitty screen on it, and you had to type all your logs. God, it was a pain in the butt. But it seems like every six months to a year we would get something else helpful. It just keeps getting better and better. It's just making our job a lot easier and safer and much more accurate.

My captains made me learn. They taught me about reading water and all that and being able to tell what the current is doing and what the tide is doing. They also showed me what it looks like when you are pulling shallow water. It's all the old-school tricks. Most of the guys these days, if the computer goes out, they want to just stop, and we can't. You got to know how to read a paper chart, old-school paper chart. It will save your life. You have to learn the old school before you learn the new school. I think my generation of towboaters, my age group and my years' experience, we kind of were right there at the crossover of everything. So we got the best of both worlds.

MICHAEL PAUL DITTO

– b. 1983 –

My name is Michael Ditto. Started in '03 and had my license in '06. My dad is a towboat captain. My brother is a relief captain. It's definitely a family occupation. It's all we know. Everybody that lives around us, we pretty much work on the river. It's not just a job. You carry other peoples' legacy on.

Out on the river, you're going to face challenges of being the younger person. When I came out for Southern, I moved up very quick, and I was always the younger person in charge. You're going to work with other people, and you have to really gain their respect. It's not going to be easy. It's going to be hard because it's not going to sit well with a younger person telling an older person what to do and being their boss. You're going to have challenges, but you got to stick to the goal that you set. If you want to move up, you're going to have to be the leader, the boss, and you're going to have to understand that you got to boss older people around at times. You've got to put your foot down and not pick it up. You can't be overrun.

I run the Ohio River mostly, and there are a lot of women pilots and captains that I run into. I have yet to run into one that couldn't drive as good as me. It's not just the guys can do it. The women that I've seen, they are pilots, and they are captains. It shows you that anybody can really do it as long as you set your mind to it.

There are guys on the boat that would like to be in the wheelhouse, but they are hard to find because of the responsibility level. Not everybody is too fond of having seven to ten guys' life in the palm of their hand. It takes a leader to do that. It's not the price of the cargo or the equipment and the boat. It's the lives are far more important.

Since I've come on the river, there have been unprecedented highs and lows. I've really been exposed to a lot since 2011. I've actually caught the whole entire record high. Then I've—I don't know if it was a record low, but I've been fortunate to catch the same stages as the older gentlemen and actually a little more. I've been lucky. We are trained to navigate the river. I pick high water any day of my career. It's easier. Some people will say it's harder, but you have more wiggle room. You can run more of the channel, so that makes your turn easier. In low water, you're restricted to one channel or one span of the bridge. I'd pick high water any day. It

is far easier and less stressful than on a low river. You're watching your sounder every five seconds. There isn't a worse feeling than going from thirty-five foot of water to five foot of water, and you got nine-foot draft. You can't stop it as easily.

DAVID JOHN KING

– b. 1984 –

My name is David John King. I've been on the river for about four or five years now. I came out to the river because of life choices with my family. My wife and I had premature kids, and we decided that we wanted a parent to be home with the them all of the time. So instead of both of us working, we started researching what could give us the best life for one working parent. I talked to a family member of mine, and they said, "Well, baby, don't you know your uncle's a river captain?" I said, "I don't know him. I don't owe him. He doesn't owe me." So I passed that by. But I get a phone call from a man I never met, and it was my uncle. He says, "Your aunt's been talking to me. She said you want to come out on the water." I was kind of blown away. So he told me to put an application in at Florida Marine Transport, and he got me hired over there. From that point on, he said, "I got you in. It's your responsibility to go where you want. But you have a long way to go to make pilot." And he said, "Just to let you know, you're not going to come out here and make captain." I guess I was ill-informed when I said I wanted to come out and be a captain. My uncle said, "You need to become a pilot first then a relief captain. Then you may become captain one day," he says, "but you have

to work on the deck first." I didn't know any of this. He said, "I'll get you there. I'll show you the way." And he did that.

I started looking into Coast Guard regulations and found out that I needed 360 days out on the water before I could even apply for a steersman license. I rode ten weeks on, two weeks off for a year and a half. At about the year mark, I had about 300-and-something days. At that point, I said, "All right, I'm going to school." I went to school. So it lasted for a month straight because they didn't do weekends. It was 21 days, but it was just Monday through Friday. Weekends were study time.

Once I got out of that school, I came back and rode an additional three months to get the rest of my days in. Once that happened, I applied for my steersman license, and I came in. The two DEs that were on my boat said, "If you get your license, we'll train you," and that's when my training began.

When I first started as a deckhand and finally got my pilot's license, it was about four years. I moved up pretty quick. I was very determined. I knew the rules. I knew what I had to do. And with me spending ten weeks out on the water at a time, two weeks at home, the majority of my life was spent on the water for those couple of years. For me, not being

home was very hard, especially having newborns. Thank God for FaceTime. I got to see my kids in video chats. Without technology I think it would have been lot harder for me to stay gone that long without seeing them.

Looking back now that I have a pilot's license, and I am a pilot now, it was well worth it. At sometimes I was working so hard focusing, I wasn't really looking at what I was doing. When I got to tankerman, I looked back and said, "Wow, that flew by pretty fast. Let's see if we can make the next jump." It's amazing that I climbed up the ladder so fast. But it's very possible. It's about a four-year run that I did before I became a pilot. That is very fast. Most people won't even talk to you about moving up that fast because it usually takes about six years. I moved up fast just because I understand the way things work. If these are the rules, then I go by them and proceed on.

Life out here on the river is never monotonous for me. I just like being on the water. So even though I may not be moving all the time, being on the water to me is just fun. I wish I had found this when I was younger because I found that it puts me more at peace. It was very stressful on the land. This puts me at peace. I feel that I'm much more peaceful out here. Being out on the water just does something for me.

If someone is thinking about working on the river and if they are old, I wouldn't suggest it. It's a young man's game. A person has to be in shape and everything else to deal with the constant tow building. But to come out here and work on deck, you have to be ready for a lot of stuff and a lot of physical conditions, rain, heat waves. It doesn't matter. We still build tow and still work every day. So there are no sick days out here.

JASON PITRE

– b. 1984 –

My name is Jason Pitre, and I am from Houma, Louisiana. I work with my hands, my mind. I've got more common sense than book smart. My education is on the water, but I haven't let it slow me down.

We rode Hurricane Gustave out in Houma on a boat. I didn't sleep. I don't like bad weather, but I think a boat is the safest place to be because it floats, and you're in the water, so if it floods, you're just going to come up with the tide.

It would be scary at times out on the river, but I experienced a lot of things that most people won't ever get to. Like seeing how the river works. The product and the cargo that gets moved up and down it, and how important it is for that river to be there. It's for merchant mariners. It's dangerous. That would be one of the main things I think I would stress is how dangerous it is, and you have to respect it. The first thing I'd say to those people out there on kayaks is, "Man, don't ever do that." They're nuts. I don't understand those people. With all the other places that they can be kayaking, they're going to do it in Mississippi. No, not me. Not at all. It's not safe. I don't know how those guys haven't gotten run over.

There's three things I'm scared of: my mama; snakes; and weekend warriors, as we call them (the kayakers, the sailboats). That's the three things that scare me in life. I have had some scary times with those weekend warriors. I have come close a few times. The worse one was running into shrimpers. They don't get out the way. I was in the canal turning into Port O'Connor jetty once. The shrimper was coming out, and I was coming in. It was one of those last-minute turns that you have to make. He was in my way and where I needed to be. So I was swinging, and I just kept on swinging out of the channel. I stopped, and that's when he darted off. I was going to run aground. I did what I had to do, but I was mad. That's probably one of the scariest ones I had with him right there. It was at night, probably about three in the morning. It was rough. I was definitely standing up. I wasn't able to talk to him on the radio, but I shined the light in his eyes. I went and threw the spotlight on him. I didn't say the best words. Those guys just don't understand how hard it is for us to stop or if something happens.

MAX TABER

– b. 1987 –

My name is Max Taber, and I've been on the river since 2012. I got on the river through working with American Cruise Lines, which is a small ship cruise company who's been in operation since 2000, and 2012 decided to launch a boat on the Mississippi River. In 2012, I started as basically an apprentice learning underneath the captain. I think a lot of boats call them steersman at other companies. When I came as an apprentice or steersman, I had already been a captain on our East Coast boats and boats in other operating areas. I got my first master's license when I was nineteen years old. I started working on the water when I was twelve on lobster boats on the Gulf of Maine during the summers. They still encourage you to go to school when you're that age, but I spent every free day I had on lobster boats and really small passenger boats. We ran ferries out to a group of islands off of New Hampshire and the Coast of Maine whale watching, on the Gulf of Maine. It took me awhile to know that I wanted to be a mariner. I didn't want to rush into anything, so I waited until second grade to make up my mind.

My grandfather was a captain on paddle-wheel steamboats on a lake in the Adirondacks in New York. His name was Captain Lee Taber. He captained steamboats and different passenger boats on Lake George in Upstate New York. So I always grew up riding on the boats. I am a mariner many generations back. When I was a child growing up, it was ocean-going type things. It was all I was familiar with growing up in the seacoast of New Hampshire. My grandfather told me that you always had to be a little bit brave. He said that that's what separated him from other captains and other people that operated boats.

Now I am working on the *American Eagle*. It was built in Salisbury, Maryland. So we did sea trials in the Chesapeake Bay. This winter, this last February, we brought it down from the Chesapeake Bay down through the Intracoastal Waterway below Cape Hatteras. And everything after Cape Hatteras was offshore down through Key West to across the Gulf of Mexico.

Ideally, I work thirty weeks out of the year. I try and take a long break during the winter stretch. In the winter, I stay on the water. My wife and I own a fifty-two-foot trawler. The last several years, we head down to the Bahamas for the winter, and then we take it back to New England in the summertime. We're in New Hampshire and Maine in the summer season, so I am on the water all the time.

On the Mississippi River, we're operating in a towboat environment even though we're not carrying barges. There's only a few of us on the river that aren't engaged in towing. So really to operate here one needs at least the basic understanding of what everybody else is doing. Being on a small maneuverable, it's pretty much our job, we think, to stay out of the way of everyone else. Ninety or maybe even a higher percentage of the time I'm on the boat. I don't leave my command. I feel tied to it.

I think plenty of mariners or seamen will tell you all the time that they're ready to get ashore, get a land job and be done with it, but I don't think any of them mean it. This is really what I love to do, and I really couldn't imagine being anywhere else. I think the river gets in your blood. It's just a fascinating area to operate a boat. There really isn't anything that I've experienced in this country that comes close to operating on the Western Rivers. We've run boats on the Columbia River and in Alaska and up and down the eastern seaboard, and it really is something different, something engaging, and something that you really connect with here on the river. With these boats on the Western River System we sail on the Ohio, the Upper Mississippi River, and the Lower with some trips up on the Cumberland River.

Because this is a new boat and she was built with modern propulsion, she's really not a true sternwheeler. We're not bound to the speeds that the sternwheelers use to be. She has a lot of horsepower, and she's able to make fourteen miles an hour through the water. Our propulsion engines are Caterpillar C32s, and we have three fullsize generators which are Caterpillar C18s. We carry a QMED, and he takes care of everything. We don't have a doctor on board. The licensed officers are all firstaid and CPR, and we have a defibrillator and oxygen.

I am twenty-eight, and I've have had my license since I was nineteen. I started as a deckhand, but I was promoted to chief mate when I was nineteen years old after twelve weeks on the boat as a deckhand. I started working in a second command capacity pretty much right away as soon as I had my license. There's a lot that goes into it. If it's something that you love doing, and you don't think about the effort that goes into it, it's just really something you do because you like to do it. For me, it was a surprise. Growing up, I didn't expect to operate on the Mississippi River. Most of the places we stopped at I probably couldn't have picked out on a map when I was working in the Gulf of Maine, but it's really been a surprise. It's something that gets in your blood. It's really a fascinating place to operate a boat.

INDEX

A

Adams, Doug, 118, 119
Admiral, 201, 202
Alamo, 193
Alamo Barge Line, 248
Albert Wolfe, 79
Alexander MacKenzie, 6, 41
Algiers Point, 67, 201
Allen, Donna, 169
Allen, Janet, 169
Allen, Richard, 169
Allen, William "Billy," 169–71
Alter, 141
Alter Barge Line, 140
American Commercial Barge Line, 27
American Cruise Lines, 313
American Eagle, 313
American Pillar, 110
American Queen, 39, 45, 71, 72, 84, 155, 226, 257
American River Transportation Company (ARTCO), 84, 127, 140
Anderson Tully Company, 11, 55
Angich, Joe, 88
Angola Prison, 170–71
Apex Towing Company, 70
Arkansas River, 50, 56, 287
Arrow Transportation, 193
Atchafalaya River, 20, 53, 132, 239, 260
Austin Golding, 251
Avalon, 45, 46, 47
Avondale Shipyard, 8–9, 121

B

Banta, Dorella, 80
Banta, Frank William, Sr., 8, 23–24, 80

Banta, George Wilson "Sonny," 8–10, 21, 22
Banta, James Wilson, 8, 19, 21, 60–61
Banta family, 59
Barge Transport, 179
Barnett, Shorty, 133, 134
Barstoff, Colonel, 54
Barton, Brad, 259
Basham, Earl, 39
Baton Rouge Coal and Towing Company, 8, 23
Bayou Pigeon, 10
Bayou Plaquemine, 10, 23, 167; Lock, 8
Bayou Sorrel, 10
Belle of Baton Rouge Casino, 202
Belle of Louisville, 46, 151
Bennett, Tim, 276
Benoit, Doug, 208
Bethel, Jim, 277
Betty Brent, 25
Biloxi, Mississippi, 88
Blessey Marine Services, 191, 208
Bob, Hurricane, 96
Boden, Vick, 233
Boggs, Gerald, 217
Bondurant, Richard T., 277–78
Booth, Captain, 3, 4
Boswell, John, 135, 219–20
Bowland, Jamie, 193
Bradford J, 118
Braun, Leo J., 34–35
Brent, Carole, 53
Brent, Howard Hayes, 31, 52–54, 63, 75
Brent, Jesse, 31, 51, 52–53, 80, 100, 126, 128
Brent, Lea, 31, 53
Brent Towing Company, 53, 56, 75, 93

Brightfield, 121–22
Brimstone, 30, 63, 185
Brister, Jeremy, 294–95
British Merchant Fleet, 174
Brooks, Luther, 89
Brown, Wesley, 125–28
Bruno, Vincent, 6
Brunswick, Red, 271
Bull Durham, 20
Bunge Grain, 56
Burt, Andy, 118–20
Bush, George, Sr., 46
Butkovich, Steve John, 6–7

C
Cairo, 51
Cairo, Illinois, 109
Canal Barge Company, 9, 10, 164
Cannon, John, 159
Capitol Fleet, 208
Capricorn, 119
Cargill, 23, 67, 79, 80
Carley, John Louis "Sonny," 107
Carole Brent, 54, 63
Carpenter, Wayne, 13, 14
Carrie B. Shwing, 10
Casey, Danny, 244–45
Cenac Towing, 96
Chapland, Katherine A., 264–65
Chapland, Otis, 264–65
Chauvin, Louisiana, 284
Chicago Mill, 50, 94, 159
Choctawhatchee River, 250
Chotin, Scott, 66, 202, 203
Chotin Transportation, 66, 132, 136, 202, 235
Christen, David, 154–56
Church, Rod, 193
Cincinnati, Ohio, 149, 150
City of Greenville, 125
City of Jonesville, 170
City of Pittsburgh, 185
City of St. Louis, 190
Coast Guard, 14, 38, 46, 47, 51, 85, 97, 106, 111, 119, 124, 126–27, 170, 186, 237, 238, 247, 275, 310
Cockrell, Robert, 206
Cockrell, Rodney, 206–7
Coffeeville Lock, 296
Cole, M. Sage, 296–97
Colorado River, 207
Columbia River, 313
Commercial Petroleum and Transport Company, 27
Commodore, 202
Compton, Buddy, 130
Conner, Earl M., 260–61
Corps of Engineers. *See* US Army Corps of Engineers

Couey, Grammel, 74
Couey, Walter, 73
Couey, William "Murry," 73–76
Coulter, Mitchell Scott, 286
Courteau, Rosalie, 71
Cox, Dale E., 234–36
Crane Brothers, 260
Crescent City, 70
Crescent Towing Company, 96
Crimson Duke, 128
Crimson Gem, 127
Crosby, Bing, 39
Crounse Corporation, 142, 192
Crow, W. O., 158
Crowley's Ridge, Arkansas, 287
Crutchfield, Mickey, 111
Cumberland River, 313

D
Daniel Webster, 125
Dauphin Island, 106
Davis, James W. "Jimbo," 157–61
Davis Marine Training, 161
Davisson, Joseph T., 121–24
Decareaux, T. Joe, 202
Delta Queen, 39, 45, 46, 47, 84, 121, 122, 123, 143, 145, 149, 150, 151, 153, 155, 157, 161, 226
DeMarrero, Harold, 39, 145
Denver, 69
Dewey, David E., 129–31, 190
Ditto, Michael Paul, 308–9
Dixie Carriers, 35, 248
Dolphin, 34
Domino, Joe, 88
Double D, 76
Driver, Doug, 119
Dufrene, Emile P., 113–15
Dugan, Bill, 150–51
Duncan, Cecil D., 189–91

E
Eastland, James O., 14
EB Ingram, 41
Edginton, Captain, 46
Edwards, Christopher R., 221–22
Edwards, Thomas, 221
Eisenhower, Dwight, 38
Evans, Danny, 225
Evansville, Indiana, 152
Evansville Marine Service, 152
Exxon, 202
Exxon Valdez, 169

F
Farley, Jim, 190

Faulkner, Jerry, 86–87
Federal Barge Line, 43, 193
Field & Stream, 193
Fields, Billy, 296–97
Flenner, Bernice, xiii
Florida Marine Transport, 310
Forbus, Ray, 34
Ford, Gerald, 46
Foreman, George, 145
Foster, Mike, 274
Foulgut, Ricky, 284–85
Frances K, 29
Franco, Captain, 59
Frank W. Banta, 10
Frog Bayou, 240
Froggett, Ira, 50

G
Gale, Joseph Van, Jr., 66–68
Gale C, 18
Gardener, Bobby, 140
Gardener, Red, 151
Gaudin, Joseph E., Jr., 230–31
General Jackson, 13, 26
Gentry, Rudolph, 180–81
George W. Banta, 167
Ghrigsby, James W. "Jim," Sr., 109–12
Gibson, Frank, 235
Glasgow, Scotland, 172
Goins, Franklin E. "Gene," Sr., 36–37, 80
Golding, Austin, xiii
Golding, John Reid, xiii
Golding, Steve, xiii, 63, 103, 136
Golding, Thomas, 53, 63
Golding Barge Line, xiii, 191
Gordon, Noble, 41, 42, 43, 44
Grammer, John, 223–24
Grand Ole Opry, 81
Great Steamboat Race, 159
Greenleaf, Toby, 89
Green River, 207
Greenville, Mississippi, 13, 51, 54, 57, 100, 127–28, 160, 178
Greenville Bridge, 18, 74, 157
Greenville Mill, 159
Guidry, Gary, 132–37, 219
Guidry, Steve, 133
Gunter, Malcolm, 62–63
Gustave, Hurricane, 312

H
Hall, John, 287
Hall, Harley Davis, Jr., 192–94
Halley's Comet, 232
Hamburg, Illinois, 41
Hamilton, Harry, 150, 151

Hampton, Gene, 43
Harriet Ann, 156
Harrington, Herman Blatz "Butch," Jr., 140–42
Harris, Bill, 37
Harris, Othelia, 19
Hartford, Johnny, 153
Harvey, Paul, 145
Harvey, Red, 79, 80, 219–20
Harvey Lock, 66
Haury, Mark, 208–10
Hawley, Clarke C. "Doc," 44–47, 151, 153
Hayes, Helen, 39, 46, 145
Haynes, A. D., 89
Hearn, John Robert, Jr., 238
Hearn, Steven, 237–38
Hemingway, Wilson, 52
Henry, Illinois, 129
Hicks, Joe, 14
Hightower, Joe, 7, 128
Hollinger, Russell, 56
Hollinger, William Alfred "Dub," Sr., 147
Hollinger, William Alfred "Peanut," Jr., 55, 104, 105–6, 147
Hollywood Marine, 262
Houma, Louisiana, 88, 120, 312
Houma Indians, 113
Hundley, Todd, 271–73
Hurley, 226
Hutto, Bill, 179

I
Igert, 144
Illinois, 21
Illinois River, 74, 79, 81, 87, 207, 284
Ingram Barge Company, 189
Inland Oil and Transportation, 164
Intracoastal Waterway, xiv, 88, 96, 167, 239, 301
Iway, 21

J
Jackson, Lucy, 19
Jackson, W. P., 70
Jason, 6, 104, 144
J-Gee, 66
Jimmy Vickers, 125
Joey Chotin, 133
John C. Byrd, 128
John Morrow, 125
Johns, Rodrick, 132
Johnson, Davey, 219
Johnson, Fontaine, 148
Johnson, Junior, 158
Johnson, Leon, 199, 250–51
Jolley, Sid, 67
Jones, Jason Paul, 288
Jones, Jimmy "Hog Head," 125

Jones, Mark "Red," 248–49
Jones, Perry Hilliard, 246–47
Jones, Ronald "Jonesy," 232–33
J. S. McDermott, 75
Jules, Captain, 66
Julia Belle, 153
Juneau, Brad, 306–7
J. W. Banta Towing Company, 18

K
Kanawha Belle, 46
Kanawha River, 45
Kaskaskia River, 207
Katrina, Hurricane, 204
Kellen, Bear, 158
Kelly, Albert, 150–51
Kesh, David, 71
Keyton, Captain, 39
King, David John, 310–11
King, Dolly, 126, 127–28
King, Charlie, 50, 51, 62
Kirby Inland Marine, 190, 191, 204
Kirth, Oscar, 190
Kleinpeter, Billy, 21

L
LaBeouf Bros., 77
Lacomb, Mike, 274
Lafitte, Louisiana, 69, 113, 154
LaGrange, Henry, 274
LaGrange, Jody, 274–75
Lake, Andy, 275
Lake Ferguson, 94, 158
Lake Pontchartrain, 77
Lake Providence, 62, 80, 304
Larom, Peter, 152
Leathers, P. T., 159
LeBlanc, Roland, 298
Lee, Robert E., 159
Leech, George, 30, 31
Lehman, Charles F., 27–28
LeMay, Percy, 52, 93, 125
LeMay, Ronnie, 125
Lily M. Friedman, 104
Linda, 154
Louden, Harry, 150
Lowery, Odis, 11–12
Luber, Jeff, 34
Lufcamp, John, 156
Lunga Point, 21
Lyman, Baker, 114

M
Mack, 62
Magnolia Marine, 129

Majestic Showboat, 45
Mama Lere, 42
Mandolini, Ally Bozette, 199
Mandolini, Markham Dewayne "Bozo," 198–200
Manthey, Joy Mary, 201–5
Margaret Brent, 37
Marian Hagested, 165, 264
Marie, Gustave Anthony "Butch," III, 284–85
Marineaux, Philo, 9, 10, 21
Marine Towing Company, 77
Mark David, 118
Markland Lock, 135, 185, 186
Martin, Perry, 73
Matchuny, Nora, 256
Matchuny, Robert Wayne "Bob," 256–57
Mathes, Ernest, 13, 100
Mathes, Mary, 103
Mathes, Richard "Dickey," 100–103
Maupin, Perry, 268–70
Mayflower, 166
McArthur, Arthur, 151
McClendon, Jack, 158
McCool, Gilder, 13, 26, 52, 53, 100
McCorkle Wright Gravel Company, 25
McCrory, Arkansas, 211
McDaniel, Jay, 170
McNeal, Simon Phillip, 223
Meadows, Barry, 62
Meece, Lou, 190
Menke, Gregory James "Greg," 149–53
Menz, Keith E., 164–65
Meramec River, 27
Metcalf, Edmond, 53
Miller, Bill, 219, 250
Miller, Charles, 250
Miller, J. R., 298–99
Miller, Roy, 6, 118, 119
Miller, Tim, xiii, 250–51
Mims, Hudy, 159
Ministry on the Rivers, 130, 204
Minnesota River, 100
Miriam Werner, 8
Miss Kae D, 127
Mississippi Queen, 39, 45, 84, 121, 143, 145, 147, 155, 158, 159, 226
Mississippi River, 18–19, 20, 53, 85, 109, 123, 232, 251, 269–70, 314
Mississippi Valley Barge Line, 56
Missouri River, 14, 29, 86, 87, 106, 207
Molloy Marine Service, 192
Monongahela River, xiv, 4, 5, 105
Morgan City, Louisiana, 19, 20, 118, 239
Murphy, Charles Kenneth, Sr., 212
Murphy, Charles Kenneth "Kenny," Jr., 211–12
M/V *Dan McMillan*, 271
M/V *John Reid*, 249

M/V *Lady Ree*, 101
M/V *Martha May*, xiii, 271
M/V *Mississippi*, 226, 227
M/V *St. Paul Socony*, 27

N
Nashville Coal Company, 40, 41
Natchez, 47, 159
Natchez Under the Hill, xiii, 14, 29
Nathan Golding, 170
National Coal, 43
National River Academy, 121, 189
Neal, Gene, 14, 25–26, 129
Neal, Louis E. "Jackie," 13–14, 80
New Iberia, Louisiana, 77, 113
New Orleans, Louisiana, 102, 121
New Orleans Barge Line, 70
New Orleans Baton Rouge Steamship Pilots Association (NOBRA), 53, 67, 123, 124
Nixon, Richard, 51
Nora's Ark, 256
Northern, 185
Northern States Power, 43
North Star Navigation, 277
Norwood, Ohio, 149
NSS *Savannah*, 96

O
Obion River, 207
O'Conner, Lee "Leo," 104–5
O. H. Ingram, 189
Ohio, 107
Ohio River, 36, 185
Olcott Marine, 144
Old Lady Mignon, 104–5
Ole Man River Towing, xiii, 198, 219, 286
Opal Lensing, 63
Opryland, 26
Orr, Jeffrey, 304
Ouachita, 79

P
Paducah, Kentucky, 130, 131, 152, 203, 216
Pam Dewey, 190
Parfait, Sonny, 77
Parks, Ken, 51
Parnell, Jimmy, 277
Patricia Ann, 157
Patrick Hurley, 41
Patton-Tully Construction, 55, 119, 125
Peck, Bert, 121
Pegram, Dee, 126
Pelican, 53
Peterkin, George, 35
Pierce, Delbert, 114

Pitre, Jason, 312
Plaquemine, Louisiana, 18, 59
Plaquemine Lock, 19, 21, 253
Plaquemine Towing Company, 18
Platte, E. J., 125
Playboy, 89, 193
Poe, Edgar Allen "Wamp" (father), 13, 26, 74
Poe, Wamp (son), 26, 74
Polliwog, 50
Polly S, 22, 24
Port City Barge Line, 129
Port O'Connor, 34, 312
Potter Towing Company, 40–41, 43
President, 201, 202
Prichard, Ray, 41

Q
Quail, Dan, 46

R
Raccoon River, 207
Raccoon Valley, 211
Ramrod, 154
Rankine, Linda, 173
Rankine, William "Bill," 172–74
Rathbone, 6
Reagan, Ronald, 46
Red, 271
Redd, Daniel Lee "Danny," 225
Reed, Clark, 51
Reed, George, 14, 25–26, 31, 36, 53, 94, 181
Reliance, 3–5
Repp, Frank, 24
Rice Queen, 124
Riley, LaVern, 209
Riley, Sam, 108
Riley, Stewart, 87
Rineheart, Louis Edward, 18–22, 252, 253
Rineheart, Marty, 252–53
Ritchie, Charlie, 143–48, 161
Ritchie, George, 143, 144
Ritchie, John, Jr., 105
Ritchie, John Baptist, Sr., 56, 84, 104, 105, 143, 144
Ritchie, Larry, 104–6, 143
Ritchie, Paul, 148
Robert Crown, 90
Robert E. Lee, 47
Roberts, Hardy, 144
Robinson, Jim, 193
Roebuck, Jim "Cannonball," 26, 30–31
Rogers, Clyde, 54
Rogers, Ginger, 145
Romero, Delfred J., 77–78
Romero, Frederick Shawn, 78
Romero, Fred Reid, 78

Rose, Glennie, 37
Rose Marie Walden, 159
Roy, Norman, 260
Rushingham, Willie, 24
Rusk, Carl, 53
Russell, Karen, 203
Russo, Peter, 77
Ruth Brent, 53, 54

S
Safety at Sea law, 149, 151
Samuel Clemens, 202
Sandage, Bud, 165
Sanderson, Tiny, 36
Scarborough, 166
Scarborough, Edmund, 166
Scarborough, William R. "Randy," 166, 264
Scarbrough, Kenny, 67
Schultz, Harold, 69–71
Seamen's Church Institute, 130–31, 152, 203–4
Shannon, Brett H., 292–93
Sharp, Jimmy F., 84–85
Shewmaker, Garland, 38–39
Shirley Bowland, 140
Shurden, Mark, 126
Sibley, 119
Simpson, James "Suitcase," 50
Sinclair Oil, 211
Sioux City and New Orleans Barge Line, 70, 90, 91
Sisters of St. Joseph, 203
Smiley, Terri L. "Sunshine," 216–18
Smith, Jean, 203, 204
Smith, J. O., 30
Smith, John S. "Smitty," 59–61
Soileau, Patrick, 239–40
Sprague, xv, 6, 9, 13, 14, 20, 43, 54, 73, 80, 94, 144, 150, 151, 202, 271
SS *Bennestvet Brovig*, 27
SS *Manhattan*, 67
Standard Oil, 202
Standard Oil Company, 54, 150
Star of Louisville, 256
Starved Rock Lock, 170
Stern, Eric, xiii, 300–301
St. Marks River, 244
Stokes, David, 160
Strassburg, 67
Streckfus, R. M., 201
Strickland, Ted, 248
Stuckey, Boyce "Pete," 282–83
Surgie, Euless, 154
Switch Boats, 208

T
Taber, Lee, 313

Taber, Max, 313–14
Tacoma, 21
Tamble, Warner, 73
Tapp, Eddie, 147
Templeton, 25
Templeton, Bill, 25, 192–93
Teresa of Calcutta, 203
Tessler, 18
Thompson, Mike, 75
3R Towing, 77
Tiger Fleet, 212
Tinkey, Jerald "Jerry," 40–44
Tolen Marine, 258
Torner, William V., 3–5
Toussaint, George, 106
Trosclair, Menville, Sr., 88–92, 188
Turnage, James, 62
Turner, Charles, 79–81, 274
Twain, Mark, 38, 47, 104, 109, 112, 145–46, 148, 206, 208; *Life on the Mississippi*, 143, 146

U
Underwood, Harry, 41
Union Barge Line, 3
US Army Corps of Engineers, 9, 38, 52, 54, 68, 75, 76, 87, 126, 127, 160, 198, 225, 226, 249, 282
USS *Juneau*, 27

V
Valda, 13
Valerius, Steve, 204
Valley Line Company, 88, 148, 188
Valley Towing Company, 125
Valley Transporter, 188
Valley Voyager, 91
Verdigris River, 107
Vermilion River, 77
Vest, Carl, 128
Vest Towing Company, 128
Vickers, Elmer "Iron Head," 29, 157
Vickers, J. E., 125, 128
Vicksburg Bridge, 18, 74, 110, 146, 181, 207, 235
Victoria Bend, 89, 233, 283

W
W. A. Barta, 104
Wagner, Ernest, 121, 151
Wakeland, Chris, 262–63
Walden, Jim, 159
Walker, John Henry, 187–88
Waller, Jesse, 118
Ward, Eileen, 181, 182
Ward, Rudy, 178–83
Watford, Jay, 272
Waverly, 87

Waxler, Damon, 223
Waxler, Ted, 223
Waxler Towing Company, 224
Weathers Transportation, 157
Weeks, Jim, 100
West, Robert, 225
Western Rivers Training Centers, 179
Wetherington, Corey, 258
Wetherington, David "D. W.," 258–59
White River, 50, 67
Wilcox, Wayne "Hootenanny," 50, 101, 159
Wilcox family, 57–58, 159
Wilkins, Dale, 190
Williams, John, 225
Williams, Lauren "Shorty," 7, 41
Williams, L. C., xiii, 219, 235, 268, 271, 272
Williams, Rex, 167–68
Williams, Wimpy, 7
Williamson, Bilbo, 51, 53
Williamson, Bill, 53

Willard, 6
Willingham, Donnie, 102
Willingham, Gene, 231
Winders, William B. "Bill," Jr., 184–86
Wolfe, Albert L., 29–31, 79, 80, 94, 100, 101
Wolfe, Clyde Luther, 80, 93
Wolfe, John, 31
Wolfe, Perry, 76, 93–95
Wolfe, Scott, 94
Wolfe, Steve, 94
Wood River, Illinois, 6, 40, 70, 235, 264, 292
Worley, Elmer, 152–53

Y
Yazoo River, 51, 52

Z
Zar, Steve, 69
Zeiczak, Joe, 96–97